LUXURY EQUESTRIAN DESIGN

edited by Wolfgang Behnken

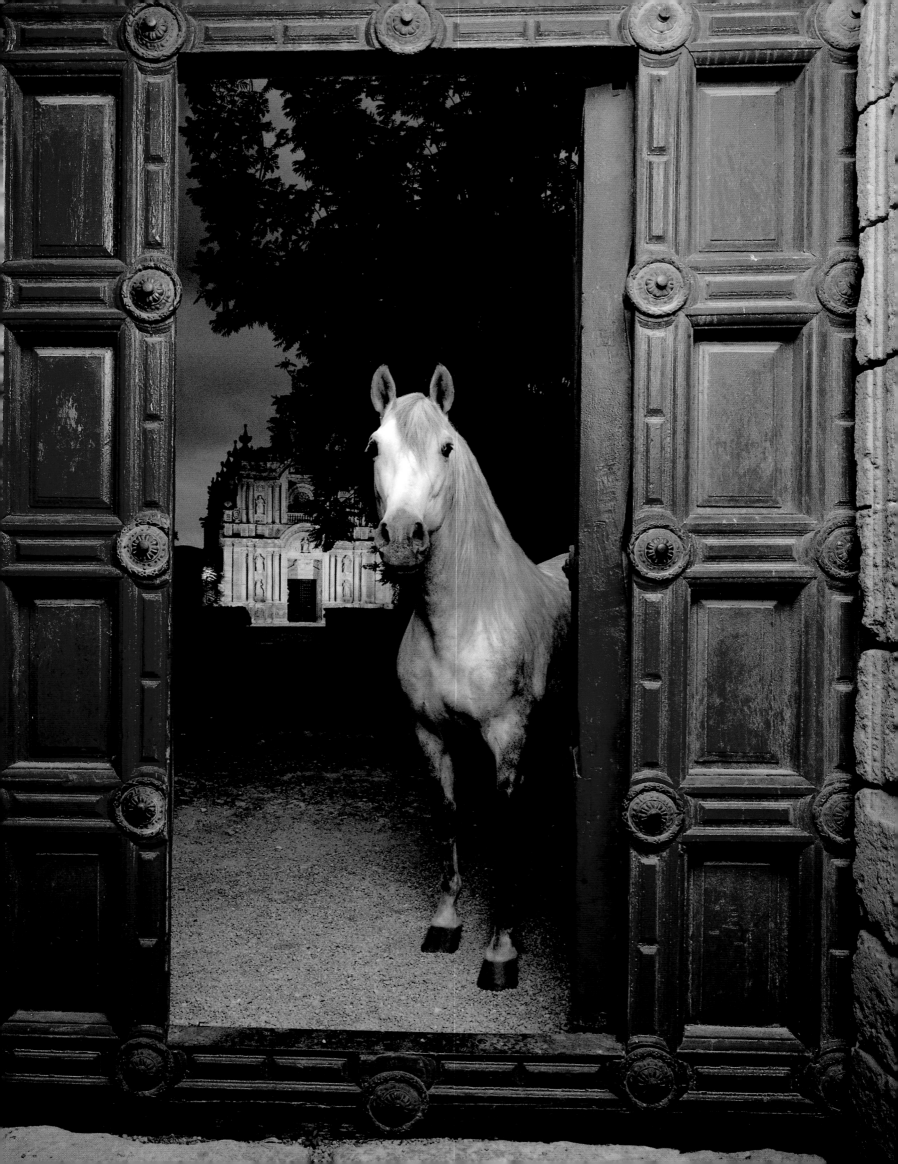

LUXURY
EQUESTRIAN DESIGN

edited by Wolfgang Behnken

teNeues

The horse was designed by a heavenly master plan, and its shape was determined by an evolutionary process of several million years. In addition, humans also interfered, putting a finishing touch on horses through breeding and selecting, so to say giving them the design of today. Form follows function. This meant that humans and horses came in closer contact, which was not always in the best interest of horses.

Up until the industrial revolution, horses were the primary means of transportation. The expensive animals, however, were usually reserved for the wealthy and powerful individuals for use as riding horses. Those who owned horses were literally elevated. Men of power and prowess moved on horseback and were able to look down on others from that height. Many rulers of long ago utilized this effect and have been elevated above their subjects of proud horses in countless monuments, even if in real life they were weak and short of height.

This situation changed dramatically once the automobile was invented. When Henry Ford subsequently introduced the car for everyone with his mass production of the self-propelled carriages, it was the launch of the mobile society. From this point on, people moved with multiple horse powers from A to B and pushed horses away from the streets. Even though cars became the new status symbols within a short period of time, they nevertheless were not able to significantly alter the relationship between humans and animals. Modern humans discovered in the horse a partner for leisure times and started searching for their happiness on the backs of horses. This resulted in the establishment of a blooming leisure industry with and around horses.

The passion for the four-legged creature no longer is the exclusive domain of nobility and reserved for the wealthy. Broad masses have been infected with the "horse virus". Be it in search of happiness as riders or by their admiration of the creatures in pictures and sounds.

The growing wealth of a society leads to it increasingly "discovering horses". Recently we read in newspapers that the Chinese have now also discovered horseback riding for themselves. They set out and buy from breeders all that is good and expensive. Great amounts of money are paid today for the champions of tomorrow. In the regions surrounding the great metropolitan cities luxurious riding establishments are springing up like mushrooms.

With this book we want to take you to the fascinating world of horses. We present you with the wealth of the various breeds, the most beautiful and noble horses, the magnificence of the old European riding schools, the luxury stables of the Arabs, fashion and accessories, equestrian legends, impressive equestrian games, horse icons in arts and media …

Even though my passion is larger than my riding abilities—I can assure you that there is nothing better than experiencing the world on horseback. On the back of a creature that is equipped with abilities that we have lost during the course of evolution. With this book, we want to impart to you some of this feeling of happiness.

Hope you enjoy reading this book.
Sincerely, Wolfgang Behnken

Entworfen wurde das Pferd von himmlischen Mächten, in Form gesetzt hat es ein Evolutionsprozess von mehreren Millionen Jahren. Zusätzlich haben die Menschen Hand angelegt und durch Zucht und Auslese dem Pferd den letzten „Schliff" gegeben, sozusagen das heutige Design verpasst: Form follows function. Dabei kamen sich Mensch und Tier näher, was nicht immer zum Wohle des Pferdes war.

Bis zum Beginn der Industrialisierung war das Pferd Fortbewegungsmittel Nummer eins. Das teure Tier war jedoch in der Regel den Wohlhabenden und Mächtigen dieser Welt als Reitpferd vorbehalten. Wer im Besitz eines Pferdes war, saß damit buchstäblich oben. Männer mit Macht und Ansehen bewegten sich zu Pferd und konnten von dort auf die anderen herabblicken. Viele Herrscher vergangener Tage machten sich diese Wirkung zu Nutze und haben sich in unzähligen Denkmälern auf stolzen Rössern über ihre Untertanen erhoben, mochten sie auch im wirklichen Leben schwach und von geringer Größe gewesen sein.

Die Sachlage änderte sich nachhaltig, als das Automobil erfunden wurde. Als dann Henry Ford mit der Massenproduktion der selbstfahrenden Kutschen das Auto für jedermann kreierte, war das der Startschuss für die mobile Gesellschaft. Fortan bewegte sich der Mensch mit vielfachen Pferdestärken von A nach B und verdrängte das Pferd von der Straße. Zwar wurde das Auto binnen kürzester Zeit zu einem neuen Statussymbol, doch konnte es die Beziehung zwischen Mensch und Tier nicht wesentlich stören. Der moderne Mensch entdeckte das Pferd als Partner für die Freizeit und suchte sein Glück auf dem Rücken der Pferde, mit der Folge, dass sich eine boomende Freizeitindustrie mit und um das Pferd installierte.

Nicht länger ist die Leidenschaft für die Vierbeiner Privileg des Adels und nur den Wohlhabenden vorbehalten. Breite Massen sind mit dem „Pferdevirus" infiziert. Sei es, dass Sie als Reiter ihr Glück suchen, sei es, dass sie die Geschöpfe in Bild und Ton verehren.

Mit wachsendem Wohlstand ist die Gesellschaft immer mehr „auf das Pferd" gekommen. Gerade lesen wir in der Zeitung, dass nun auch die Chinesen den Reitsport für sich entdeckt haben: Sie schwärmen aus und kaufen bei Züchtern auf, was gut und teuer ist. Dabei werden für die Champions von morgen Unsummen gezahlt. In den Peripherien der Megapolen schießen derweil luxuriöse Reitanlagen wie Pilze aus dem Boden.

Mit dem vorliegenden Buch wollen wir Sie in die faszinierende Welt rund um das Pferd entführen. Wir zeigen Ihnen den Reichtum der verschiedenen Rassen, die schönsten und edelsten Pferde, die Pracht der alten europäischen Reitschulen, die Luxusställe der Araber, Mode und Accessoires, die Legenden des Reitsports, prachtvolle Reiterspiele, Pferdeikonen in Kunst und Medien….

Auch wenn meine Leidenschaft größer als meine reiterliche Fähigkeit ist – ich versichere Ihnen, nichts ist schöner als auf dem Rücken eines Pferdes die Welt zu erleben. Mit einem Geschöpf, das mit Fähigkeiten ausgestattet ist, die uns im Laufe der Evolution verloren gegangen sind. Ein wenig von diesem Glücksgefühl möchten wir Ihnen mit diesem Buch vermitteln.

Viel Spaß beim Lesen.
Herzlichst, Wolfgang Behnken

Le cheval a été conçu par des puissances célestes et mis en forme par un processus d'évolution sur plusieurs millions d'années. De plus, les hommes ont mis la main à la pâte pour parfaire le cheval par l'élevage et la sélection et lui donner pour ainsi dire son design actuel : la forme suit la fonction. Ceci a également permis le rapprochement de l'homme et de l'animal, ce qui n'a pas toujours été pour le bien-être du cheval.

Jusqu'au début de l'ère industrielle, le cheval était le moyen de transport numéro un. Cependant, comme cheval de selle, cet animal coûteux était en général réservé aux riches et aux puissants. Quiconque possédait un cheval était littéralement haut placé. Ceux qui jouissaient du pouvoir et de la considération se déplaçaient juchés sur un cheval et pouvaient toiser les autres. Nombre de souverains des siècles passés ont exploité ce privilège dans d'innombrables monuments où, du haut de leur monture, ils s'élèvent au-dessus de leurs sujets, même si, en réalité, ils étaient faibles et de peu d'envergure.

La situation changea durablement quand fut inventée l'automobile. Quand Henry Ford créa la voiture pour Monsieur Tout-le-Monde, grâce à la production à la chaîne de la calèche automotrice, ce fut le lancement de la société de mobilité. A partir de là, l'homme s'est déplacé de A à B grâce à de puissants chevaux-vapeur et a écarté le cheval de la route. Il est vrai que la voiture est devenue en un rien de temps un nouveau symbole de statut social ; ceci n'a pourtant pas altéré sensiblement la relation de l'homme avec l'animal. L'homme moderne a découvert le cheval comme compagnon de loisirs et s'est mis à chercher son bonheur sur le dos des chevaux, ce qui déboucha sur le développement d'une industrie des loisirs florissante avec le cheval et autour de lui.

La passion pour ces quadrupèdes n'est plus le seul privilège de la noblesse, réservée uniquement aux personnes aisées. De grandes foules ont contracté le « virus du cheval ». Soit ils recherchent leur bonheur comme cavalier, soit ils l'adorent par le son et l'image.

La prospérité aidant, la société a fini par prendre goût au cheval. Nous lisons justement dans le journal que les Chinois aussi ont désormais découvert le sport équestre : ils se déploient de par le monde et achètent auprès des éleveurs ce qui est bon et cher. Des sommes considérables sont déboursées pour les champions de demain. A la périphérie des mégapoles, des centres équestres somptueux poussent comme des champignons.

Ce livre a pour objectif de vous transporter dans le monde fascinant du cheval. Nous vous montrons la richesse des différentes races, les chevaux les plus beaux et les plus nobles, la magnificence des vieilles écoles d'équitation européennes, les écuries de luxe des Arabes, la mode et les accessoires, les légendes du sport hippique, de superbes concours de cavaliers, des chevaux faisant figure d'icône dans l'art et les médias …

Même si ma passion est plus grande que mon talent de cavalier – je vous assure qu'il n'y a rien de plus beau que de monter à cheval et de découvrir le monde de là-haut. Avec une créature qui détient des facultés que nous avons perdues au cours de l'évolution. C'est ce sentiment de bonheur que nous voudrions vous faire partager avec ce livre.

Je vous souhaite bonne lecture.
Bien à vous, Wolfgang Behnken

El caballo fue creado por fuerzas divinas y el proceso de evolución se encargó de ponerlo en forma hace millones de años. Los hombres también han influido sobre él y a través de la cría y la selección, le han dado al caballo el último "pulido" o, por así decirlo, su diseño actual: la forma al servicio de la función. Durante este proceso hubo un mayor acercamiento entre el hombre y el animal, lo que no siempre fue ventajoso para el caballo.

Hasta el comienzo de la industrialización, el caballo era el medio de transporte más importante. Este caro animal, sin embargo, estaba reservado para los más pudientes y poderosos como caballo de montar. Quien poseía uno de estos ejemplares, estaba literalmente sentado arriba. Los hombres con poder y reputación podían mirar a los demás desde su posición. Muchos señores del pasado se aprovecharon de este efecto elevándose en innumerables monumentos por encima de sus súbditos a lomos de orgullosos corceles, a pesar de que en la vida real fueran personajes débiles y de estatura pequeña.

La situación cambió para siempre cuando se inventó el automóvil. El comienzo de la sociedad móvil fue cuando Henry Ford fabricó en serie la carroza que se conducía sola, facilitando a todos un vehículo. A partir de ese momento, el hombre empezó a desplazarse de un lugar a otro con la potencia de varios caballos, echando al animal de la calle. A pesar de que el coche se convirtió en símbolo de nivel social en poco tiempo, no afectó de forma fundamental a la relación entre el hombre y el caballo. El hombre moderno descubrió el caballo como compañero de ocio y buscó su suerte a lomos de él, con el resultado de una industria del tiempo libre en expansión entorno al caballo.

La pasión por este animal no quedó reservada para la nobleza y los ricos. La amplia masa de la población fue infectada con el "virus equino". Ya sea porque buscan su suerte como jinete o porque le rinden culto a través de la imagen y el sonido.

Conforme aumenta el bienestar de la sociedad, más se acercan sus miembros al caballo. Hoy podemos leer en los periódicos que los chinos descubren ahora la equitación: muchos de ellos compran en criadores lo que es bueno y caro, y pagan hoy cantidades ingentes por los campeones de mañana. En las periferias de las megalópolis, los hipódromos de lujo surgen del suelo como las setas.

Con este libro queremos llevarle al fascinante mundo del caballo. Le descubrimos la riqueza de las diferentes razas, los caballos más bellos y nobles, la suntuosidad de las antiguas escuelas de equitación europeas, los establos de lujo de los árabes, la moda y los accesorios, las leyendas de la equitación, los soberbios juegos de jinetes, los caballos convertidos en iconos en el arte y los medios …

Aunque mi pasión por la hípica sea mayor que mis aptitudes, le aseguro que no hay nada más bonito que experimentar el mundo a lomos de un caballo. Con una criatura que posee capacidades que nosotros, las personas, hemos ido perdiendo con la evolución. Con esta obra queremos transmitirle un poco de esta dicha.

Espero que se divierta leyéndolo.
Cordialmente, Wolfgang Behnken

Creato da forze celesti, il cavallo ha preso forma grazie ad un processo evolutivo durato milioni di anni. Infine l'uomo, con incroci e selezioni, ha dato al cavallo l'ultimo "tocco", conferendogli per così dire il suo aspetto attuale: la forma segue la funzione. Nel corso di questo processo, uomo e animale hanno instaurato un rapporto che non sempre ha giovato al cavallo.

Prima dell'industrializzazione, il cavallo era il mezzo di locomozione più diffuso. Ad utilizzare come cavalcatura il costoso animale erano però generalmente solo le classi più potenti e benestanti. Chi possedeva un cavallo godeva di una posizione di chiaro privilegio: spostarsi a cavallo guardando gli altri dall'alto in basso era una prerogativa degli uomini potenti e degni di rispetto. Molti sovrani del passato sfruttarono questa situazione e, a dispetto del fatto che la loro indole, nella vita reale, si rivelava spesso debole e meschina, si innalzarono al di sopra dei loro sudditi facendosi raffigurare in molti monumenti in groppa a nobili destrieri.

Quando fu inventata l'automobile, la situazione cambiò drasticamente. E quando Henry Ford, con la produzione in massa di queste carrozze auto-trainanti, rese l'automobile un mezzo alla portata di tutti, ebbe inizio l'era della società mobile. L'uomo continuò a spostarsi da A a B con veicoli sempre più veloci, e il cavallo scomparve dalle strade. In breve tempo, l'automobile divenne un nuovo status symbol, ma ciò non poté essenzialmente distruggere il rapporto tra uomo e animale. L'uomo moderno scoprì il cavallo come compagno del proprio tempo libero e cercò la felicità sulla sua groppa; la conseguenza fu l'esplosione di una fiorente industria del tempo libero che ruotava intorno al cavallo.

La passione per questo quadrupede non è più un privilegio dei nobili a cui possono avere accesso solo i benestanti. Il "virus equino" ha colpito la massa contagiando sia gli appassionati di equitazione sia coloro che amano il cavallo come opera d'arte.

La crescita del benessere ha agevolato il diffondersi della passione per i cavalli. Dai giornali apprendiamo che anche i cinesi hanno ormai scoperto gli sport equestri: a frotte, acquistano dagli allevatori esemplari pregiati e costosi, pagando per i futuri campioni cifre da capogiro. Nelle periferie delle metropoli, i maneggi spuntano come funghi lussuosi.

Questo libro rapirà il lettore nell'affascinante mondo dei cavalli, mostrandogli la molteplicità delle razze equine, i cavalli più belli ed eleganti, lo splendore delle scuole d'equitazione europee, le lussuose stalle degli arabi, la moda e gli accessori, le leggende dell'ippica, lo sfarzo dei giochi equestri, il culto del cavallo come opera d'arte e come fenomeno mediatico …

Anche se la mia passione supera di gran lunga le mie capacità di cavaliere, il mio messaggio al lettore è che non c'è nulla di più bello che scoprire il mondo sulla groppa di un cavallo, una creatura ancora dotata di quelle capacità che noi, nel corso dell'evoluzione, abbiamo perduto. Trasmettere un poco di questa felicità è l'intento di questo libro.

Buona lettura.
Cordialmente, Wolfgang Behnken

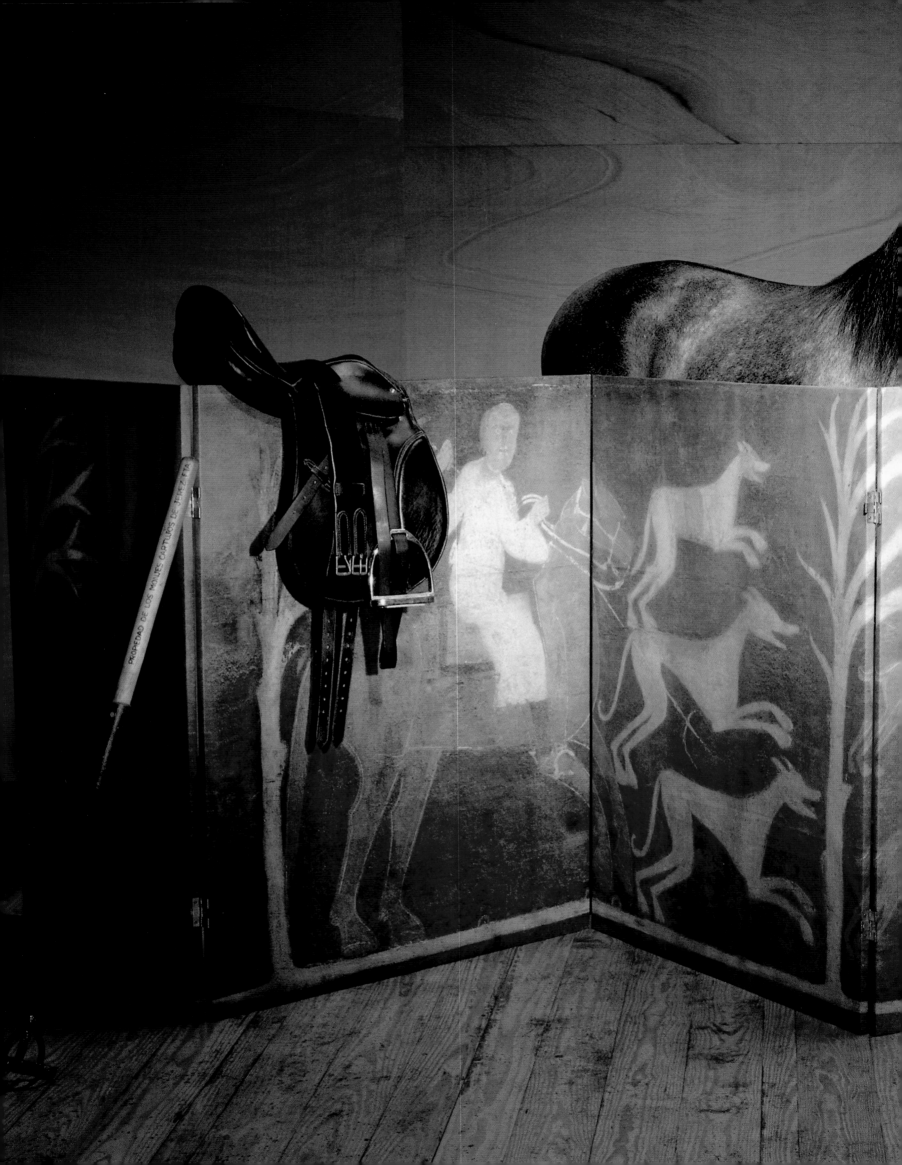

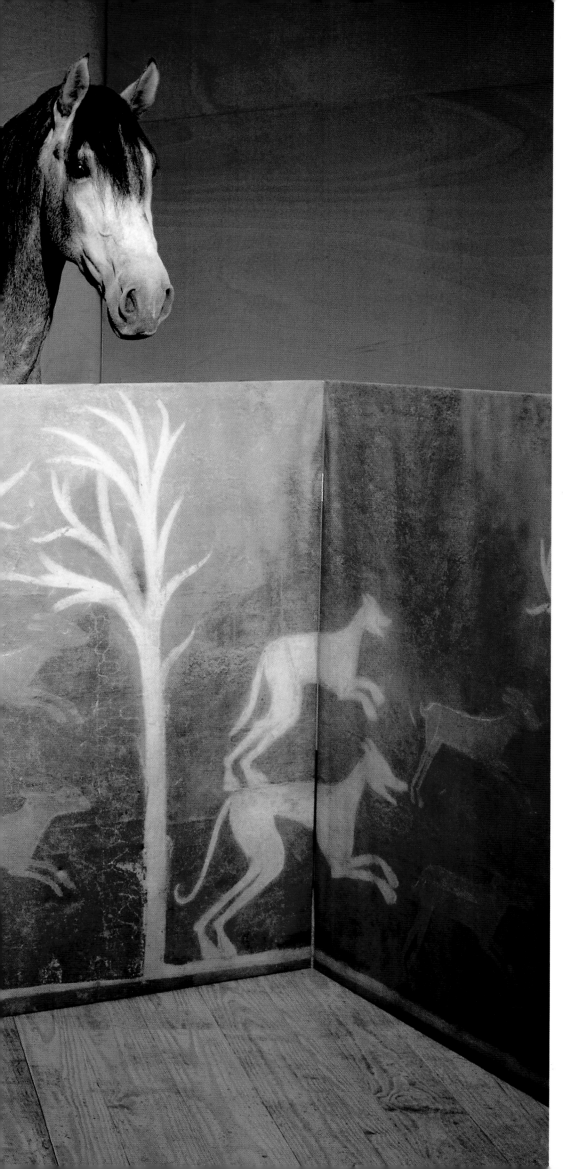

Beauty: The horse behind the divider belongs to one of the world's most noble breeds: the Carthujanos. The Spanish breed owes its name to the Carthusian order of Jerez de la Frontera. In the 15th century, the monks were granted 9,900 acres by the Spanish royal family for the establishment of a stud farm. It is estimated that around 1,000 horses of this ancient breed still exist around the world today.

Schönheit: Das Pferd hinter dem Paravent gehört zu den edelsten der Welt, den Cartujanos. Die spanische Rasse verdankt ihren Namen dem Kartäuserorden von Jerez de la Frontera. Die Mönche bekamen im 15. Jahrhundert vom Spanischen Königshaus 4000 Hektar zur Gründung eines Gestüts vermacht. Weltweit soll es noch etwa 1000 Pferde aus dieser alten Zucht geben.

Beauté : le cheval derrière le paravent fait partie des plus nobles au monde, les Cartujanos. Cette race espagnole doit son nom à l'ordre des Chartreux de Jerez de la Frontera. Au 15ème siècle, la maison royale légua aux moines Chartreux 4000 hectares pour la fondation d'un haras. Il semblerait qu'il y ait encore, de par le monde, 1000 de chevaux issus de cet ancien élevage.

Belleza: El caballo de detrás del biombo pertenece a una de las razas más exquisitas del mundo; los Cartujanos. Esta raza española debe su nombre a la Orden Cartujana de Jerez de la Frontera. Los monjes de esta orden recibieron en el siglo XV de la casa real española 4.000 hectáreas para crear un criadero de caballos. En todo el mundo debe haber todavía unos 1.000 caballos de esta antigua cría.

Bellezza: il cavallo dietro il paravento è un Cartujano, uno degli esemplari più pregiati del mondo. Questa razza spagnola deve il proprio nome all'ordine dei Certosini di Jerez de la Frontera. Nel XV secolo questi monaci ricevettero dalla casa reale di Spagna 4000 ettari da destinare all'allevamento equino. Pare che al mondo esistano ancora circa 1000 cavalli provenienti da questo antico allevamento.

CONTENTS

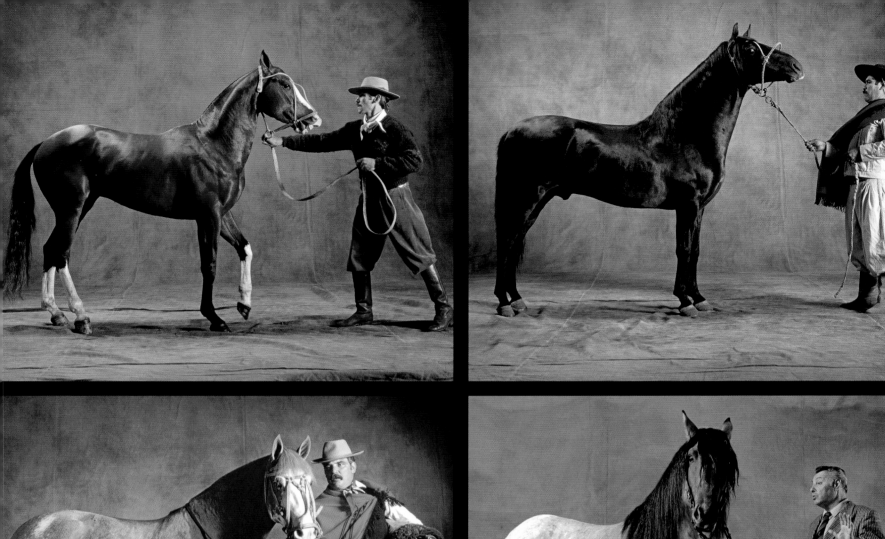
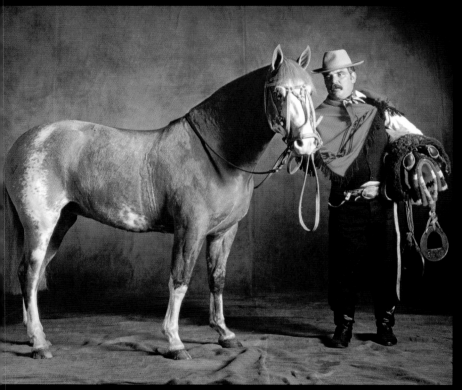
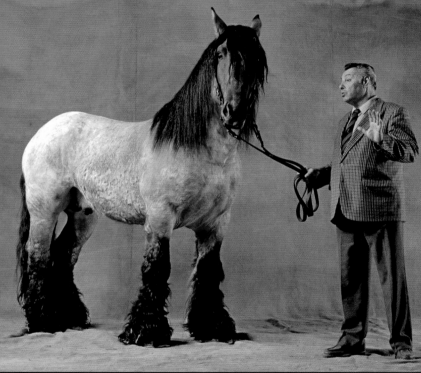
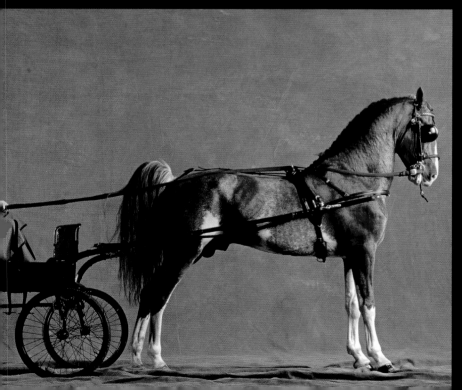
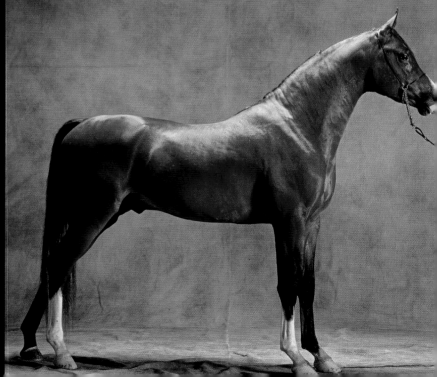

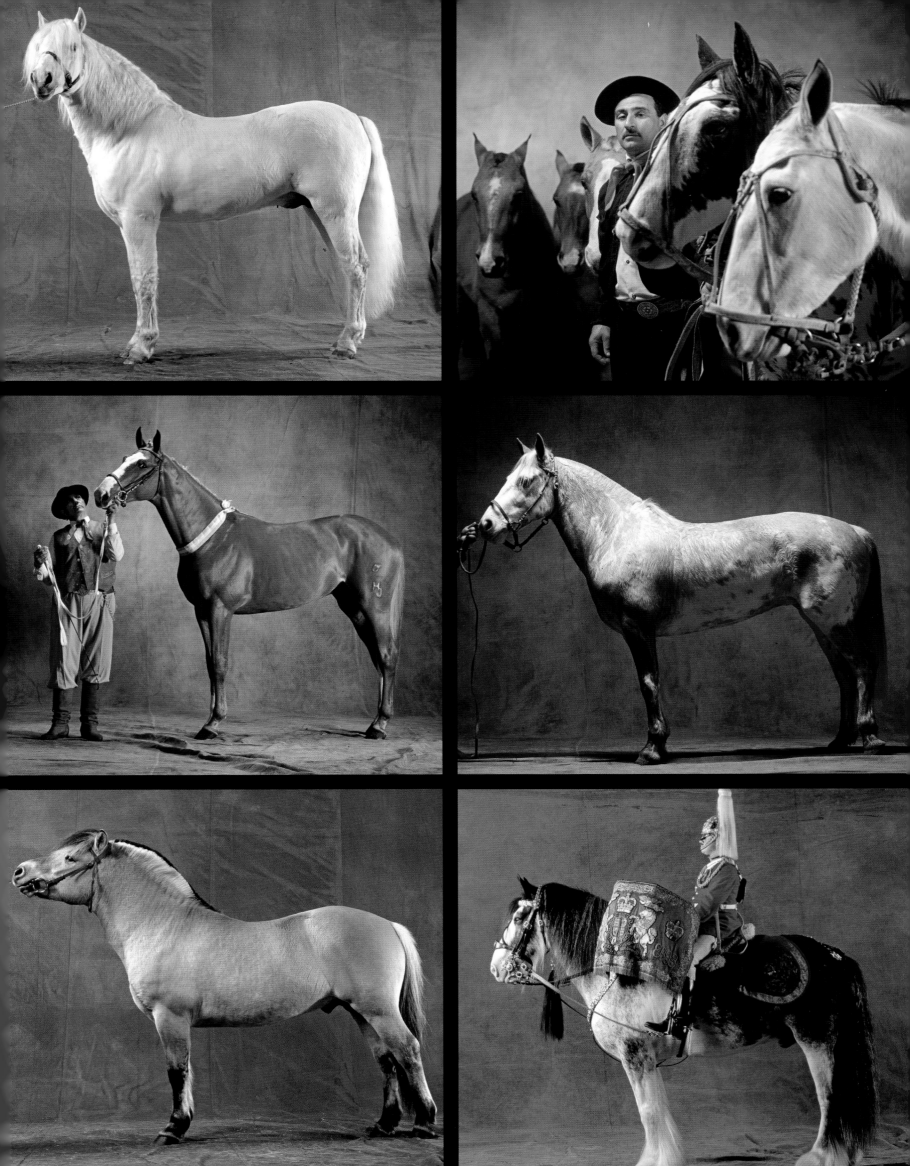

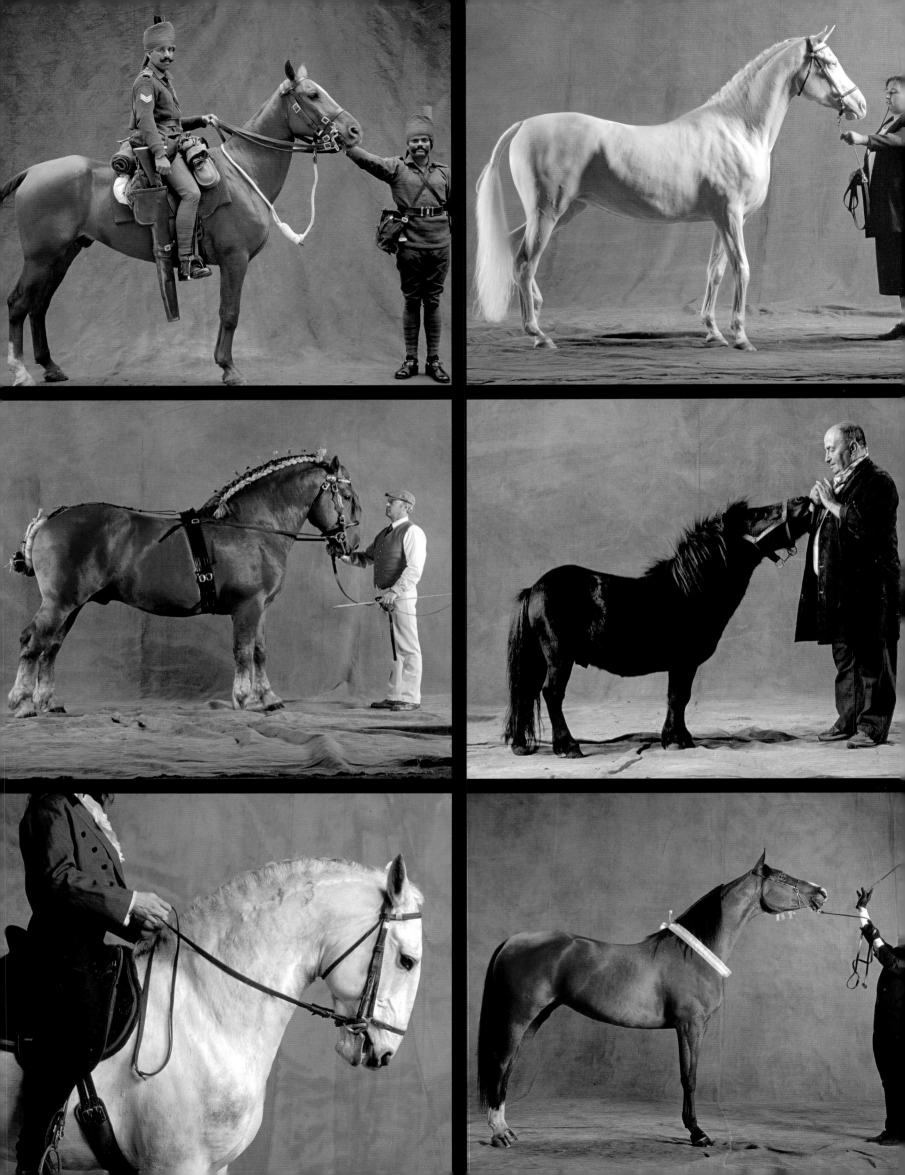

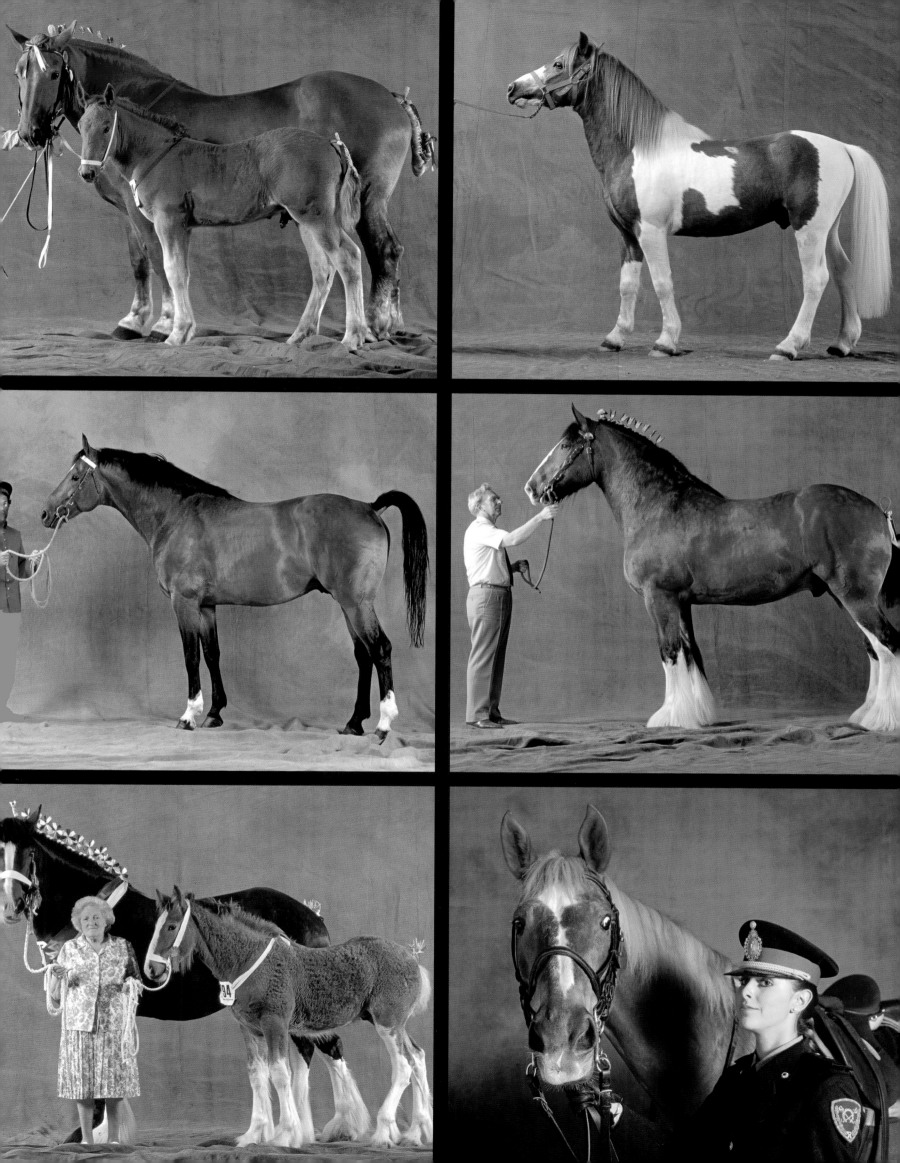

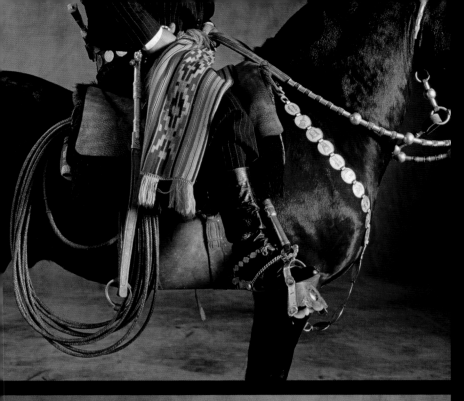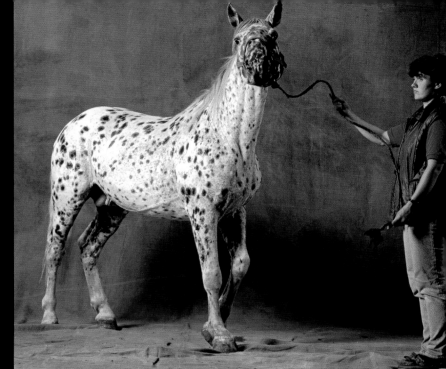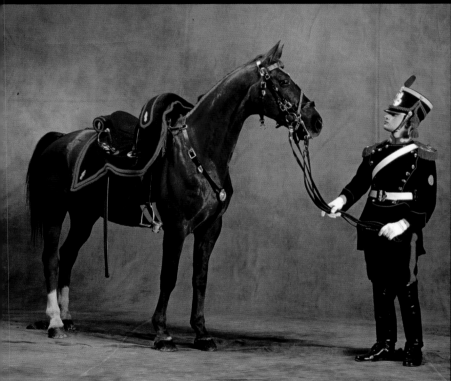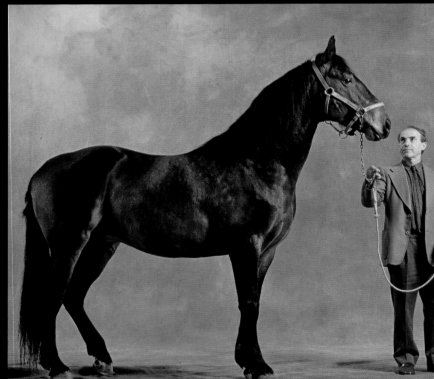

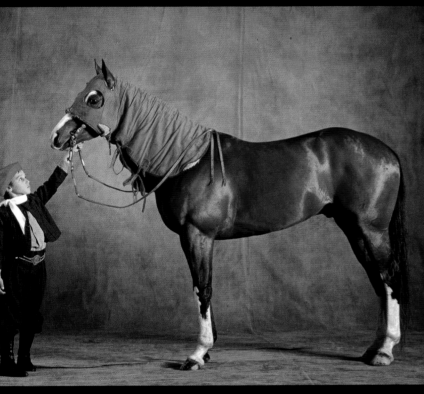
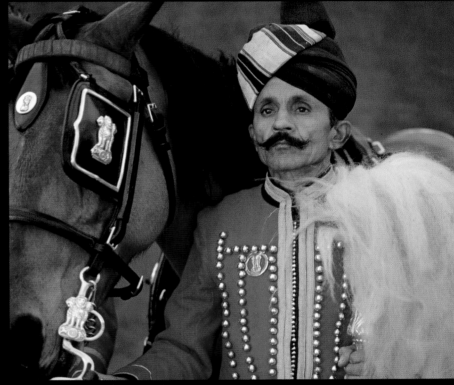
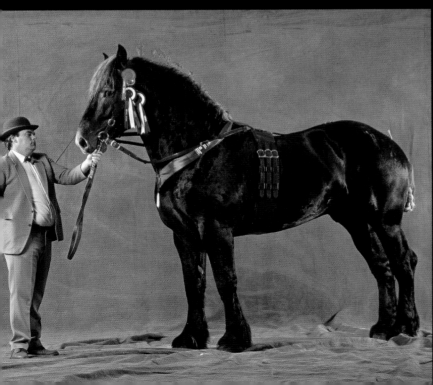
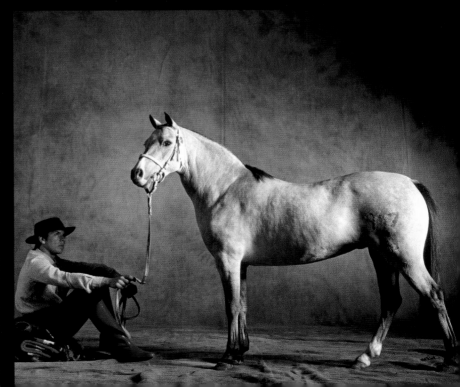

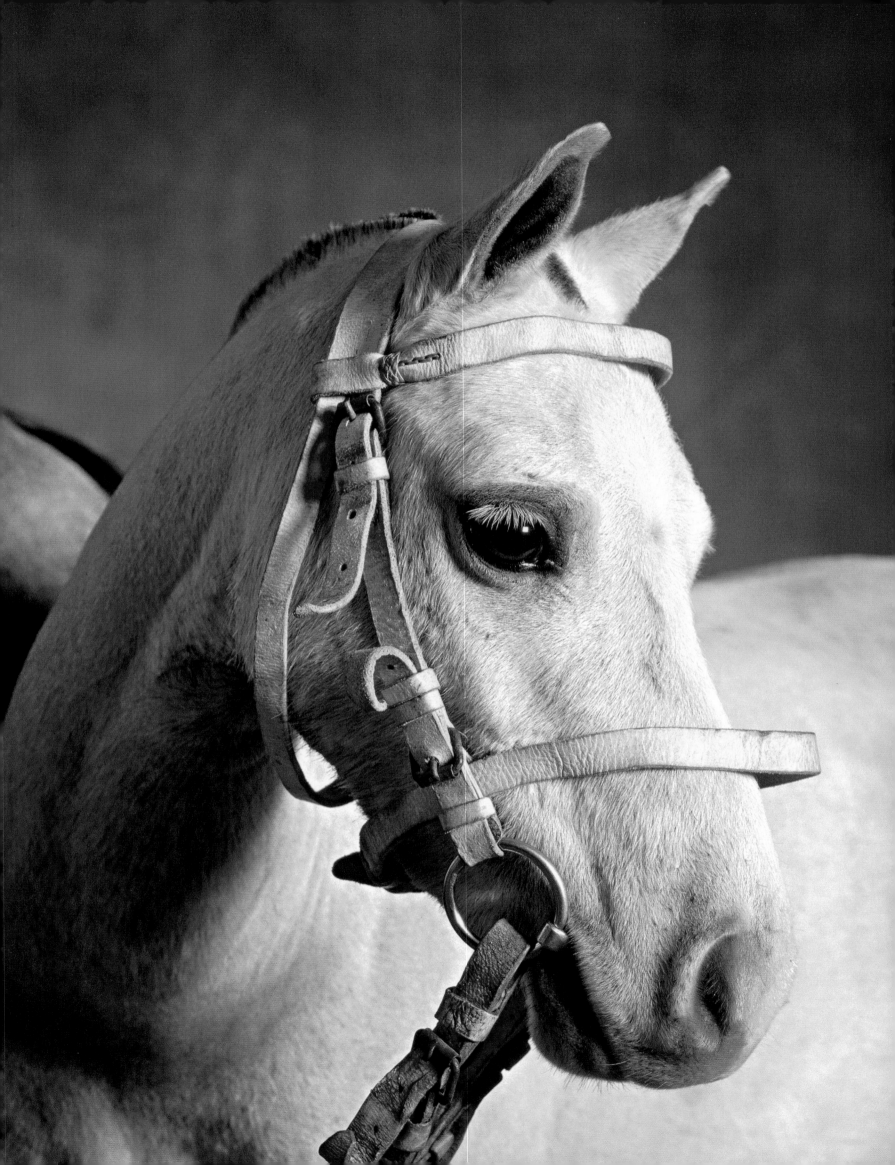

1: Ombucito Impacto, an Argentinian polo horse.

2: Mess Chango, a Peruvian Paso Horse.

3: Unknown horse.

4: A group of Criollos.

5: Errecu Luna, a Criolla Horse.

6: Horse with owner.

7: Henry Jotor Honor, a Selle Francais Horse.

8: Cuyano Huinca Carinosa, Criolla Horse.

9: Neneside Acojack, a Hackney Horse, heading a carriage.

10: ZT Mondebil, an Arabian Horse.

11:Utto Jeuneetalon, a Norwegian Fjord Pony.

12:British cavalryman on Clydesdale Horse.

13: Indian cavalrymen with Mount.

14: Colebridge Silver Charm, an Arabian horse.

15: Horses with owner.

16: Seven-year-old Pottok Pony.

17: Dalling Hoe Prince Charles, a Suffolk Punch Horse.

18: Seven-year-old Shetland Pony.

19: Horse with owner.

20: Henry, a Shire Horse.

21: Horse with owner.

22: E. S. Nasdam, an Anglo-Arabian Horse.

23: Horses with owner.

24: Mounted police officer with horse.

25: Decorative Track adorns Criollo.

26: An Appaloosa Horse.

27: Indian Cavalryman on Mount.

28: Martin Fierro Mancha, an Argentinian Petiso Horse.

29: Grenadier with horse.

30: A Maremma Horse.

31: An Argentinian polo horse.

32: Presidential coachman with Mount.

33: Welsh Pony.

34: Two Camargue Horses.

35: A Percheron horse.

36: Bragadense Celosa, an Argentinian Petiso Horse.

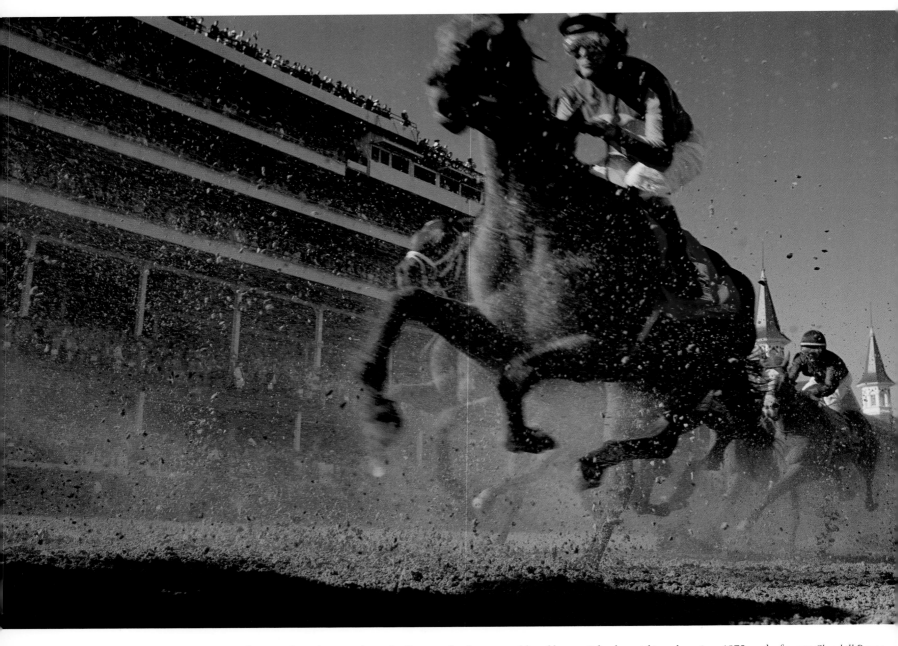

An arena dedicated to horsepower: The *Kentucky Derby* is a traditional gallop race for three-year old stud horses. It has been taking place since 1875 on the famous *Churchill Downs* race track.

Arena für Pferdestärken: Das *Kentucky Derby* ist ein klassisches Galopprennen für dreijährige Zuchtpferde, das seit 1875 auf der berühmten Rennbahn *Churchill Downs* ausgetragen wird.

Arène des grands champions : le *Kentucky Derby* est une course de galop classique pour chevaux d'élevage de trois ans, qui a lieu depuis 1875 sur le célèbre hippodrome de *Churchill Downs*.

Arena para los caballos de potencia: El *Kentucky Derby* es un clásico de las carreras de galope para los caballos de cría de tres años y, desde 1875, se celebra en el famoso hipódromo *Churchill Downs*.

Un'arena per la potenza dei cavalli: Il *Kentucky Derby* è una classica corsa al galoppo per cavalli d'allevamento dell'età di tre anni. La gara si tiene sin dal 1875 nel famoso ippodromo *Churchill Downs*.

The Legend

What a marvelous animal. The elegance of its movements stirs the heart, its talents cannot be missed. Its velvety sensitive nose detects water across a distance of several hundred miles. A total of 16 muscles control its long ears, turning them towards the sound source, and it is able to detect sounds of 25,000 hertz, that cannot be heard by the rider on its back. The rider is atop an animal whose pulmonary alveoli have a total surface volume of a park, 26,900 square feet, nearly twenty times that of human beings. An amazing creature.

Catherine the Great was observed braiding a gemstone into the headband of her favorite stallion. This move however, greatly damaged her reputation. For his work *Phaedrus*, the philosopher Plato chose the image of two horses to exemplify the conflict of the human soul. One is black and ugly, untamed and passionate, while the other is a white horse of noble growth, obedient, tame and seeking lofty goals. Since life ties them both to the same carriage, it is not uncommon for violent conflicts to arise. Human beings are better off in the saddle, where the horse elevates them. For the short of statute Napoleon, the white Arabian horse *Marengo* was virtually a majestically trotting throne. The emperor could not be missed.

In the Greek mythology, Centaurs are considered to be the perfect symbiosis of human and horse, a vindictive breed. They are even guilty of killing the great Hercules by poisoning him. Not a model for success.

On wheels, things progressed better. Carriage races are among the earliest sports of human history. Since 680 Before Christ, they have been the royal discipline at the Olympics. The Macedonian Philipp II. ("a kingdom for a horse!"), the father of Alexander the Great, was a repeated winner of carriage races, while the later Emperor Tiberius was able to secure a win racing for Rome. Nero also raced. Even though he fell off the carriage, the smart organizers nevertheless declared him the winner because the madman paid one million sesterces and released the province of Greece from all taxes. Later, however, these 211th Olympic games were deleted from documentation.

"I believe in the horse. The automobile is only a temporary phenomenon," confessed German emperor Wilhelm II., well-known as a lover of equestrian sculptures. However, reliable forecasts were not his strength. The days of the carthorses were numbered. They are no longer in use, and have become unemployed. Nowadays, jumping, racing and dressage horses for sports and games are bred, the new exclusive domains of the noble animal.

Magic of the Orient. Sheikh Mohammed bin Raashid al-Maktoum of Dubai is building a seventh heaven on earth, and is married to Princess Haya of Jordan, the most beautiful princess under the sun. But his passion are *Singspiel, Street Cry* and *Moon Ballad*, his magnificent horses, the galloping *Million Dollar Babies* on green turf and hot sand. 30 million dollars are involved. On the race course of Nad al-Sheba, the Arab world competes with the West on equal terms, with heavy breathing and head to head, the USA are waging a galloping desert storm. One time, the winner was *Captain Steve*, a second time it was *Roses in May*. In return, the Arab horse *War Emblem* gained the winner's garland of red roses at the *Kentucky Derby*, it is the proud horse of Ahmed bin Salman, a Saudi Arabian prince.

Whether blue or red blood, it is the stable that matters. Charlotte Casiraghi, daughter of Princess Caroline of Hanover and the late speedboat driver Stefano Casiraghi, loves horseback riding just as much as Athina Onassis, the world's youngest billionaire, and her husband Ivaro de Miranda Neto. Whether top model or pit babe, art dealer, oil prince or billionaire, they are all addicted to the expensive hobby, the race for the *Große Preis von Aachen*, the *Große Volkswagen Preis von Baden*, and the *Prix de l'Arc de Triomphe*. Horses gallop across the frozen St. Moritz lake, White Turf attracts thousands of visitors to the ice, while attending celebrities enjoy themselves and exude an international atmosphere. Whoever wins three races becomes the "King of the Engadine", a daring title in the alpine nation that is in love with titles!

Horses are en vogue. Their breeds are hot. Risk Sharing Funds for Arabian stallions are in great demand. 20 buyers combined their funds of 15 million dollars for the purchase of the Arabian stallion *Aladin*. The sperm of the noble horse is apportioned, sold at auctions, mailed out and deep frozen for successful breeding.

Today the threshold country of Brazil is stepping up the exclusive breeding business of Arabian thoroughbreds. 30,000 magnificent horses are grazing near the Amazon, a new turf for the kings of the wind. Arabian horses have their own set of rules. Works of art do not practice competitive sports. The beauty kings with the unmistakable swan necks and the black velvet eyes, prance *just for fun*, show classic dressage or Latin-American dances, the hot-blooded top models among animals, shaven and oiled, with cosmetic surgery and make-up. The happiness on earth.

Discussing strategy: Prior to the race in Keeneland, Pat Day receives final instructions from his trainer. Over the course of his career, Day won more than 8,000 races.

Strategiebesprechung: Pat Day holt sich vor dem Rennen in Keeneland die letzten Anweisungen von seinem Trainer. Day gewann mehr als 8000 Rennen in seiner Karriere.

Briefing stratégique : Pat Day reçoit, avant la course à Keeneland, les dernières instructions de son entraîneur. Durant sa carrière, Day a gagné plus de 8000 courses.

Decidiendo la estrategia: Pat Day recibe las últimas indicaciones de su entrenador antes de la carrera en Keeneland. Day ganó más de 8.000 carreras en su vida profesional.

Discutendo la strategia: Pat Day riceve le ultime istruzioni dell'allenatore prima della corsa di Keeneland. In tutta la sua carriera, Day ha vinto più di 8000 gare.

Der Mythos

Was für ein herrliches Tier. Die Eleganz seiner Bewegungen berührt das Herz, seine Talente sind unübersehbar. Seine samtige Spürnase erschnuppert Wasser auf Hunderte von Metern. Lange Ohren werden von 16 Muskeln zur Schallquelle gedreht, orten Töne von 25000 Hertz, die für den Reiter auf dem Rücken unhörbar bleiben. Er reitet ein Tier, dessen Lungenbläschen eine Oberfläche vom Format eines Parkgrundstückes bilden, 2500 Quadratmeter, annähernd zwanzigmal so viel wie bei einem Menschen. Ein erstaunliches Geschöpf.

Katharina die Große wurde beobachtet, wie sie ihrem Lieblingshengst einen Edelstein ins Stirnband flocht, was ihrem Ruf allerdings sehr geschadet hat. Der Philosoph Platon wählt in seinem *Phaidros* das Bild zweier Rosse, um den Zwiespalt der menschlichen Seele zu zeigen, das eine schwarz und hässlich, ungezähmt und leidenschaftlich, das andere ein Schimmel von edlem Wuchs, folgsam, gefügig und nach Höherem strebend. Weil das Leben beide vor einen Karren spannt, fliegen schon mal die Fetzen. Eine bessere Figur macht der Mensch im Sattel, das Pferd erhebt ihn. Für den kleinwüchsigen Napoleon war der Araber-Schimmel *Marengo* ein geradezu majestätisch trabender Thron. Der Kaiser war nicht zu übersehen.

In der griechischen Mythologie gelten die Kentauren als vollkommene Symbiose von Mensch und Pferd, ein rachsüchtiges Geschlecht. Sogar den großen Herakles haben sie auf dem Gewissen, Giftmord. Kein Erfolgsmodell.

Besser lief es auf Rädern. Wagenrennen gehören zum Frühsport der Weltgeschichte, seit 680 vor Christus sind sie die Königsdisziplin bei den Olympischen Spielen. Der Makedonier Philipp II. („Ein Königreich für ein Pferd!"), Vater Alexanders des Großen, siegte mehrfach im olympischen Wagenrennen, der spätere Kaiser Tiberius holte einen Rennsieg für Rom. Auch Nero kam dabei in Fahrt. Er fiel zwar vom Wagen, aber eine kluge Regie machte ihn trotzdem zum Sieger, denn der Wahnsinnige zahlte eine Million Sesterzen und befreite die Provinz Griechenland von allen Steuern. Später wurden diese 211. Olympischen Spiele allerdings aus den Urkunden getilgt.

„Ich glaube an das Pferd. Das Auto ist nur eine vorübergehende Erscheinung", bekannte der deutsche Kaiser Wilhelm II., bekanntlich ein Liebhaber von Reiterdenkmälern. Doch verlässliche Prognosen waren nie seine Stärke. Die Tage des Kaltbluts waren gezählt. Sie haben ausgedient, sind arbeitslos geworden. Gezüchtet werden Spring-, Renn- und Dressurpferde für Spiel und Sport, den neuen und exklusiven Domänen des edlen Tieres.

Zauber des Orients. Scheich Mohammed bin Raashid al-Maktoum von Dubai baut am siebten Himmel auf Erden, heiratet Prinzessin Haya von Jordanien, die schönste Königstochter unter der Sonne. Doch seine Leidenschaft gilt *Singspiel, Street Cry* und *Moon Ballad*, seinen herrlichen Pferden, den galoppierenden *Million Dollar Babies* auf grünem Turf und heißem Sand. 30 Millionen Dollar sind im Spiel. Auf der Rennbahn von Nad al-Sheba kämpft die arabische mit der westlichen Welt auf gleicher Augenhöhe, mit heißem Atem, Kopf an Kopf, entfesseln die USA einen Wüstensturm im Galopp. Einmal siegt *Captain Steve*, ein anderes Mal *Roses in May*. Dafür holt Arabiens *War Emblem* beim *Kentucky Derby* den Siegerkranz aus roten Rosen, das stolze Pferd Achmed bin Salmans, eines saudiarabischen Prinzen.

Blaues oder rotes Blut. Auf den Stall kommt es an. Charlotte Casiraghi, Tochter der Prinzessin Caroline von Hannover und des verunglückten Speedbootfahrers Stefano Casiraghi, reitet ebenso begeistert wie Athina Onassis, jüngste Milliardärin der Welt, und deren Mann Ivaro de Miranda Neto. Ob Supermodel oder Boxenluder, Kunsthändler, Ölprinz oder Milliardär, sie sind dem teuren Steckenpferd verfallen, der Jagd nach dem *Großen Preis von Aachen*, dem *Großen Volkswagen Preis von Baden*, dem *Prix de l'Arc de Triomphe*. Pferde galoppieren über den zugefrorenen St.-Moritz-See, White Turf lockt Tausende aufs Eis, angereiste Prominenz genießt und verströmt internationales Flair. Wer drei Rennen gewinnt, wird „König des Engadins", ein kühner Titel in der titelverliebten Alpenrepublik!

Pferde sind der Renner. Rasse läuft. Risk Sharing Funds für Araberhengste machen Furore. 20 Käufer legen für den Araberhengst *Aladin* 15 Millionen Dollar in den Topf. Die Samen des edlen Tieres werden quotiert, versteigert, versandt und tiefgekühlt zur erfolgreichen Zucht.

Nun bringt das Schwellenland Brasilien das exklusive Zuchtbusiness für Arabisches Vollblut auf Trab. 30000 herrliche Pferde weiden am Amazonas, Neuland für die Könige des Windes. Für Araber gelten eigene Gesetze. Kunstwerke treiben keinen Leistungssport. Die Schönheitskönige mit dem unverwechselbaren Schwanenhals und den samtschwarzen Augen tänzeln *just for fun*, zeigen klassische Dressur oder auch lateinamerikanische Tänze, rassige Topmodels der Tierwelt, rasiert und geölt, schönheitsoperiert und geschminkt. Das Glück der Erde.

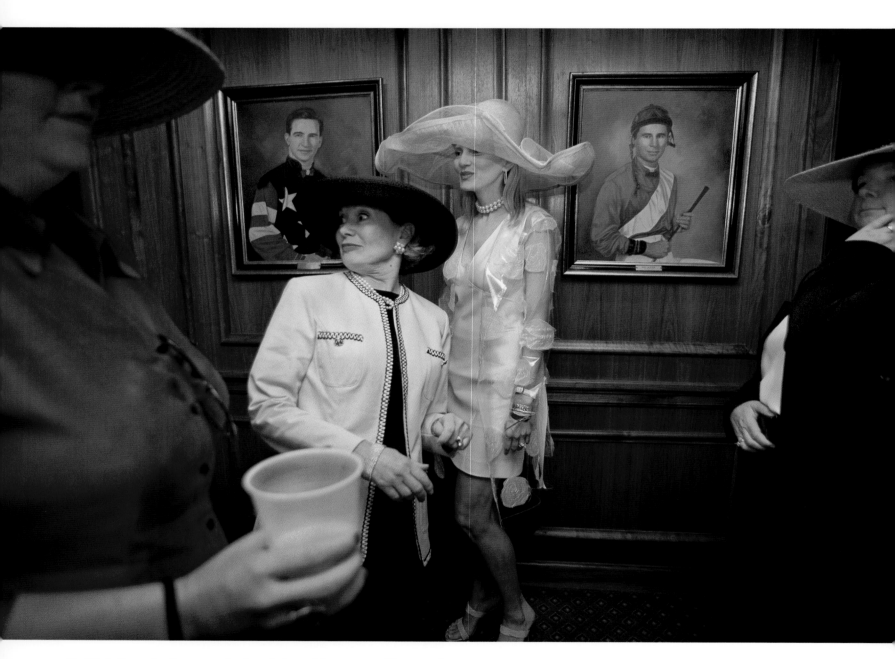

Turf Club, Kentucky: Extravagant headgear in front of the portraits of famous jockeys.

Turf Club, Kentucky: Extravagante Kopfbedeckungen vor den Porträts berühmter Jockeys.

Turf Club du Kentucky : d'extravagants couvre-chefs devant les portraits de jockeys célèbres.

Turf Club, Kentucky: Extravagantes sombreros delante de los retratos de famosos jinetes.

Turf Club, Kentucky: copricapo stravaganti davanti ai ritratti di illustri fantini.

Le mythe

Quel magnifique animal ! L'élégance de ses mouvements nous va droit au cœur, ses talents sont évidents. Son museau de velours hume l'eau à des centaines de mètres. 16 muscles tournent vers la source du son ses longues oreilles, localisant des fréquences de 25000 Hertz, inaudibles pour le cavalier qui est sur son dos. Celui-ci chevauche un animal dont les alvéoles pulmonaires couvrent la surface d'un parc, à savoir 2500 mètres carrés, presque vingt fois plus que chez l'homme. Une créature étonnante.

Catherine la Grande fut observée en train d'entremêler une pierre précieuse dans le bandeau de son étalon préféré, ce qui nuisit à vrai dire beaucoup à sa réputation. Dans son *Phèdre*, le philosophe Platon choisit la figure de deux chevaux pour dépeindre la dichotomie de l'âme humaine, noire et laide, indomptée et passionnée, d'une part, cheval blanc racé, soumis, docile et cherchant l'élévation, d'autre part. Parce qu'ils sont tous les deux attelés par la vie à une charrette, il arrive qu'éclatent les conflits. L'homme en selle, soulevé par le cheval, fait meilleure impression. Pour l'homme de petite taille qu'était Napoléon, le cheval blanc arabe *Marengo* faisait figure de trône trottant majestueusement. Il était impossible de ne pas remarquer l'empereur.

Dans la mythologie grecque, les centaures représentent la symbiose parfaite de l'homme et du cheval, une espèce avide de vengeance. Ils ont même le grand Héraclès sur la conscience, empoisonné. Le contraire d'une référence pour le succès.

Cela va beaucoup mieux avec des roues. Les courses de chars constituent l'un des premiers sports de l'histoire mondiale et sont la discipline reine des Jeux Olympiques depuis 680 avant Jésus Christ. Le macédonien Philippe II (« Un royaume pour un cheval ! »), père d'Alexandre le Grand, fut plusieurs fois vainqueur de courses de chars olympiques ; quant au futur empereur Tibère, il remporta une victoire pour Rome. Néron aussi prit le départ. Il tomba même du char, mais une régie intelligente le déclara pourtant vainqueur car ce fou paya un million de sesterces et exonéra la province de la Grèce de tout impôt. Plus tard cependant, ces 211ème Jeux Olympiques disparurent des archives.

« J'ai foi dans le cheval. La voiture n'est qu'une apparition passagère », déclara l'empereur allemand Guillaume II, un amateur bien connu de monuments à cheval. Mais les pronostics fiables n'ont jamais été sa spécialité. Les jours du cheval de trait étaient comptés. Devenus inutiles, ils sont au chômage. On élève désormais des sauteurs, des chevaux de course et de dressage pour le loisir et le sport, le nouveau domaine exclusif de ce noble animal.

Magie de l'orient : le cheikh Mohammed bin Rashid al-Maktoum de Dubai construit le septième ciel sur terre, épouse la princesse Haya de Jordanie, la plus belle des filles de roi sous le soleil. Pourtant, sa passion a pour nom *Singspiel, Street Cry* et *Moon Ballad,* ses merveilleux chevaux, ses *Million Dollar Babies* galopant sur des pelouses vertes ou du sable chaud. 30 millions de dollars sont en jeu. Sur l'hippodrome de Nad al-Sheba, le monde arabe se mesure au monde occidental, à égalité, le souffle chaud, côte à côte, les Etats-Unis déchaînant une tempête du désert au galop. Une fois, c'est *Captain Steve* qui gagne, une autre fois, *Roses in May*. Par contre,

lors *Kentucky Derby*, c'est *War Emblem* d'Arabie, le fier cheval d'Ahmed bin Salman, un prince saoudien, qui s'adjuge la couronne de roses rouges de la victoire.

Sang bleu ou rouge : cela dépend de l'écurie. Charlotte Casiraghi, la fille de la princesse Caroline de Hanovre et du pilote de vedettes rapides Stefano Casiraghi, est une cavalière passionnée, tout comme Athina Onassis, la plus jeune milliardaire du monde, et son mari Ivaro de Miranda Neto. Qu'ils soient top modèle, groupie allumeuse de F1, marchand d'art, prince du pétrole ou milliardaire, ils ont tous succombé à ce coûteux passe-temps, la chasse au *Große Preis von Aachen*, au *Große Volkswagen Preis von Baden* ou au *Prix de l'Arc de Triomphe*. Des chevaux galopent sur le lac gelé de Saint-Maurice, la piste blanche attire des milliers de personnalités sur la glace, le Gotha ici présent dégage un charme international et s'en délecte à la fois. Quiconque gagne trois courses est nommé « Roi de l'Engadine », un titre audacieux dans cette république des Alpes si amoureuse des titres !

Le cheval est un article à succès. La race marche bien. Les fonds de partage des risques pour les étalons arabes font fureur. Vingt acheteurs mettent 15 millions de dollars dans un tronc commun pour l'étalon arabe Aladin. La semence du noble animal est cotée, mise aux enchères, expédiée et congelée pour une reproduction fructueuse.

Aujourd'hui, le Brésil, nouveau pays industrialisé, vient secouer le business exclusif de l'élevage du pur-sang arabe. 30000 magnifiques chevaux paissent le long de l'Amazone, la nouvelle terre des rois du vent. Pour les arabes, il y a des règles particulières. De telles œuvres d'art ne pratiquent pas de sport de haut niveau. Ces princes de la beauté avec leur incomparable cou de cygne et leurs yeux de velours noir gambadent uniquement pour le plaisir, font des démonstrations de dressage classique ou de danses latino-américaines ; ce sont les tops modèles de race du monde animal, rasés, huilés, maquillés et d'une beauté de chirurgie esthétique. Le bonheur sur terre.

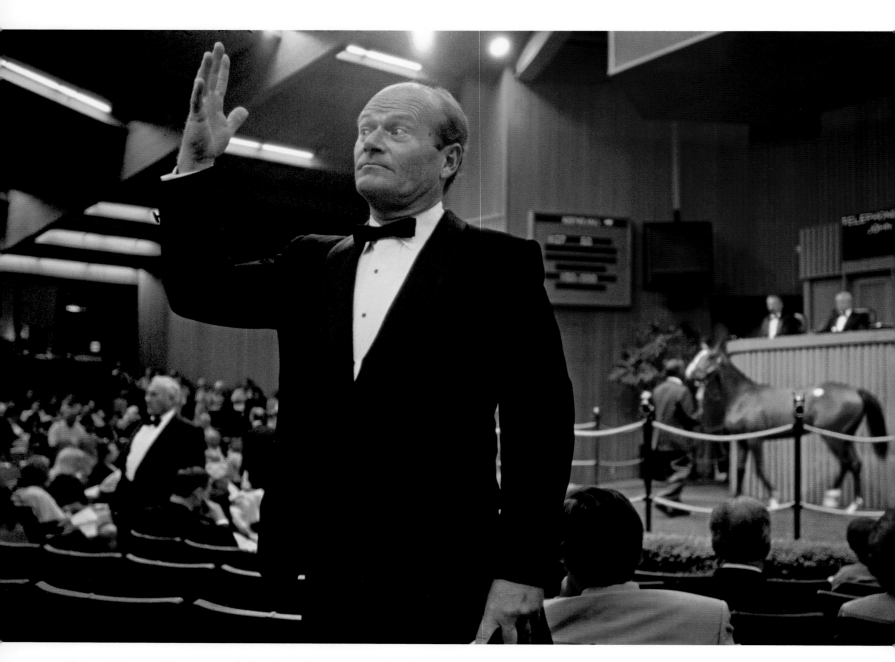

Under the hammer: Horses are usually bought at public auctions—and really dressed up prior to the sale. The highest price paid for a two-year old: 750,000 Dollar.

Unterm Hammer: Pferde werden meistens bei öffentlichen Versteigerungen erworben – und vor dem Verkauf richtig herausgeputzt. Der Höchstpreis für einen Zweijährigen: 750 000 Dollar.

Sous le marteau : les chevaux s'achètent généralement lors d'enchères publiques – et sont toilettés avec soin avant la vente. L'enchère maximum pour un deux ans : 750000 dollars.

Bajo el martillo: Los caballos suelen adquirirse en subastas públicas, para las que son previamente engalanados. El precio más alto pagado por un caballo de dos años: 750.000 dólares.

All'asta: solitamente i cavalli, opportunamente agghindati prima della vendita, vengono acquistati nel corso di aste pubbliche. Il prezzo più alto pagato per un esemplare di due anni ammonta a 750000 dollari.

El mito

Qué animal más espléndido. La elegancia de sus movimientos es conmovedora, su talento, incalculable. Su aterciopelada nariz puede olfatear el agua a cientos de metros. 16 músculos convierten sus largas orejas en cavidades de resonancia, perciben tonos de 25.000 hercios, inaudibles para el jinete montado sobre su lomo. Él está sobre un animal cuyos alvéolos pulmonares ocupan la superficie del tamaño de un parque, 2.500 metros cuadrados, casi veinte veces más que el ser humano. Una criatura sorprendente.

Catarina la Grande fue sorprendida trenzando una cinta para la frente de su semental preferido con una piedra preciosa, lo que dañó seriamente su reputación. El filósofo Platón seleccionó en su *Phaidros* la imagen de dos corceles para simbolizar la división del alma humana; uno negro y feo, indómito y apasionado, y el otro un caballo de porte noble, dócil, manso y aspirando a alcanzar la perfección. Como la vida les ha colocado delante del mismo carro a veces se producen violentos enfrentamientos. La silla mejora el porte del hombre, el caballo le eleva. Para Napoleón, corto de estatura, el caballo árabe *Marengo* era un trono majestuoso al trote. Resultaba imposible no ver al emperador.

En la mitología griega, los centauros eran la simbiosis perfecta entre el hombre y el caballo, un género sediento de venganza. Incluso asesinaron con veneno al gran Heracles. Un modelo sin éxito.

Con las ruedas se consiguió un mejor resultado. Las carreras de carros son una de las primeras disciplinas deportivas de la historia; desde el año 680 antes de Cristo eran la disciplina reina de los Juegos Olímpicos. El macedonio Filipo II ("¡Un reino por un caballo!"), padre de Alejandro Magno, venció varias veces en las carreras olímpicas. El futuro emperador Tiberio se hizo con un triunfo para Roma. Nerón también participó en las competiciones. Y, a pesar de caerse del carro, su inteligente gobierno le convirtió en ganador porque este demente pagó un millón de sestercios y liberó a la provincia de Grecia de todos los impuestos. Más tarde estos Juegos Olímpicos, los 211, fueron eliminados de las actas.

"Yo creo en el caballo. El automóvil es sólo una aparición pasajera", reconoció el emperador alemán Guillermo II, que, como es sabido, era amante de los monumentos ecuestres. Pero los pronósticos fiables no eran una de sus virtudes. Los días de los caballos de sangre fría estaban contados. Se habían vuelto inservibles y fueron despedidos. Ahora se crían caballos de saltos, de carreras y de adiestramiento para el juego y el deporte, los nuevos y exclusivos dominios de este noble animal.

La magia de Oriente. El jeque de Dubai Mohammed bin Raashid al-Maktoum construye su séptimo cielo en la tierra. Casado con la princesa Haya de Jordania, la más bella de las hijas del rey bajo el sol, su pasión está reservada para *Singspiel, Street Cry* y *Moon Ballad*, sus espléndidos caballos, los *Million Dollar Babies* que galopan sobre el verde turf y la arena caliente. Hay 30 millones de dólares en juego. En la pista del hipódromo de Nad al-Sheba el mundo oriental se enfrenta al occidental a una misma altura, con el aliento caliente, muy igualados, Estados Unidos desata una tormenta de arena al galope. Una vez gana *Captain Steve* y otra, *Roses in May*. A cambio el *War Emblem* árabe se hace en el *Kentucky Derby* con la corona del vencedor de rosas rojas; es el orgulloso caballo de Achmed bin Salman, un príncipe de Arabia Saudí.

Sangre azul o roja. Lo importante es el establo. Charlotte Casiraghi, hija de la princesa Carolina de Hannover y del malogrado piloto de embarcaciones rápidas Stefano Casiraghi, es tan amante de los caballos como Athina Onassis, la millonaria más joven del mundo, y su marido Alvaro de Miranda Neto. Tanto supermodelos como chicas de la Fórmula 1, marchantes de arte, príncipes del petróleo o multimillonarios, todos se han rendido al caro caballito; la caza del *Große Preis von Aachen*, el *Große Volkswagen Preis von Baden*, el *Prix de l'Arc de Triomphe*. Los caballos galopan sobre el lago helado de St. Moritz, White Turf atrae a miles de personas al hielo; los famosos llegados de todo el mundo disfrutan del evento y desprenden estilo internacional. Quien gana tres de las carreras es coronado "Rey de la Engadina", ¡un atrevido título en la república de los Alpes, tan amante de los títulos!

Los caballos son todo un éxito de ventas. Los fondos de riesgo para los sementales árabes causan furor. Veinte compradores pagaron por el semental árabe *Aladin* 15 millones de dólares. El semen de este noble caballo se cotiza, se subasta, se envía y se congela para conseguir una cría de éxito.

Ahora el país emergente Brasil está poniendo al trote el exclusivo negocio de la cría de caballos purasangre árabes. 30.000 maravillosos caballos pastan en el Amazonas, tierra virgen para el rey del viento. Los árabes tienen sus propias leyes. Las obras de arte no practican deporte de competición. Los reyes de la belleza, con su inconfundible cuello de cisne y sus ojos de terciopelo negro, andan con paso ligero *just for fun*, se mueven al ritmo del adiestramiento clásico o bailes latinoamericanos; raciales "top models" del mundo animal, afeitadas y aceitadas, con operaciones estéticas y pintadas. La dicha en la tierra.

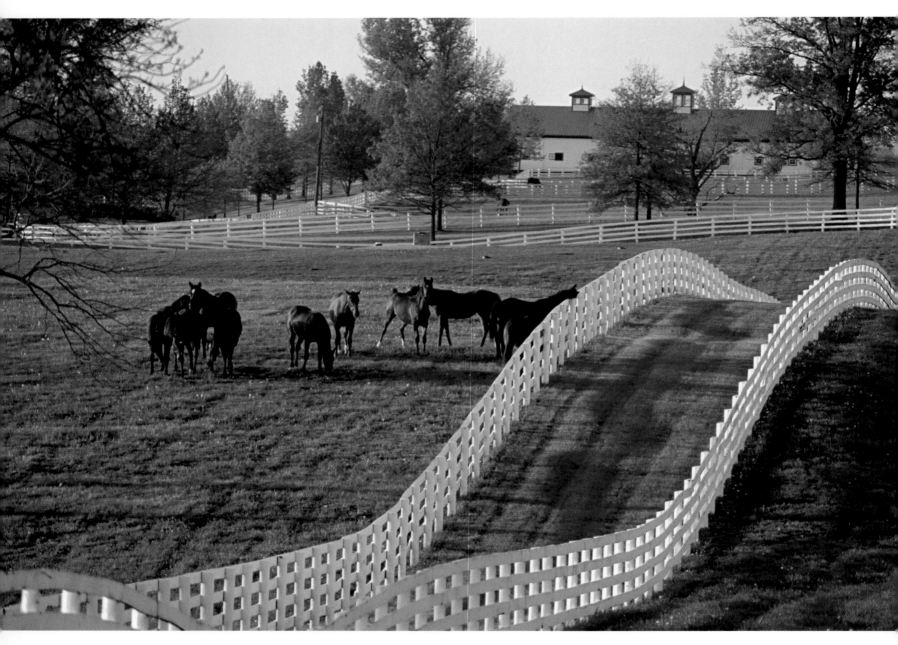

Noble territory: White fences surround the premises of the Donamire Farm in Kentucky. The wooden fences with the four planks cost around 10,000 dollars per half a mile. Thus the enclosure of the farm is more expensive than the construction of a single-family home.

Edles Revier: Weiße Zäune umrahmen das Gelände der Donamire Farm in Kentucky. Die Holzzäune mit den vier Planken kosten pro Kilometer etwa 10000 Dollar. Die Einfassung einer solchen Farm ist teurer als der Bau eines neuen Einfamilienhauses.

Noble enclos : des barrières blanches entourent la ferme Donamire dans le Kentucky. Les barrières de bois avec les quatre madriers coûtent quelque 10000 dollars par kilomètre. Un tel enclos de ferme revient ainsi plus cher que la construction d'une maison neuve particulière.

Un terreno exquisito: Vallas blancas rodean los terrenos de la granja Donamire en Kentucky. Los vallados de madera con los cuatro tablones cuestan unos 10.000 dólares por kilómetro. Con lo que una cerca de este tipo es más cara que la construcción de una casa unifamiliar.

Elegante ritiro: steccati bianchi circondano la tenuta della Donamire Farm nel Kentucky. Questi steccati di legno a quattro assi costano circa 10000 dollari al chilometro; il costo di una recinzione di questo tipo intorno ad una fattoria supera quello di una casa monofamiliare di nuova costruzione.

Il mito

Che splendido animale, dalle movenze così eleganti che toccano il cuore e dagli innumerevoli talenti! Dal naso vellutato in grado di fiutare l'acqua a centinaia di metri. Ben 16 muscoli indirizzano le lunghe orecchie verso la fonte del suono: il cavallo è in grado di localizzare suoni da 25000 Hertz, non udibili da chi sta in sella. I suoi alveoli polmonari hanno una superficie pari a 2500 metri quadrati, l'equivalente di un parco, quasi venti volte quella dell'uomo. Il cavallo: una creatura eccezionale.

Caterina di Russia fu osservata incastonare una pietra preziosa nel frontalino del suo stallone preferito, cosa che non giovò per nulla alla sua fama. Per rappresentare il dissidio dell'anima umana, il filosofo Platone, nel *Fedro*, scelse l'immagine di due destrieri: uno nero e brutto, indomito e passionale, l'altro bianco e nobile, docile e ubbidiente, anelante ad alte gesta; e poiché erano attaccati ad un unico carro, lottavano tra loro. Destino migliore toccò all'uomo, in sella, innalzato dal cavallo. Per Napoleone, che era di bassa statura, il cavallo grigio arabo, *Marengo*, in groppa al quale trottava, fungeva da trono regale: impossibile non vedere l'imperatore.

Nella mitologia greca, i centauri rappresentavano la perfetta simbiosi tra l'uomo e il cavallo. Ma erano tipi vendicativi: si macchiarono perfino dell'uccisione del grande Eracle, che morì avvelenato. Un esempio da evitare.

Si andò meglio sulle ruote. La corsa dei carri fu una delle prime manifestazioni sportive della storia e, sin dal 680 ante Cristo, rappresentò la disciplina principale delle Olimpiadi. Filippo II il Macedone ("Il mio regno per un cavallo!"), padre di Alessandro il Grande, vinse più volte le gare olimpiche di corsa dei carri, e anche il futuro imperatore Tiberio riportò una vittoria in nome di Roma. Vi partecipò perfino Nerone, il quale cadde da cavallo ma fu ugualmente proclamato vincitore: astutamente, pagò un milione di sesterzi ed esentò la provincia della Grecia dal versamento di tutti i tributi. In seguito, tuttavia, questa Olimpiade, la 211ª, fu cancellata dagli annali.

"Io credo nel cavallo. L'automobile è soltanto un'apparizione temporanea", sosteneva l'imperatore tedesco Guglielmo II, il quale, si sa, amava i monumenti equestri. Ma le previsioni affidabili non sono mai state il suo forte. I giorni dei cavalli a sangue freddo erano contati: ormai questi animali non avevano più nessuna funzione. L'allevamento si concentrò sui cavalli da salto, da corsa e da dressage per il gioco e lo sport, i nuovi domini esclusivi di questo nobile animale.

Magia dell'Oriente: lo sceicco del Dubai, Mohammed bin Raashid al-Maktoum, cerca la felicità terrena sposando Haya di Giordania, la principessa più bella del mondo. Ma la sua passione restano *Singspiel*, *Street Cry* e *Moon Ballad*, i suoi magnifici cavalli, gioielli da un milione di dollari lanciati al galoppo sul terreno verde e la sabbia rovente degli ippodromi. 30 milioni di dollari sono la posta in gioco. All'ippodromo di Nad al-Sheba, il mondo arabo e quello occidentale lottano alla pari, il fiato caldo, testa a testa, e gli Stati Uniti scatenano al galoppo una tempesta nel deserto. Una volta vince *Captain Steve*, un'altra *Roses in May*, mentre l'arabo *War Emblem* conquista la ghirlanda di rose rosse del vincitore al *Kentucky Derby*; il fiero animale appartiene al principe saudita Achmed bin Salman.

Sangue blu o sangue rosso? Dipende dalla scuderia. Charlotte Casiraghi, figlia della principessa Carolina di Hannover e di Stefano Casiraghi, che perse la vita in un incidente durante una gara di off-shore, sport di cui era appassionato, ama cavalcare quanto Athina Onassis, la miliardaria più giovane del mondo, e il suo marito Álvaro de Miranda Neto. Topmodel, ragazze dei box, commercianti d'arte, petrolieri o miliardari, tutti sono ammaliati da questo costoso passatempo, alla caccia del *Große Preis von Aachen*, del *Große Volkswagen Preis von Baden*, del *Prix l'Arc de Triomphe*. I cavalli galoppano sul lago ghiacciato di St. Moritz, l'ippodromo bianco attira sul ghiaccio migliaia di appassionati, i VIP arrivano e si divertono, dando al tutto un tocco di internazionalità. Chi riesce a vincere tre corse diventa il "re dell'Engadina", un appellativo audace per lo stato alpino che tanto ama i titoli.

I cavalli sono di grande attualità, la razza è quella che conta. I fondi risk sharing per stalloni arabi fanno furore. Venti acquirenti stanziano 15 milioni di dollari per lo stallone arabo *Aladin*. Lo sperma del nobile animale viene quotato, venduto all'asta, spedito e congelato per permettere l'allevamento dei suoi discendenti.

Il Brasile, paese emergente, sta ora lanciando l'esclusivo business dell'allevamento dei purosangue arabi. 30000 magnifici cavalli popolano i pascoli dell'Amazzonia, nuova meta dei signori del vento. Leggi proprie governano gli esemplari arabi: questi capolavori non praticano nessuno sport da competizione. Veri campioni di bellezza, dall'inconfondibile collo di cigno e dai neri occhi di velluto, trotterellano *just for fun*, si esibiscono in gare classiche di dressage o in balli latino-americani. Le focose bellezze del mondo animale, rasate e impomatate, oggetto di interventi di chirurgia estetica e di sedute di maquillage, sono la felicità della terra.

Following Page

Powerful nutrition: The Manchester Farm in Lexington, Kentucky. Millions of years ago, seashells were in abundance in Bluegrass Country—the ground is therefore rich in calcium, which is good for building up muscles.

Kraftnahrung: Die Manchester Farm in Lexington, Kentucky. In Bluegrass Country lagen vor Millionen von Jahren Muscheln – die Erde ist deshalb reich an Kalzium, das gut für den Muskelaufbau ist.

Alimentation énergétique : la ferme Manchester à Lexington, Kentucky. Il y a des millions d'années, le Bluegrass Country était couvert de coquillages – c'est pourquoi la terre est riche en calcium, favorable au développement des muscles.

Alimentación energética: La granja de Manchester en Lexington, Kentucky. En Bluegrass Country había, hace millones de años, moluscos —por eso la tierra es rica en calcio, que es bueno para la musculatura.

Nutrimento corroborante: la Manchester Farm di Lexington, nel Kentucky. Milioni di anni fa, nel Bluegrass Country, giacevano moltissime conchiglie: per questo motivo la terra è ricca di calcio, ottimo corroborante della muscolatura.

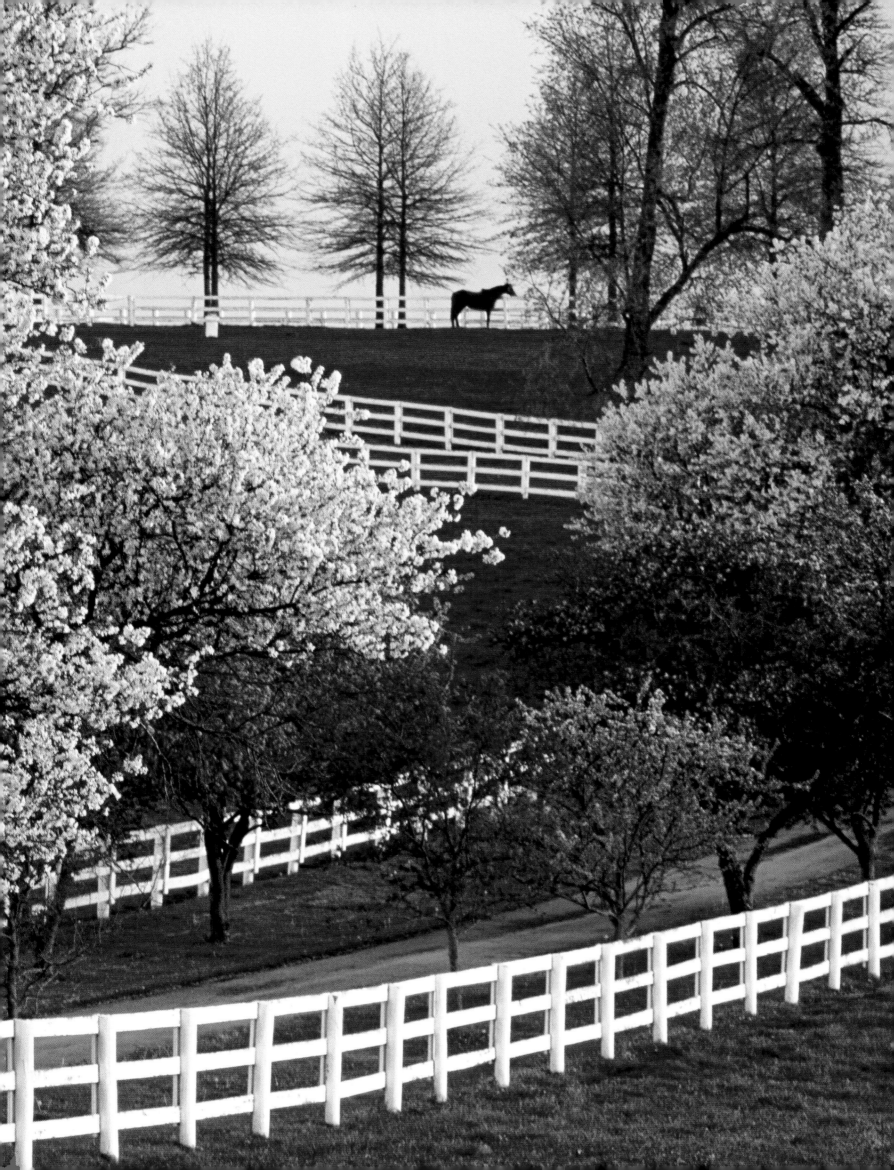

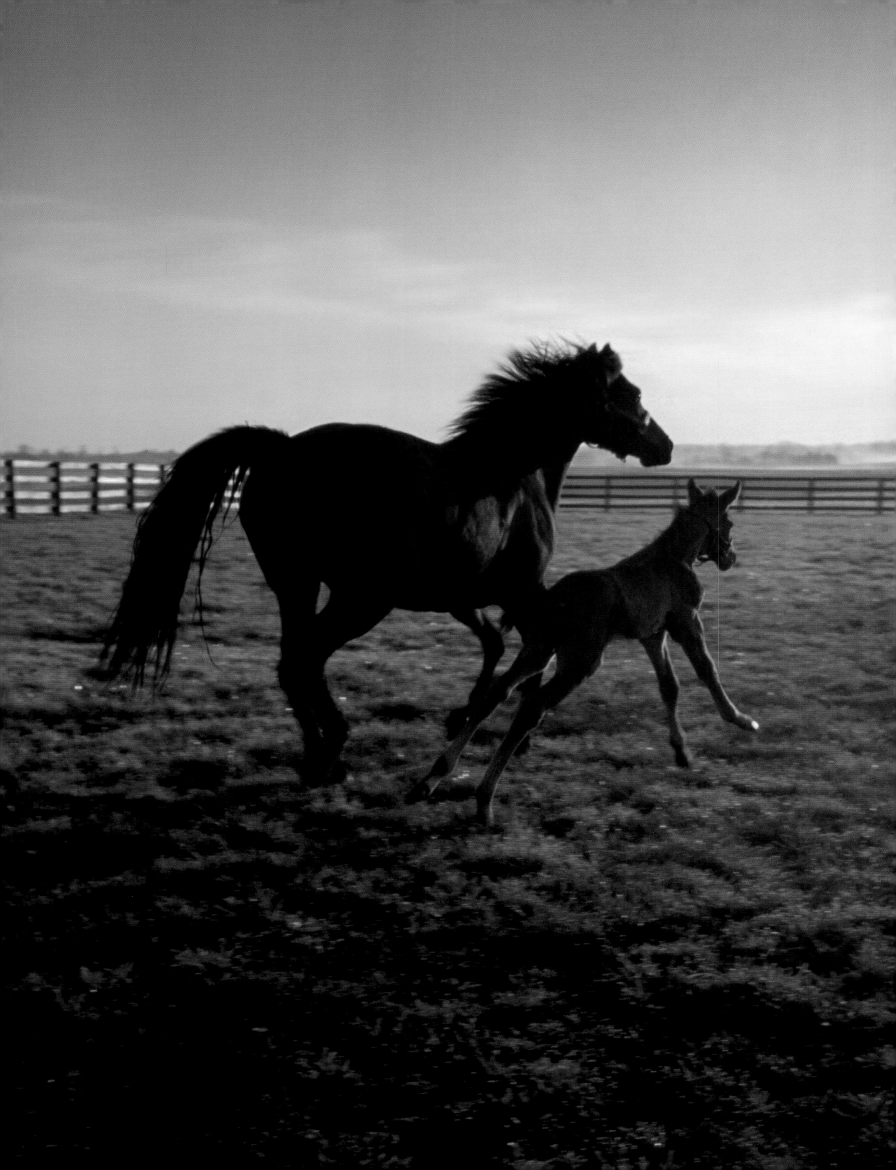

Studs & Breeding

The large stud farms and breeding regions from Kentucky to Trakehnen, the most important breeding families, the classic riding schools.

Die großen Gestüte und Zuchtgebiete von Kentucky bis Trakehnen, die bedeutendsten Züchterfamilien, die klassischen Reitschulen.

Les grands haras et domaines d'élevage du Kentucky à Trakehnen, les grandes familles d'éleveurs, les écoles d'équitation classiques.

Los mayores acaballaderos y zonas de cría de Kentucky a Trakehnen, las familias más relevantes de la cría de caballos, las clásicas escuelas de equitación.

I maggiori allevamenti e le zone in cui si trovano dal Kentucky a Trakehnen, le famiglie di allevatori più importanti e le scuole classiche di equitazione.

Home of the winners: The breeders of the *Claiborne Farm* have produced many derby winners.

Heimat der Sieger: Die Züchter der *Claiborne-Farm* haben viele Derbysieger hervorgebracht.

Patrie des vainqueurs : les éleveurs de la *Claiborne Farm* ont produit de nombreux vainqueurs de derby.

La patria del campeón: Los criadores de la *granja Claiborne* han conseguido criar a muchos campeones del derby.

Terra di vincitori: gli allevatori della *Claiborne Farm* hanno prodotto molti vincitori di derby.

Following Page

Luxury residence: This estate in Kentucky is home of the award-winning stallion *Thunder Gulch*. The breeder had bridges built on the premises as well as stables of stone that occasionally are even equipped with chandeliers.

Luxusbehausung: Auf diesem Anwesen in Kentucky lebt der preisgekrönte Hengst *Thunder Gulch*. Der Züchter ließ auf dem Gelände Brücken bauen und Ställe aus Stein, die teilweise sogar mit Kronleuchtern ausgestattet sind.

Demeure de luxe : c'est sur cette propriété dans le Kentucky que vit l'étalon primé *Thunder Gulch*. L'éleveur y a fait construire des ponts et des écuries en pierre, en partie éclairées par des lustres.

Cuadras de lujo: En estas instalaciones en Kentucky vive el semental *Thunder Gulch*, ganador de varios premios. El criador hizo levantar en los terrenos puentes y cuadras de piedra que, en algunos casos, están decoradas con lámparas de araña.

Un alloggio di lusso: in questa tenuta del Kentucky vive lo stallone *Thunder Gulch*, vincitore di diversi premi. Su quest'area l'allevatore ha fatto costruire ponti e scuderie di pietra addirittura provviste, in parte, di lampadari di cristallo.

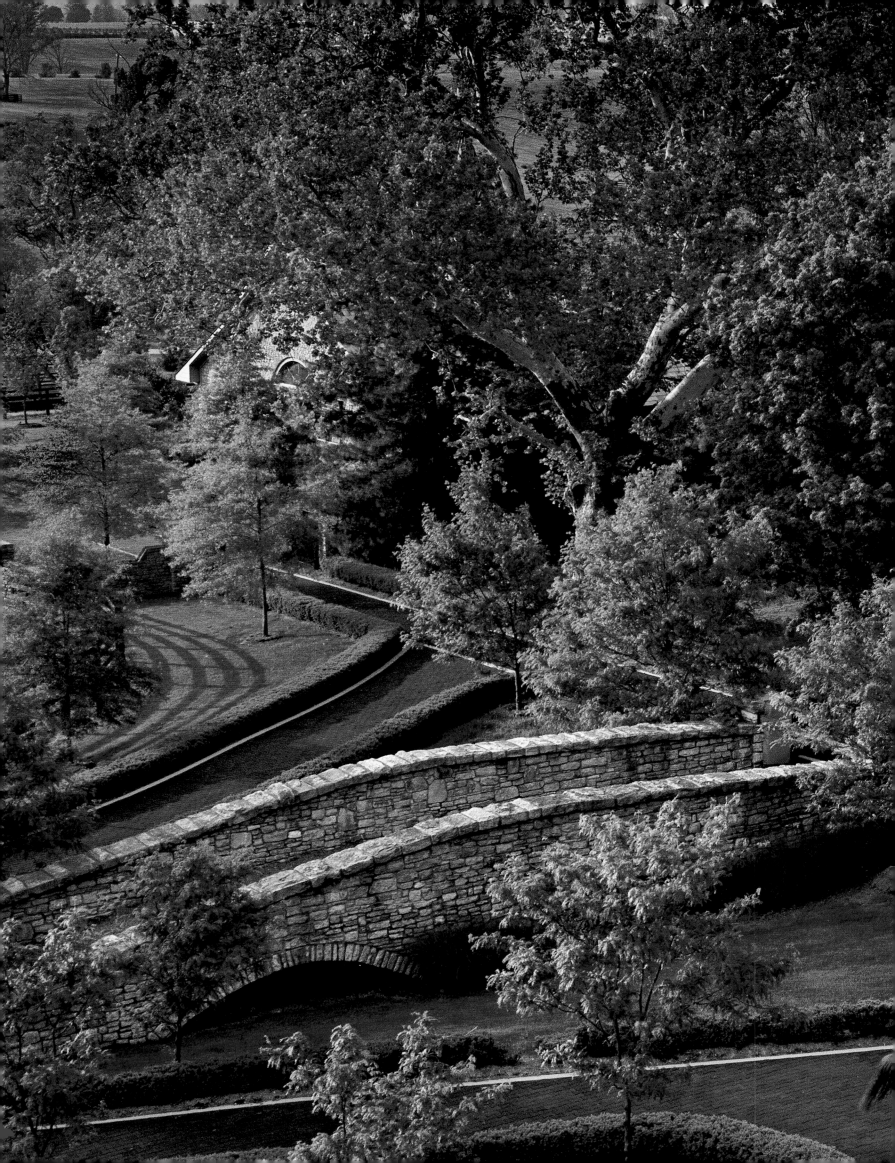

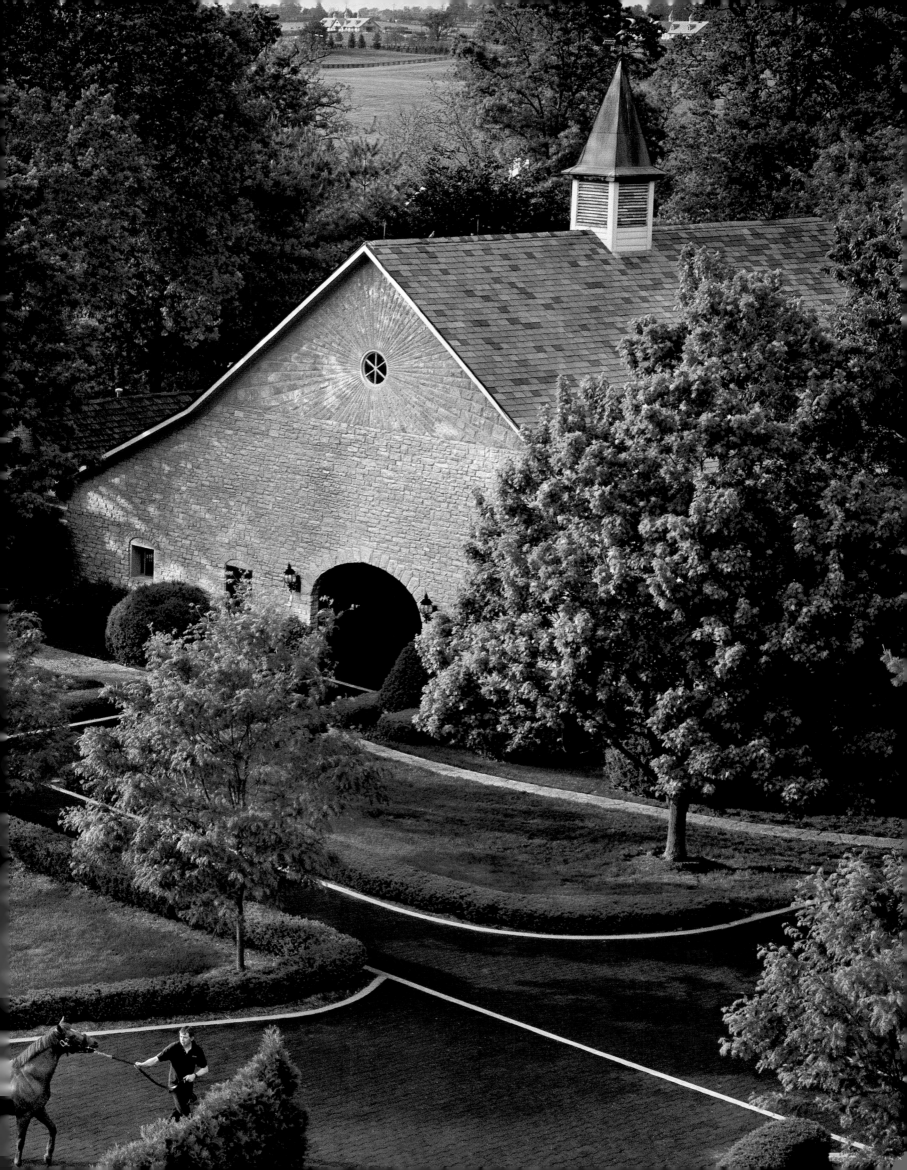

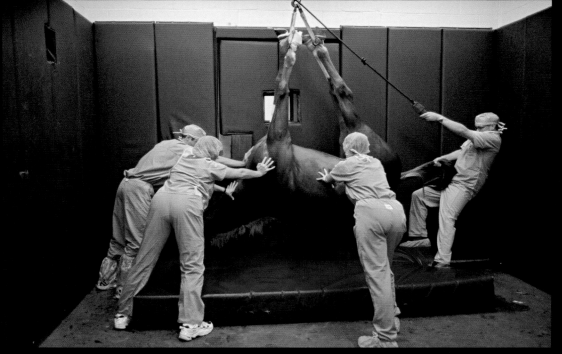

Horse clinic in Lexington

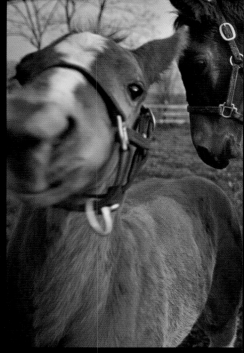

Breeding paddock

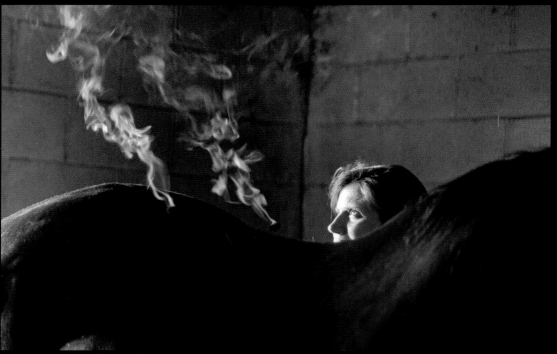

Acupuncture and smoke of Chinese herbs

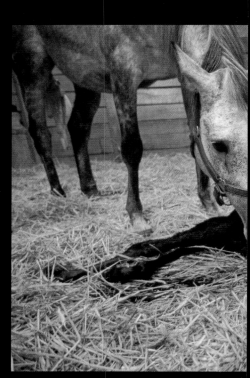

Mare and foal

Stations of a horse's life: The days when horses were purely used as farm animals are long since gone. Today they are status symbols and expensive hobbies that participate in races—thus they need care and attention.

Stationen eines Pferdelebens: Längst sind die Zeiten vorbei, als Pferde ausschließlich als Nutztiere eingesetzt wurden. Heute sind sie Statussymbol, teures Hobby und nehmen an Wettkämpfen teil – und brauchen deshalb Pflege und Fürsorge.

Etapes de la vie d'un cheval : les temps sont révolus où les chevaux n'étaient que des animaux productifs. Devenus des symboles de statut social et de coûteux passe-temps, ils participent à des concours – et nécessitent donc des soins et de l'attention.

Las estaciones de la vida de un caballo: Hace mucho tiempo que dejó de utilizarse a los caballos como animales de carga. Hoy son un símbolo del estatus social, un pasatiempo caro y participan en competiciones, por eso necesitan atención y cuidados.

Tappe della vita di un cavallo: sono ormai finiti i tempi in cui i cavalli erano utilizzati solo come animali domestici. Oggi essi costituiscono uno status symbol e sono un hobby costoso, che prevede la partecipazione a delle gare. Richiedono quindi cure e assistenza.

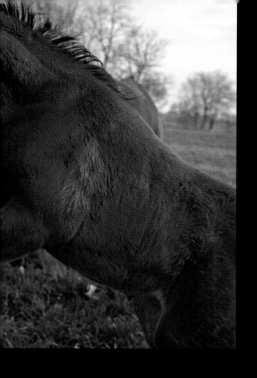

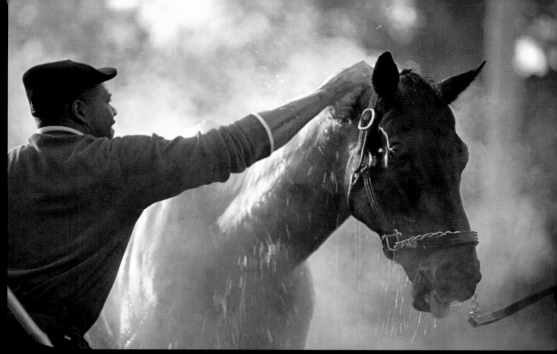

Cooling down after the training

The grave of *Seattle Slew*, 28, the *Triple Crown* winner

Following Page

Trakehner: A herd of Trakehners on a meadow in Masuria in Northern Poland. The horses hail originally from Trakehnen in East Prussia. The origins of the breed goes back to the 13th century, the era of the Teutonic Knights

Trakehner: Trakehner-Herde auf einer Wiese in Masuren in Nordpolen. Die Pferde stammen ursprünglich aus Trakehnen Ostpreußen. Die Anfänge der Zucht gehen bis ins 13. Jahrhundert, die Zeit des Deutschritterordens, zurück

Trakehner : troupeau de Trakehner dans un pré de Mazurie, au Nord de la Pologne. A l'origine, ces chevaux viennent de Trakehnen en Prusse orientale. Les débuts de l'élevage remontent au 13ème siècle, à l'époque des chevaliers de l'ordre teutonique

Trakehner: Manada de caballos trakehner en un prado de Masuren, en el norte de Polonia. Estos caballos tienen su origen en Trakehner en la Prusia oriental. Los comienzos de la cría se remontan al siglo XIII, el tiempo de las órdenes de los caballeros alemanes

Trakehner: un branco di cavalli Trakehner in un prato a Masuren, nel Polo Nord. Questi cavalli sono originari di Trakehner nella Prussia orientale. L'allevamento fu iniziato nel XIII secolo, all'epoca dell'Ordine dei Cavalieri Teutonici

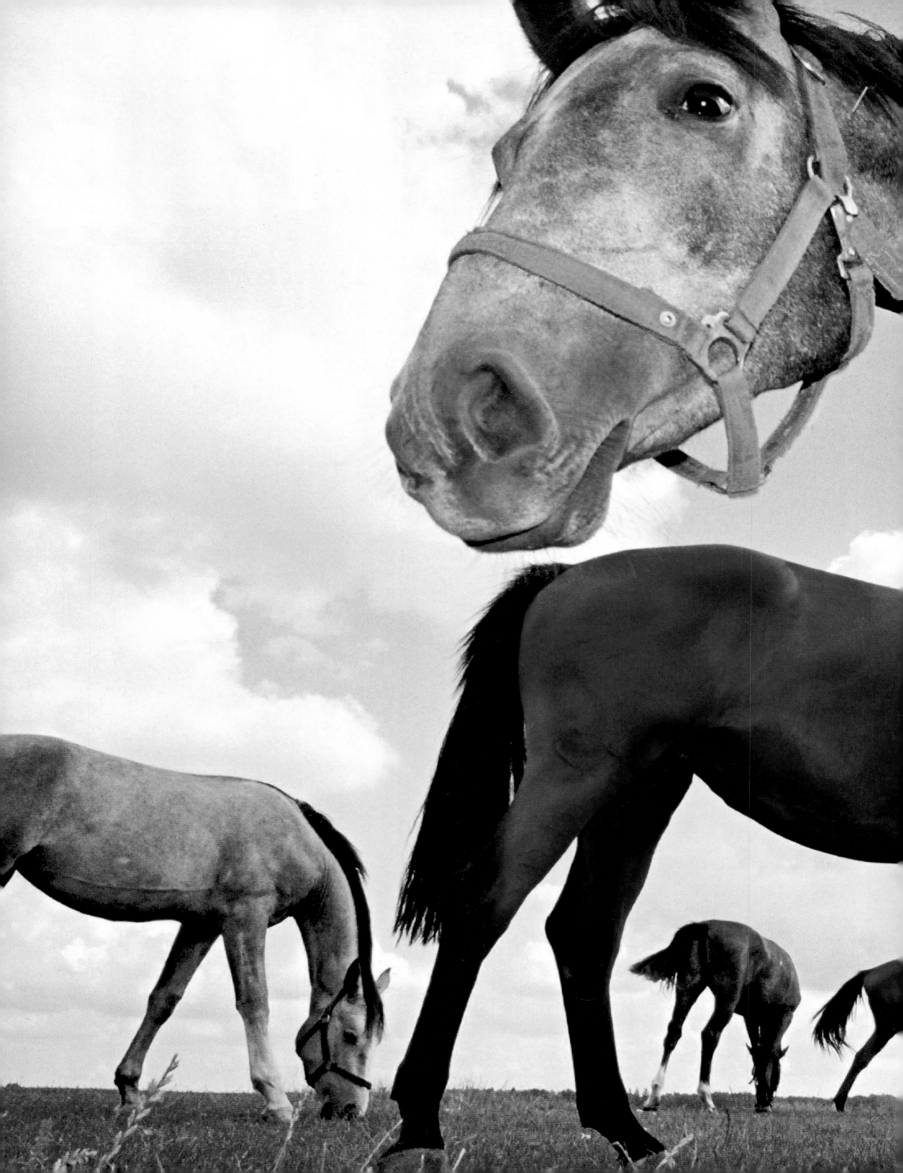

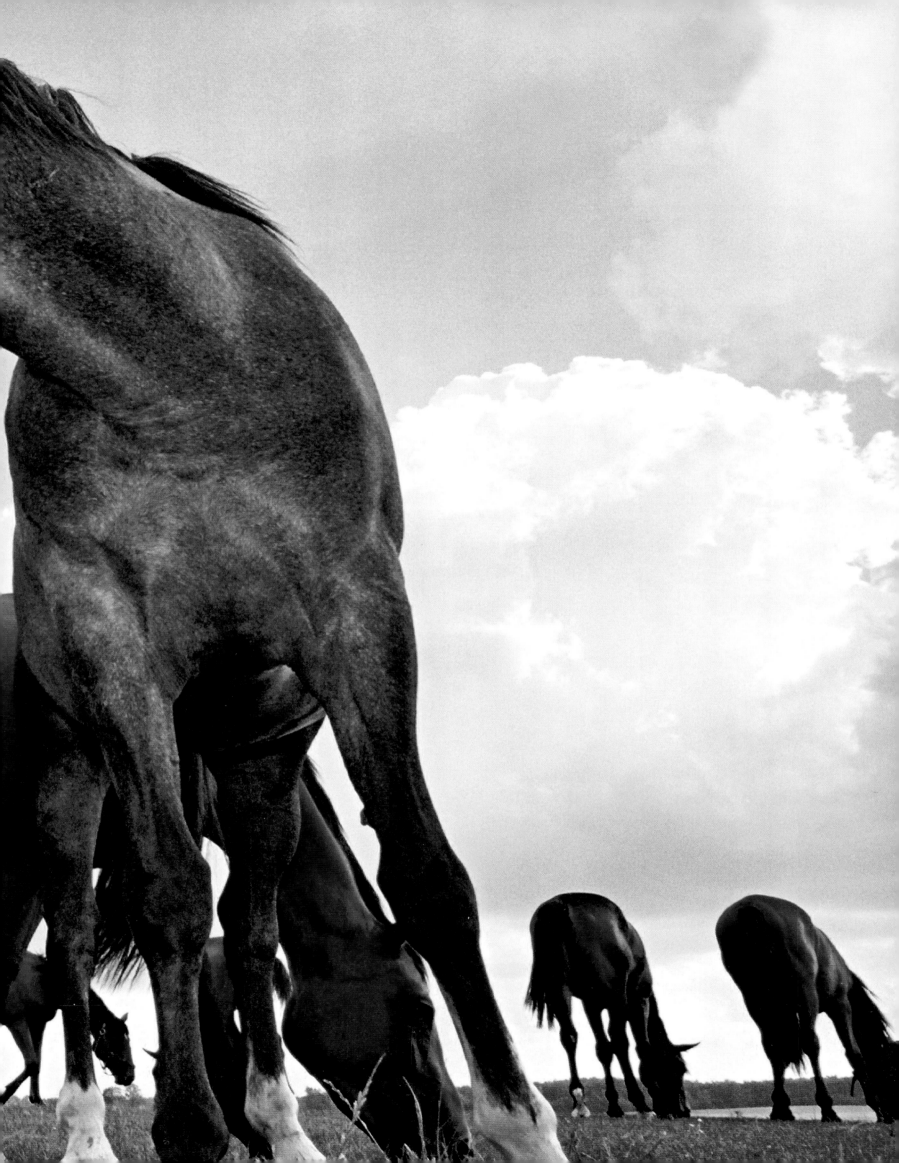

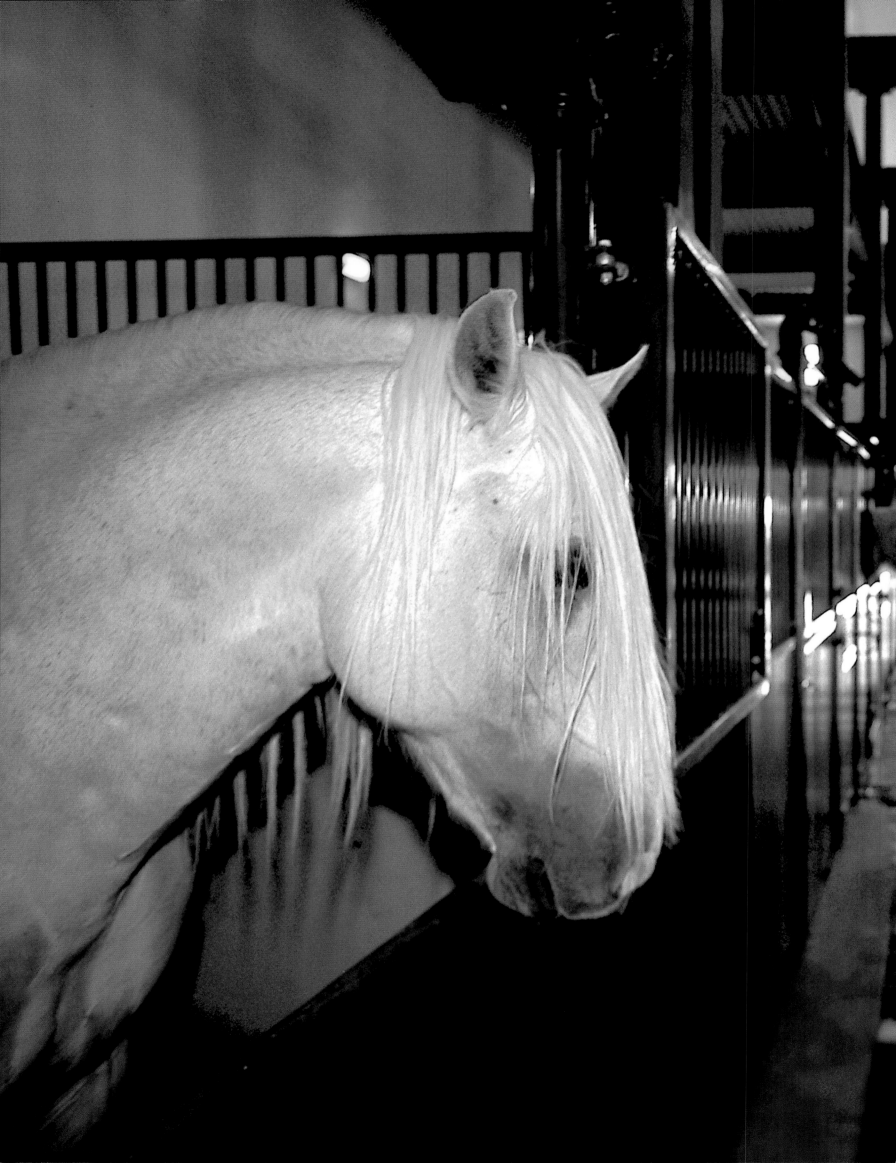

Jordan: Stable of the *Royal Jordanian Equestrian Federation* in Amman, capital of the Hashemite Kingdom of Jordan.

Jordanien: Stall des *Königlichen Instituts der arabischen Reitkunst* in Amman, der Hauptstadt des Haschemitischen Königreichs.

Jordanie : l'écurie de l'*Institut Royal de l'Art Équestre Arabe* à Amman, capitale du royaume hachémite.

Jordania: Establo del *Instituto Real de la Equitación Árabe* en Ammán, la capital del reino Hachemita.

Giordania: la stalla dell'*Istituto reale di cavalleria arab* ad Amman, la capitale del regno hashimita.

Following Page

Leisurely walk: A keeper leads an Arabian race horse of Sheikh Mohammed bin Raschid al-Maktoum.

Spaziergang: Ein Pfleger führt ein arabisches Rennpferd von Scheich Mohammed bin Raschid al-Maktoum.

Promenade : un soigneur mène un cheval de course arabe du Cheikh Mohammed Bin Rashid al-Maktoum.

Paseo: Un cuidador conduce un caballo árabe de carreras del jeque Mohammed bin Raschid al-Maktoum.

Passeggiata: uno artiere conduce un cavallo da corsa arabo di proprietà dello sceicco Mohammed bin Raschid al-Maktoum.

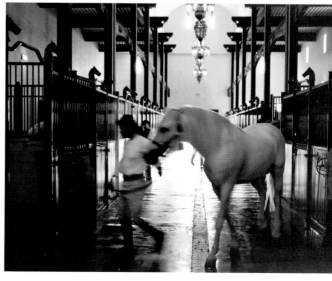

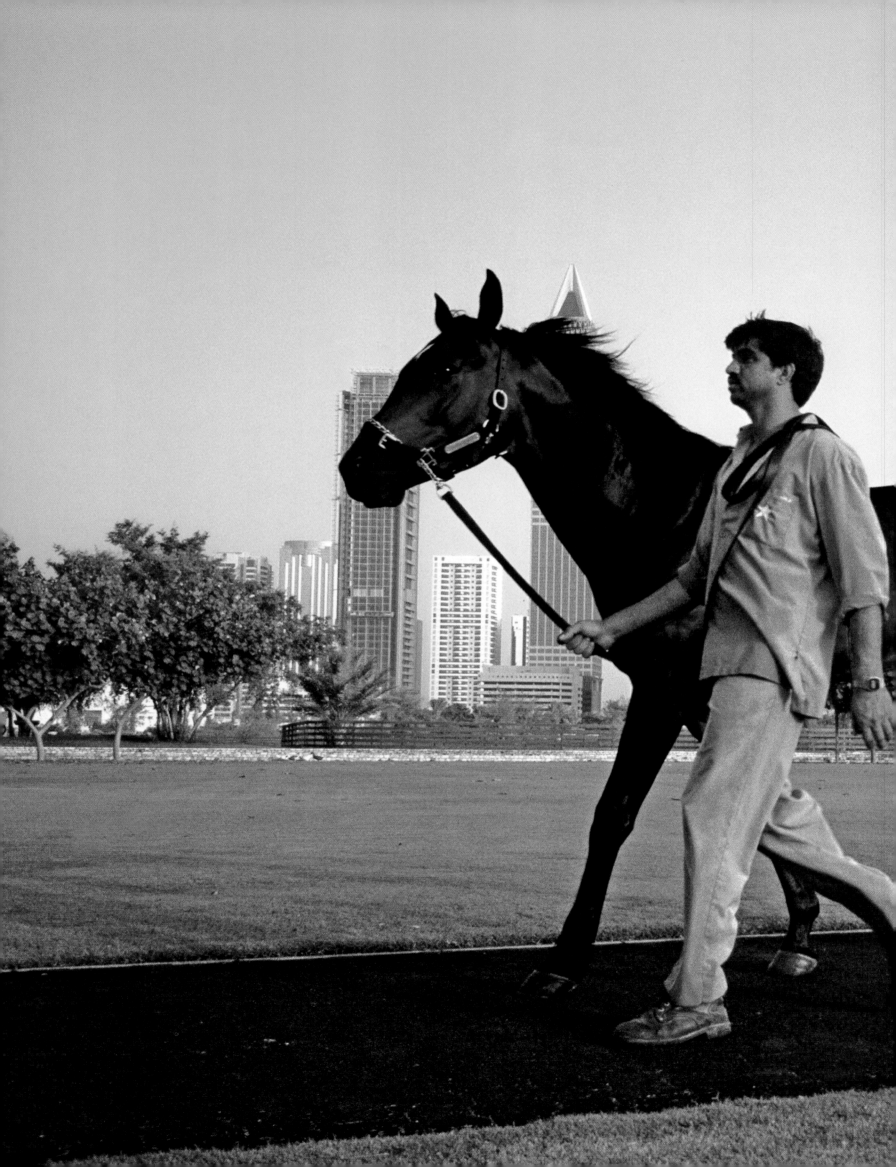

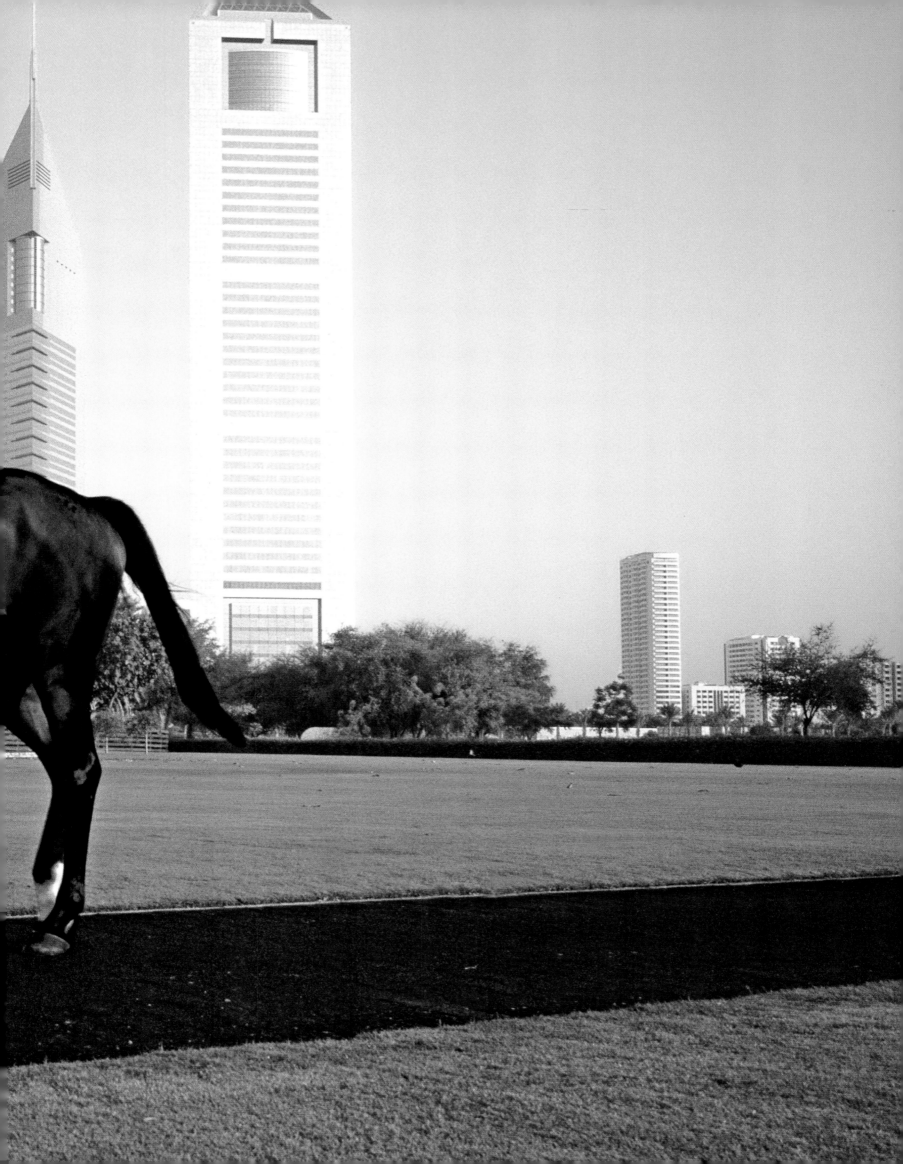

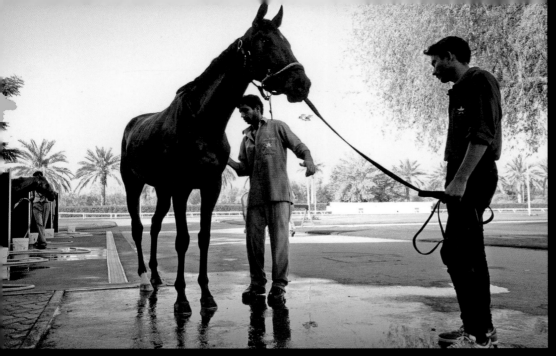

Cold shower

Fitness bath

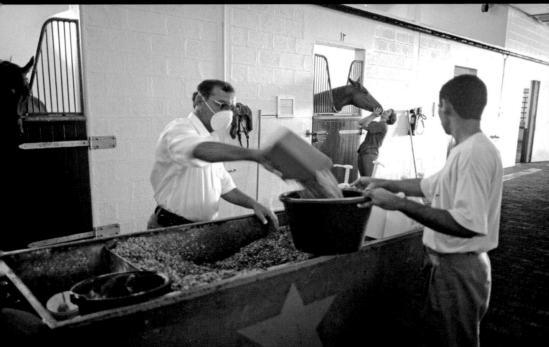

Sterile feed

Treadmill

Luxurious creatures : The Arabian racehorses of Sheikh Muhammad enjoy special treatment. On average, twice the number of keepers attend to the horses than in other stables. In addition, it is the world's most beautiful and noble estate for horses.

Luxusgeschöpfe: Die arabischen Rennpferde von Scheich Mohammed genießen eine besondere Behandlung. Im Schnitt kümmern sich doppelt so viele Pfleger um die Tiere als in anderen Ställen. Zudem gibt es auf dieser Welt kein schöneres oder edleres Anwesen für Pferde.

Créatures de luxe : Les chevaux de course arabes du Cheikh Mohammed bénéficient d'un traitement spécial. En moyenne, deux fois plus de soigneurs que dans les autres écuries s'occupent des animaux. En outre, il n'y a pas, au monde, de propriété plus belle et plus noble pour les chevaux.

Criaturas de lujo: Los caballos árabes de carreras del jeque Mohammed disfrutan de un cuidado especial. De media se ocupan de ellos el doble de personal que en otros establos. Además, están alojados en las cuadras más bellas y nobles del mundo.

Creature di lusso: i cavalli da corsa arabi dello sceicco Mohammed godono di un trattamento particolare: in media, un numero di artieri doppio rispetto a quello di altre scuderie si occupa di loro. Questa è inoltre la tenuta per cavalli più bella ed elegante del mondo.

Head wash

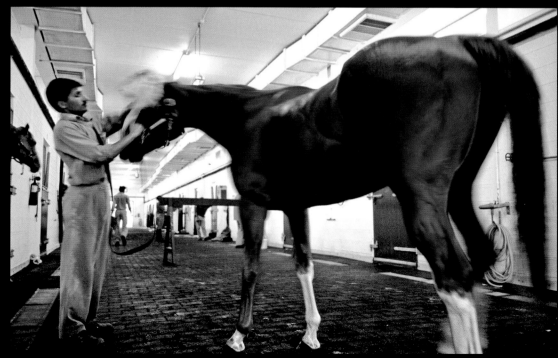
Massage

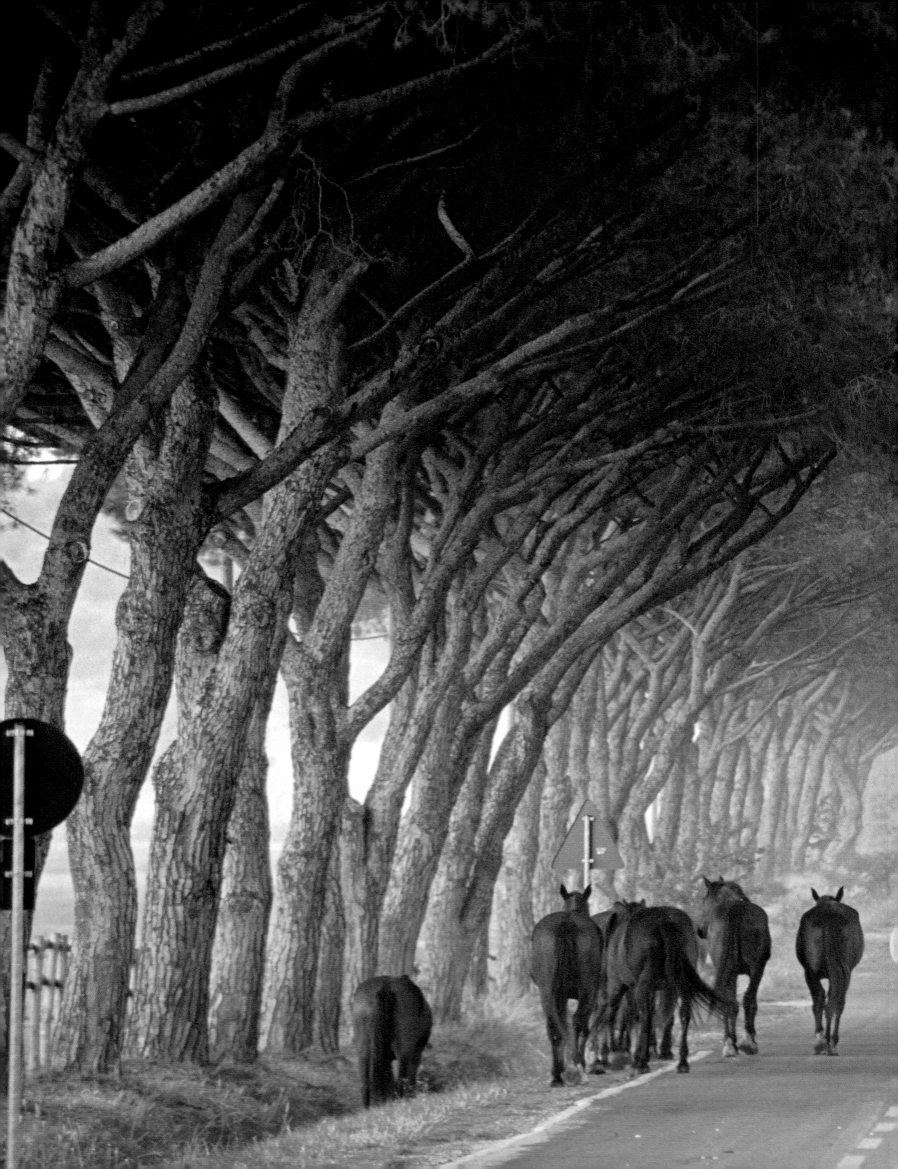

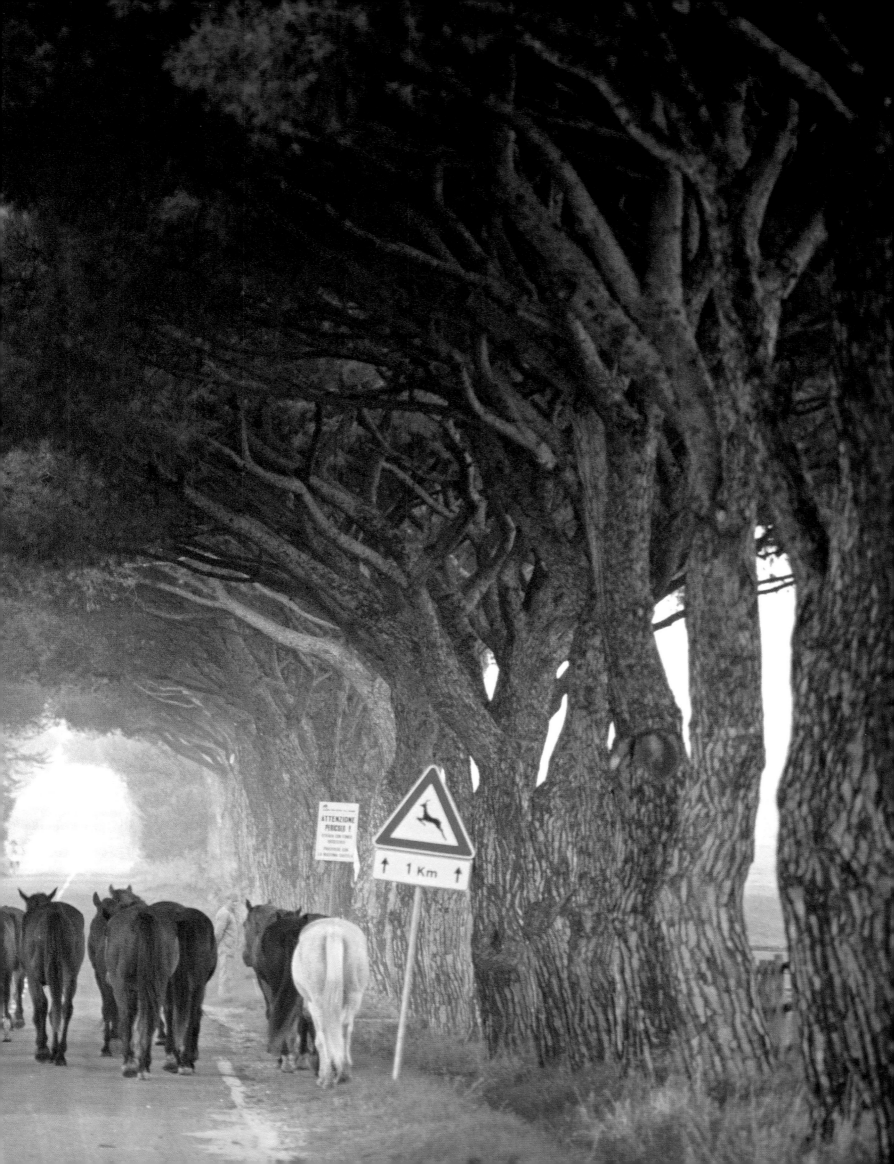

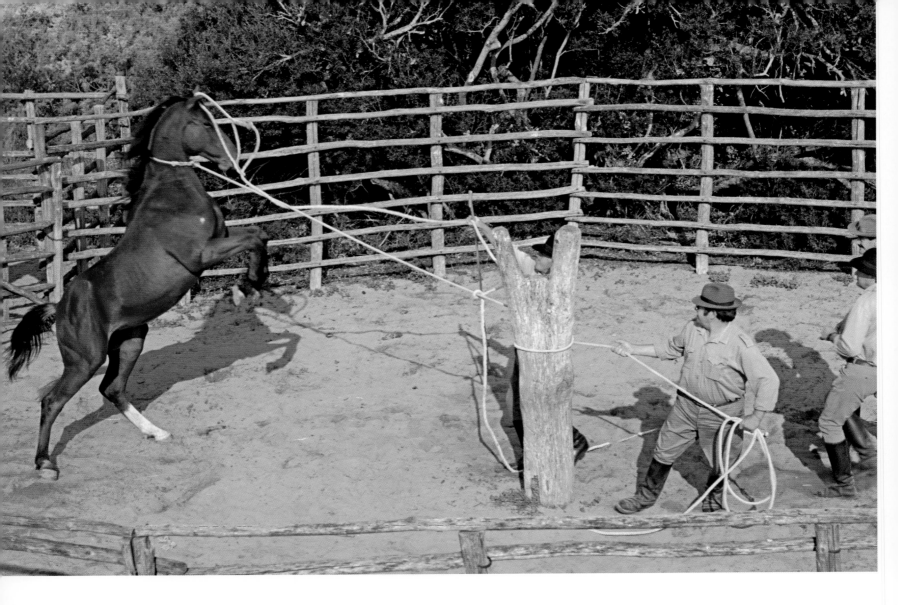

Maremma, Tuscany: A keeper catches a Maremma horse to subsequently brand it.

Maremma, Toskana: Ein Pfleger fängt ein Maremma-Pferd ein, um es anschließend mit einem Brandzeichen zu versehen.

Maremma, Toscane : un soigneur attrape un cheval de Maremma qui sera ensuite marqué au fer.

Maremma, Toscana: Un cuidador prende a un caballo Maremma para marcarlo después con el hierro candente.

Maremma, Toscana: un artiere cattura un cavallo maremmano per marchiarlo.

Pardubice, Czech Republic: A herd of the Kladruby stud farm, the world's oldest of its kind. It was established in 1579 by Emperor Rudolf II. Its purpose was the breeding of huge, representative, white horses for the carriages of the Prague royal court.

Pardubitz, Tschechien: Eine Herde des Gestüts Kladrub, dem ältesten der Welt. Es wurde 1579 von Kaiser Rudolf II. mit der Aufgabe gegründet, mächtige, repräsentative Schimmel für die Kutschen des Prager Hofes zu züchten.

Pardubice, République Tchèque : un troupeau du haras Kladrub, le plus ancien au monde. Il fut fondé en 1579 par l'empereur Rodolphe II dans le but d'élever des chevaux blancs puissants et représentatifs pour les carrosses de la cour de Prague.

Pardubice, Chequia: Una manada del criadero Kladrub, el más antiguo del mundo. Fue fundado por el Emperador Rodolfo II en 1579 con el objetivo de criar poderosos y representativos caballos blancos para los carruajes de la corte de Praga.

Pardubice, Repubblica Ceca: un branco dell'allevamento Kladrub, il più antico del mondo. Fu fondato nel 1579 dall'imperatore Rodolfo II con l'intento di allevare cavalli grigi belli e possenti per le carrozze della corte di Praga.

Previous Page

On the way home: a herd on an alley in Tuscany lined with pine trees.

Heimweg: Eine Herde auf einer von Pinienbäumen gesäumten Allee in der Toskana.

Retour au bercail : un troupeau sur une allée bordée de pins en Toscane.

Camino a casa: Una manada en un paseo rodeado de pinos en la Toscana.

Ritorno a casa: un branco risale un viale di pini in Toscana.

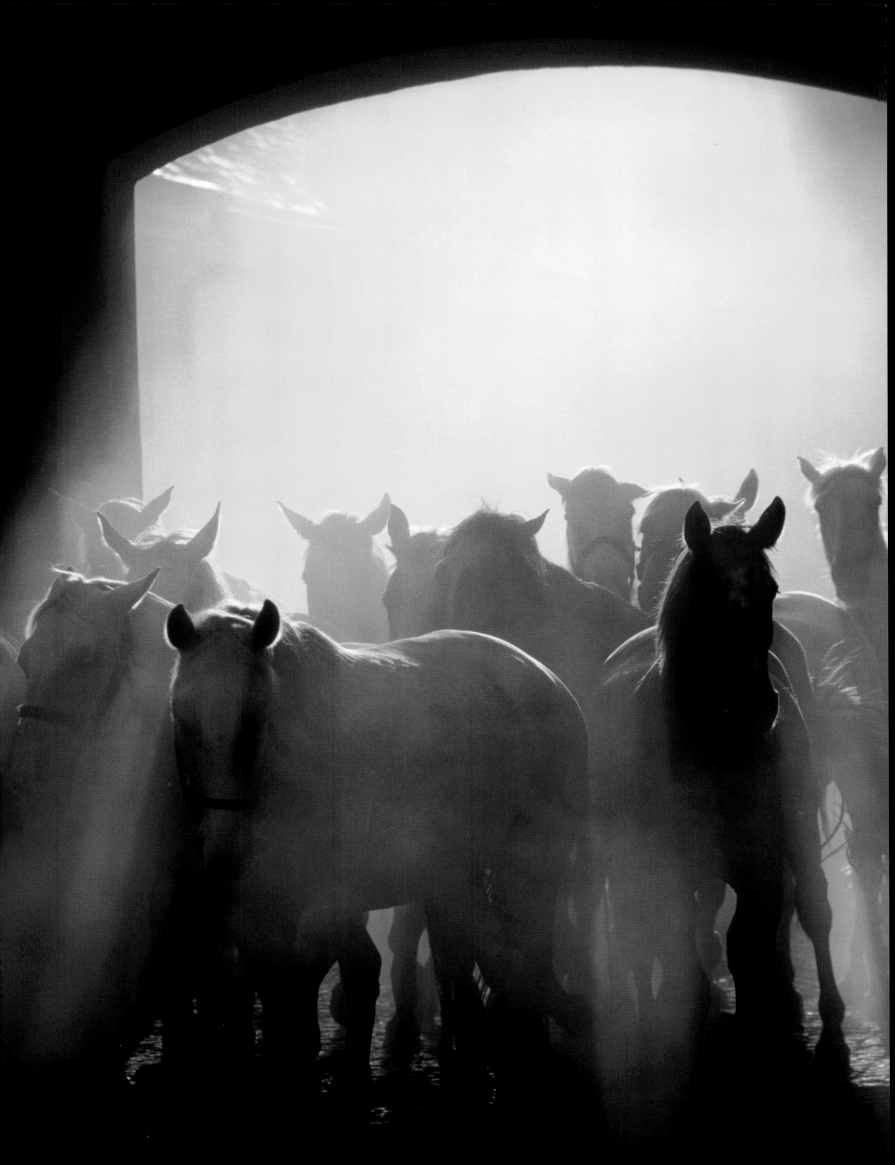

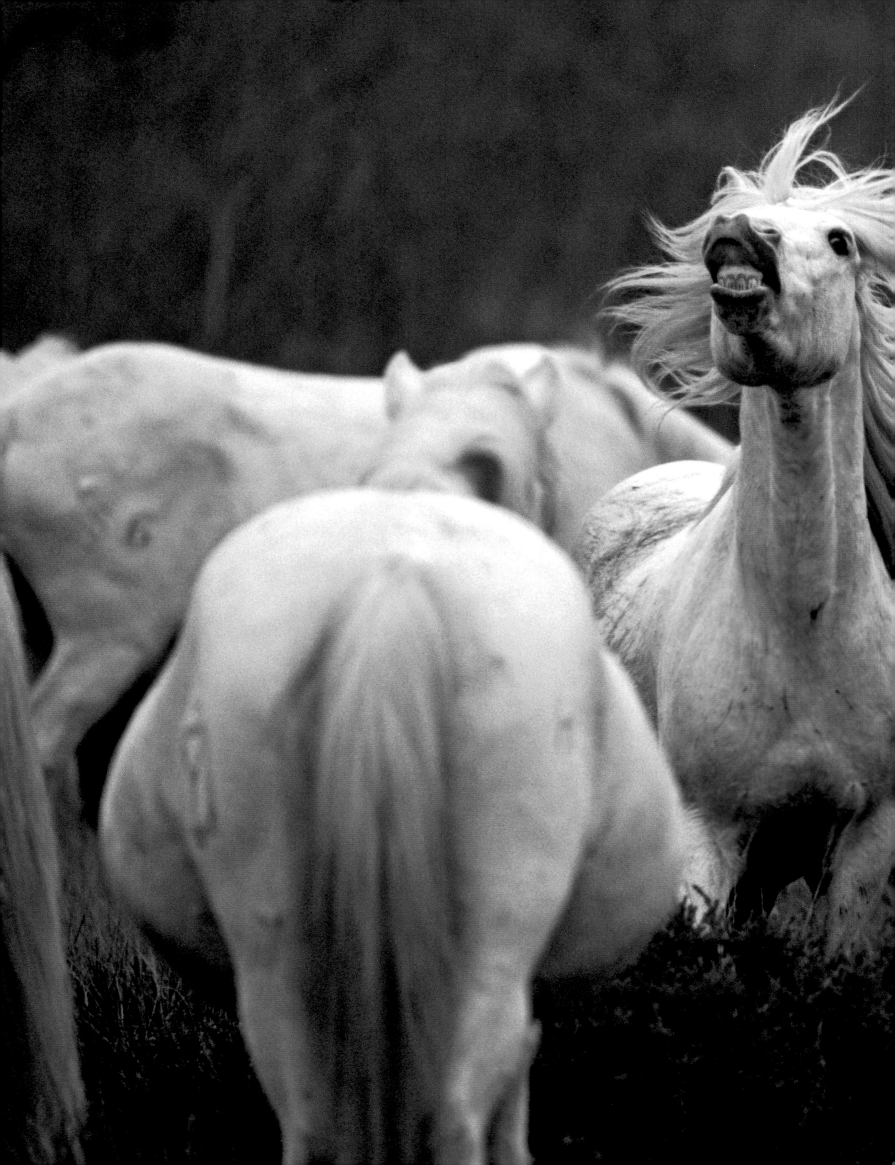

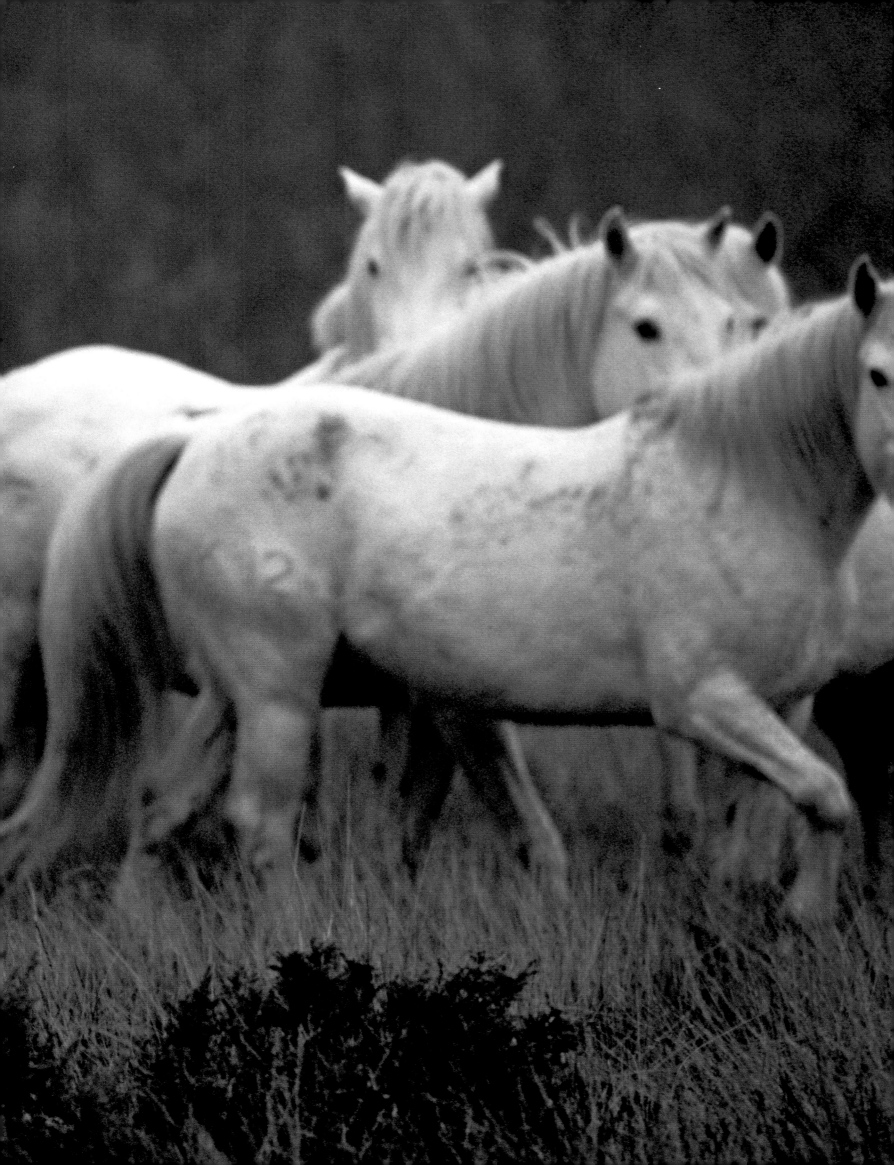

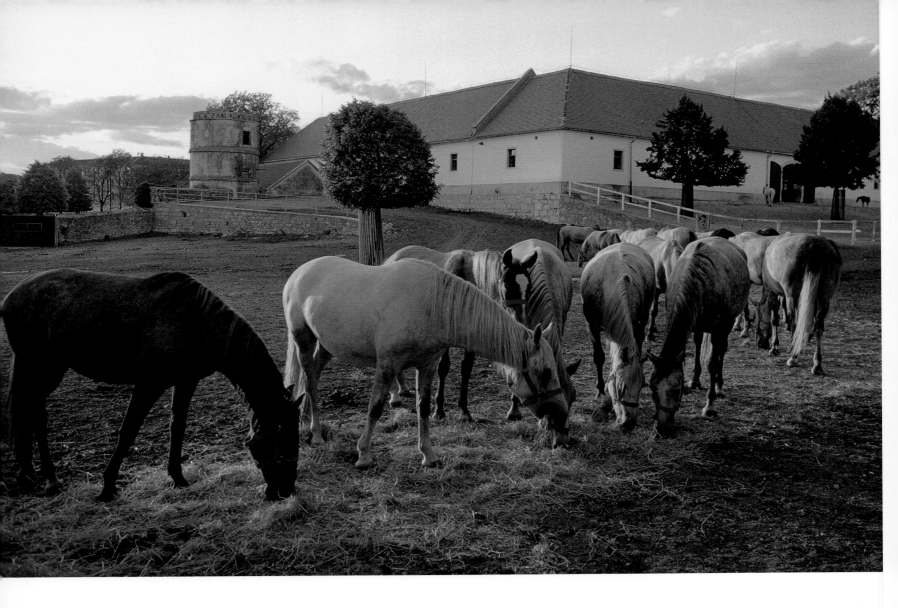

Lipica, Slovenia: The snow-white Lipizzaner are the world's most famous horse breed. They are bred in Lipica near Triest, until they are old enough for the *Spanish Riding School* of Vienna, that maintains the more than 400-year old tradition of the Habsburg horse breeding and horsemanship.

Lipica, Slowenien: Die schneeweißen Lipizzaner sind die berühmteste Pferderasse der Welt. Sie werden in Lipica in der Nähe von Triest gezüchtet, bis sie alt genug sind für die *Spanische Hofreitschule* in Wien, welche die mehr als 400-jährige Tradition der Habsburger Pferdehaltung und Reitkunst bewahrt.

Lipica, Slovénie : le Lipizzan, à la robe blanche, représente la race de chevaux la plus célèbre au monde. Il est élevé à Lipica, près de Trieste, jusqu'à ce qu'il soit assez âgé pour rejoindre *l'Ecole Espagnole d'Equitation* de Vienne qui perpétue la tradition vieille de 400 ans de la manipulation des chevaux et de l'art équestre des Habsbourg.

Lipica, Eslovenia: Los Lipizzaner, de color blanco como la nieve, son la raza de caballos más famosa del mundo. Se crían en Lipica, cerca de Trieste, hasta que tienen la edad suficiente para entrar en la *Escuela Española de Equitación* en Viena, que mantiene la tradición de más de 400 años de antigüedad de los Habsburgo en el cuidado de estos animales y en la equitación.

Lipica, Slovenia: i cavalli lipizzani, dal manto bianchissimo, sono la razza equina più famosa del mondo. Vengono allevati a Lipica, nei pressi di Trieste, finché non hanno raggiunto l'età per la *Scuola di equitazione spagnola* di Vienna, che vanta una tradizione di equitazione e allevamento equino vecchia più di 400 anni, risalente al periodo asburgico.

Previous Page

Threatening gesture: Camargue stallion with his herd.

Drohgebärde: Camargue-Hengst mit seiner Herde.

Air menaçant : un étalon de Camargue avec son troupeau.

Gesto amenazante: Semental Camargue con su manada.

Esibizione di minaccia: uno stallone bianco della Camargue con il suo branco.

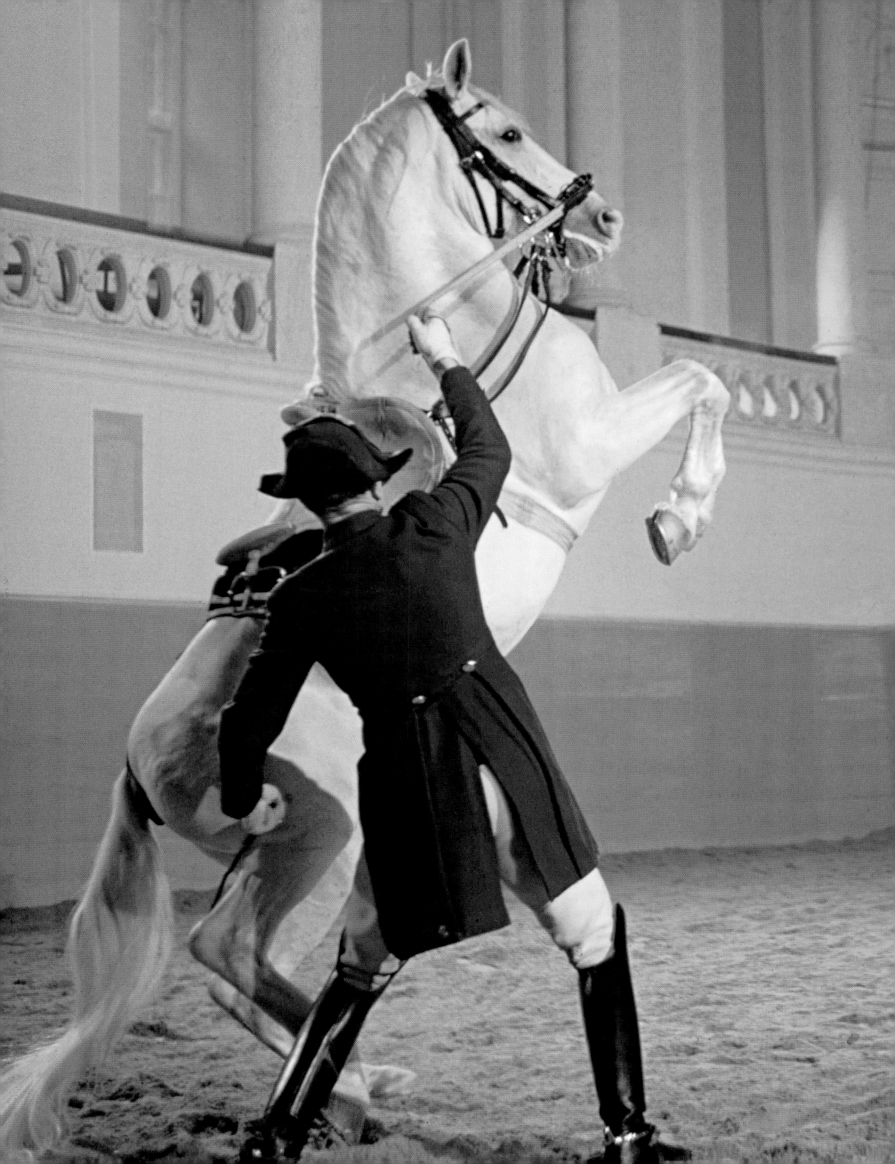

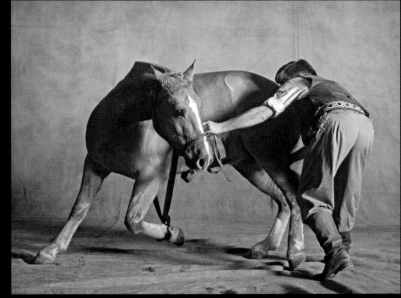
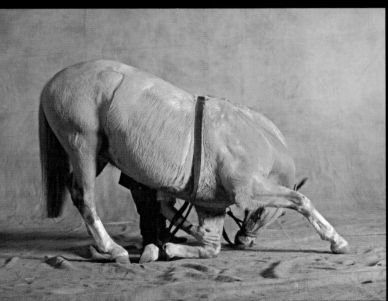
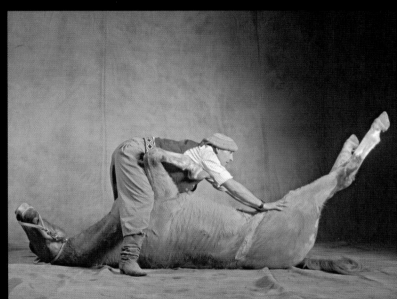

Criollo, Argentinia: Criollos are considered to be the most resilient and toughest horses in the world. They can withstand extreme climatic conditions with little feed, and are particularly enduring and lively. Martin Hardoy is training the Criollo horse *Ayacucho Coscorrón*.

Criollo, Argentinien: Der Criollo gilt als das widerstandsfähigste und zäheste Pferd der Welt. Er kann bei extremen klimatischen Bedingungen mit wenig Futter auskommen, ist besonders ausdauernd und lebendig. Martin Hardoy dressiert das Criollo-Pferd *Ayacucho Coscorrón*.

Criollo, Argentine : le Criollo passe pour être le cheval le plus résistant et le plus tenace au monde. Se contentant de peu de nourriture dans des conditions climatiques extrêmes, il est particulièrement endurant et vif. Martin Hardoy dresse le Criollo *Ayacucho Coscorrón*.

Criollo, Argentina: El Criollo tiene fama de ser el caballo más resistente y tenaz del mundo. Puede soportar las condiciones climáticas más extremas con poco alimento, es especialmente perseverante y despierto. Martin Hardoy domando al caballo Criollo *Ayacucho Coscorrón*.

Criollo, Argentina: il Criollo è considerato il cavallo più robusto e resistente del mondo. Di indole vivace, è in grado di adattarsi con poco cibo a condizioni climatiche estreme ed è particolarmente resistente alla fatica. Nella foto, Martin Hardoy addestra il cavallo criollo *Ayacucho Coscorrón*.

Following Page

Western idyll: Cowboys on a ranch in Tuscarora, Nevada.

Westernromantik: Cowboys auf einer Ranch in Tuscarora, Nevada.

Romantisme de western : des cow-boys sur un ranch à Tuscarora, Nevada.

Romanticismo del oeste: Vaqueros en un rancho en Tuscarora, Nevada.

Atmosfera western: cowboy in un ranch di Tuscarora, nel Nevada.

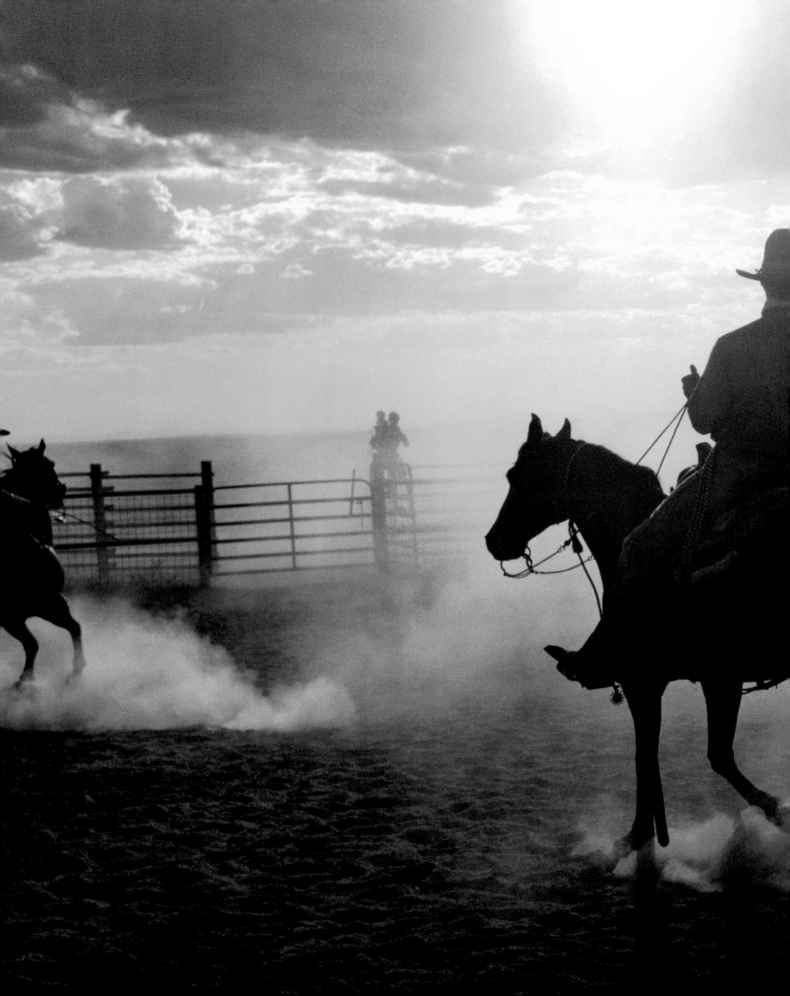

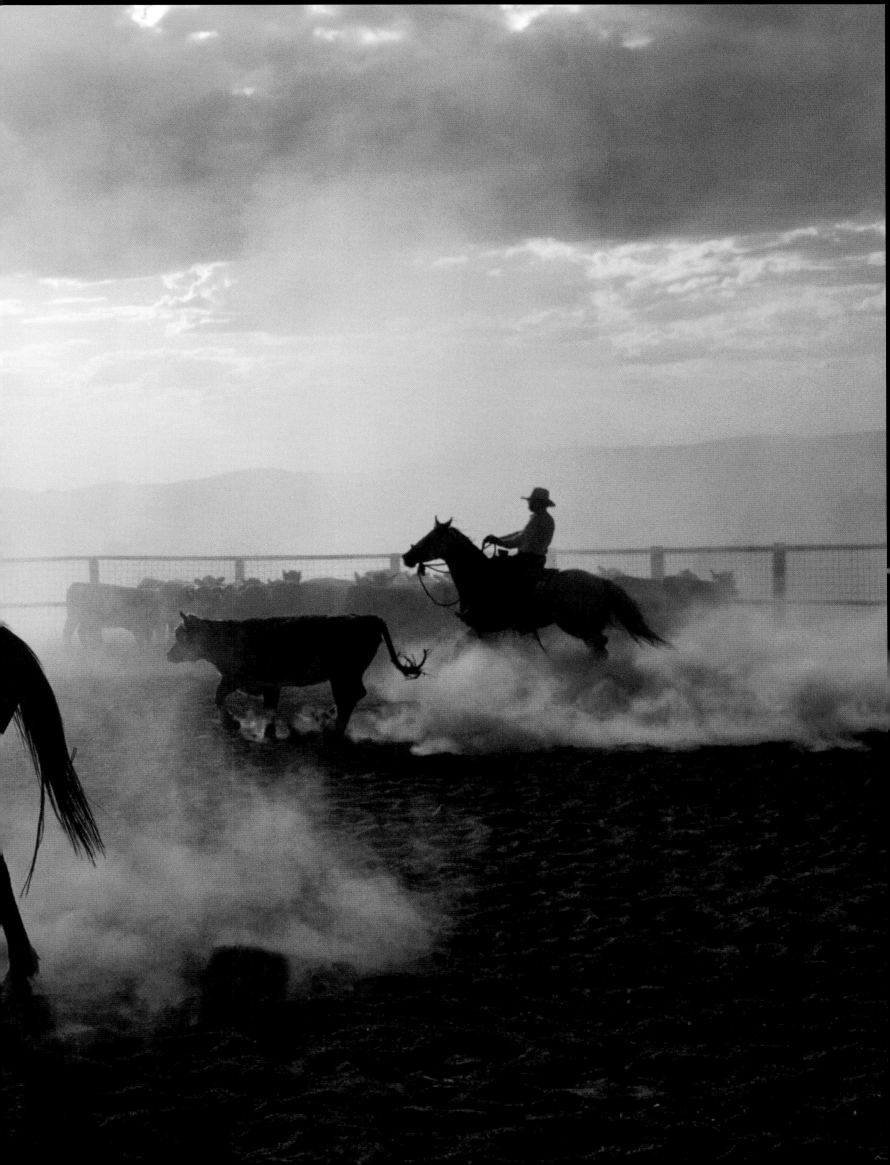

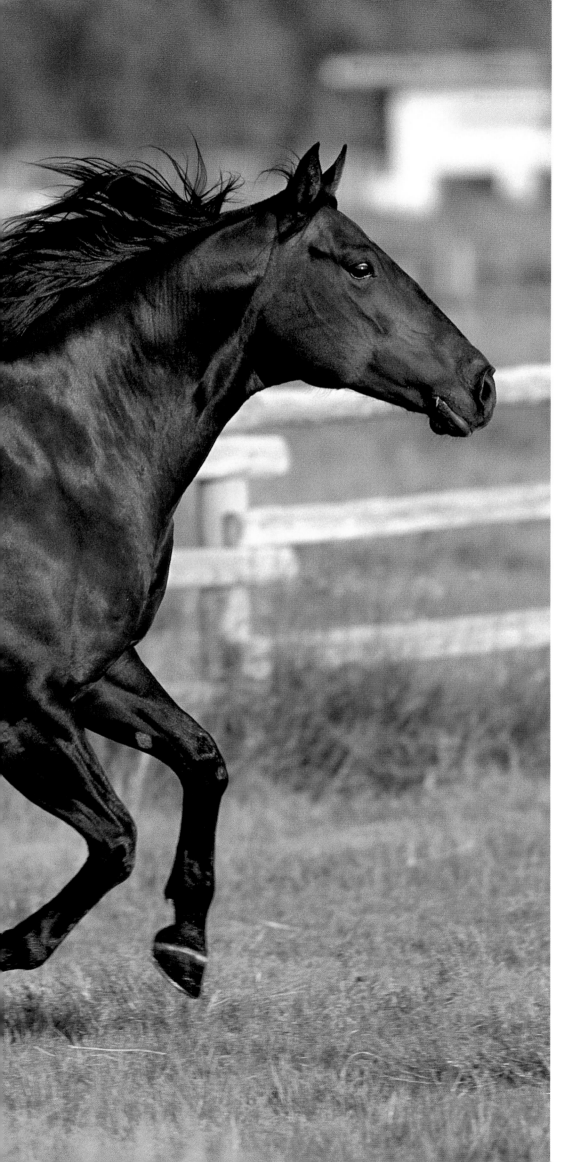

Reining horse, USA: Horses had been extinct on the American continent before the Conquistadors of Spain and Portugal reintroduced them again. The American Quarter Horse and the white spotted Appaloosa are the working horses of cowboys and also popular as leisure horses.

Westernpferd, USA: Pferde waren auf dem amerikanischen Kontinent ausgestorben, bevor die Konquistadoren aus Spanien und Portugal sie zurück in das Land brachten. Das American Quarter Horse und das weiß gefleckte Appaloosa sind die Arbeitspferde der Cowboys und beliebt als Freizeitpferde.

Cheval western, USA : les chevaux avaient disparu du continent américain avant que les conquistadors espagnols et portugais ne les y ramènent. Le Quarter Horse américain et l'Appaloosa à la robe mouchetée de blanc sont les chevaux de travail des cow-boys mais ils sont aussi appréciés comme chevaux de loisir.

Caballo del oeste, EE.UU.: Los caballos habían desaparecido del continente americano hasta que los conquistadores españoles y portugueses los volvieron a traer. El American Quarter Horse y el blanco con manchas Appaloosa son los caballos de trabajo de los vaqueros, y son muy populares como animales para el tiempo libre.

Cavallo del west, USA: il cavallo, un tempo completamente scomparso dal continente americano, fu riportato in America dai Conquistadores spagnoli e portoghesi. L'American Quarter Horse e l'Appaloosa, pezzato di bianco, sono i cavalli da lavoro dei cowboy; sia l'uno sia l'altro sono tra i più apprezzati animali da tempo libero.

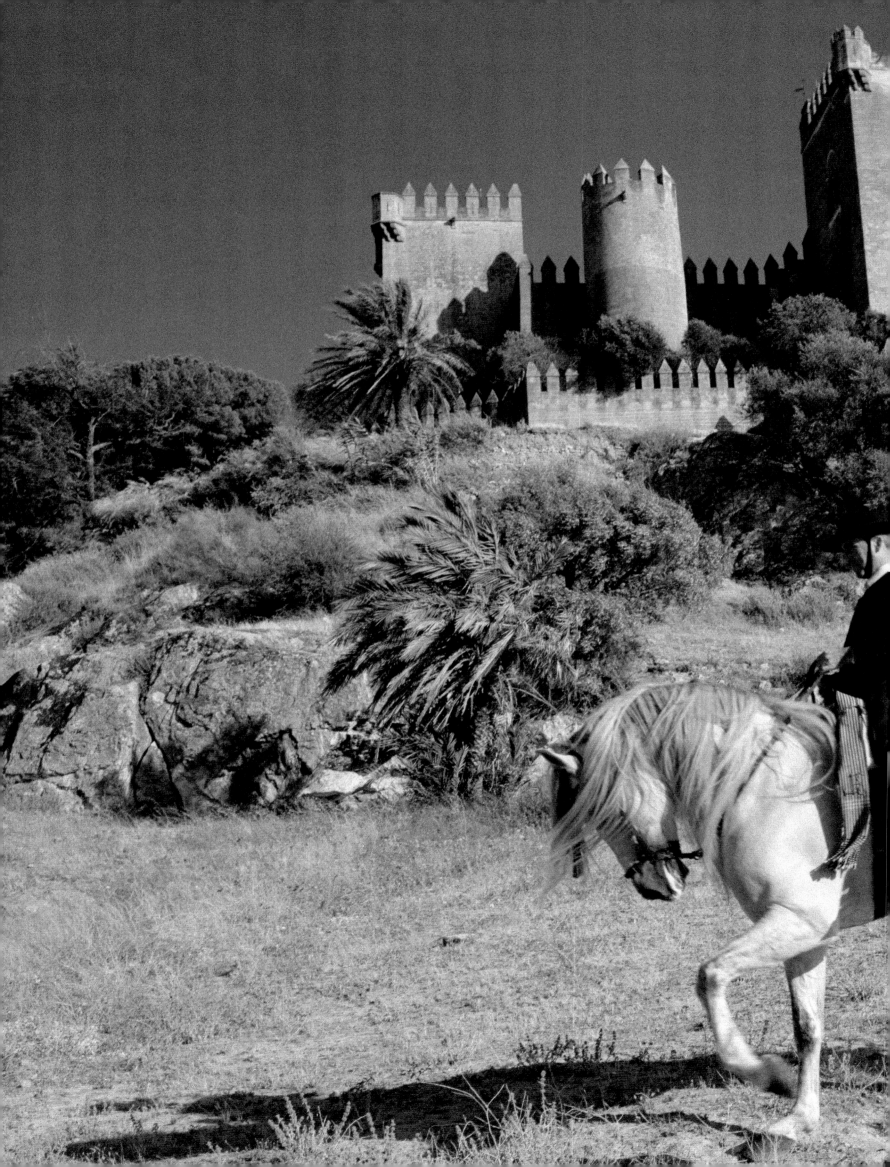

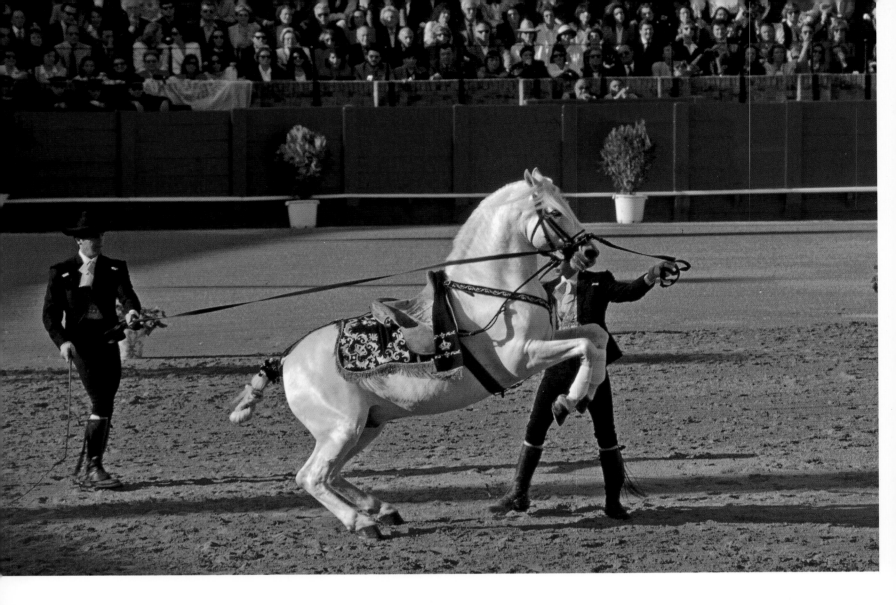

Royal riding school: In the Spanish Jerez, the breeding of horses has been a tradition since the 14th century. In the royal Andalusian riding school *Real Escuel Andaluza del Arte Ecuestre*, more than 80 horses are trained. The school was established by Álvaro Domecq in the year 1973. The Domecq family also breeds the best fighting bulls and produces the best sherry of the region.

Hofreitschule: Im spanischen Jerez hat die Zucht edler Pferde seit dem 14. Jahrhundert Tradition. In der königlich-andalusischen Reitschule *Real Escuela Andaluza del Arte Ecuestre* werden über 80 Pferde dressiert. Gegründet hat die Schule Álvaro Domecq im Jahre 1973. Die Familie Domecq züchtet zudem die besten Kampfstiere und brennt den besten Sherry der Region.

École royale d'équitation : à Jerez, en Espagne, l'élevage de chevaux nobles est une tradition depuis le 14^{ème} siècle. Dans l'école royale d'équitation andalouse *Real Escuela Andaluza del Arte Ecuestre*, sont dressés plus de 80 chevaux. Álvaro Domecq a fondé l'école en 1973. La famille Domecq élève en outre les meilleurs taureaux de corrida et distille le meilleur Sherry de la région.

Escuela de equitación: En Jerez, España, la cría de caballos nobles tiene tradición desde el siglo XIV. En la escuela de equitación andaluza *Real Escuela Andaluza del Arte Ecuestre* se doma a más de 80 caballos. Esta escuela fue fundada por Álvaro Domecq en 1973. La familia Domecq cría también los mejores toros y elabora el mejor jerez de la región.

Scuola di equitazione di corte: a Jerez, in Spagna, l'allevamento di cavalli pregiati è una tradizione che risale al XIV secolo. Nella scuola di equitazione reale andalusa *Real Escuel Andaluza del Arte Equestre*, fondata nel 1973 da Álvaro Domecq, si addestrwano più di 80 cavalli. La famiglia Domecq alleva inoltre i migliori animali da combattimento e produce il miglior sherry della regione.

Previous Page

Andalusian: The Spanish horse, shown here at a breeding farm in Cordoba, was originally bred by Philip II.

Andalusier: Das spanische Pferd, hier auf einem Gestüt in Cordoba, wurde ursprünglich von Philip II. gezüchtet.

Andalou : ce cheval espagnol, ici dans un haras à Cordoba, fut élevé à l'origine par Philippe II.

Andaluz: El caballo Andaluz, aquí en un acaballadero en Córdoba, fue criado en sus orígenes por Felipe II.

Cavallo Andaluso: questa razza spagnola fu allevata, in origine, da Filippo II. L'esemplare della foto proviene da un allevamento di Cordoba.

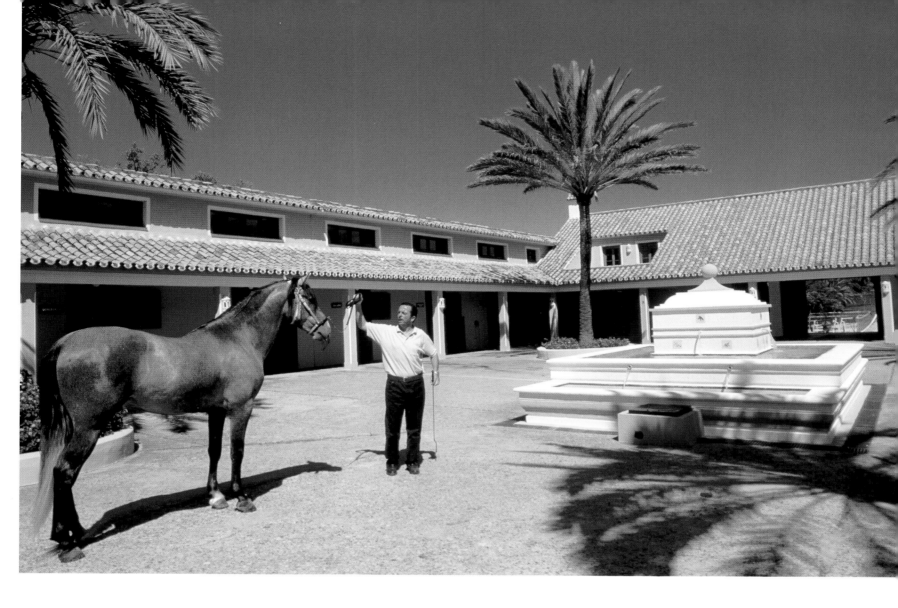

Presentation: *La Zagaleta* riding stable in Benahavís, Malaga province.

Vorführung: der Reitstall *La Zagaleta* in Benahavís, Provinz Malaga.

Démonstration : le centre équestre *La Zagaleta* à Benahavís, dans la province de Malaga.

Presentación: Establo *La Zagaleta* en Benahavís, provincia de Málaga.

Esibizione: la scuderia *La Zagaleta* a Benahavís, nella provincia di Malaga.

Following Page

Morning labor: Luis Domecq on the family finca *Los Alburejos*.

Morgenarbeit: Luis Domecq auf der Familienfinca *Los Alburejos*.

Travail matinal : Luis Domecq sur la finca familiale *Los Alburejos*.

Trabajo matutino: Luis Domecq en la finca familiar *Los Alburejos*.

Il lavoro del mattino: Luis Domecq nella finca di famiglia *Los Alburejos*.

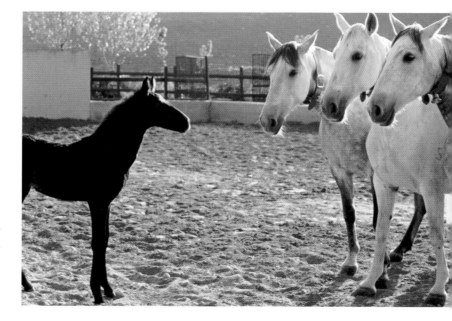

Nursery: Mares with foal at the Finca *La Aldara* near Sevilla.

Kinderstube: Stuten mit Fohlen auf der Finca *La Aldara* bei Sevilla.

Nurserie : juments avec leurs poulains sur la finca *La Aldara* près de Séville.

Guardería: Yeguas con potros en la finca *La Aldara*, en Sevilla.

La stanza dei piccoli: giumente e puledri nella finca *La Aldara* nei pressi di Siviglia.

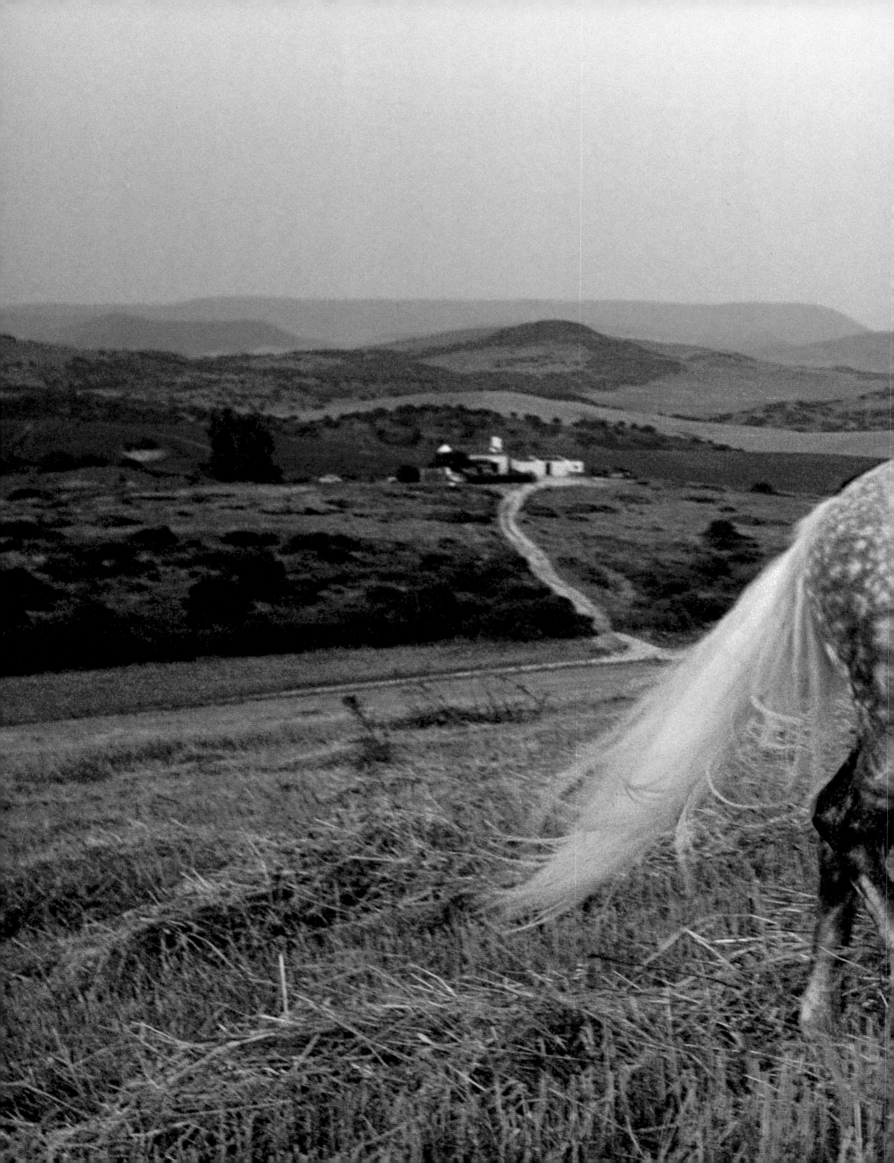

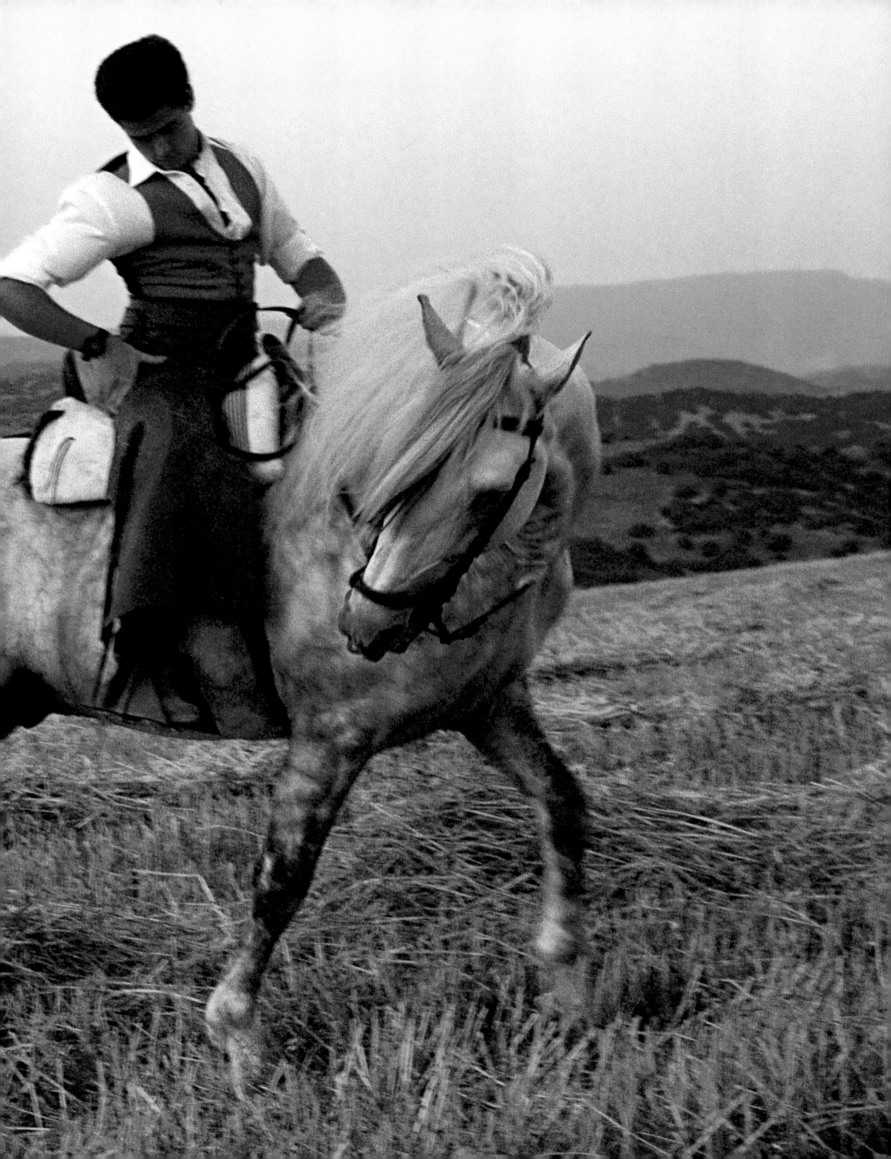

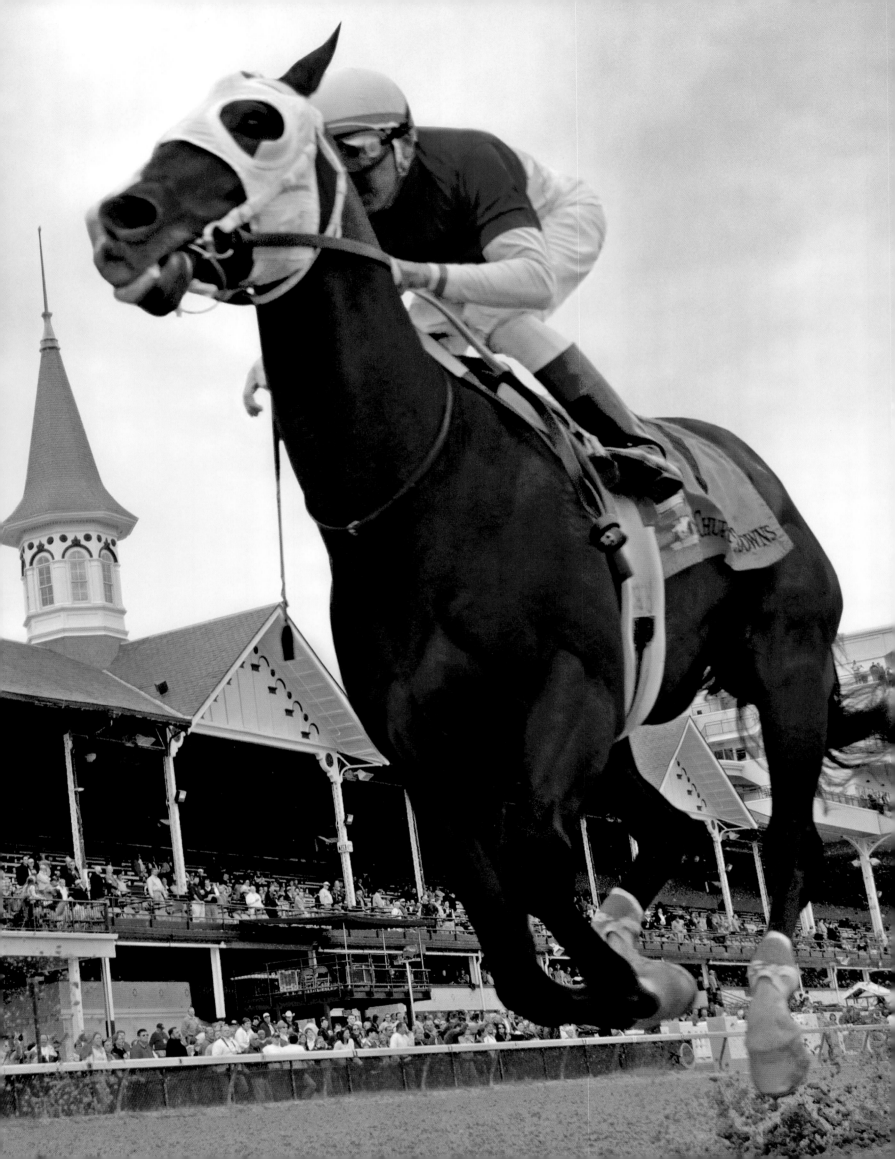

Racing & Society

The large race courses, the fashionable trial gallop, the important turf fields of the old and the new world, the million-dollar champions.

Die großen Rennbahnen, der modische Aufgalopp, die wichtigen Rennbahnen der alten und neuen Welt, die Champions im Wert von Millionen.

Les grands hippodromes, le galop de préparation moderne, les champs de course importants de l'ancien et du nouveau monde, les champions qui valent des millions.

Los grandes hipódromos, el moderno paseillo antes de la salida, las importantes carreras en el mundo viejo y nuevo, campeones millonarios.

I grandi ippodromi, il galoppo iniziale all'insegna dello stile, le piste più importanti del vecchio e del nuovo mondo, i campioni che valgono milioni.

Fascination: whenever the best three-year old horses compete on *Churchill Downs*, more than 140,000 spectators are present and the public life in Kentucky comes to a stand.

Faszination: Wenn auf *Churchill Downs* die besten Dreijährigen antreten, sind mehr als 140000 Zuschauer anwesend, und das öffentliche Leben in Kentucky kommt zum Erliegen.

Fascination : quand les meilleurs trois ans se présentent sur *Churchill Downs*, il y a plus de 140000 spectateurs et la vie publique s'arrête dans le Kentucky.

Fascinación: Cuando los mejores caballos de tres años hacen su entrada en *Churchill Downs*, los 140.000 espectadores y la vida pública de Kentucky se quedan paralizados.

Fascino: quando i migliori esemplari di tre anni gareggiano nell'ippodromo di *Churchill Downs* davanti a più di 140000 spettatori, la vita pubblica del Kentucky si ferma.

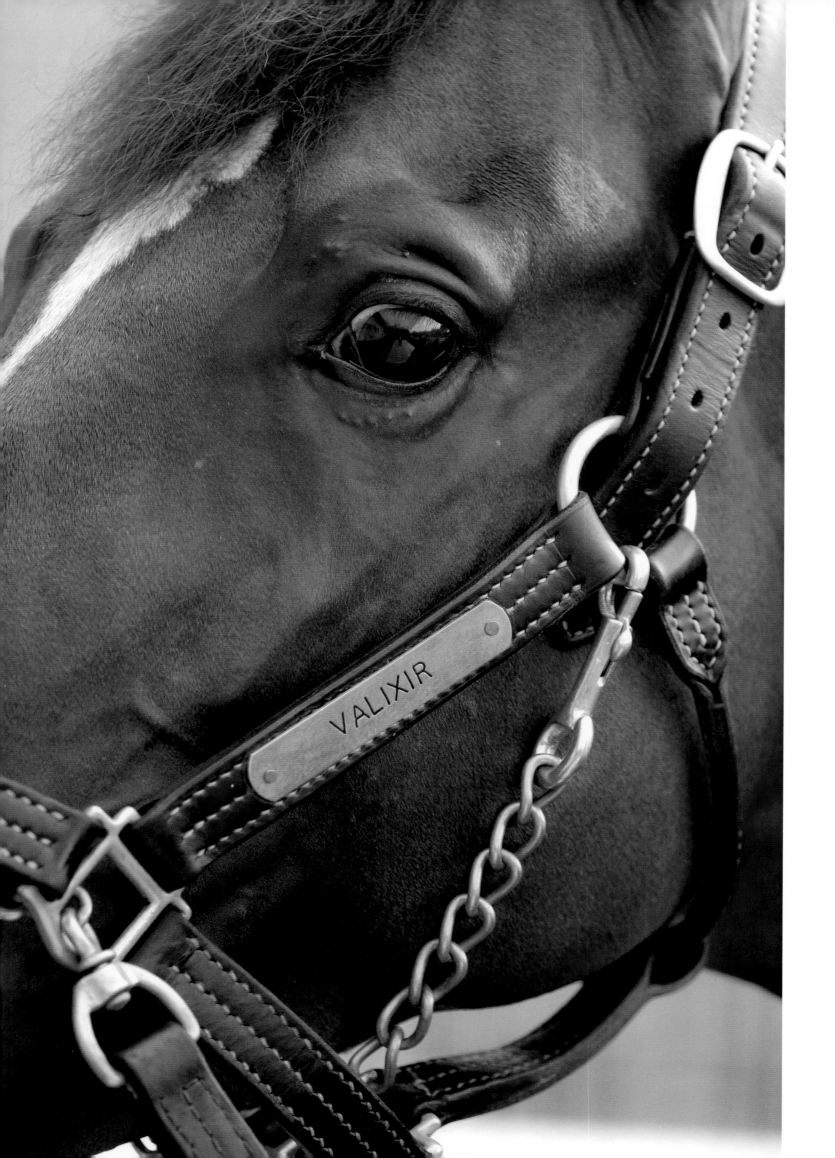

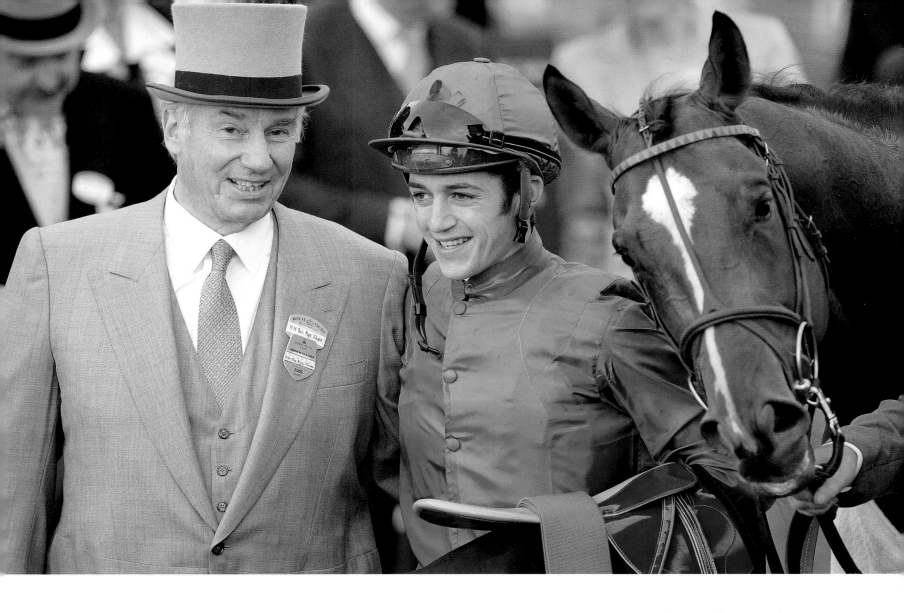

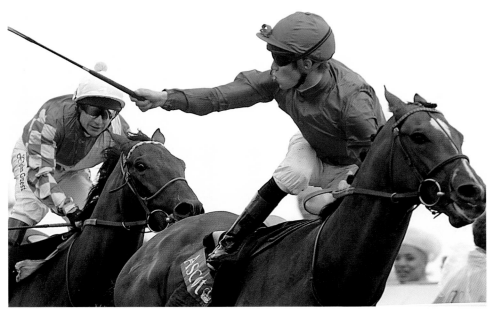

Legends: *Valixir* is a champion of international race courses and has brought in enormously high prize money amounts for his owner, HH Aga Khan. The French jockey Christophe Soumillon won with *Valixir* the *Queen Anne Stakes* in Ascot.

Legenden: *Valixir* ist ein Champion der internationalen Rennbahnen und brachte seinem Besitzer, HH Aga Khan, enorm hohe Preisgelder ein. Der französische Jockey Christophe Soumillon gewann mit *Valixir* das *Queen Anne Stakes* in Ascot.

Légendes : *Valixir,* champion des hippodromes internationaux, rapporta à son propriétaire, Son Altesse l'Aga Khan, des sommes considérables pour les trophées remportés. Le jockey français Christophe Soumillon gagna avec *Valixir* le *Queen Anne Stakes* à Ascot.

Leyendas: *Valixir* es un campeón de las carreras internacionales y ganó para su propietario, HH Aga Khan, formidables premios en metálico. El jinete francés Christophe Soumillon ganó con *Valixir* el *Queen Anne Stakes* en Ascot.

Leggende: grazie a *Valixir,* campione di fama internazionale, HH Aga Khan, suo proprietario, ha vinto enormi somme di denaro. Il fantino francese Christophe Soumillon ha vinto con *Valixir* il *Queen Anne Stakes* di Ascot.

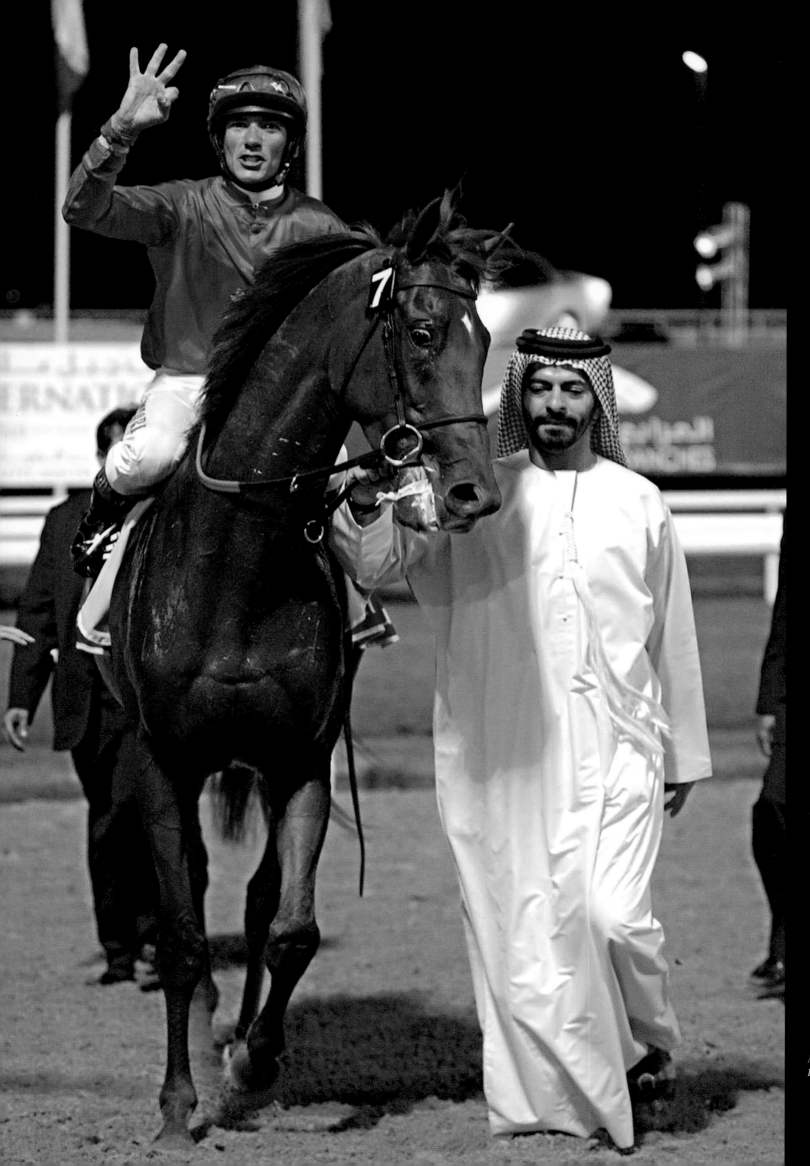

Moon Ballad,
Dubai World Cup

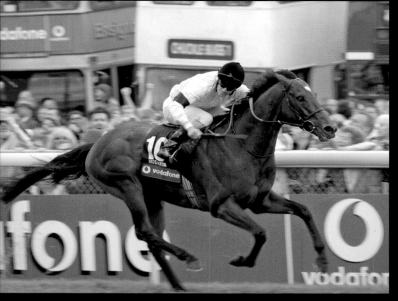

Motivator, Epsom Derby, England.

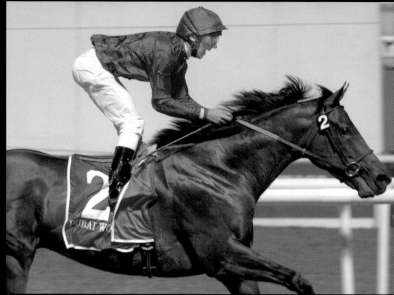

Godolphin, Dubai Millennium, Dubai

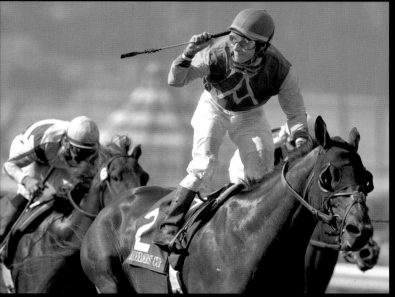

Pleasantly Perfect, Breeder's Cup, Santa Anita.

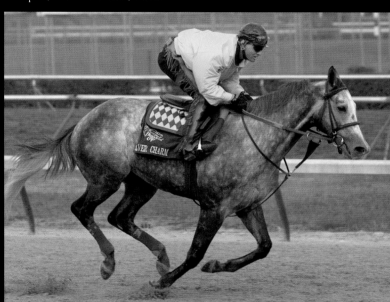

Silver Charm, Louisville.

The stars of the race course: The keeping of horses is possibly the most noble and at the same time most beautiful way to spend one's money. At any rate, their owners do not spare any amount to try and turn their animals into stars, maybe even legends. But only very few succeed in this.

Die Stars der Rennbahn: Vielleicht ist das Halten von Rennpferden die nobelste und zugleich schönste Art, Geld auszugeben. Jedenfalls scheuen Besitzer keine Kosten, damit aus ihren Tieren einmal ein Star wird, später gar ein Mythos. Doch nur wenigen gelingt dies.

Stars de l'hippodrome : l'élevage de chevaux de course est peut-être la manière la plus noble et la plus belle à la fois, de dépenser son argent. Les propriétaires, en tout cas, ne regardent pas à la dépense pour que leurs animaux deviennent un jour une star, voire, plus tard, un mythe. Mais seuls quelques uns y parviennent.

Las estrellas del hipódromo: Quizá el mantener caballos de carreras sea la forma más noble y bella de gastarse el dinero. En cualquier caso, los propietarios no reparan en gastos para que sus animales se conviertan alguna vez en una estrella e incluso, más tarde, en un mito. Pero sólo unos pocos lo consiguen.

Le stelle dell'ippodromo: mantenere dei cavalli da corsa è probabilmente il modo più nobile e contemporaneamente più piacevole di spendere il proprio denaro. In ogni caso, per fare dei loro cavalli delle vere stelle, o addirittura un mito, i proprietari non badano a spese. Ma solo pochi riescono in questo intento.

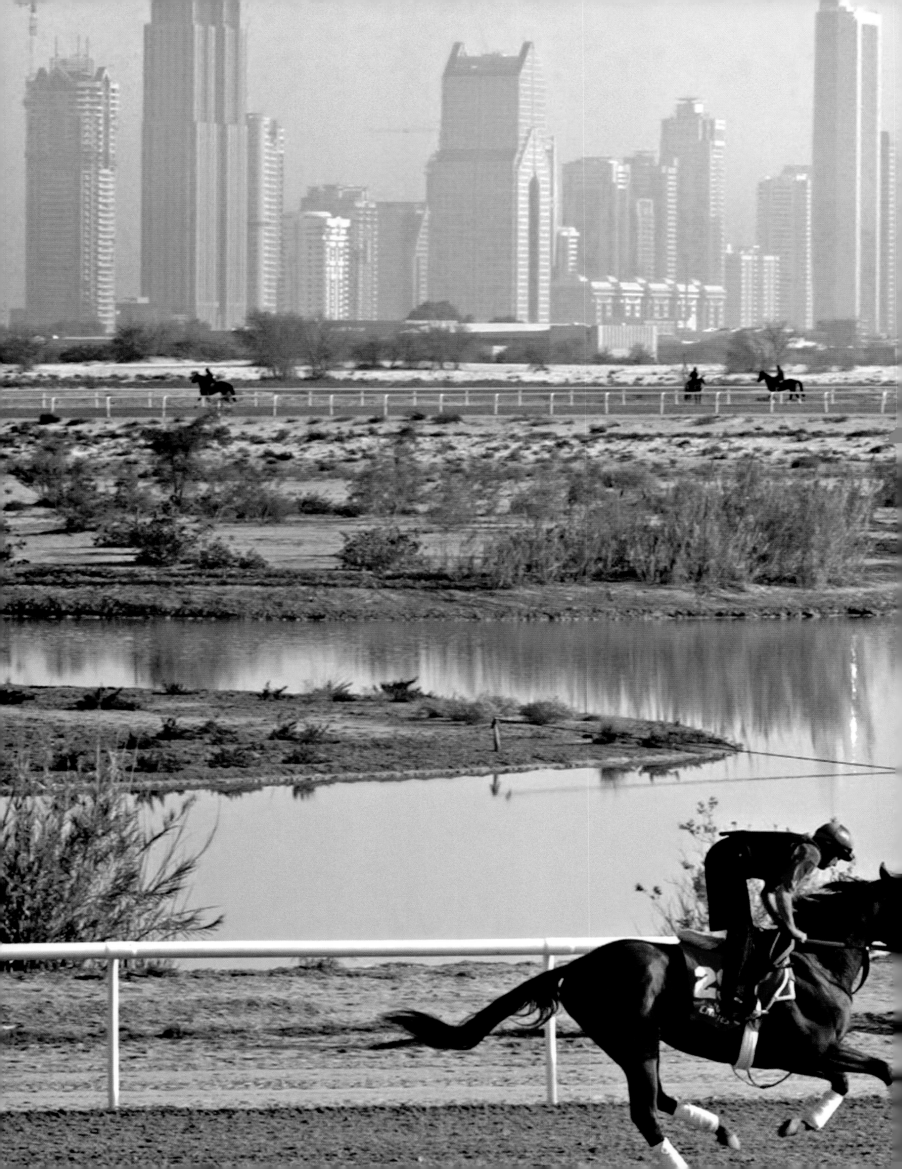

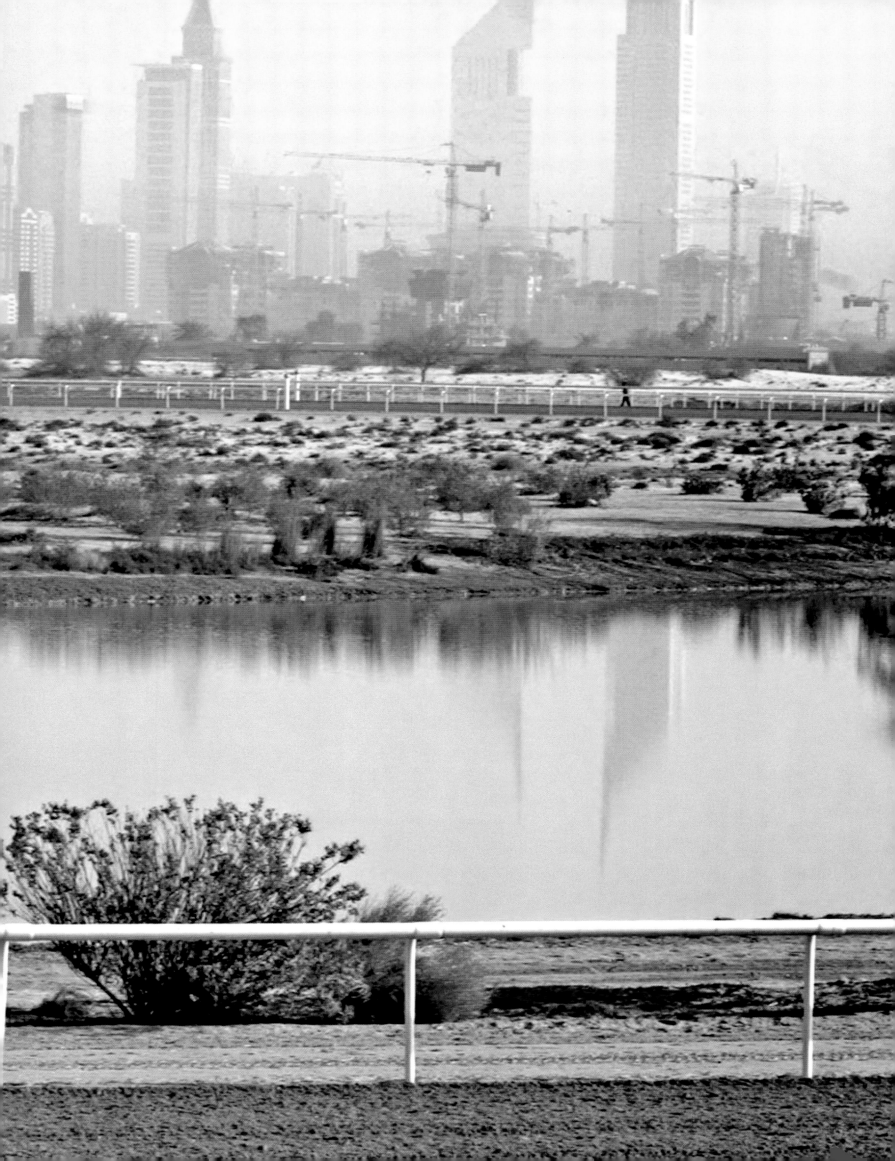

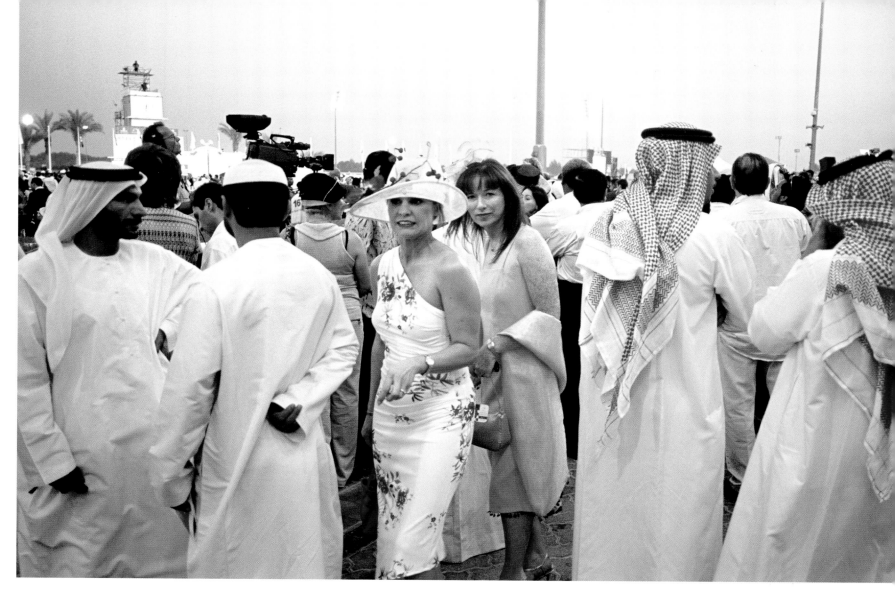

East meets West: Oil sheiks meet the European "race nobility" and observe the events from the ultramodern grandstand.

East meets West: Ölscheichs treffen auf europäischen „Rennadel" und beobachten das Geschehen von der hochmodernen Haupttribüne aus.

L'est rencontre l'ouest : les cheikhs de l'or noir rencontrent la « noblesse des champs de courses » européenne et observent les événements du haut de la très moderne tribune principale.

Oriente con occidente: Los jeques del petróleo se encuentran con la "nobleza de las carreras" europea y observan las carreras desde las modernas tribunas principales.

East meets West: gli sceicchi del petrolio incontrano la "nobiltà europea dello sport equestre" e osservano la scena dalla futuristica tribuna principale.

Previous Page

Dubai, superlative race: The city's skyline with its high-rises is the backdrop for the *Dubai World Cup*, the race with the highest prize money in the world—six million dollars.

Dubai, Rennen der Superlative: Die Skyline der Stadt mit ihren Hochhäusern bildet die Kulisse für das mit sechs Millionen Dollar höchst dotierte Turnier der Welt, den *Dubai World Cup*.

Dubaï, course des superlatifs : la silhouette de la ville avec ses gratte-ciel constitue le décor de la *Dubaï World Cup*, le tournoi le plus doté au monde avec ses six millions de dollars.

Dubai, una carrera superlativa: El perfil de la ciudad, con sus rascacielos, forma el escenario de la *Dubai World Cup*, la carrera dotada con el mayor premio del mundo, seis millones de dólares.

Dubai, corsa dei superlativi: lo skyline della città ed i suoi grattacieli sono lo scenario del torneo che, con sei milioni di dollari, ha la dotazione in premi più alta del mondo: il *Dubai World Cup*.

Durban, shrill chic: The Greyville Race Course in Durban near the Indian Ocean is the venue for South Africa's largest horse race. This is where the new high society of Africa meets.

Durban, schriller Schick: In Durban am Indischen Ozean findet auf der Greyville-Rennbahn das größte Pferderennen Südafrikas statt. Hier trifft sich die neue High Society Afrikas.

Durban, un chic tapageur : à Durban, au bord de l'océan indien, a lieu la plus grande course de chevaux d'Afrique du sud, sur l'hippodrome de Greyville, où se retrouve la nouvelle haute société d'Afrique.

Durban, elegantemente estridente: En Durban, en el océano Índico, se celebra la carrera Greyville, la mayor competición de Sudáfrica. Aquí se reúne la nueva alta sociedad africana.

Durban, eleganza e stravaganza: a Durban, sull'Oceano Indiano, nell'ippodromo di Greyville si svolge la corsa più importante del Sudafrica. È qui che si dà appuntamento la nuova high society africana.

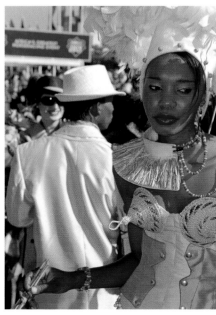

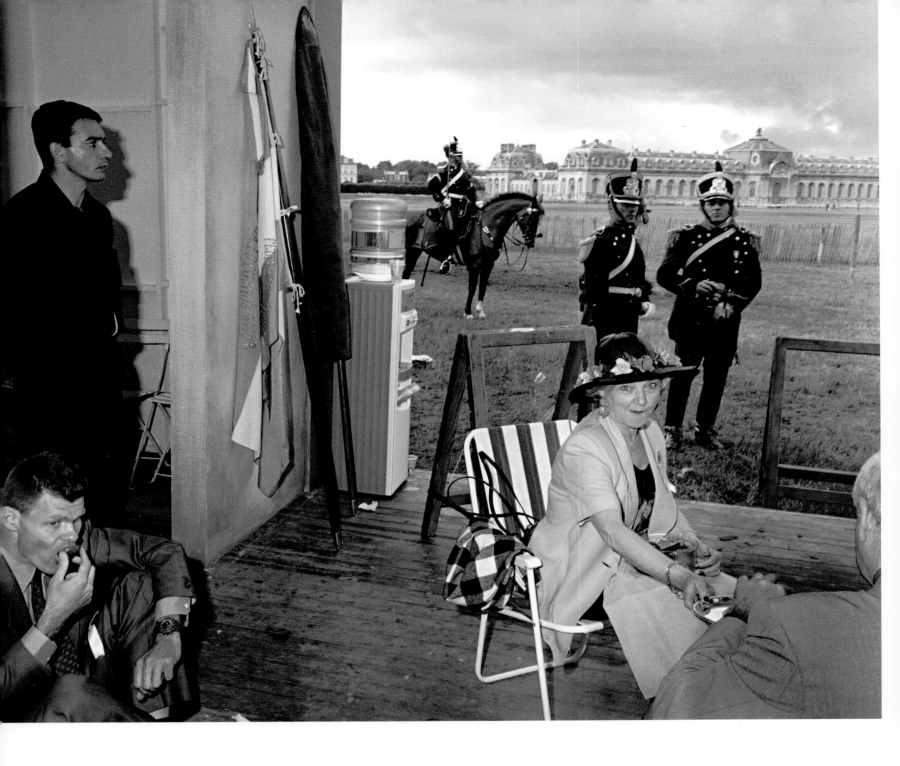

Chantilly: In August of every year, it is tradition to celebrate during a picnic on the grass in front of the Hippodrome. The cause of the event is the *Prix de Diane*—one of France's most important horse races.

Chantilly: Jedes Jahr im August wird traditionell bei einem Picknick auf dem Rasen vor dem Hippodrom gefeiert. Anlass ist der *Prix de Diane* – eines der bedeutendsten Pferderennen Frankreichs.

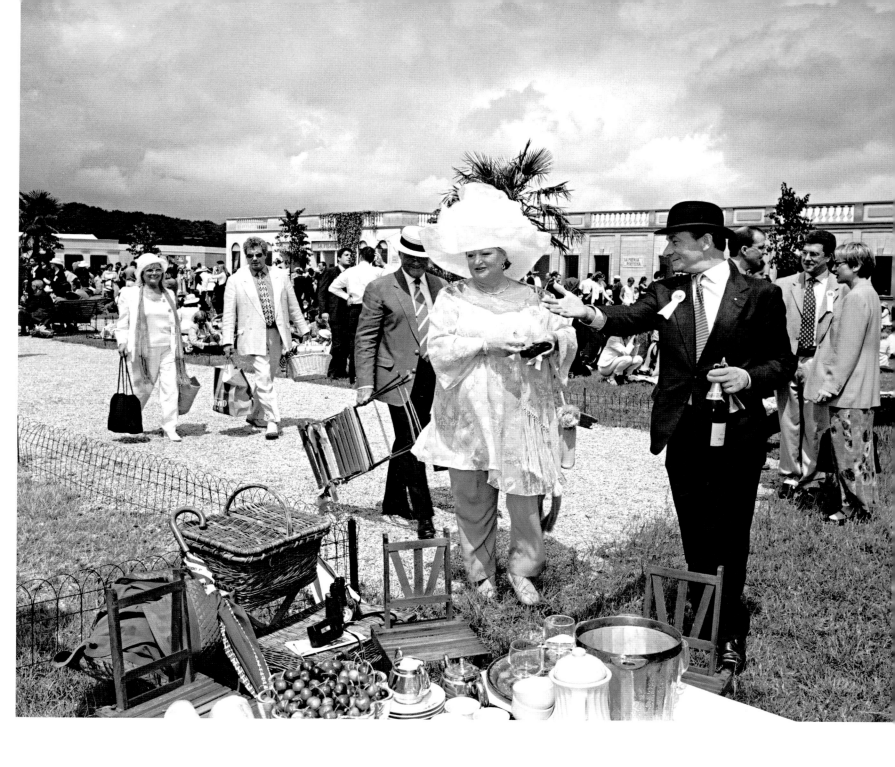

Chantilly : chaque année, en août, a lieu le traditionnel pique-nique festif sur la pelouse devant l'hippodrome – à l'occasion du *Prix de Diane* – l'une des courses françaises les plus importantes.

Chantilly: Todos los años, en agosto, se celebra el tradicional picnic en la hierba del hipódromo. El motivo es el *Prix de Diane* –una de las carreras más importantes de Francia.

Chantilly: ogni anno, in agosto, in occasione del *Prix de Diane*, una delle corse francesi di maggior interesse, sul prato davanti all'ippodromo ha luogo il tradizionale picnic.

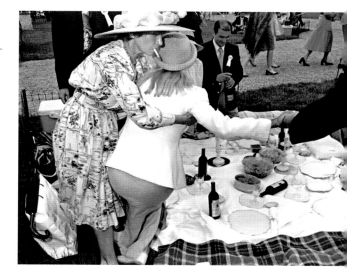

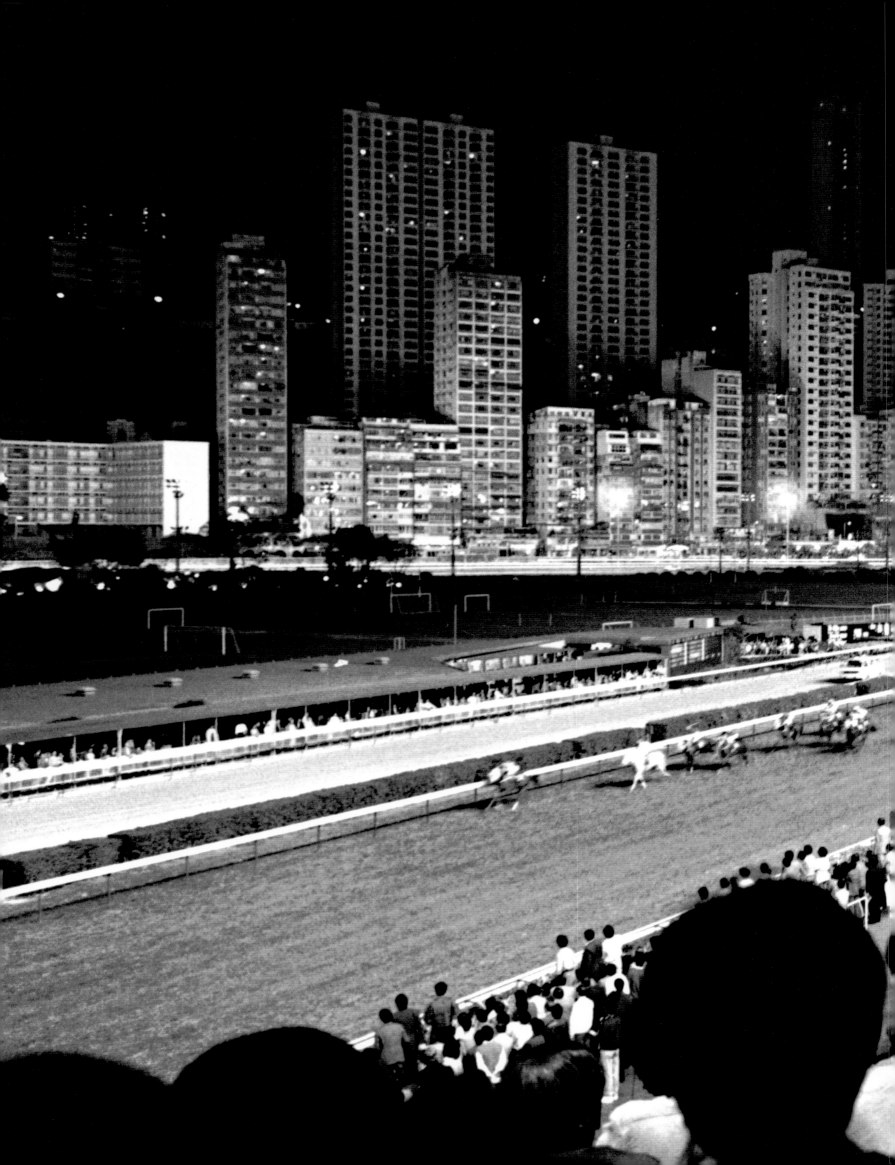

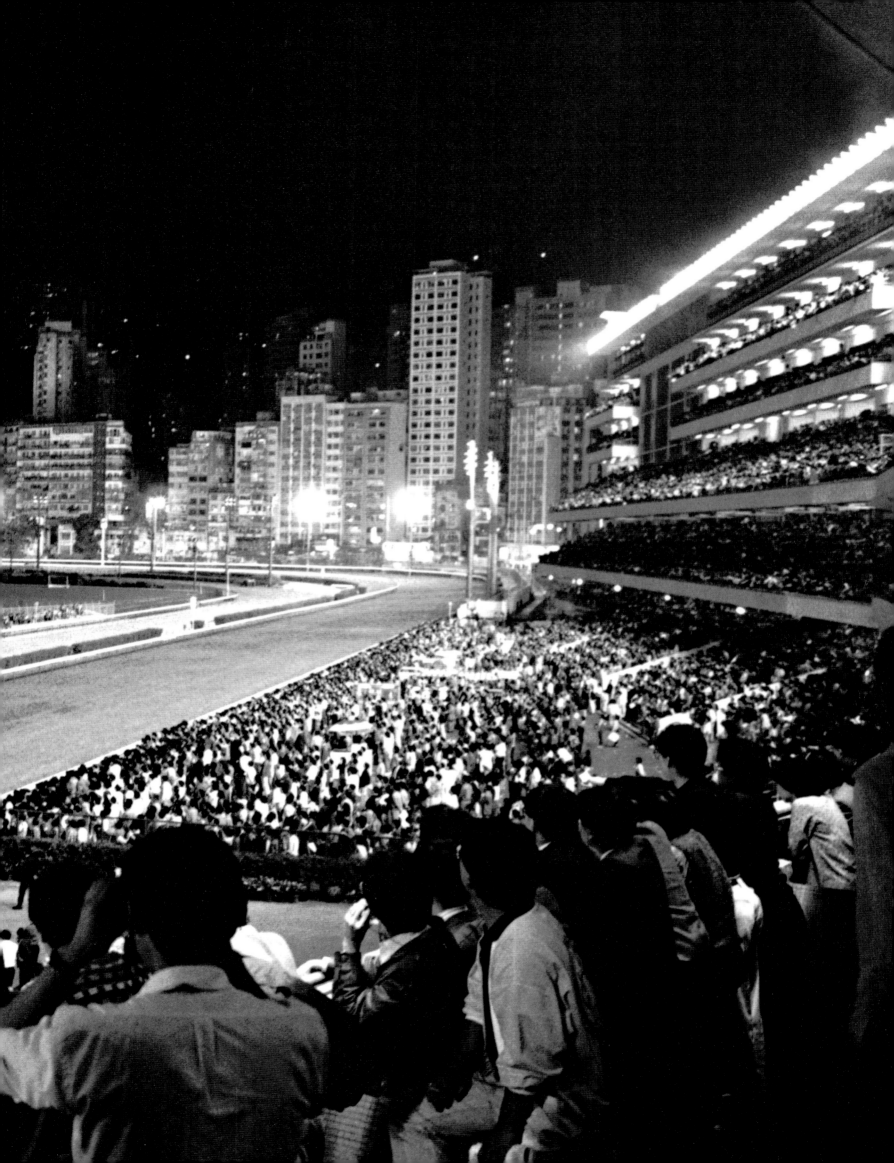

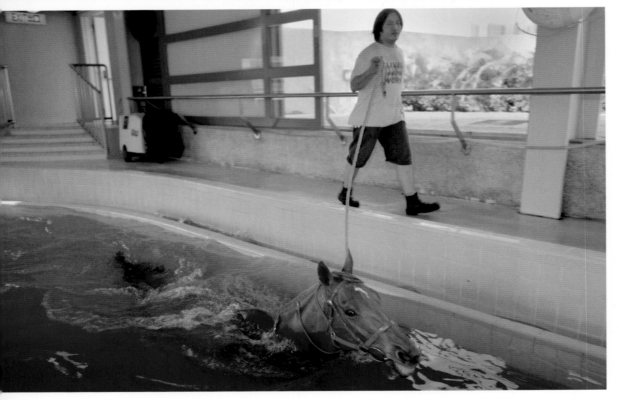

Hong Kong, game of millions among skyscrapers:
On the race courses of *Happy Valley* and *Sha Tin*, visitors annually spend billions on horse bets. The races take place between September and June. With their air-conditioned stables and horse swimming pools, the race courses are among the most modern in the world.

Hongkong, Millionenspiel zwischen Wolkenkratzern:
Auf den Rennbahnen von *Happy Valley* und *Sha Tin* geben die Besucher jährlich Milliardenbeträge für Pferdewetten aus. Die Rennen finden zwischen September und Juni statt. Die Rennbahnen zählen mit ihren klimatisierten Ställen und Pferdeschwimmbecken zu den modernsten der Welt.

Hong Kong, des millions d'enjeux entre les gratte-ciel :
sur les hippodromes de *Happy Valley* et *Sha Tin*, les visiteurs dépensent annuellement des milliards en paris. Les courses ont lieu de septembre à juin. Avec leurs écuries climatisées et leurs piscines pour les chevaux, ces hippodromes sont considérés comme les plus modernes au monde.

Hong Kong, un juego de millones entre los rascacielos:
En los hipódromos *Happy Valley* y *Sha Tin*, los visitantes se gastan todos los años millones en apuestas. Las carreras se celebran desde septiembre hasta junio. Estos hipódromos se encuentran entre los más modernos del mundo con sus cuadras climatizadas y las piscinas para los caballos.

Hong Kong, un gioco da milioni tra i grattacieli:
i visitatori spendono ogni anno miliardi in scommesse negli ippodromi di *Happy Valley* e di *Sha Tin*. Le corse si svolgono tra settembre e giugno. Questi ippodromi, tra i più moderni del mondo, hanno stalle climatizzate e piscine per i cavalli.

Previous Page

Imposing: The *Happy Valley* race course in the heart of Hong Kong.

Imposant: Die *Happy-Valley*-Rennbahn mitten in Hongkong.

Impressionant : l'hippodrome *Happy Valley* au cœur de Hong Kong.

Impresionante: La carrera *Happy Valley* en el centro de Hong Kong.

Imponente: l'ippodromo *Happy Valley* nel centro di Hong Kong.

Following Page

Iffezheim: daily morning work with the horses.

Iffezheim: tägliche Morgenarbeit mit den Pferden.

Iffezheim : travail matinal quotidien avec les chevaux.

Iffezheim: diario trabajo matutino con los caballos.

Iffezheim: i cavalli richiedono cure giornaliere.

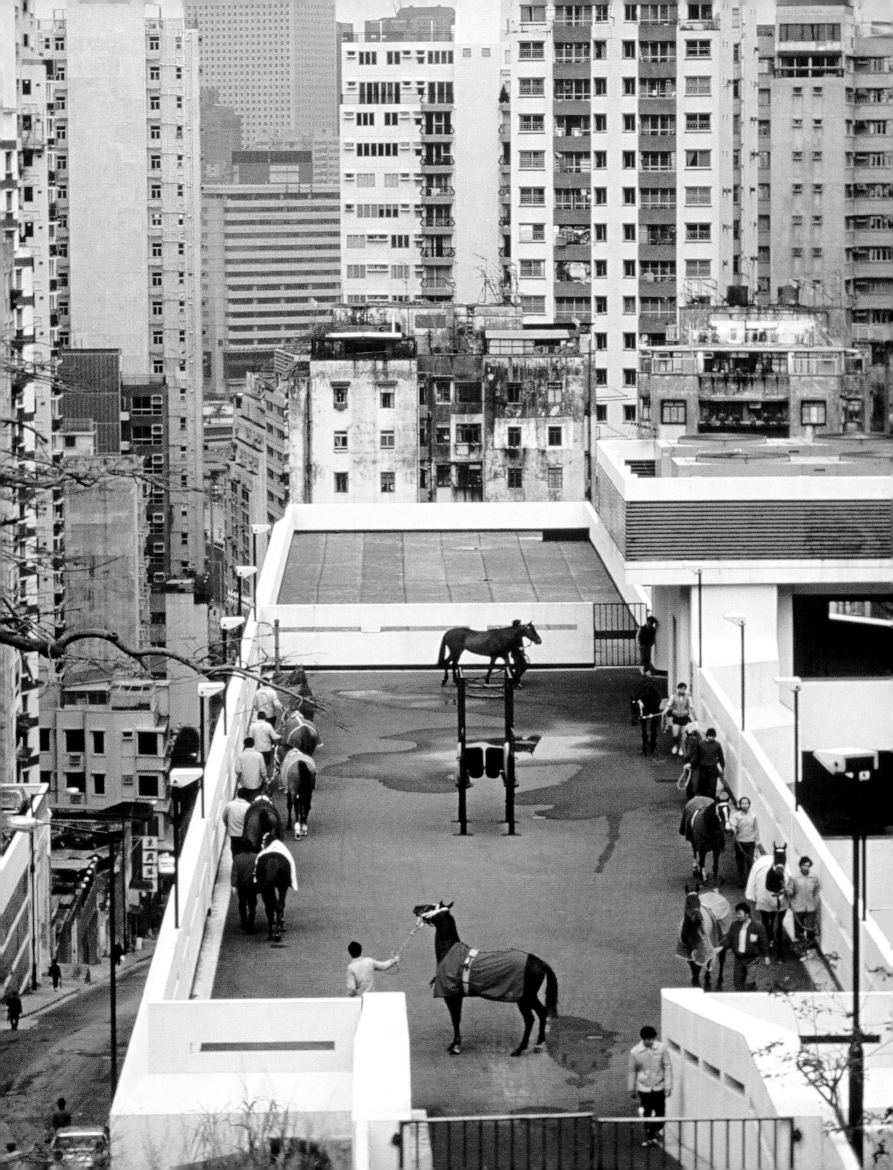

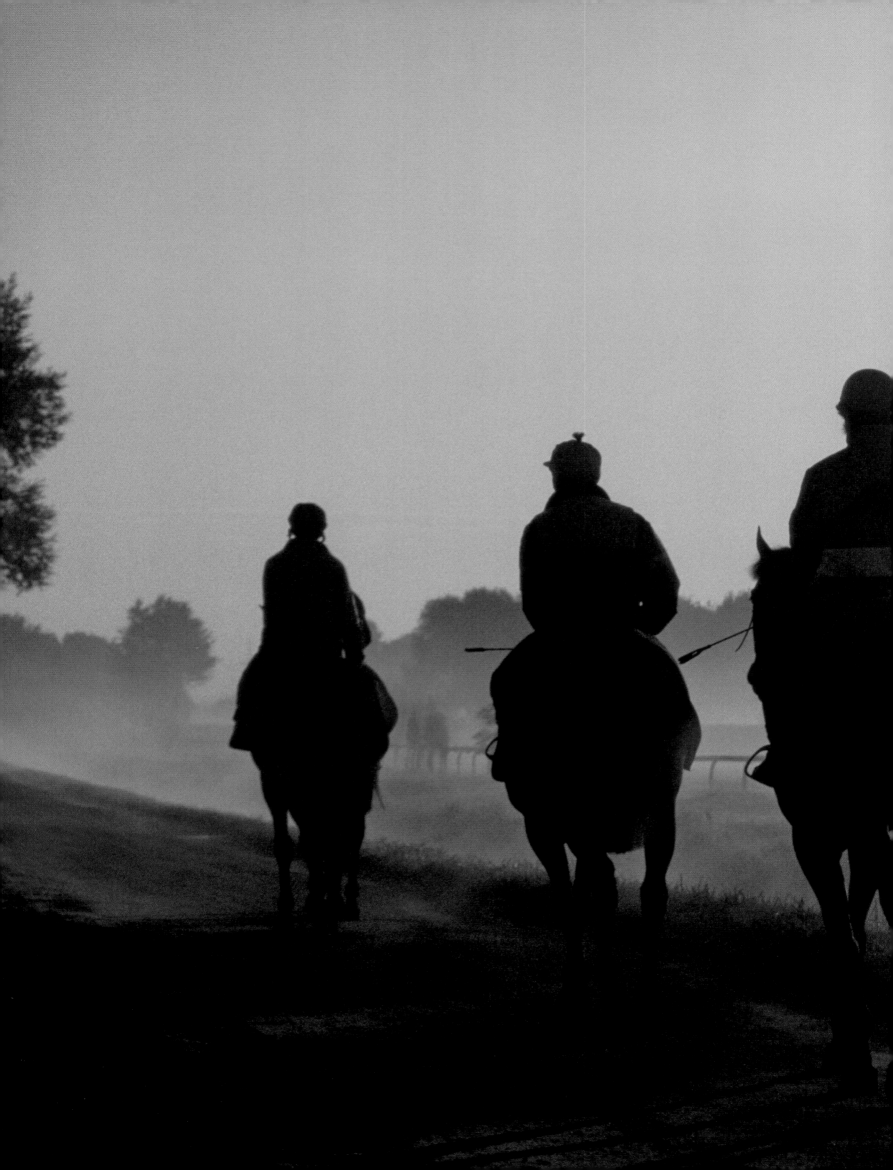

The Royals

Equestrian sports are the free play of power, high life in its most elegant form, a royal pastime. In Ascot, established 1711, the Royal family to this day drives up in horse carriages. This is where the high nobility of horse breeding meets, where the delegates of the Emirates delicately step in their boxes, where France's *Sharmadal* meets England's *Motivator*. The Aga Khan sends *Valixir* and *Aznavour* to the race, while the queen of England traditionally has horses of her own in the race.

On the occasion of her golden jubilee, the queen showed *All The Queen's Horses*, a royal horse exhibition featuring 1,000 horses. Queen Mum, who was mad about horses until the end of her 101 years, organized a private race as late as ten days prior to her death. Great Britain, a kingdom on horseback, Prince Philip lead the Windsor team as long as he was able to, while Prince Charles, Prince Harry and Prince William are passionate polo players. Princess Anne, author of an autobiography suitably entitled *Riding Through My Life*, was the first member of the British Royal family to participate in the Olympic games. Her husband Mark Phillips did not quit riding following the divorce. Today he is the trainer of the United States Equestrian Team. Their daughter Zara nearly made it into the Olympic team in Athens. When her horse bit her, the sensational press whinnied, not exactly chivalrous of them.

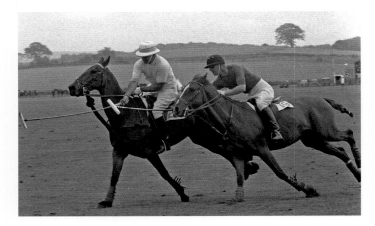

Parade of the Princes: Back then, in 1954, the queen was still a princess: Elizabeth of England during a parade for the King. Prince Philip, Duke of Edinburgh, during a polo game in *Cowdray Park*.

Prinzenparade: Damals, 1954, war die Königin noch Prinzessin: Elizabeth von England bei einer Parade für den König. Prinz Philip, Duke of Edinburgh, während eines Polo-Spiels im *Cowdray Park*.

Parade des princes : jadis, en 1954, la reine était encore princesse : Elisabeth d'Angleterre lors d'une parade pour le roi. Le prince Philip, duc d'Édimbourg, pendant un match de polo dans le *Cowdray Park*.

Desfile principesco: Entonces, en 1954, la reina era aún princesa: Isabel de Inglaterra en un desfile en honor del Rey. El príncipe Felipe, Duque de Edimburgo, durante un partido de polo en *Cowdray Park*.

Parata dei principi: allora, nel 1954, la regina era ancora principessa: ecco Elisabetta d'Inghilterra ad una parata in onore del re. Il principe Filippo, duca di Edinburgo, durante una partita di polo al *Cowdray Park*.

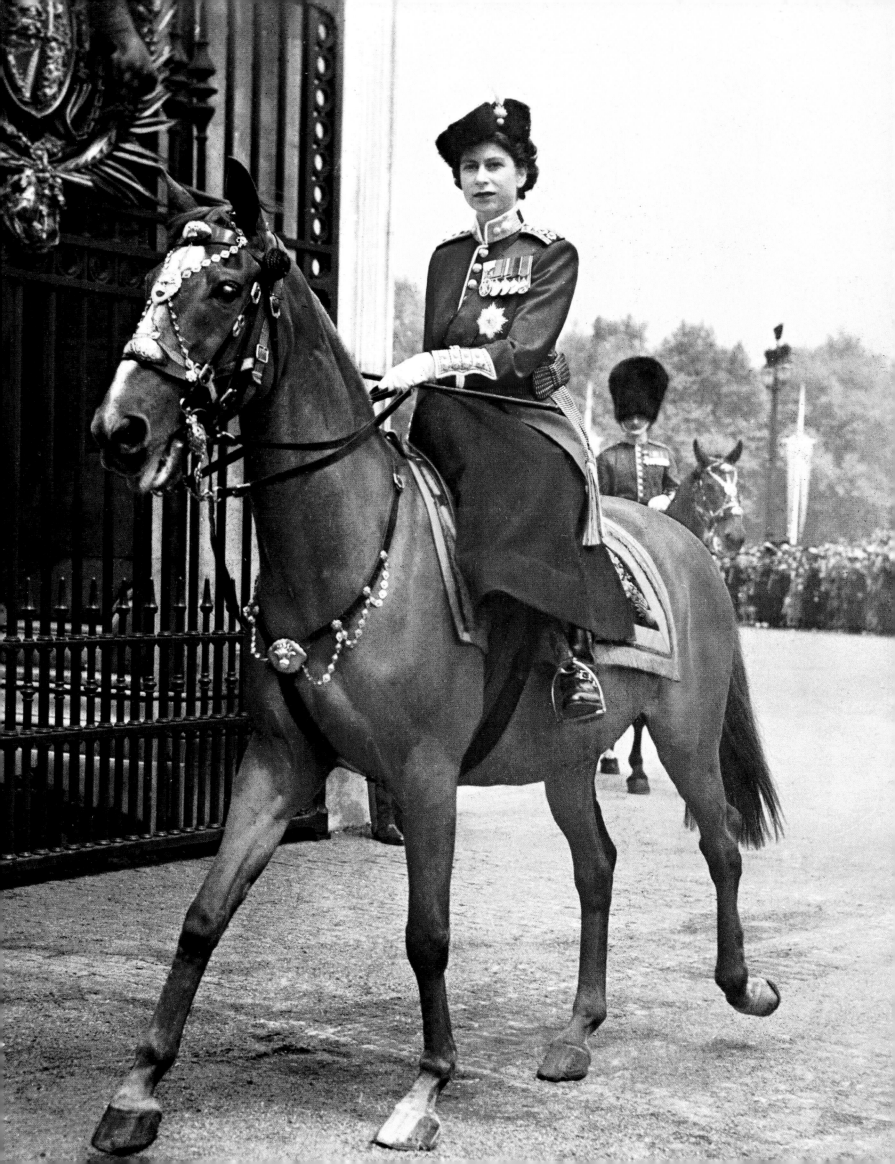

Die Royals

Pferdesport ist das Spielbein der Macht, High Life in seiner elegantesten Form, königlicher Zeitvertreib. In Ascot, gegründet 1711, fahren die Royals noch heute in Kutschen vor. Hier trifft sich der Hochadel der Pferdezucht, tänzeln die Abgesandten der Emirate in ihren Boxen, trifft Frankreichs *Sharmadal* auf Englands *Motivator*. Der Aga Khan schickt *Valixir* und *Aznavour* ins Rennen, und die Königin von England ist traditionell mit eigenen Pferden am Start.

Zum goldenen Thronjubiläum zeigt Elisabeth II. *All The Queen's Horses*, eine königliche Pferdeshow mit 1000 Pferden. Queen Mum, pferdeverrückt bis ans Ende ihrer 101 Lebensjahre, organisiert noch zehn Tage vor ihrem Tod ein privates Rennen. Great Britain, ein Königreich zu Pferd. Prinz Philip führt das Windsor-Team, so lange er kann, Prinz Charles, Prinz Harry und Prinz William sind leidenschaftliche Polospieler. Prinzessin Anne, Autorin einer Autobiographie mit dem passenden Titel *Riding Through My Life*, nimmt als erstes Mitglied des englischen Königshauses an den Olympischen Spielen teil. Ihren Gatten Mark Phillips wirft auch die Scheidung nicht aus dem Sattel. Heute trainiert er die amerikanischen Vielseitigkeitsreiter. Die gemeinsame Tochter Zara schafft beinahe die Teilnahme an den Olympischen Spielen in Athen. Als sie von ihrem Pferd gebissen wird, wiehert die Journaille. Ritterlich ist das nicht.

Les « Royals »

Le sport hippique est le membre au lever du pouvoir, la vie de château dans sa forme la plus élégante, un passe-temps royal. Fondé à Ascot en 1711, les « Royals » roulent aujourd'hui encore en carrosse. La haute noblesse de l'élevage de chevaux s'y rencontre, les envoyés des Émirats y dansent dans leurs boxes, le français *Sharmadal* croise l'anglais *Motivator*. L'Aga Khan fait courir *Valixir* et *Aznavour* et la reine d'Angleterre, suivant la tradition, est au départ avec ses propres chevaux.

Pour son jubilé d'or, la reine Elisabeth II présente *All The Queen's Horses*, une exposition hippique royale avec 1000 chevaux. Quelques jours encore avant sa mort, la reine mère, toujours passionnée de chevaux à 101 ans, organise une course privée. La Grande-Bretagne : un royaume à cheval. Tant qu'il le peut, le prince Philip mène l'équipe de Windsor, les princes Charles, Harry et William sont de fervents joueurs de polo. La princesse Anne, auteur d'une autobiographie intitulée très à propos *Riding Through My Life*, est le premier membre de la famille royale à participer à des Jeux Olympiques. Quant à son époux Mark Phillips, le divorce ne l'a pas désarçonné. Aujourd'hui, il entraîne les cavaliers de concours complet américains. Leur fille Zara manque de peu la participation aux Jeux Olympiques d'Athènes. Quand son cheval la mordit, la « journaille » hennit. Ce qui n'est pas très chevaleresque.

Prince Charles

Princess Anne

La famiglia real britanica

I reali d' Inghilterra

La equitación es la muestra de poder, la vida de lujo en su forma más elegante, una forma regia de pasar el tiempo. En Ascot, inaugurado en 1711, los miembros de la familia real británica siguen paseándose hoy en carrozas. Aquí se encuentran los aristócratas de la cría de caballos, los enviados de los Emiratos Árabes piafan en sus cuadras, el francés *Sharmadal* se mide con el *Motivator* de Inglaterra. El Aga Khan envía a *Valixir* y *Aznavour* a la carrera y la reina de Inglaterra participa tradicionalmente en las competiciones con sus propios caballos.

Para celebrar su cincuenta aniversario en el trono la reina Elisabeth II muestra *All The Queen's Horses*, un espectáculo real con 1.000 de caballos. La Reina Madre, una entusiasta de los caballos hasta los últimos días de su vida de 101 años, organizó diez días antes de fallecer una carrera privada. Gran Bretaña, un reino a caballo. El príncipe Philip capitaneará hasta que pueda el equipo de Windsor, el príncipe Charles, el príncipe Harry y el príncipe William son verdaderos amantes del polo. La princesa Anne, autora de una autobiografía con el oportuno título *Riding Through My Life*, es el primer miembro de la casa real que ha participado en los Juegos Olímpicos. Su esposo, Mark Phillips, tampoco se bajó de la silla de montar después del divorcio y, en la actualidad, entrena a los polifacéticos jinetes estadounidenses. Su hija en común Zara, casi consiguió clasificarse para los Juegos Olímpicos en Atenas. Y cuando fue mordida por su caballo relincharon los diarios. Eso no es nada caballeroso.

L'equitazione è l'espressione del potere, la forma di "high life" più elegante, il passatempo dei re. I reali d'Inghilterra si fermano ancora oggi in carrozza a Ascot, la cui pista fu inaugurata nel 1711. È qui che si incontrano i più begli esemplari dell'allevamento equino: i destrieri degli emiri scalpitano nelle scuderie, e purosangue francesi e inglesi, come *Sharmadal* e *Motivator*, fanno a gara tra loro. L'Aga Khan manda in pista *Valixir* e *Aznavour*, mentre la regina d'Inghilterra, secondo la tradizione, partecipa alle corse con i propri cavalli.

In occasione del cinquantenario del regno di Elisabetta II è stato organizzato *All The Queen's Horses*, uno show regale al quale hanno partecipato 1000 cavalli. La regina madre, da sempre e fino all'età di 101 anni grande appassionata di cavalli, ha organizzato corse private fino a dieci giorni prima della morte. La Gran Bretagna, ovvero un regno a cavallo: il principe Filippo comanda tuttora il corpo di cavalleria di Windsor, e continuerà a farlo finché sarà in grado di occuparsene; i principi Carlo, Harry e William sono appassionati giocatori di polo; la principessa Anna, autrice di un'autobiografia dall'esauriente titolo *Riding Through My Life*, è il primo membro della famiglia reale inglese ad aver partecipato ai giochi olimpici. E neanche il divorzio è riuscito a disarcionare il suo ex-consorte, Mark Phillips, che oggi allena i cavalieri americani nel concorso completo. La loro figlia Zara è stata ad un passo dal partecipare alle Olimpiadi di Atene. Quando fu morsa dal suo cavallo, la stampa da strapazzo non risparmiò i commenti ironici: poco cavalleresco, in verità.

Zara Phillips

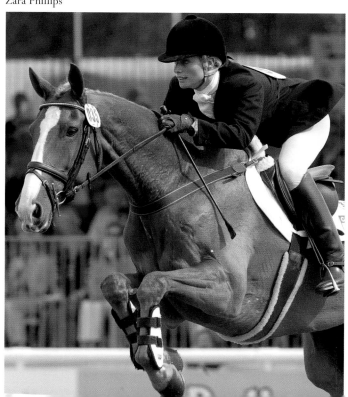

Prince William

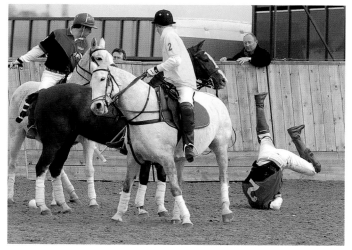

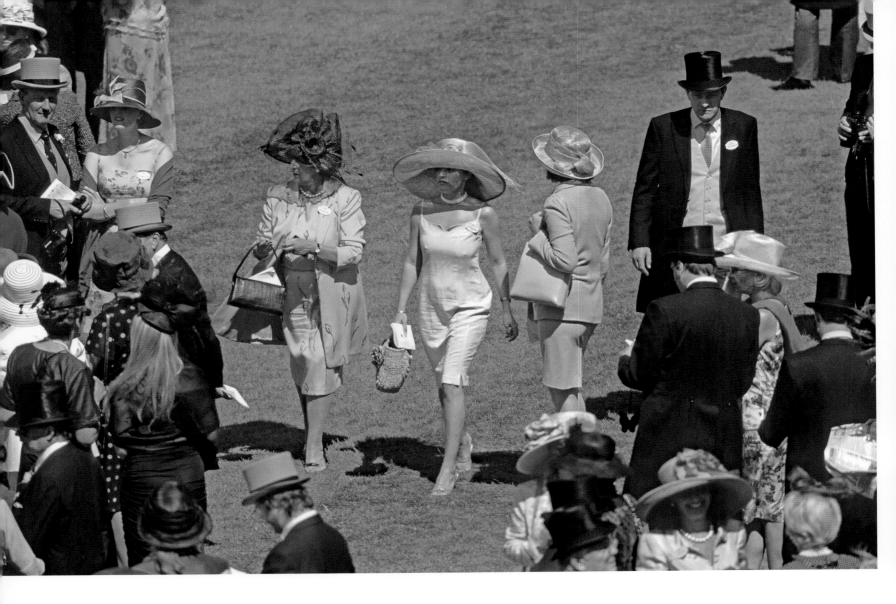

Ascot, the world's race with the richest tradition: Since August 1711, the race has been taking place near London. It is a must for the British society. The most important day is the third race day, also known as *Ladies Day*, on which the *Gold Cup*, takes place. The race is held under the auspices of the royal family.

Ascot, traditionellstes Rennen der Welt: Seit August 1711 wird das Turnier in der Nähe von London veranstaltet und ist ein Pflichttermin für die britische Gesellschaft. Der wichtigste Tag ist der dritte Renntag, an dem der *Gold Cup* stattfindet, auch als *Ladies Day* bekannt. Die Schirmherrschaft des Turniers übernimmt das Königshaus.

Ascot, la course la plus traditionnelle au monde : depuis le mois d'aout 1711, ce tournoi organisé près de Londres est le rendez-vous obligatoire de la société britannique. Le jour le plus important est le troisième jour de course, celui de la *Gold Cup*, appelé également *Ladies Day*. La Maison royale assure le patronage du tournoi.

Ascot, la carrera más tradicional del mundo: Esta carrera se celebra desde el agosto de 1711 en las cercanías de Londres y es una cita obligada para la sociedad británica. El día más importante es el tercer día de las carreras, cuando tiene lugar la *Gold Cup*, este día es también conocido como el *Ladies Day*. Los caballos corren a cargo de la Casa Real.

Ascot, la corsa più tradizionale del mondo: il torneo, che si svolge nei pressi di Londra sin dall'agosto del 1711, è un appuntamento d'obbligo per la società inglese. La terza giornata è quella più importante perché ha luogo la *Gold Cup*, conosciuta anche come *Ladies Day*. Patrona del torneo è la casa reale.

Previous Page

Competition: The annual competition for the most outrageous hat in Ascot.

Konkurrenz: Jährlicher Wettbewerb um den auffälligsten Hut in Ascot.

Concurrence : Concours annuel du chapeau le plus voyant à Ascot.

Competenzia: Competición anual en Ascot por el sombrero más llamativo.

Concorrenza: Ad Ascot si gareggia ogni anno per il cappello più eccentrico.

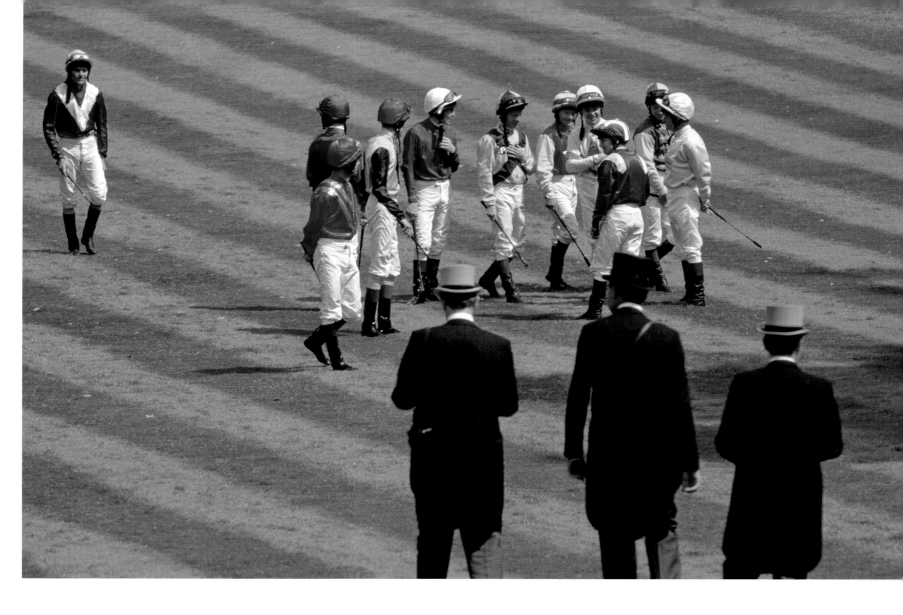

Following Page

A big party: 150,000 bottles of champagne, 100,000 bottles of wine, 6.7 tons of salmon and 5 tons of strawberries are consumed on average.

Große Party: 150000 Flaschen Champagner, 100000 Flaschen Wein, 6,7 Tonnen Lachs und 5 Tonnen Erdbeeren werden durchschnittlich konsumiert.

Une grande fête : 150000 bouteilles de champagne, 100000 bouteilles de vin, 6,7 tonnes de saumon et 5 tonnes de fraises sont consommées en moyenne.

Gran fiesta: Se consumen, de media, 150.000 botellas de champán, 6,7 toneladas de salmón y 5 toneladas de fresas.

Sontuoso party: in media, vengono consumate 150000 bottiglie di champagne, 100000 bottiglie di vino, 6,7 tonnellate di salmone e 5 tonnellate di fragole.

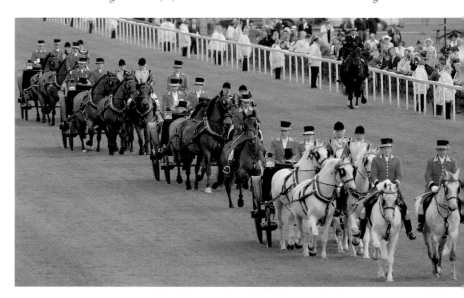

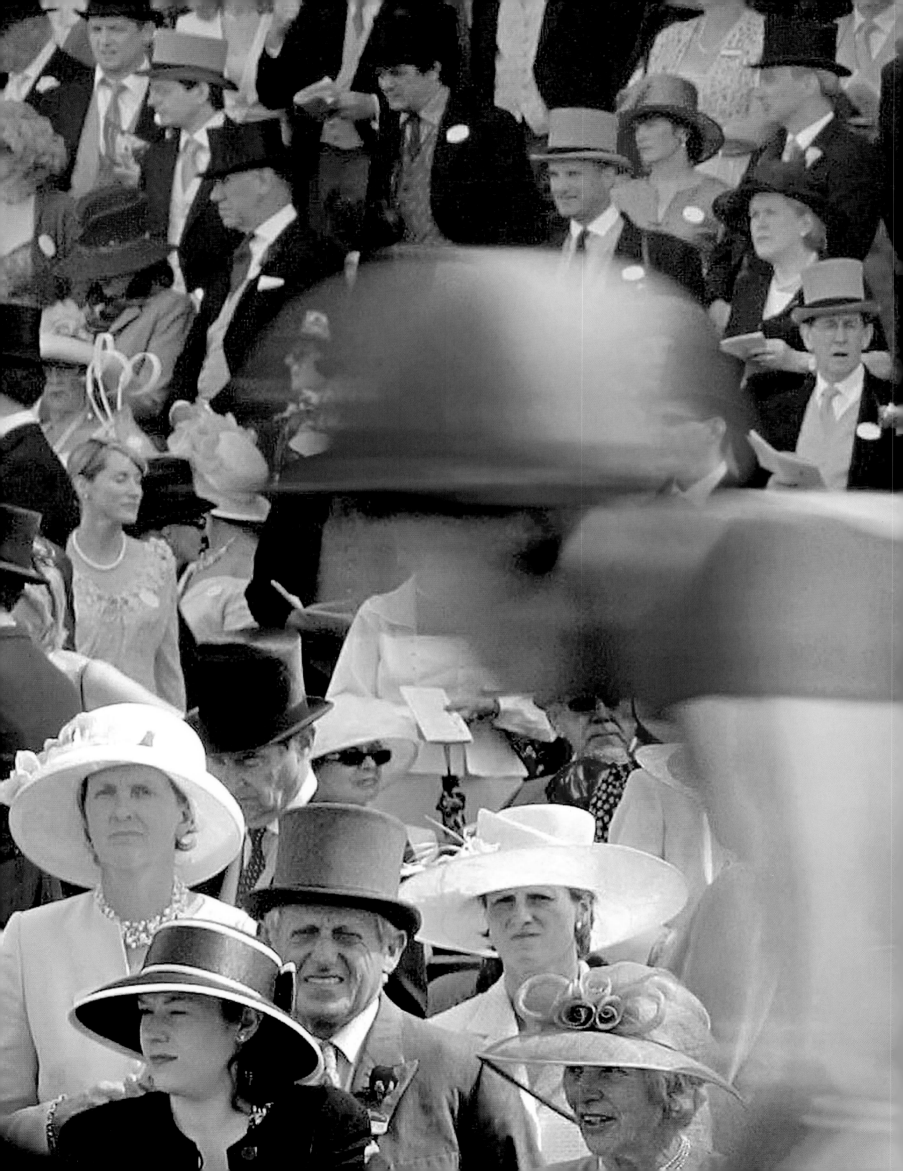

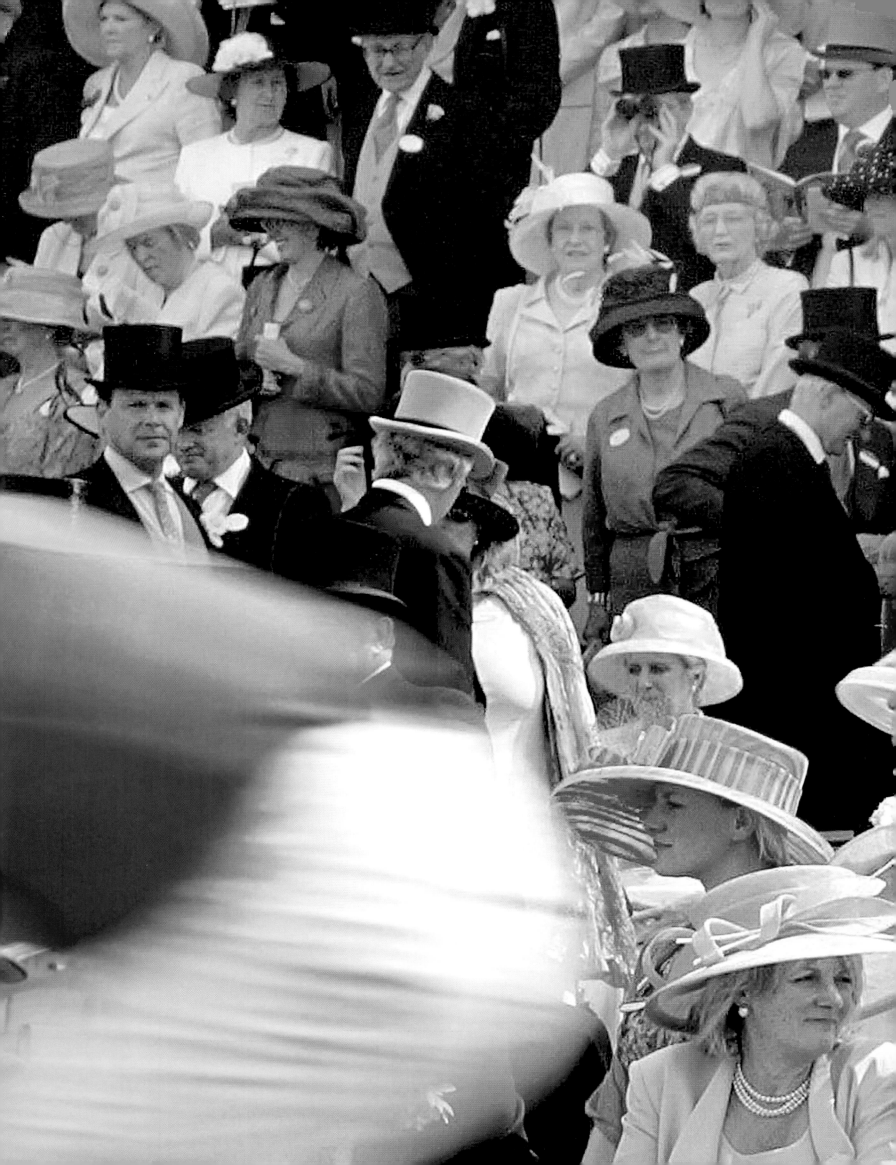

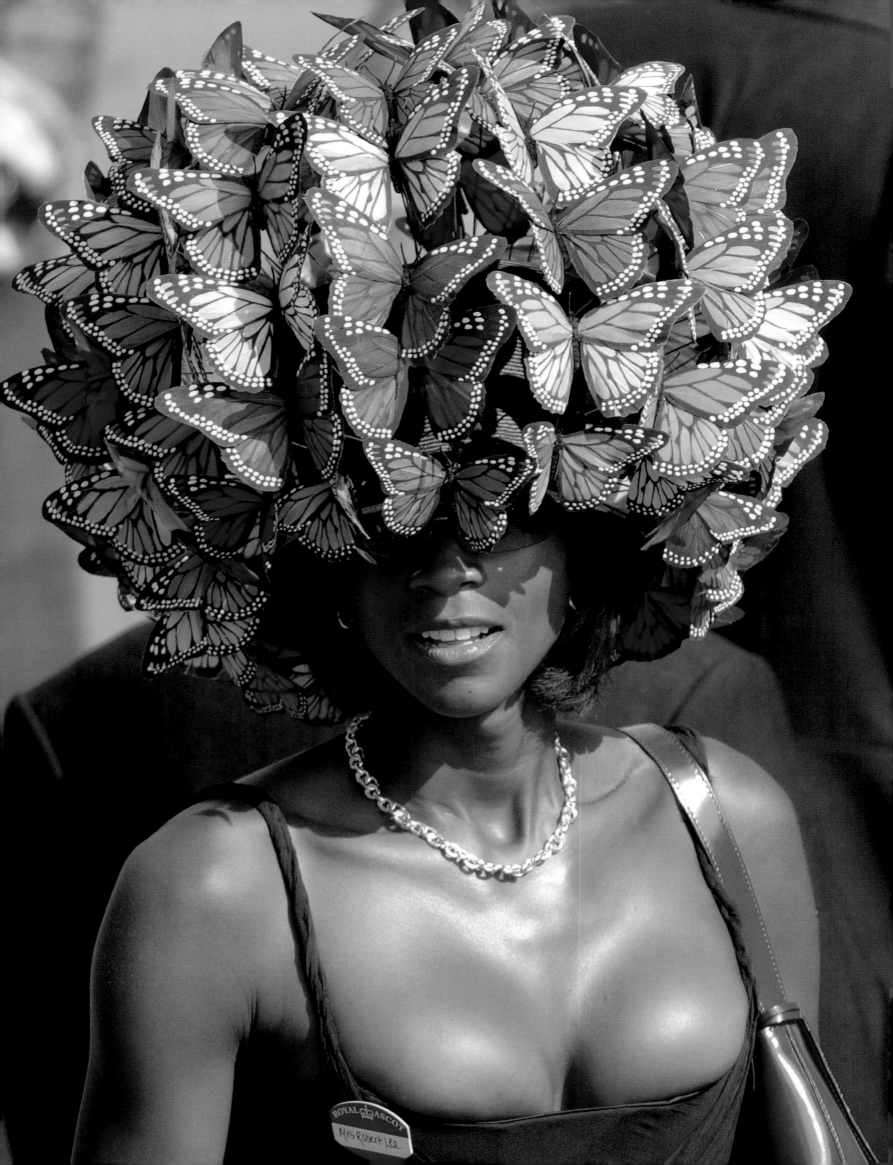

 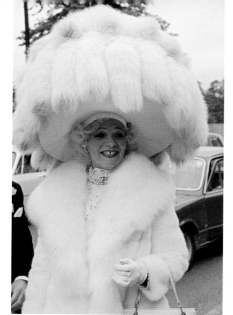 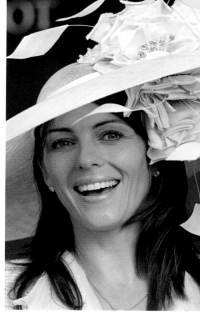

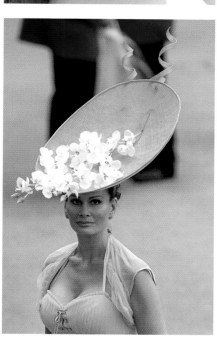 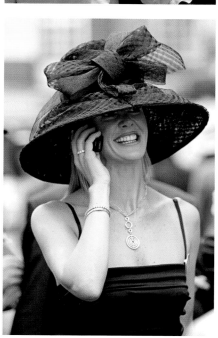

Hats are a must: The trademark of Ascot is the wearing of hats, regardless if shrill, large, colorful or classic.

Hutpflicht: Markenzeichen ist das Tragen von Hüten, egal, ob schrill, groß, farbig oder klassisch.

Chapeau obligé : la distinction est le port d'un chapeau, qu'il soit voyant, immense, coloré ou classique.

Sombrero obligatorio: Lo importante es llevar sombrero, da igual si es extravagante, grande, de color o clásico.

Il cappello è d'obbligo: caratteristica inconfondibile sono i cappelli, non importa se stravaganti, grandi, colorati o classici.

Very British: Time seems to stand still for a few days and the British society celebrates itself. Men wear a *Morning Suit* (tuxedo or a formal dark suit with striped trousers), women and children are dressed accordingly.

Very british: Für ein paar Tage scheint die Zeit stehen geblieben zu sein und die britische Gesellschaft feiert sich selbst. Männer tragen einen *Morning suit* (Frack oder Stresemann), Frauen und Kinder entsprechende Kleidung.

Très british : le temps semble s'arrêter pour quelques jours et la société britannique s'autocélébre. Les hommes portent un *Morning suit* (queue-de-pie ou costume Stresemann), les femmes et les enfants une tenue adéquate.

Muy británico: Durante un par de días parece que si se parara el tiempo y la sociedad británica se celebra a sí misma. Los hombres llevan un *morning suit* (frac o stresemann), y las mujeres y los niños también se visten de acuerdo con la ocasión.

Very british: il tempo sembra fermarsi per alcuni giorni, mentre la società inglese celebra se stessa. Gli uomini indossano la *morning suit* (il frac o il tight), e anche le donne e i bambini sono vestiti elegantemente.

The Evolution

Its evolution took place relatively late—the cute, marmot-like hoofed animal that resembles a Cape Hyrax. The rabbit-sized forest dweller mutated into the *Eohippus*, the aurora horse, the steppe animal, the runner. Around six million years ago, *Equus caballus*, the prototype of today's domestic horse, emerged in America. Together with its relatives, it hiked towards the West via Alaska and the Bering Land Bridge to Asia, Europe and as far as Africa. One mystery remains: the primeval horse of America became extinct around 8,000 years ago and no one knows why.

Initially, the relationship between humans and horses was of a rather remote nature. Horses became companions of humans much later than cows and donkeys, sheep and goats, pigs and dogs. This took place not in the rich high cultures, but rather in the vast expanses of barren, pathless steppes.

Nomads caught and tamed horses and soon recognized their immeasurable advantages. Their raids almost caused the ruin of some wealthy nations. Speed led to victory. Armies on horseback were unbeatable. The art of war picked up speed, chariots thundered through antiquity. Hethites and Assyrians, Scythians and the nations of Israel trampled their enemies. King Solomon the wise allegedly owned 40,000 carriage horses in addition to 12,000 riding horses.

Horses elevated the fighting spirit and self-worth of warriors to a super-human level. The legendary stallion *Bucephalos* carried Alexander the Great all the way to India, where he named a flourishing city after his horse— Bucephala, today's Jaipur. Caligula, the Roman emperor who was crazy about horses and also enjoyed being a gladiator, race driver, dancer and singer, made his horse *Incitatus* ("hothead") a senator and endowed it with a marble palace with a manger made of ivory and its own domestic staff.

The Bible states that the son of God was satisfied with a donkey. But there is also another story. One day, Allah took a handful of wind and blew His breath into it. This is how He created the horse. It was meant to fly without wings and win without a sword. Subsequently, Prophet Muhammad flew on the back of the winged mare *Al Burak* from Medina to Jerusalem. From there, it took him up to the seventh heaven, where there is no lack of beautiful women and horses.

Without horses, Islam would have never been able to conquer a world empire in the course of a few centuries. Horses carried the new faith into the world, kept the powerful firmly established in their seats and communicated the latest news. As early as the 6th century Before Christ, postal riders on horseback galloped across the 1,654-mile long king's highway between Lydia and Mesopotamia. In the vast empire of Genghis Khan, a courier service of fast horses served a network of 36,000 miles with 1,400 stations. This was a world record! Long since, the Chinese had also discovered that a Great Wall could not stop the nations on horseback from the North. Therefore they themselves banked on horses, offering up to 40 bales of silk for a valuable animal and also started to breed horses.

Around the world, there are around 300 different breeds of horses. Three wild species are considered to be the ancestors of modern horses. In addition to the above-mentioned forest horse, these are the Asian Przewalski's horse that exists to this day, and its lighter subspecies, the Tarpan. Once upon a time, the Przewalski's horse roamed the steppes of Asia. It owes its name to the Russian traveller who discovered the light yellow, enduring wild horses in 1879 at the edge of the Gobi desert.

The *Equus przewalskii przewalskii Poljakoff* is the ancestor of the wild Mongolian horses with which Genghis Khan stormed the Christian Occident. He is said to have owned 10,000 white horses.

When Columbus discovered the New World, many exotic animals lived there, but not a single horse. In 1519, Hernán Cortés arrived in Mexico with 600 foot soldiers and 16 horses, enough to conquer the Aztec empire. " We owe our victory not only to God, but also to our horses", he allegedly called out. Shortly thereafter, Francisco Vásquez de Coronado and Hernando de Soto travelled to the Mississippi in search of gold with a few hundred horses. However, they only had two mares along, which was not exactly conducive to the spread of the species. It was only the Christian missionaries that established horses once again on the continent of its origin. Around the year 1600, a large horse breeding area emerged near the Santa Fe region. Possibly some horses simply ran away from there or maybe also some native American stablelads were instrumental in this.

By the late 18th century already, the era of pedestrians ended on the American continent. Within barely 200 years the number of Mustangs reached hundreds of thousands and native Americans became the last horse-back riding nation on earth. The descendants of Arabian horses became the symbol for freedom and adventure.

England's famous horses also descended from Arabian horses, the *Godolphin Barb*, the *Darley Arabian* and the *Byerley Turk*, who were mated with local mares on the British isles in the 17th century. Globally, there are around 300 horse breeds divided into thoroughbreds, crossbreeds, carthorses and ponies. All crossbreeds, whether Trakehner, Lipizzaner, Hanoverians or Anglo-Normans, carry the genes of Arabian thoroughbreds in them. In the sport of show jumping, primarily Holstein Horses and Hanoverians have established themselves. The latter also dominate dressage, while galloping races are the domain of the English thoroughbred.

The world's largest breed is considered to be the English Shire Horse, with a withers height of 6 feet and a weight of up to 2,420 pound, the same weight as a medium-sized car.

The carthorse is its most powerful relative. One HP, i.e. horsepower, became the basic measure of power in the mobile society. It is the power needed to move 75 kilograms in one second the distance of 3,28 feet. It is worth mentioning that a well-trained carthorse can reach up to 25 HP.

But nowadays primarily crossbreeds, leisure horses, are bred. They are four-legged athletes, jumping, riding, racing and dressage horses for leisure and sports. Globally, there are five million registered sports horses. Of the American Quarter Horse alone, there are three million animals in existence. Their name derives from a popular sport, short sprint races across a quarter of a mile. On February 5, 1945 in Mexico City, one of these racers, "Big Racket", reached a speed of 43,15 miles per hour, making it the world's fastest horse, unbeaten to this day.

Die Evolution

ie Evolution bringt es spät auf Trab, das possierliche, murmeltierartige Huftier, das einem Klippschliefer ähnelt. Der kaninchengroße Waldbewohner mutiert zum *Eohippus*, zum Pferd der Morgenröte, zum Steppentier, zum Renner. Vor rund sechs Millionen Jahren kommt der Prototyp des heutigen Hauspferdes in die Hufe, *Equus caballus*, und zwar in Amerika. Er wandert mit seinen Verwandten westwärts über Alaska und die Bering-Landbrücke nach Asien, Europa und bis nach Afrika. Ein Rätsel bleibt: Die Ur-Pferde in Amerika starben aus, vor rund 8000 Jahren. Niemand weiß, warum.

Die Beziehung zwischen Mensch und Pferd ist anfangs eher distanzierter Natur. Viel später als Rind und Esel, Schaf und Ziege, Schwein und Hund wird das Pferd zum Gefährten des Menschen, und zwar nicht in den reichen Hochkulturen, sondern in den Weiten karger, wegloser Steppen.

Nomaden fangen und zähmen das Pferd, erkennen bald seine unschätzbaren Vorzüge. Ihre Überfälle treiben reiche Völker an den Rand des Ruins. Schnelligkeit bringt den Sieg. Reiterheere sind unschlagbar. Die Kriegskunst nimmt Fahrt auf, Streitwagen donnern durch die Antike. Hethiter und Assyrer, Skythen und die Stämme Israels reiten ihre Feinde nieder. Der weise König Salomo soll 40000 Wagenpferde besessen haben und 12000 Reitpferde dazu.

Das Pferd hebt Kampfgeist und Selbstgefühl der Krieger auf übermenschliches Niveau. Der legendäre Hengst *Bukephalos* trägt Alexander den Großen bis nach Indien, wo er einem aufblühenden Ort den Namen seines Pferdes gibt – Bukephala, das heutige Jaipur. Und der Pferdenarr Caligula, römischer Kaiser, der sich auch als Gladiator, Rennfahrer, Tänzer und Sänger gefällt, ernennt sein Pferd *Incitatus* („Heißsporn") zum Senator und spendiert ihm einen Marmorpalast mit einer Futterkrippe aus Elfenbein und eigenem Personal.

Die Bibel berichtet, dass Gottes Sohn mit einem Esel zufrieden war. Aber es gibt auch eine andere Geschichte. Eines Tages nahm Allah eine Hand voll Wind und hauchte seinen Odem hinein. So schuf er das Pferd. Es sollte fliegen ohne Flügel und siegen ohne Schwert. Und so flog Mohammed, der Prophet, auf der geflügelten Stute *Al Burak* von Medina nach Jerusalem. Von dort trug sie ihn in den Siebenten Himmel, wo es an schönen Frauen und Rossen nicht mangelt.

Ohne Pferde hätte der Islam niemals in wenigen Jahrzehnten ein Weltreich erobert. Das Pferd trägt den neuen Glauben in die Welt, hält die Mächtigen im Sattel und bringt die Nachrichten. Schon im 6. Jahrhundert vor Christus galoppieren Reiter im Postdienst über die 2757 Kilometer lange Königsstraße zwischen Lydien und Mesopotamien. Im Großreich des Dschingis Khan bedient ein Kurierdienst schneller Pferde ein Netz von 60000 Kilometern mit 1400 Stationen. Weltrekord! Längst haben auch die Chinesen erkannt, dass eine Große Mauer die Reitervölker aus dem Norden nicht aufhalten kann. Also setzen sie selbst aufs Pferd, bieten bis zu 40 Ballen Seide für ein wertvolles Tier, beginnen mit der Zucht.

Weltweit existieren rund 300 Pferderassen. Drei Wildformen gelten als Ahnen des modernen Pferdes, neben dem erwähnten Waldpferd noch das asiatische Przewalski-Pferd, das es bis heute als eigenständige Art gibt, und dessen leichtere Unterart, das Tarpan. Einst hat das Przewalski-Pferd die Steppen Asiens bevölkert. Seinen Namen verdankt es dem russischen Reisenden, der die fahlgelben, zähen Wildpferde 1879 am Rand der

Wüste Gobi entdeckte. Vom *Equus Przewalskii Przewalskii Poljakoff* stammten die wilden Mongolenpferde ab, mit denen Dschingis Khan das Christliche Abendland überrannte. 10000 Schimmel soll er besessen haben.

Als Kolumbus die Neue Welt entdeckt, leben dort viele exotische Tiere, aber kein einziges Pferd. 1519 landet Hernán Cortés mit 600 Fußsoldaten und 16 Pferden in Mexiko, genug, um das Reich der Azteken zu erobern. „Wir haben den Sieg nicht nur Gott, sondern auch unseren Pferden zu verdanken", soll er ausgerufen haben. Wenig später ziehen Francisco Vásquez de Coronado und Hernando de Soto auf der Suche nach Gold mit einigen hundert Pferden an den Mississippi, aber sie haben nur zwei Stuten dabei, was der Verbreitung der Rasse nicht eben dienlich ist. Erst die christlichen Missionen etablieren das Pferd wieder auf dem Kontinent seiner Herkunft. Bei Santa Fe entsteht um 1600 ein großes Pferdezuchtgebiet. Vermutlich sind einige Pferde dort einfach entlaufen, vielleicht haben indianische Stalljungen nachgeholfen.

Schon Ende des 18. Jahrhunderts geht in Amerika die Epoche der Fußgänger zu Ende. Innerhalb von kaum 200 Jahren wächst die Zahl der Mustangs in die Hunderttausende, entwickeln sich die Indianer zum letzten Reitervolk auf dieser Erde. Die Nachfahren arabischer Pferde werden zum Sinnbild von Freiheit und Abenteuer.

Auch Englands berühmte Pferde stammen von Arabern ab, dem *Godolphin Barb*, dem *Darley Arabian* und dem *Byerley Turk*, die im 17. Jahrhundert auf die britischen Inseln und mit einheimischen Stuten gepaart wurden. Weltweit existieren an die 300 Pferderassen, unterteilt in Vollblut, Warmblut, Kaltblut und Pony. Alle Warmblüter, ob Trakehner und Lippizaner, Hannoveraner und Anglo-Normannen, tragen die Gene des Arabischen Vollbluts in sich. Im Springsport haben sich vor allem Holsteiner und Hannoveraner durchgesetzt, Letzterer ist auch in der Dressur führend, während das Galopprennen eine Domäne des Englischen Vollbluts darstellt.

Als größte Rasse der Welt gilt das englische Shire Horse, mit einer Widerristhöhe von 1,85 Meter und bis zu 1100 Kilogramm, dem Gewicht eines Mittelklassewagens.

Das Kaltblut ist sein kräftigster Verwandter: Ein PS, die Pferdestärke, wird zum Generalmaß der mobilen Gesellschaft, die Kraft, die nötig ist, um 75 Kilogramm in einer Sekunde einen Meter weit zu bewegen. Bemerkenswert immerhin, dass es ein gut trainierter Kaltblüter auf 25 PS bringen kann.

Doch heute werden vor allem Warmblüter, Freizeitpferde, gezüchtet, vierbeinige Leistungssportler, Spring-, Renn- und Dressurpferde für Spiel und Sport. Weltweit sind fünf Millionen Sportpferde registriert. Allein das amerikanische Quarter Horse bringt es auf drei Millionen Exemplare. Sie verdanken ihren Namen einem Volkssport, den kurzen Sprintrennen über eine Viertelmeile („Quarter"), was 402,34 Metern entspricht. Einer dieser Renner, „Big Racket", erreichte am 5. Februar 1945 in Mexico Stadt eine Geschwindigkeit von 69,6 Stundenkilometern und wurde damit zum schnellsten Pferd der Welt, bis heute ungeschlagen.

L'évolution

L'évolution ne démarre que tardivement chez ce drôle d'ongulé du type de la marmotte qui ressemble à un blaireau des rochers. Cet habitant des forêts, de la taille d'un lapin, devient *l'éohippus*, le cheval de l'aurore, l'animal des steppes, le coursier. Il y a quelque six millions d'années, le prototype de l'actuel cheval domestique, *l'Equus caballus,* acquiert un sabot, et ce, en Amérique. Avec ses congénères, il migre alors à l'ouest, par l'Alaska et l'isthme de Béring, vers l'Asie, l'Europe et jusqu'en Afrique. Un mystère subsiste : les chevaux d'origine en Amérique disparurent, il y a environ 8000 ans, pour une raison inconnue.

Les rapports entre l'homme et le cheval sont tout d'abord assez distants. C'est seulement bien plus tard que le bœuf et l'âne, le mouton et la chèvre, le cochon et le chien, que le cheval devient le compagnon de l'homme, non pas dans les zones riches de culture en altitude mais dans les immenses steppes arides et perdues.

Les nomades capturent et apprivoisent le cheval et découvrent vite ses inestimables qualités. Leurs raids provoquent presque la ruine de peuples riches. La rapidité est synonyme de victoire. Les armées de cavaliers sont invincibles. L'art de la guerre progresse rapidement, un tourbillon de chars traverse l'Antiquité. Les Hittites et les Assyriens, les Scythes et les tribus d'Israël écrasent leurs ennemis grâce à leurs chevaux. On rapporte que Salomon, le roi sage, possédait 40000 chevaux de trait et 12000 chevaux de selle.

Le cheval confère aux guerriers une combativité et une assurance pratiquement surhumaines. Le légendaire étalon *Bucéphale* porte Alexandre le Grand jusqu'en Inde où il donne à un endroit florissant le nom de sa monture – Bukephala, l'actuelle Jaipur. De même, l'empereur romain Caligula, fou de chevaux, qui se complait aussi dans les rôles de gladiateur, coureur, danseur et chanteur, nomme son cheval *Incitatus* (« tête chaude ») sénateur et lui fait don d'un palais de marbre avec une mangeoire en ivoire et des serviteurs attitrés.

La Bible raconte que le fils de Dieu se satisfaisait d'un âne. Mais il existe également une autre histoire. Un jour, Allah prit une poignée de vent et lui insuffla la vie. Ainsi créa-t-il le cheval. Il était censé voler sans ailes et vaincre sans épée. C'est ainsi que le prophète Mahomet vola sur la jument ailée *Al Burak* de Médina à Jérusalem. De là, elle l'emporta au septième ciel, où ne manquent ni les jolies femmes ni les chevaux.

Sans les chevaux, l'islam n'aurait jamais conquis un tel empire en quelques siècles. Le cheval répand la nouvelle foi dans le monde, gardent les puissants en selle et apporte les nouvelles. Dès le 6ème siècle avant Jésus-Christ, les cavaliers du service postal parcourent au galop les 2757 kilomètres de la voie royale entre la Lydie et la Mésopotamie. Au royaume de Gengis Khan, un service de messagerie par chevaux rapides entretient un réseau de 60000 kilomètres avec 1400 relais. Un record mondial ! Depuis longtemps, les Chinois ont compris qu'une grande muraille ne peut retenir les tribus de cavaliers venant du nord. Ils misent donc, eux aussi, sur le cheval, offrant jusqu'à 40 balles de soie pour un précieux animal, et commencent l'élevage.

Il existe, de par le monde, quelque 300 races de chevaux. Trois espèces de chevaux sauvages sont considérées comme les ancêtres du cheval moderne ; outre le cheval des forêts déjà évoqué, il y a le cheval asiatique de Przewalski qui est resté une espèce autonome jusqu'à ce jour, et son cousin plus léger, le Tarpan. Jadis le cheval de Przewalski peuplait les steppes d'Asie. Il doit son nom au voyageur russe qui découvrit ces chevaux sauvages, résistants, à la robe jaune pâle, au bord du désert de Gobi en 1879. De l'*Equus przewalskii przewalskii Poljakoff* descendent les chevaux mongols sauvages avec lesquels Gengis Khan envahit l'occident chrétien. On dit qu'il possédait 10000 chevaux blancs.

Quand Colomb découvre le Nouveau Monde, de nombreux animaux exotiques vivent là-bas, mais il n'y a pas un seul cheval. En 1519, Hernán Cortés débarque au Mexique avec 600 fantassins et 16 chevaux, assez pour conquérir le royaume des Aztèques. Selon la légende, il s'écria : « nous ne devons pas la victoire qu'à Dieu, mais aussi à nos chevaux ». Peu après, Francisco Vásquez de Coronado et Hernando de Soto partent à la recherche de l'or avec quelques centaines de chevaux, sur le Mississippi, mais ils n'ont que deux juments, ce qui n'est pas vraiment propice à l'expansion de la race. Ce sont seulement les missionnaires chrétiens qui réimplantent le cheval sur son continent d'origine. Vers 1600 apparaît à Santa Fe un grand domaine d'élevage de chevaux. Probablement quelques chevaux se sont-ils simplement échappés, avec, peut-être, la complicité de palefreniers indiens.

La fin du 18ème siècle marque déjà la fin de l'époque des piétons. En l'espace d'à peine 200 ans, le nombre des mustangs atteint plusieurs centaines de milliers, les Indiens devenant le dernier peuple de cavaliers sur terre. Les descendants des chevaux arabes deviennent les symboles de la liberté et de l'aventure.

Les célèbres chevaux anglais descendent également de chevaux arabes, de *Godolphin Barb*, de *Darley Arabian* et de *Byerley Turk* qui furent envoyés dans les îles britanniques au 17ème siècle et saillirent quelques juments sur place. Il existe dans le monde environ 300 races de chevaux, divisées en pur-sang, sang chaud, trait et poney. Tous les sang-chaud, que ce soit des Trakehnens et des Lipizzans, des Hanovre et des Anglo-Normands, portent les gênes des pur-sang arabes. Dans le saut d'obstacles, se sont imposés avant tout le Holstein et le Hanovre, ce dernier étant également leader dans le dressage, tandis que la course au galop est dominée par le pur-sang anglais.

Le Shire Horse anglais est considéré comme la plus grande race au monde, avec une taille au garrot de 1,85 mètre et un poids allant jusqu'à 1100 kilogrammes, le poids d'une voiture de catégorie moyenne.

Le trait est son cousin le plus puissant : le CV, le cheval-vapeur, est l'unité de mesure utilisée par nos sociétés de la mobilité ; c'est la puissance nécessaire pour déplacer d'un mètre 75 kilogrammes en une seconde. Il est remarquable qu'un trait bien entraîné puisse afficher jusqu'à 25 CV.

De nos jours, cependant, on élève avant tout des sang-chaud, des chevaux de loisir, des sportifs quadrupèdes de haut niveau, des sauteurs, des chevaux de course et de dressage pour le loisir et le sport. Dans le monde entier, cinq millions de chevaux sportifs sont enregistrés. La seule variété américaine de Quarter Horse compte trois millions d'individus. Ils doivent leur nom à un sport populaire, la course de sprint sur un quart de mile (« Quarter ») qui correspond à 402,34 mètres. L'un de ces coureurs, « Big Racket », atteignit le 5 février 1945, à Mexico, la vitesse de 69,6 kilomètres/heure et devint ainsi le cheval le plus rapide au monde. Il est invaincu jusqu'à maintenant.

La evolución

La evolución tardó en crear a este feo animal ungulado y del tipo de una marmota parecido a un damán de las rocas. Este habitante de los bosques del tamaño de un conejo mutó a un *Eohippus*, el caballo del alba, a animal estepario y a velocista. Hace unos seis millones de años el prototipo del actual caballo domesticado, el *Equus caballus*, desarrolló las pezuñas en América. Emigró con sus parientes hacia el oeste, a través de Alasca y el puente de tierra de Bering, hasta Asia, Europa y África y, aún hoy, sigue siendo un misterio la causa de su extinción en el continente americano hace unos 8.000 años.

La relación entre las personas y el caballo fue al principio más bien distante y el animal se convirtió en su compañero mucho más tarde que la vaca y el asno, que la oveja y la cabra, que el cerdo y el perro. Esta convivencia no comenzó en las culturas desarrolladas sino en las inmensas, áridas e intransitables estepas.

Los nómadas capturaron y domesticaron al caballo y pronto reconocieron sus inestimables ventajas. Los asaltos que a sus lomos realizaban llevaban casi a la ruina a los pueblos ricos. La rapidez les daba la victoria. Las tropas a caballo eran invencibles. El arte de la guerra experimentó un auge y el retumbe de los carros de combate recorrió la Antigüedad. Hititas y asirios, escitas y las tribus de Israel vencen a sus enemigos a caballo. Se cuenta que el sabio rey Salomón poseía 40.000 caballos de tiro y 12.000 de silla.

El caballo eleva el espíritu de lucha y la seguridad del guerrero hasta un nivel sobrehumano. El mítico semental *Bucéfalo* llevó a Alejandro Magno hasta la India y aquí el guerrero dio a un floreciente pueblo el nombre de su caballo: Bucéfala, la actual Jaipur. El fanático de los caballos Calígula, emperador romano y conocido también por ser gladiador, jinete de carreras, bailarín y cantante, nombró senador de Roma a su caballo *Incitatus* ("impulsivo") y le regaló un palacio de mármol con un comedero de marfil y personal propio.

La Biblia cuenta que el Hijo de Dios se dio por satisfecho con un asno. Pero también hay otra historia. Un día Alá cogió viento con una mano y exhaló en él su aliento. Así creó al caballo. Debía volar sin alas y vencer sin espada. A así voló Mohamed, el profeta, sobre la yegua alada *Al Burak* desde Medina hasta Jerusalén. Y desde allí el animal le llevó al séptimo cielo donde abundaban las mujeres preciosas y las rosas.

Sin los caballos el Islam no habría conquistado un imperio en pocas décadas. El caballo llevó la nueva fe al mundo, mantuvo a los poderosos en el poder y transportó el correo. Ya en el siglo VI antes de Cristo los jinetes cabalgaban más de 2.757 kilómetros de las calles imperiales entre Lidia y Mesopotamia para llevar los mensajes. En el gran reino de Genghis Kahn el servicio de mensajería de veloces caballos cubría una red de 60.000 kilómetros con 1.400 estaciones. ¡Un récord mundial! Los chinos también se dieron pronto cuenta de que un gran muro no podría detener a los pueblos de jinetes del norte. Por eso se montaron ellos también en los caballos llegando a ofrecer hasta 40 balas de seda por uno de estos valiosos animales; éste fue el comienzo de su cría.

En todo el mundo existen unas 300 razas de caballos. Hay tres formas salvajes similares al caballo moderno; además del ya nombrado caballo silvestre existe el caballo asiático Przewalski, una especie que sigue siendo independiente hasta hoy, y su subespecie el tarpán. El Przewalski pobló antiguamente las estepas de Asia. Su nombre se lo debe al viajero ruso del mismo nombre que, en 1879, descubrió en los límites del desierto Gobi a este robusto animal salvaje de color amarillo pálido. Los caballos salvajes de Mongolia con los que el Genghis Kahn conquistó el Occidente cristiano provienen del *Equus przewalskii przewalskii Poljakoff*. Según la leyenda el Genghis Kahn poseyó 10.000 caballos blancos.

Cuando Colón descubrió el Nuevo Mundo vivían allí muchos animales exóticos, pero ningún caballo. En 1519 Hernán Cortés desembarcó en México con 600 soldados de infantería y 16 caballos, suficientes para conquistar el reino de los aztecas. Según la leyenda, las palabras del español fueron: "Debemos agradecer la victoria no sólo a Dios, sino también a los caballos". Poco después Francisco Vásquez de Coronado y Hernando de Soto se dirigieron al Mississippi con unos cientos de caballos para buscar oro, pero sólo llevaban dos yeguas, lo que no facilitó especialmente la expansión de la raza. Fueron las misiones cristianas las que volvieron a establecer el caballo en su continente original. En Santa Fe se creó, en torno a 1600, una gran zona para la cría de caballos. Seguramente algunos de ellos se escaparon, quizás con la ayuda de los trabajadores indios de los establos.

A finales del siglo XVIII la época de los peatones en América llegaba a su fin. En un periodo de apenas 200 años aumentó hasta cientos de miles el número de los Mustang, y los indios se convirtieron en el último pueblo de jinetes del planeta. Los descendientes de los caballos árabes se transformaron en el símbolo de la libertad y la aventura.

Los famosos caballos de Inglaterra también proceden de los árabes, de *Godolphin Barb*, de *Darley Arabian* y de *Byerley Turk*, que fueron cruzados en la isla británica con yeguas del país en el siglo XVII. En todo el mundo existen unas 300 razas de caballos que se dividen en purasangre, caballos de sangre caliente, de sangre fría y ponis. Todos los caballos de sangre caliente, Trakener y Lippizano, Hannoverano y Anglo-normando, tienen los genes del purasangre árabe. En el deporte de los saltos se han impuesto, sobre todo, el Holsteiner y el Hannoverano; este último también se sitúa a la cabeza en la doma, mientras que las carreras son el dominio del purasangre inglés.

La mayor raza del mundo es la del británico Shire Horse, con una altura a la cruz de 1,85 metros y hasta 1.100 kilogramos; el peso de un turismo. El caballo de sangre fría es su familiar más robusto. El caballo se utiliza como la medida general de potencia del negocio del automóvil y hace referencia a la fuerza necesaria para desplazar un metro 75 kilos en un segundo. Por lo menos sorprendente es que un caballo de sangre fría bien entrenado pueda alcanzar los 25 CV.

En la actualidad se crían, sobre todo, caballos de sangre caliente, de tiempo libre, deportistas de competición de cuatro patas, caballos de saltos, de carreras y de adiestramiento para el juego y el deporte. En todo el mundo hay registrados cinco millones de caballos de deporte. Sólo del Cuarto de Milla americano hay tres millones de ejemplares. Estos animales deben su nombre a un deporte popular; una carrera de corta distancia a lo largo de un cuarto de milla ("Quarter"), 402,34 metros. Uno de estos corredores, el "Big Racket", alcanzó el 5 de febrero de 1945 una velocidad de 69,6 kilómetros por hora en Ciudad de México, convirtiéndose así en el caballo más rápido del mundo y, hasta hoy, sigue siendo imbatible.

L'evoluzione

L'evoluzione di questo buffo ungulato simile alla marmotta, il cui aspetto ricorda quello di una procavia, si protrasse lentamente nel tempo. Abitante dei boschi, non più grande di un coniglio, mutò in *Eohippus*, il cavallo dell'aurora, in animale delle steppe, in corridore. Il prototipo dell'attuale cavallo domestico, l'*Equus caballus*, comparve in America circa sei milioni di anni fa; esso migrò verso occidente con i suoi consanguinei, attraverso l'Alaska e lo stretto di Bering, e raggiunge l'Asia, l'Europa e l'Africa. Ma un mistero resta: i progenitori americani del cavallo si sono estinti circa 8000 anni fa. Nessuno sa perché.

Il rapporto tra uomo e cavallo fu, all'inizio, piuttosto distaccato. Il cavallo divenne compagno dell'uomo molto più tardi della mucca, dell'asino, della pecora, della capra, del maiale e del cane; e ciò non avvenne presso le civiltà avanzate e ricche, bensì nelle steppe sconfinate, brulle e prive di vie di comunicazione.

A catturare e addomesticare il cavallo furono le popolazioni nomadi, che ben presto si accorsero degli inestimabili pregi di questo animale. Aggredirono i popoli ricchi trascinandoli sull'orlo della rovina: la velocità determinava la vittoria. Gli eserciti a cavallo erano invincibili. L'abilità bellica crebbe, l'antichità fu pervasa dal fragore dei carri da guerra: Ittiti, Assiri, Sciiti e le tribù di Israele stroncavano al galoppo i loro nemici. Si racconta che Salomone, il re saggio, possedesse 40000 cavalli da tiro e 12000 cavalli da sella.

Il cavallo rese sovrumani lo spirito combattivo e l'orgoglio dei guerrieri. Il leggendario stallone *Bucefalo* portò Alessandro Magno fino in India, e qui il condottiero impose il nome del proprio destriero ad una città fiorente: Bucefala, l'attuale Jaipur. Caligola, invece, l'imperatore romano follemente innamorato dei cavalli, che si compiaceva di essere anche gladiatore, auriga, danzatore e cantore, nominò senatore il proprio cavallo *Incitatus* ("Impetuoso") e gli fece dono di un palazzo di marmo, di servitù e di una mangiatoia eburnea.

Secondo la Bibbia, il Figlio di Dio si accontentava di un asinello. Ma si racconta anche un'altra storia. Un giorno Allah prese un pugno di vento e vi inalò il proprio respiro. Creò così il cavallo, l'animale in grado di volare senza ali e di vincere senza spada. E Maometto, il profeta, volò da Medina a Gerusalemme in groppa alla giumenta alata *Al Burak*. Da lì, essa lo portò nel settimo cielo, popolato di donne bellissime e di magnifici destrieri.

Senza il cavallo, l'Islam non avrebbe mai conquistato in pochi decenni un impero così vasto. Il cavallo portava nel mondo la nuova religione, era sinonimo di potenza e faceva da messaggero. Già nel VI secolo prima di Cristo, i corrieri a cavallo galoppavano lungo i 2757 chilometri della strada reale che collegava la Lidia alla Mesopotamia. Nell'impero di Gengis Khan, un servizio di corrieri veloci a cavallo serviva una rete di 60000 chilometri con 1400 tappe: un record mondiale! Ormai anche i Cinesi avevano capito che la Grande Muraglia non poteva fermare gli eserciti a cavallo che scendevano da nord. Cominciarono quindi ad utilizzare anch'essi il cavallo, pagando fino a 40 balle di seta per un animale pregiato e iniziandone l'allevamento.

Al mondo esistono circa 300 razze equine. Tre specie selvatiche sono considerate le progenitrici del cavallo moderno: oltre al già citato esemplare dei boschi, ci sono il cavallo di Przewalski asiatico, che vive ancora oggi come specie a sé stante, e una sottospecie più leggera, il tarpan. Un tempo, il cavallo di Przewalski popolava le steppe dell'Asia. Deve il suo nome al viaggiatore russo che nel 1879, ai confini del deserto di Gobi, scoprì questi cavalli selvaggi dal manto gialliccio, assai resistenti alla fatica. Dalla specie *Equus przewalskii przewalskii Poljakoff* discendono i cavalli selvaggi mongoli con cui Gengis Khan, di cui si racconta che possedesse 10000 destrieri bianchi, travolse l'occidente cristiano.

Quando Colombo scoprì il Nuovo Mondo, laggiù vivevano molti animali esotici, ma non il cavallo. Nel 1519 Fernando Cortés approdò in Messico con 600 fanti e 16 cavalli, abbastanza per conquistare il regno azteco. Di lui, si racconta che abbia proclamato "Dobbiamo la vittoria non soltanto a Dio, ma anche ai nostri cavalli". Qualche tempo dopo, Francisco Vásquez de Coronado e Fernando de Soto raggiunsero il Mississippi alla ricerca dell'oro con alcune centinaia di cavalli; ma avevano con sé soltanto due giumente, e non fu possibile diffondere la razza. Solo le missioni cristiane riuscirono ad insediare nuovamente il cavallo nel suo continente d'origine. Intorno al 1600, nei pressi di Santa Fe, una vasta zona fu destinata all'allevamento equino. Probabilmente alcuni cavalli riuscirono a scappare, aiutati forse dagli stallieri indiani.

Già alla fine del XVIII secolo, più nessuno in America andava a piedi. Nel giro di meno di 200 anni, il numero dei mustang aumentò fino a raggiungere le centinaia di migliaia, e gli indiani divennero l'ultima popolazione a cavallo del mondo. I discendenti dei cavalli arabi diventarono così il simbolo della libertà e dell'avventura.

Anche i celebri cavalli inglesi discendono dagli esemplari arabi, il *Godolphin Barb*, il *Darley Arabian* e il *Byerley Turk*, accoppiati nel XVII secolo in Inghilterra con giumente locali. Al mondo esistono circa 300 razze equine, suddivise in cavalli purosangue, cavalli a sangue caldo, cavalli da tiro e pony. Tutti i cavalli a sangue caldo, Trakehner, Lipizzani, Hannover e Anglo-normanni, discendono dai purosangue arabi. Nelle gare di salto si sono imposte soprattutto le razze Holsteiner e Hannover. Quest'ultima è al primo posto anche nel dressage, mentre il galoppo è la specialità dei purosangue inglesi.

I cavalli più grandi del mondo sono quelli della razza inglese Shire Horse, con un'altezza al garrese di 1,85 metri; possono raggiungere i 1100 chili, il peso di una vettura di classe media.

Il cavallo da tiro è l'esemplare equino più robusto: il CV, il cavallo vapore, è la misura universale della società motorizzata, ed è uguale alla forza necessaria per spostare di un metro in un secondo 75 chilogrammi. Si noti che un cavallo da tiro ben allenato è in grado di raggiungere i 25 CV.

Oggi, tuttavia, vengono allevati soprattutto cavalli a sangue caldo per il tempo libero, cavalli da competizione, da salto, da corsa e da dressage destinati al gioco e allo sport. In tutto il mondo sono registrati cinque milioni di cavalli da competizione. I Quarter Horse americani raggiungono da soli i tre milioni di esemplari. Devono il loro nome ad uno sport popolare, la breve corsa sprint su un quarto di miglio ("Quarter"), pari a 402,34 metri. Uno di questi cavalli, "Big Racket", il 5 febbraio 1945 ha raggiunto a Città del Messico la velocità di 69,6 chilometri orari, diventando il cavallo più veloce del mondo. Il suo record è ancora oggi imbattuto.

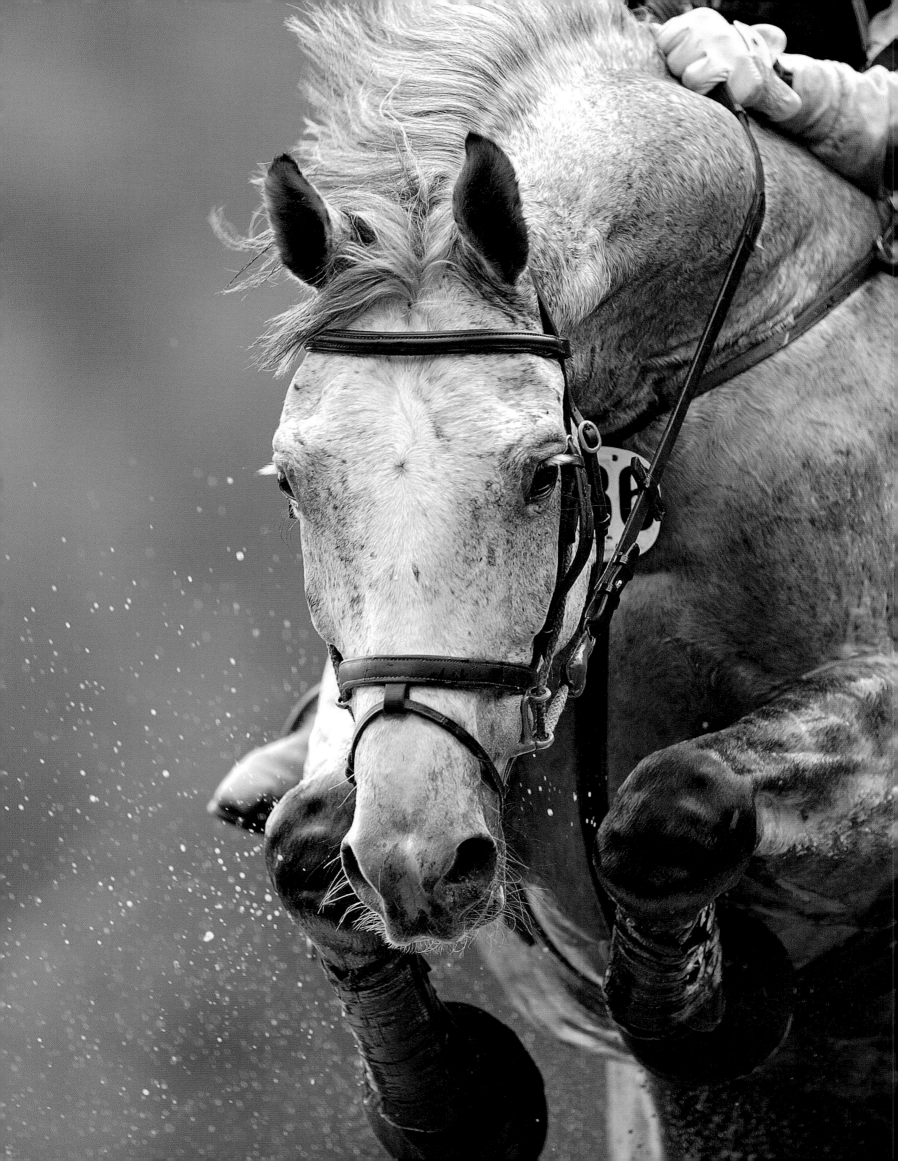

Trial

The world of competition: Steeplechase, show jumping, eventing, dressage, reining, drag hunting and polo, the sport of kings.

Die Welt des Wettkampfs: Steeplechase, Springreiten, Eventing, Dressur, Westernreiten, Jagdreiten und Polo, der Sport der Könige.

Le monde des concours : Steeple-chase, saut d'obstacles, concours complet, dressage, équitation western, chasse à courre et polo, le sport des rois.

El mundo de la competición: Carreras de obstáculos, saltos, eventing, doma, hípica del oeste, caza y polo, el deporte de los reyes.

Il mondo delle gare: lo steeplechase, il salto, l'eventing, il dressage, la cavalcata western, la caccia a cavallo e il polo, lo sport dei re.

Concentration: The Swedish rider Marie Carlerbeck on *Onyx*.

Konzentration: die schwedische Reiterin Marie Carlerbeck auf *Onyx*.

Concentration : la cavalière suédoise Marie Carlerbeck sur *Onyx*.

Concentración: La jinete sueca Marie Carlerbeck sobre *Onyx*.

Concentrazione: l'amazzone svedese Marie Carlerbeck su *Onyx*.

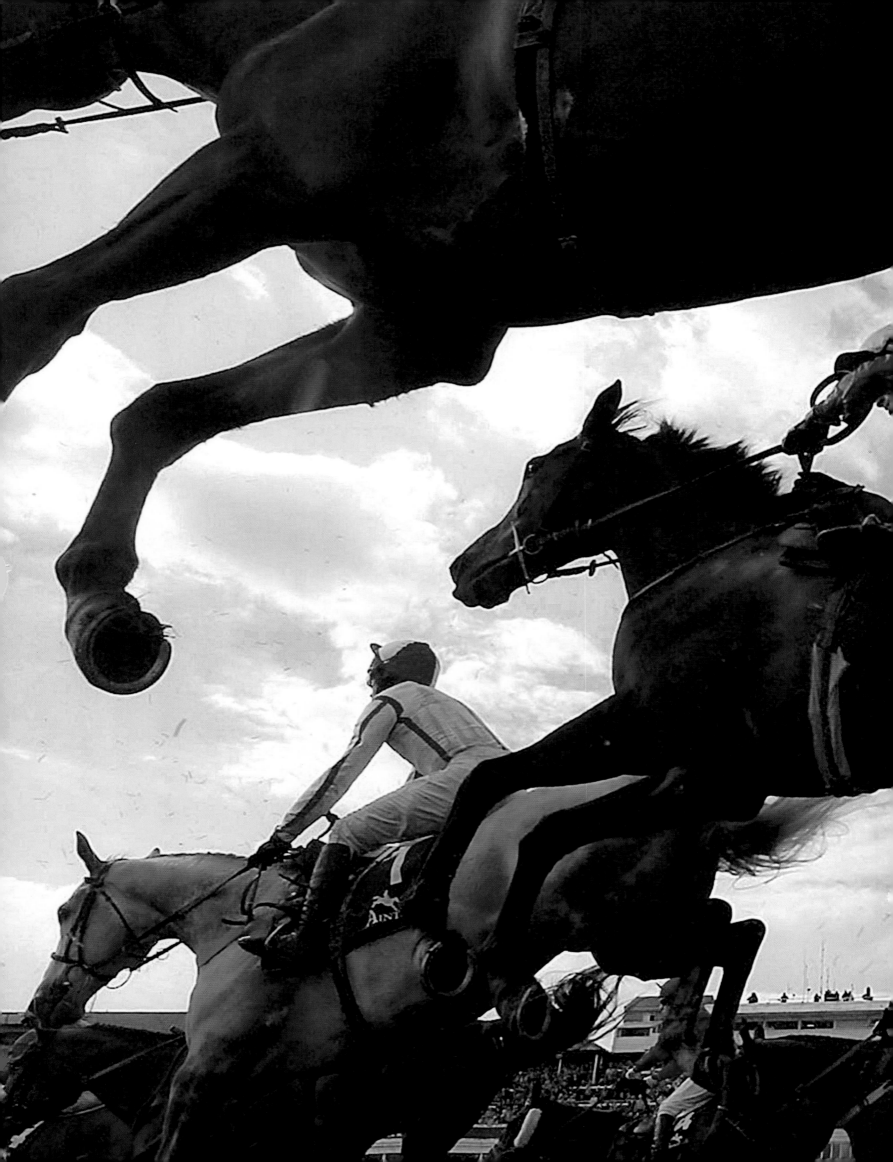

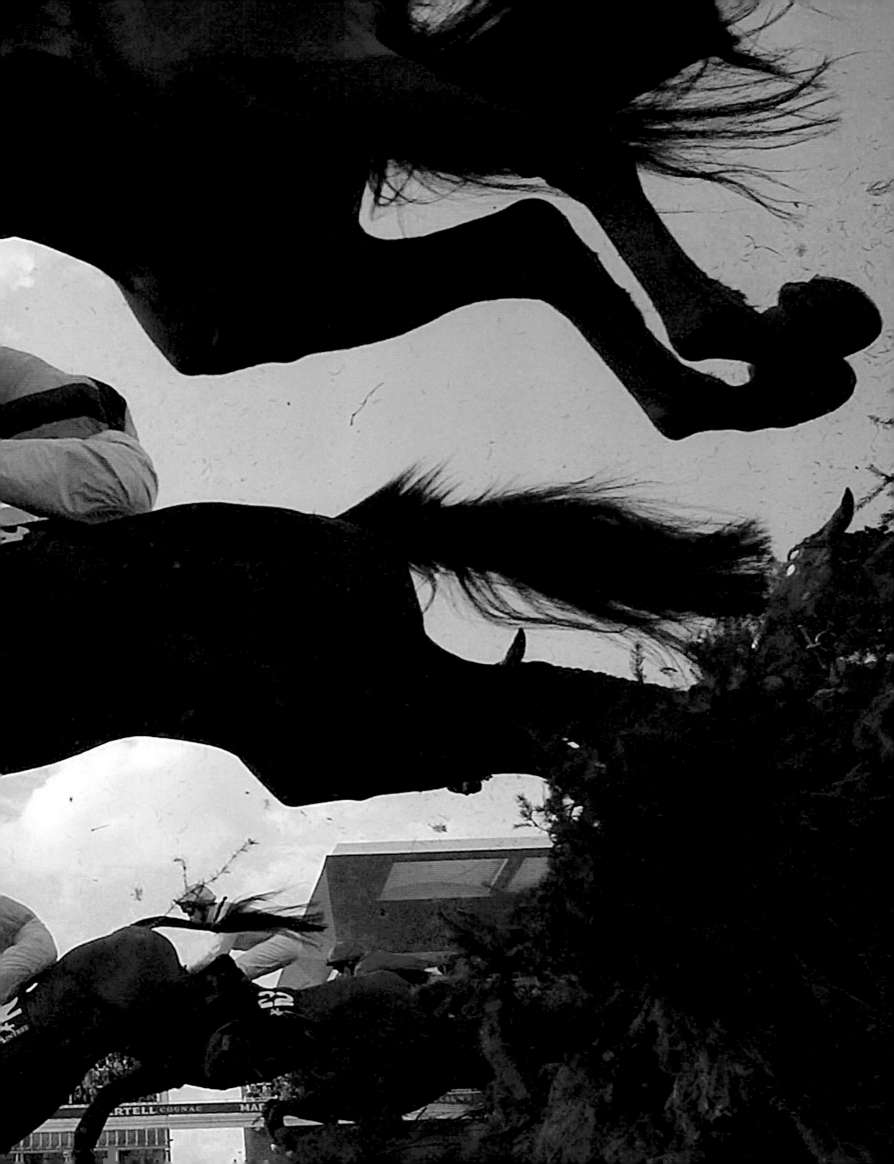

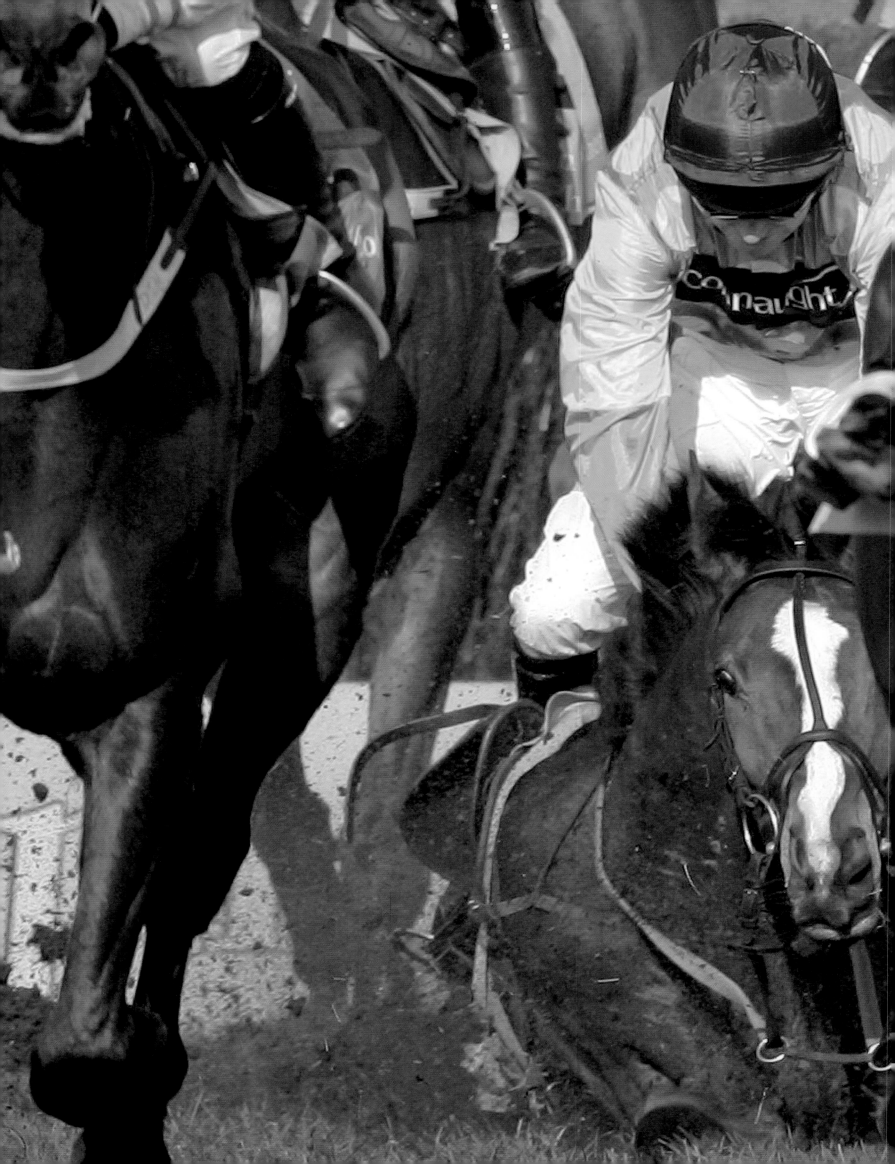

Previous Page

Daring leap: Leap across a water jump at the
Aintree Grand National Meeting.

Mutiger Sprung: Sprung über einen Wassergraben
beim *Aintree Grand National Meeting*.

Un saut courageux : Saut par-dessus la rivière lors
de l'*Aintree Grand National Meeting*.

Salto valiente: Salto sobre un foso de agua en
el *Aintree Grand National Meeting*.

Un salto coraggioso: Salto su uno specchio d'acqua
durante il *Aintree Grand National Meeting*.

Steeplechase: The world's most famous steeplechase is
the *Aintree Grand National Meeting* near Liverpool. The
show-jumping course is infamous for its obstacles and
only a small number of participating horses actually cross
the finish post. Some do not survive the race and have
to be put to sleep. The jockey Ruby Walsh falls with
Kauto Star.

Steeplechase: Das berühmteste Hindernisrennen der
Welt ist das *Aintree Grand National Meeting* bei Liverpool.
Der Parcours ist berüchtigt für seine Hindernisse, nur
ein geringer Teil der Pferde erreicht das Ziel. Einige
überleben das Rennen nicht und müssen eingeschläfert
werden. Der Jockey Ruby Walsh stürzt mit *Kauto Star*.

Course d'obstacle : le steeple-chase le plus connu
au monde est l'*Aintree Grand National Meeting* près de
Liverpool. Le parcours est craint pour ses obstacles,
seul un petit nombre de chevaux arrivent au but.
Certains ne survivent pas à la course et doivent être
euthanasiés. Le jockey Ruby Walsh tombe avec
Kauto Star.

Steeplechase: La más famosa carrera de obstáculos del
mundo es la *Aintree Grand National Meeting* en Liverpool.
El recorrido es temido por sus obstáculos y sólo pocos
caballos alcanzan la meta. Algunos no sobreviven la
carrera y deben ser sedados. El jinete Ruby Walsh se
cae con *Kauto Star*.

Steeplechase: la corsa a ostacoli più famosa del mondo
è il *Aintree Grand National Meeting*, che si svolge nei pressi
di Liverpool. Il percorso ha fama di essere estremamente
pericoloso: solo un numero esiguo di cavalli raggiunge il
traguardo, alcuni devono essere abbattuti. Il fantino
Ruby Walsh cade con *Kauto Star*.

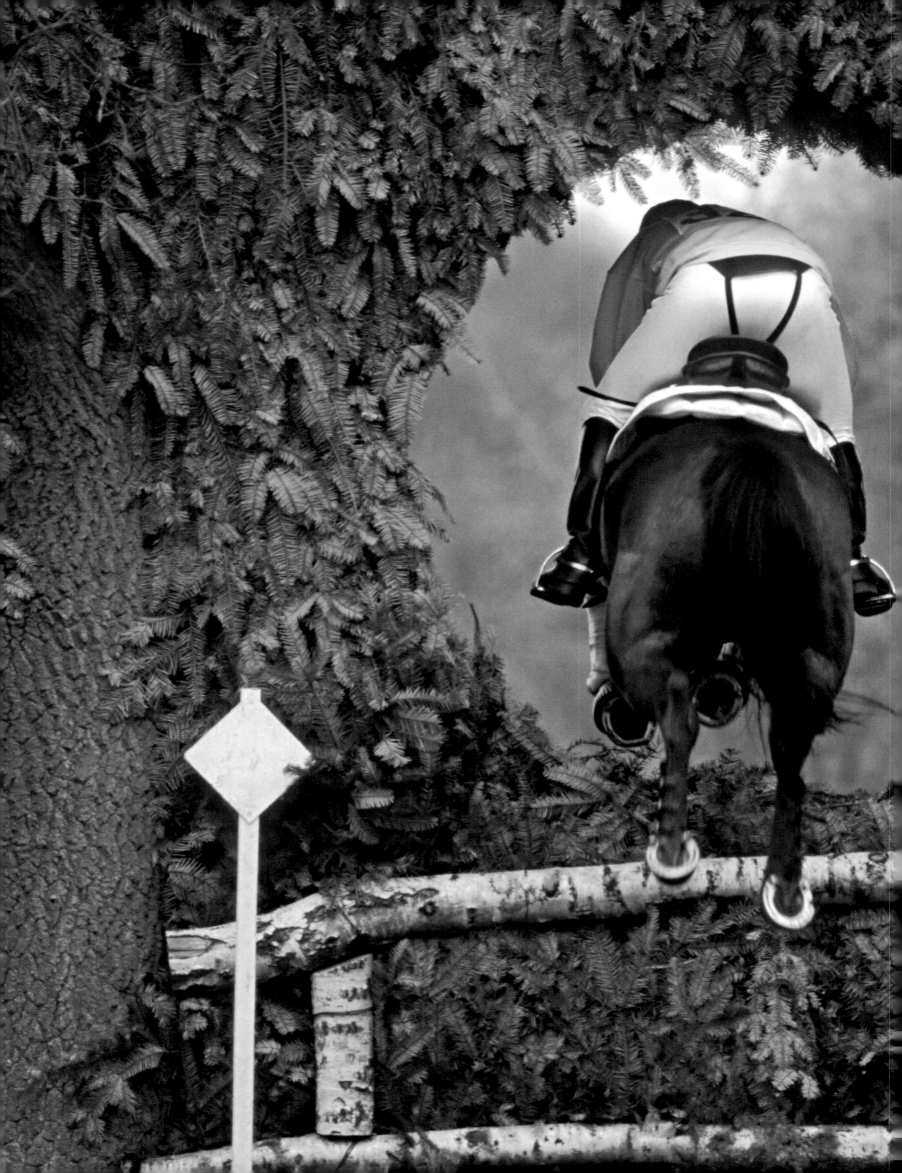

Eventing: The three disciplines of dressage, cross-country and show jumping together constitute the eventing, previously known as military. The *Eulenloch* is considered to be a difficult exam. During the horse trial in Luhmühlen, Germany, a rider masters this exercise perfectly.

Eventing: Die drei Disziplinen Dressur, Gelände und Springen bilden zusammen die Vielseitigkeitsprüfung, früher Military. Das *Eulenloch* gilt als eine harte Prüfung. Beim Turnier in Luhmühlen in Deutschland meistert ein Reiter diese Übung perfekt.

Concours complet : les trois disciplines, dressage, parcours extérieur et épreuves d'obstacles, constituent le concours complet d'équitation, anciennement appelé le military. L'*Eulenloch* est considéré comme une épreuve difficile. Au concours de Luhmühlen, en Allemagne, le cavalier maîtrise parfaitement cet exercice.

Eventing: Las tres disciplinas, doma, tierra y saltos, conforman la prueba más completa llamada antiguamente Military. El salto *Eulenloch* tiene fama de ser el examen más duro. Durante el torneo en Luhmühlen, Alemania, un jinete supera perfectamente este ejercicio.

Eventing: il dressage, il cross-country ed il salto a ostacoli sono le tre discipline che compongono il concorso completo, prima conosciuto come Military. Una prova difficilissima è il salto attraverso un'apertura: al torneo di Luhmühlen, in Germania, un cavaliere esegue perfettamente questa prova.

Following Page

High jump: With a great leap, Marcus Ehning on *Nolte's Küchengirl* clears the jump at the CHIO in Aachen.

Absprung: Mit einem gewaltigen Satz überwindet Marcus Ehning auf *Nolte's Küchengirl* das Hindernis auf dem CHIO in Aachen.

S'enlever : dans un énorme bond, Marcus Ehning franchit l'obstacle sur « Nolte's Küchengirl » au CHIO (Concours Hippique International Officiel) d'Aix-la-Chapelle.

Salto: Con un espectacular salto, Marcus Ehning salva el obstáculo sobre *Nolte's Küchengirl* en el CHIO de Aquisgrán.

Slancio: Marcus Ehing su *Nolte's Küchengirl* supera con uno straordinario salto un ostacolo al CHIO di Aquisgrana.

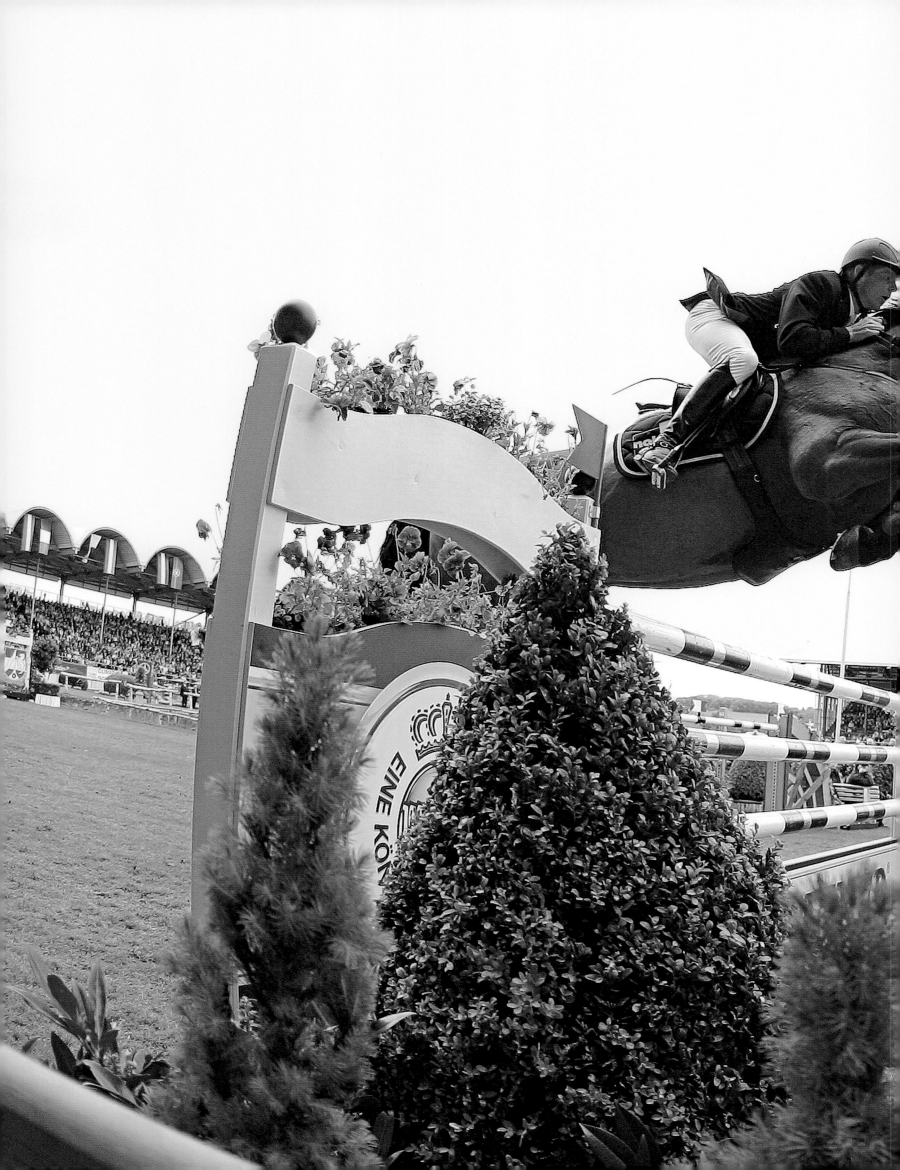

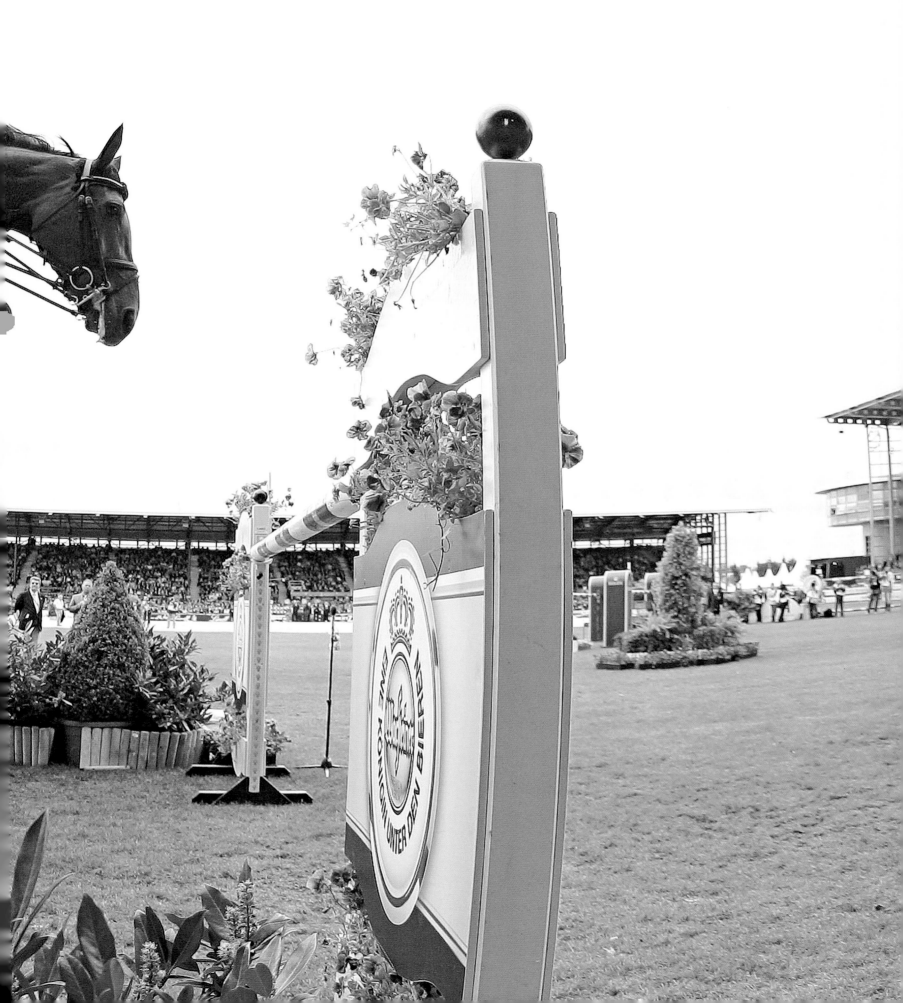

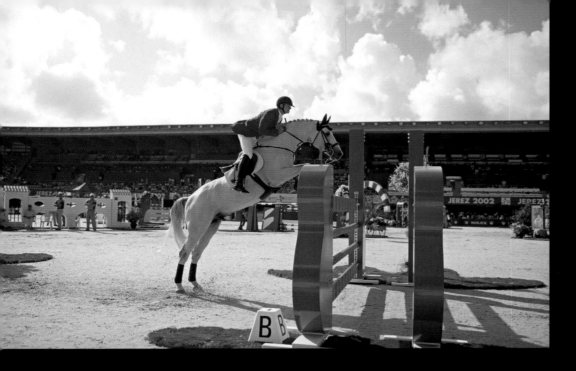

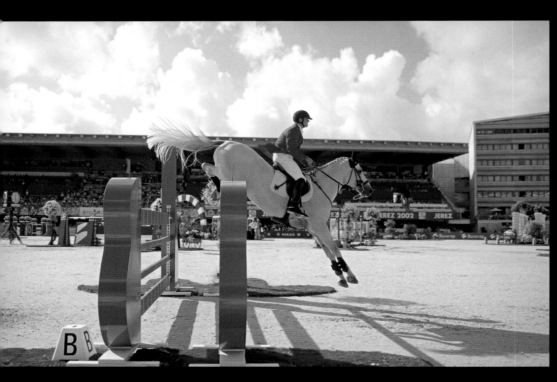

The perfect jump: Otto Becker jumps with *Dobel' Cento* over an oxer at the World Equestrian Games in Jerez, Spain

Der perfekte Sprung: Otto Becker springt mit *Dobel's Cento* über einen Oxer bei den Weltreiterspielen im spanischen Jerez.

Saut parfait : Otto Becker saute avec *Dobel's Cento* par-dessus un oxer lors du Championnat du Monde à Jerez en Espagne.

El salto perfecto: Otto Becker salta con *Dobel's Cento* sobre un oxer en los juegos mundiales de hípica, Jerez.

L salto perfetto: Otto Becker salta con *Dobel's Cento*, un oxer durante i Giochi Mondiali Equestri di Jerez, Spagna

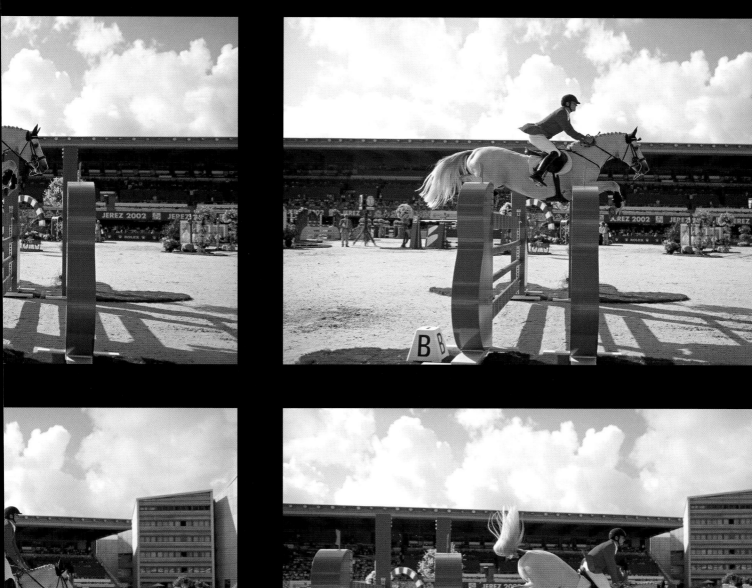
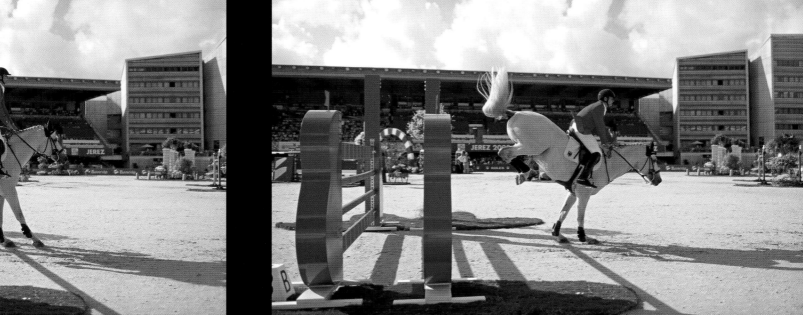

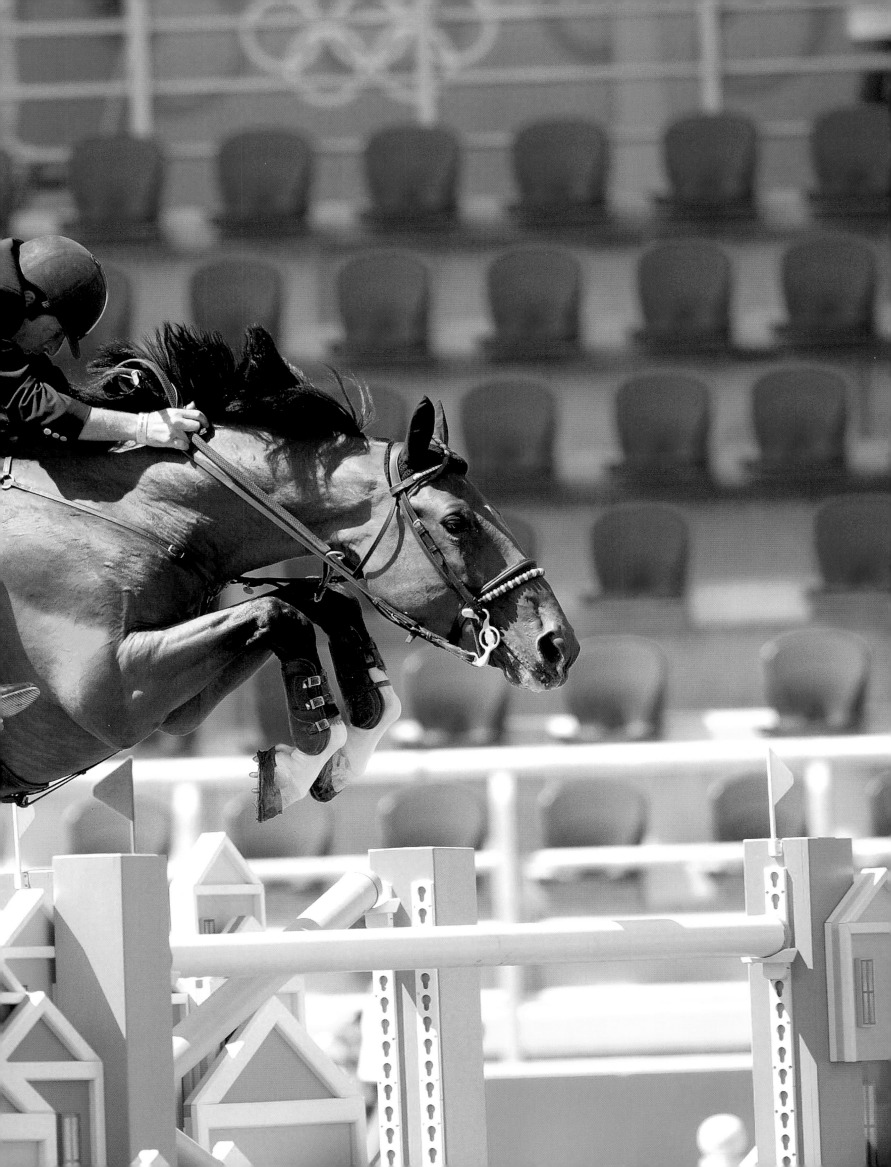

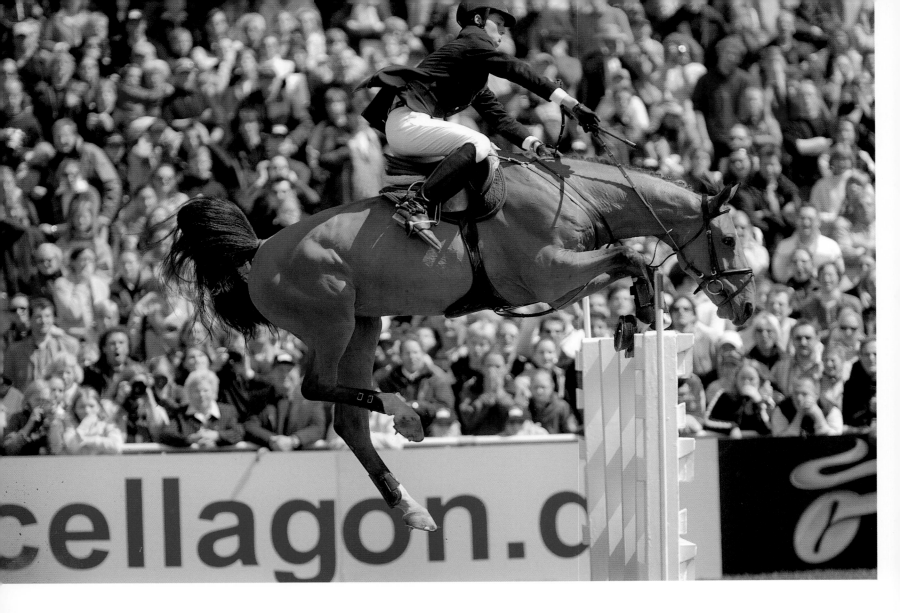

Previous Page

Flying phase: The native Egyptian André Sakakini masters a jump at the Olympic Games.

Flugphase: Der gebürtige Ägypter André Sakakini überwindet ein Hindernis bei den Olympischen Spielen.

Phase de vol : André Sakakini, égyptien d'origine, franchit un obstacle aux Jeux Olympiques.

Fase de vuelo: André Sakakini, egipcio de nacimiento, supera un obstáculo en los Juegos Olímpicos.

Fase di volo: André Sakakini, nato in Egitto, supera un ostacolo ai Giochi Olimpici.

The great rampart: The feared jump of the Hamburg derby. A rider during the descend in perfect form (on the right). The Swiss native Steve Guerdat on *Trolex* failed to clear the jump after the rampart.

Der große Wall: Das gefürchtete Hindernis auf dem Hamburger Derby. Ein Turnierreiter beim formvollendeten Abstieg (rechts). Der Schweizer Steve Guerdat auf *Trolex* scheiterte am Hindernis nach dem Wall.

Le grand mur: l'obstacle redouté du derby de Hambourg. Un cavalier de concours dans une descente d'une parfaite technicité. Le Suisse Steve Guerdat sur *Trolex* a échoué à l'obstacle après le mur.

El gran muro: El temido obstáculo en el derbi de Hamburgo. Un jinete después de completar la bajada (derecha). El suizo Steve Guerdat sobre *Trolex* no supera el obstáculo después del muro.

Il grande vallo: L'ostacolo più temuto al Derby di Amburgo. Un cavaliere del concorso durante la discesa perfetta (destra). Lo svizzero Steve Guerdat su *Trolex* fa un errore all'ostacolo dopo il vallo.

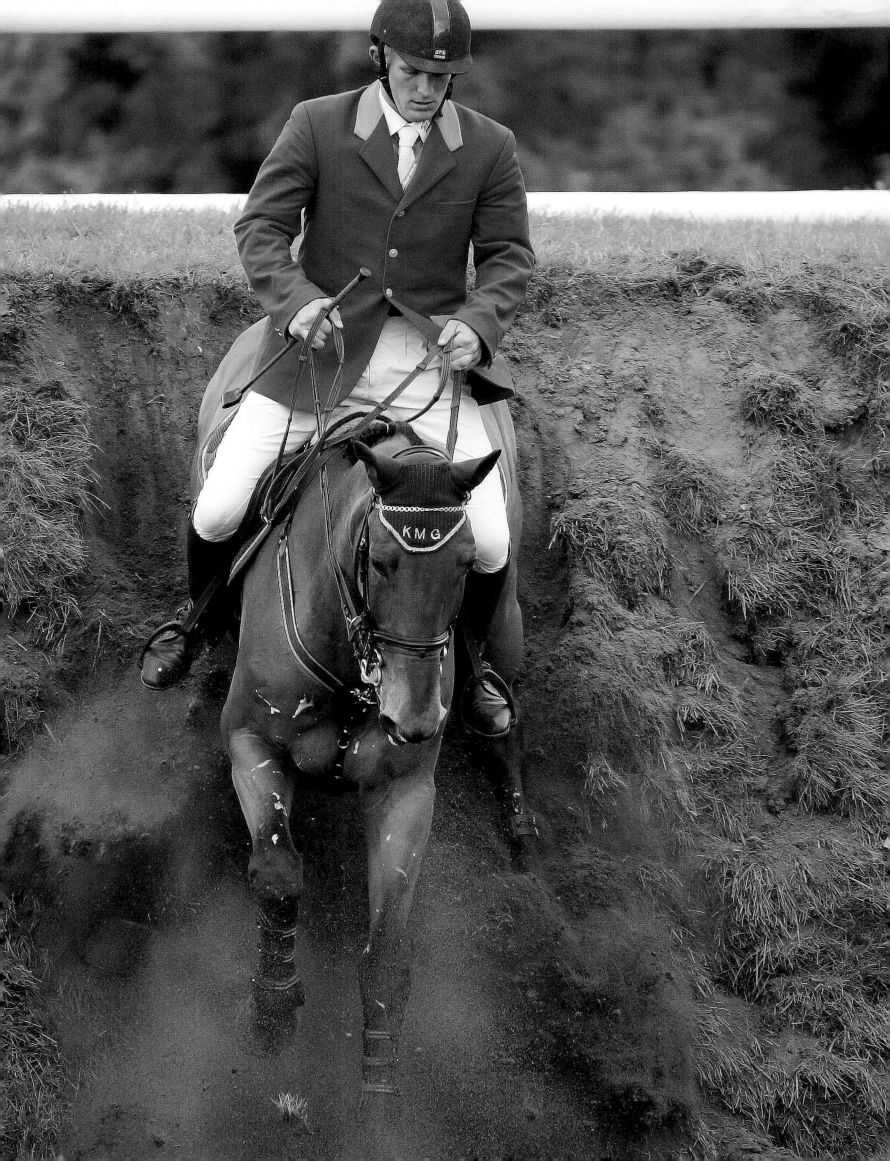

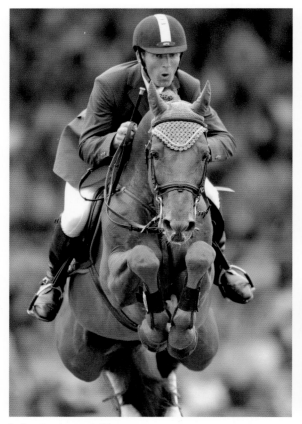

Ludger Beerbaum, *Goldfever*

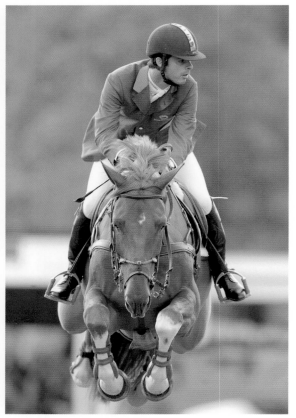

Rodrigo Pessoa, *Giffard*

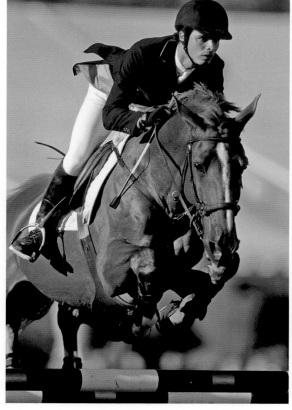

Rodrigo Pessoa, *Baloubet*

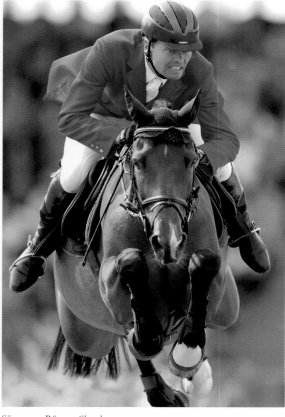

Sören von Rönne, *Chandra*

World Equestrian Games, Jerez:
The Mexican rider Lizaro.

Weltreiterspiele, Jerez:
der mexikanische Reiter Lizaro.

Les Jeux Equestres Mondiaux, Jerez :
le cavalier mexicain Lizaro.

Juegos mundiales de hípica, Jerez:
El jinete mexicano Lizaro.

Giochi equestri mondiali, Jerez:
il cavaliere messicano Lizaro.

Following Page

World Equestrian Festival: Dressage stadium CHIO in Aachen, *Concours Hippique International Officiel.*

Weltfest des Pferdesports: Dressurstadion CHIO in Aachen, *Concours Hippique International Officiel.*

Fête mondiale du sport hippique : le stade équestre CHIO d'Aix-la-Chapelle, *Concours Hippique International Officiel.*

Fiesta mundial de equitación: Estadio de doma CHIO en Aquisgrán, *Concours Hippique International Officiel.*

Festa mondiale dello sport equestre: lo stadio di Dressage allo CHIO di Aquisgrana, *Concours Hippique International Officiel.*

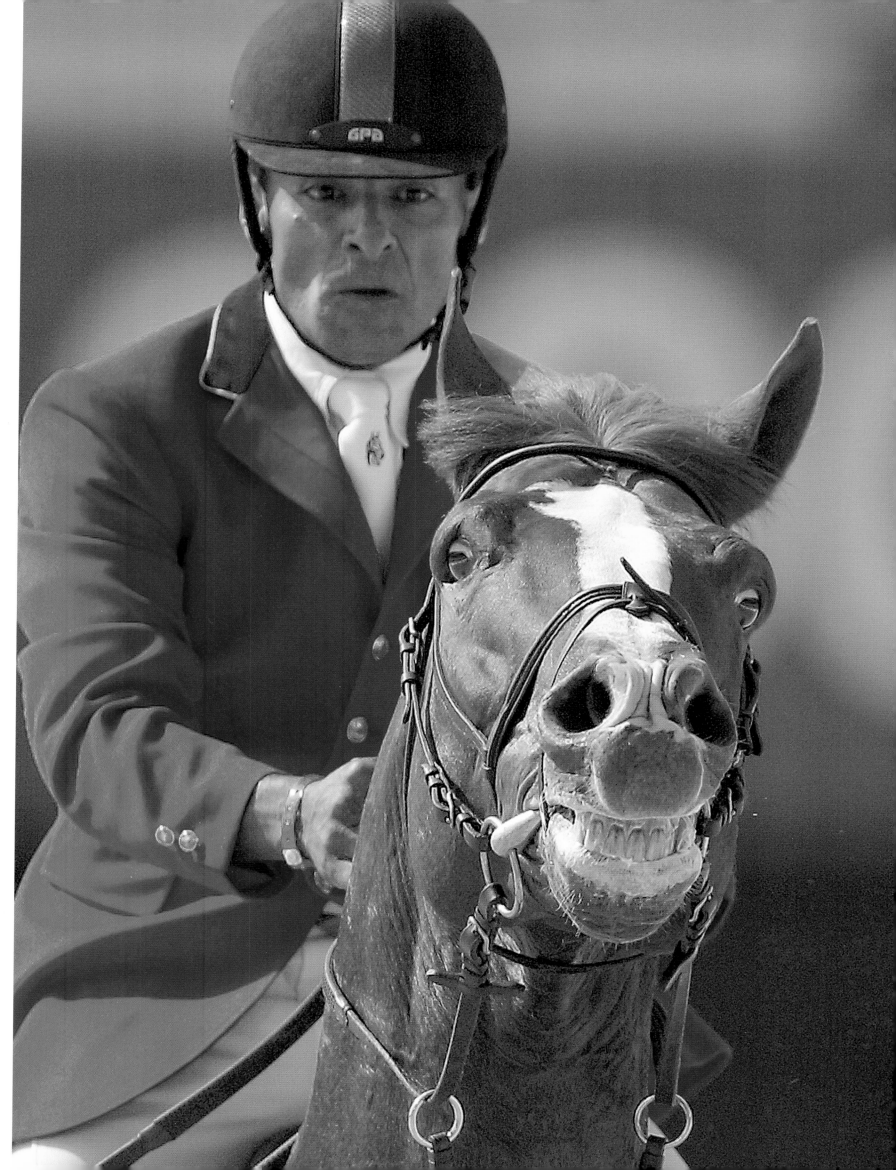

Dressage—grace and elegance: The royal discipline of equestrian sports shows the basic horse gaits—walk, trot and gallop—at their highest degree of perfection. The higher disciplines of dressage include more complex movements such as the traversale, passage, piaffe or canter pirouette. Dressage riding as a sport originated in the late 19th century as a competitive sport between officers.

Dressur – Anmut und Eleganz: Die Königsdisziplin des Reitsports zeigt die Grundgangarten des Pferdes – Schritt, Trab und Galopp – in höchster Perfektion. In den höheren Disziplinen der Dressur werden komplizierte Bewegungsabläufe wie Traversale, Passage, Piaffe oder Galopppirouette gezeigt. Das Dressurreiten als Sport entstand Ende des 19. Jahrhunderts als Wettkampf zwischen Offizieren.

Le dressage – grâce et élégance : la discipline reine du sport équestre fait la démonstration des allures de base du cheval –pas, trot et galop – avec une extrême perfection. Les disciplines supérieures du dressage montrent des enchaînements plus compliqués tels que la diagonale, le passage, le piaffer ou la pirouette au galop. L'école de basse en tant que sport est apparue à la fin du 19ème siècle comme compétition entre les officiers.

Doma –gracia y elegancia: La disciplina reina de la equitación muestra los pasos básicos del caballo, paso, trote y galope, en su máxima perfección. En las disciplinas más altas de la doma se muestran series de movimientos más complicadas como traversale, passage, piaffé o pirueta al galope. La equitación de doma como deporte surgió en el siglo XIX como competición entre los oficiales.

Dressage, ovvero grazia ed eleganza: la disciplina per eccellenza dello sport equestre mostra le andature base del cavallo, ossia il passo, il trotto ed il galoppo, nella loro massima perfezione. Le discipline superiori del dressage prevedono l'esecuzione di complicate figure come il travers, il passage, il piaffe o la piroetta al galoppo. La disciplina sportiva del dressage nacque alla fine del XIX secolo come gara tra gli ufficiali.

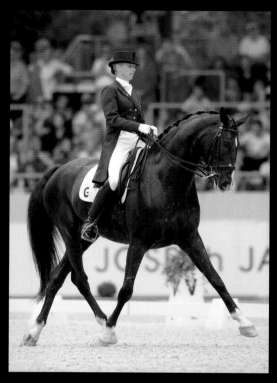

Anky van Grunsven, *Salinero*

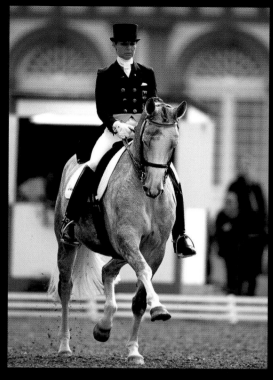

Monika Theodorescu, *Fleur*

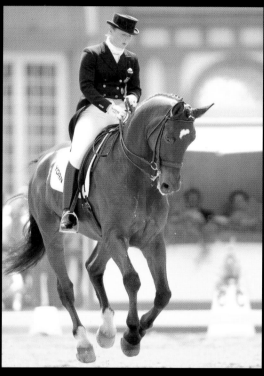

Isabell Werth, *Apache*

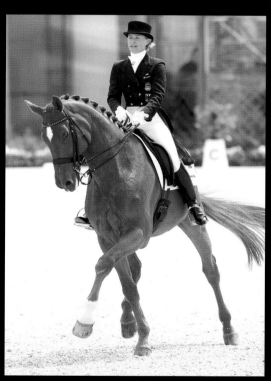

Nadine Kapellmann, *Elvis*

Victoria Max-Theurer: youngest participant at the Olympic Games in Athens.

Victoria Max-Theurer: jüngste Teilnehmerin der Olympischen Spiele in Athen.

Victoria Max-Theurer : la plus jeune participante aux Jeux Olympiques d'Athènes.

Victoria Max-Theurer: la participante más joven de los Juegos Olímpicos en Atenas.

Victoria Max-Theurer: la più giovane partecipante ai giochi olimpici di Atene.

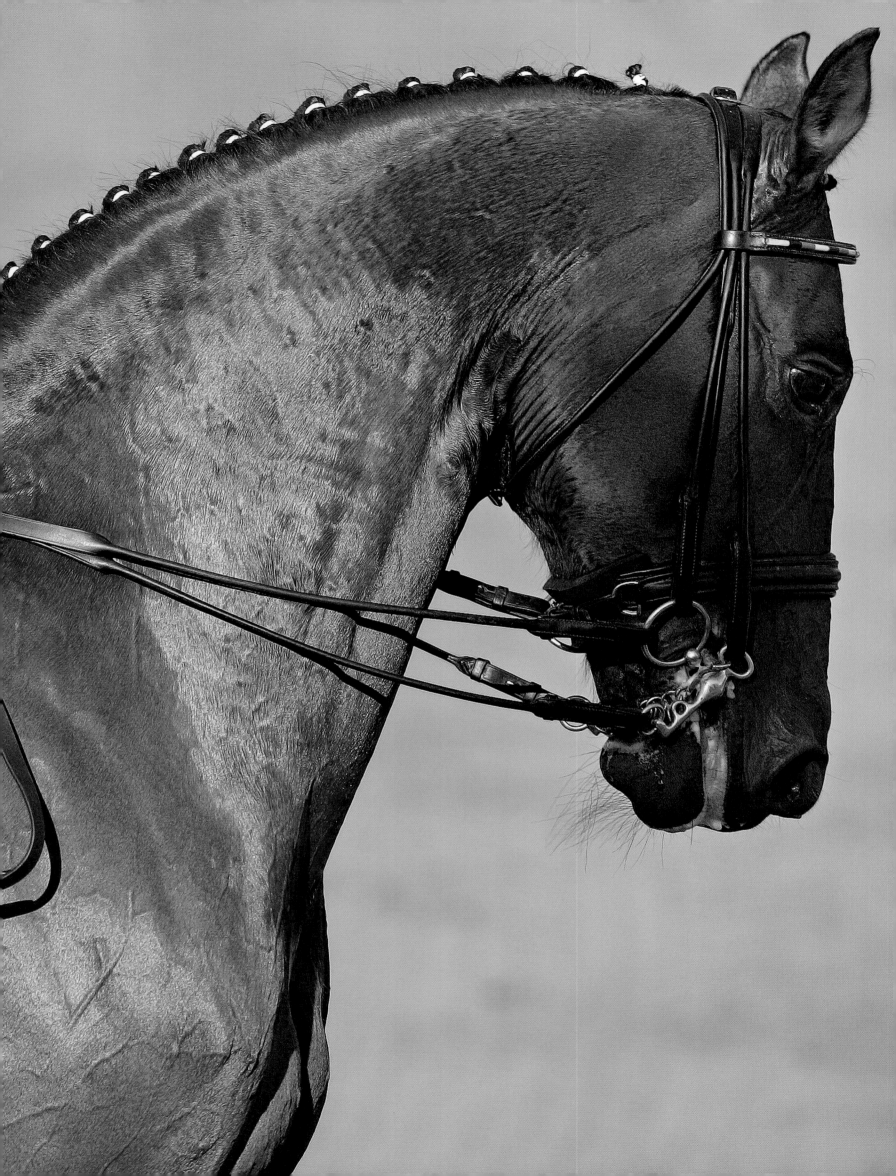

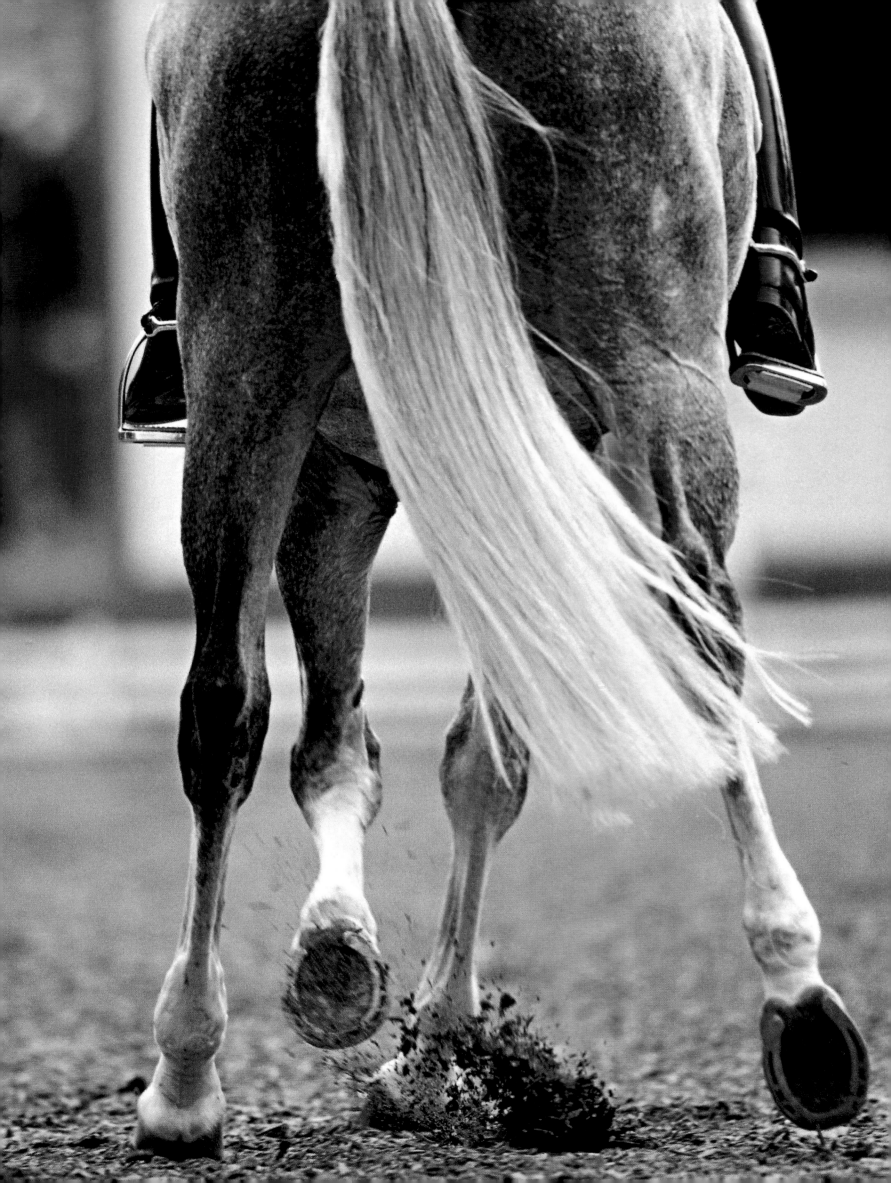

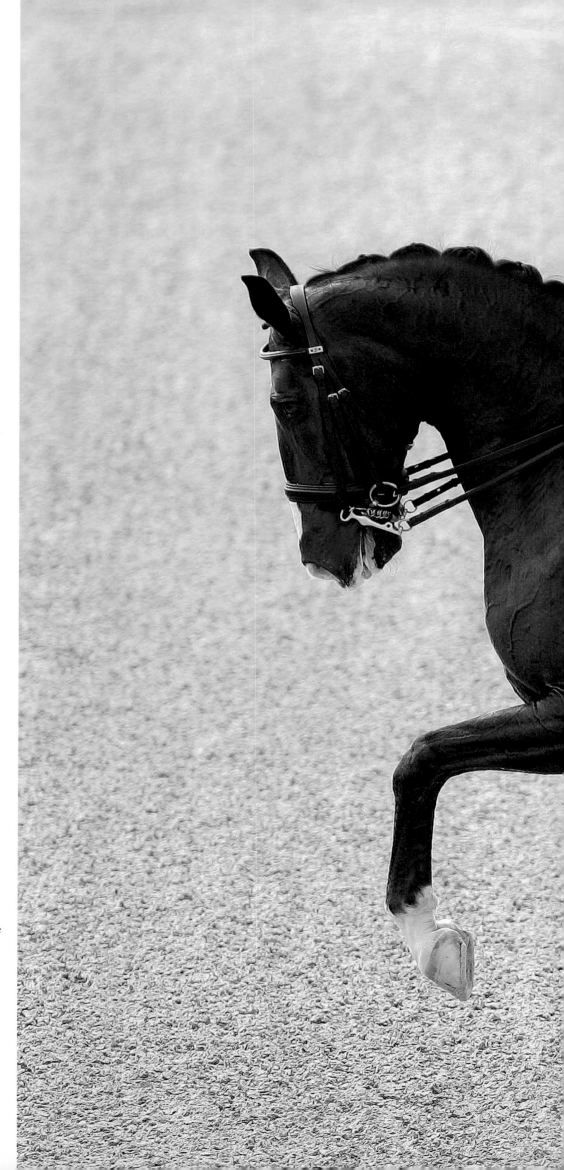

Previous Page

Studies: Isabell Werth with *Satchmo* and a traversale at the *Grand Prix Special*.

Studien: Isabell Werth mit *Satchmo* und eine Traversale beim *Grand Prix Special*.

Etudes : Isabell Werth avec *Satchmo* et une diagonale au *Grand Prix Special*.

Estudios: Isabell Werth con *Satchmo* y un traversale de *Grand Prix Special*.

Studi: Isabell Werth con *Satchmo* e un travers al *Grand Prix Special*.

Salinero: Anky van Grunsven is the most successful Dutch dressage rider. Her horse *Salinero* already won the Olympic Games at ten years of age.

Salinero: Anky van Grunsven ist die erfolgreichste niederländische Dressurreiterin. Ihr Pferd *Salinero* gewann schon mit zehn Jahren die Olympischen Spiele.

Salinero : Anky van Grunsven est la cavalière de dressage néerlandaise la plus célèbre. A l'âge de dix ans, son cheval *Salinero* a déjà gagné les jeux olympiques.

Salinero: Anky van Grunsven es la jinete de doma holandesa de mayor éxito. Su caballo *Salinero* ganó a los diez años los Juegos Olímpicos.

Salinero: Anky van Grunsven è la migliore amazzone olandese nella disciplina del dressage. Il suo cavallo *Salinero* ha vinto i giochi olimpici già a soli dieci anni.

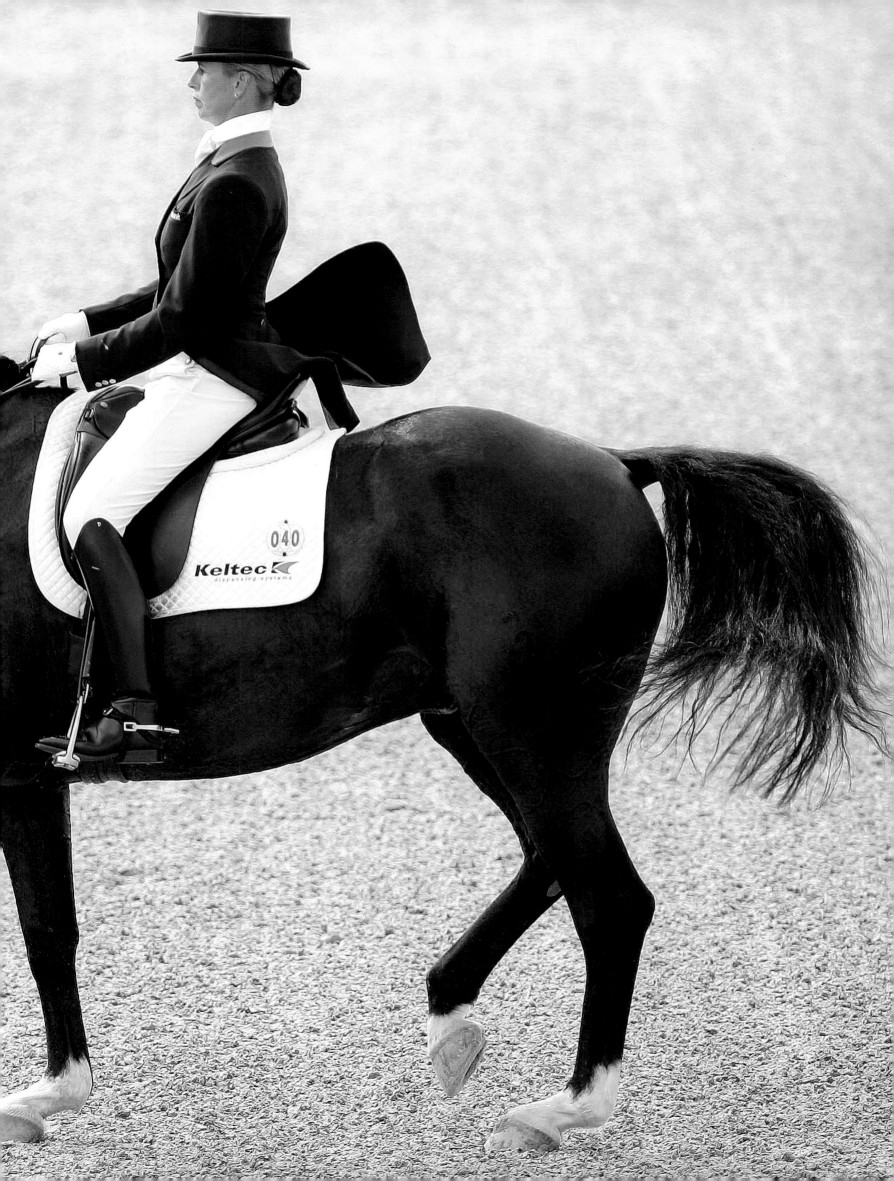

Fairy tale castle: The *Burghley House* residence in Lincolnshire, England, is one of the most beautiful venues for horse trials, in which the royal family also regularly attends. For example, Zara Phillips participates in the trials. She thus follows the footsteps of her parents, who won several trials in the 1970's.

Märchenschloss: Die Residenz *Burghley House* in Lincolnshire, England, ist einer der schönsten Austragungsorte für Turniere, bei denen regelmäßig auch die königliche Familie mitwirkt. So nimmt zum Beispiel Zara Phillips an den Turnieren teil. Sie folgt damit ihren Eltern nach, die in den 70er-Jahren einige Turniere gewonnen hatten.

Un château de conte de fées : la résidence *Burghley House* dans le Lincolnshire en Angleterre est l'un des plus beaux endroits où sont disputés des tournois auxquels la famille royale participe également régulièrement. Zara Phillips, par exemple, participe aux tournois. Ainsi suit-elle l'exemple de ses parents qui avaient remporté quelques concours dans les années 70.

Palacio de cuento de hadas: La residencia *Burghley House* en Lincolnshire, Inglaterra, es uno de los más bellos escenarios de las competiciones en las que participa regularmente la familia real como, por ejemplo, Zara Phillips. Ella sigue la tradición de sus padres, que ganaron algunos campeonatos en la década de 1970.

Un castello da fiaba: la residenza *Burghley House* a Lincolnshire, in Inghilterra, è uno dei luoghi più belli in cui si svolgono concorsi ai quali partecipa regolarmente anche la famiglia reale, rappresentata, tra gli altri, da Zara Phillips. Zara segue così le orme dei genitori, che negli anni 70 hanno vinto alcuni concorsi.

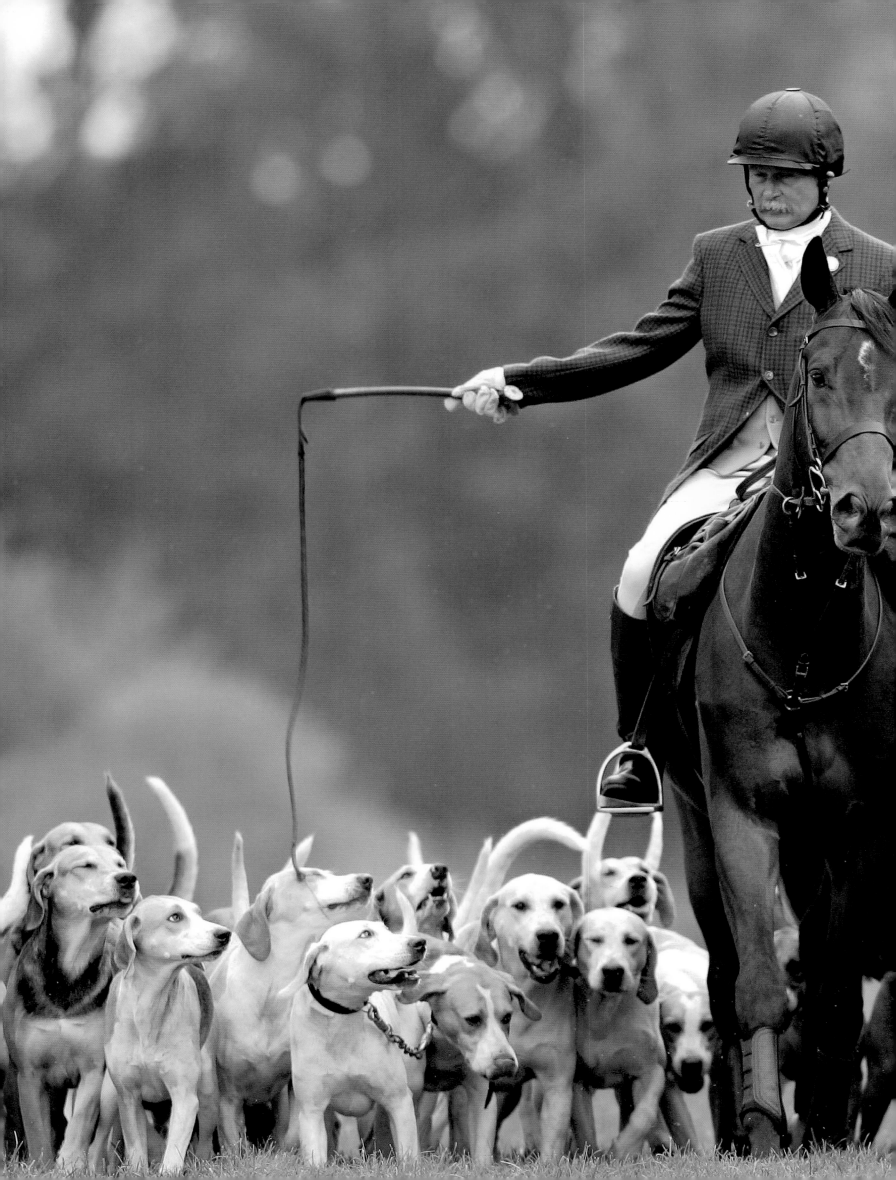

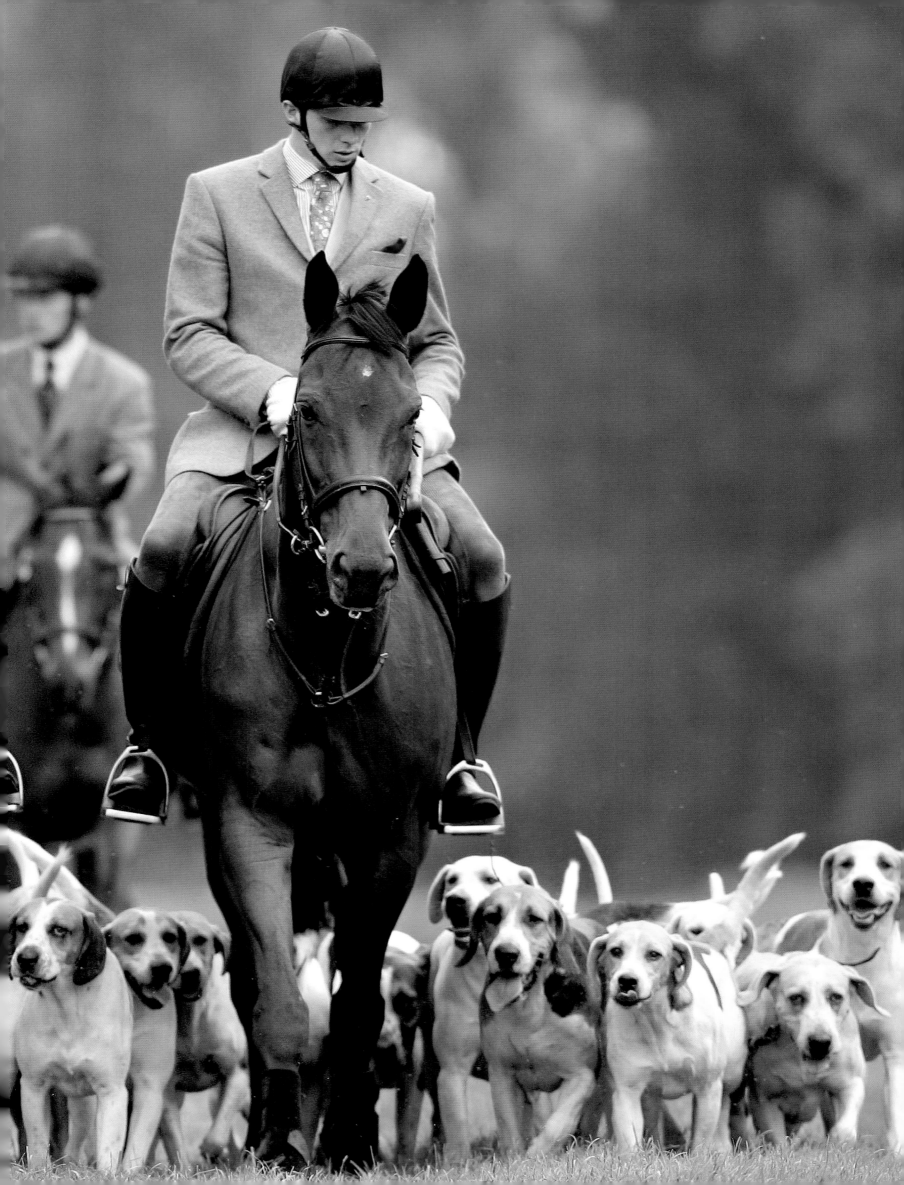

Gathering

Provisions

Rest

Trail

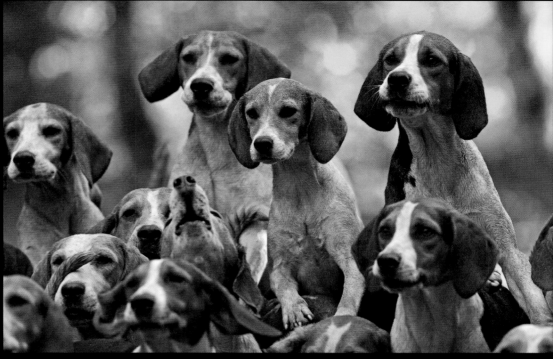

Pack

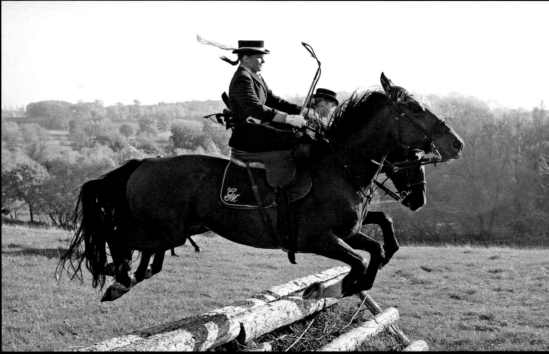

Side-saddle

Social hunt: Nature and its various jumps constitute the setting for drag hunting. As opposed to fox hunting, drag hunting is purely sportive.
No wildlife is shot, but the hounds follow the so-called drag, which has been treated with artificial scents.

Gesellschafts-Jagd: Die Natur und ihre Hindernisse bilden den Rahmen für das Jagdreiten. Anders als bei der Fuchsjagd ist Jagdreiten ein reiner Sport.
Es wird kein Wild geschossen, sondern die Hunde folgen der so genannten Schleppe, die mit einem Duftstoff versehen ist.

Chasse en société : la nature et ses obstacles constituent le cadre de la chasse à courre. Contrairement à la chasse au renard, la chasse à courre est purement sportive.
Aucun gibier n'est abattu, la meute poursuit seulement ce qu'on appelle la traîne odorante.

Grupo de caza: La naturaleza y sus obstáculos son el marco para la equitación de caza. Esta disciplina es, al contrario que la caza del zorro, un deporte.
No se dispara contra venado sino que los perros siguen un rastro artificial creado con una sustancia aromática.

Caccia di società: la natura e i suoi ostacoli costituiscono la cornice della caccia a cavallo che, diversamente dalla caccia alla volpe, ha un intento puramente sportivo:
non si spara alla selvaggina, e i cani inseguono soltanto la traccia di un odore.

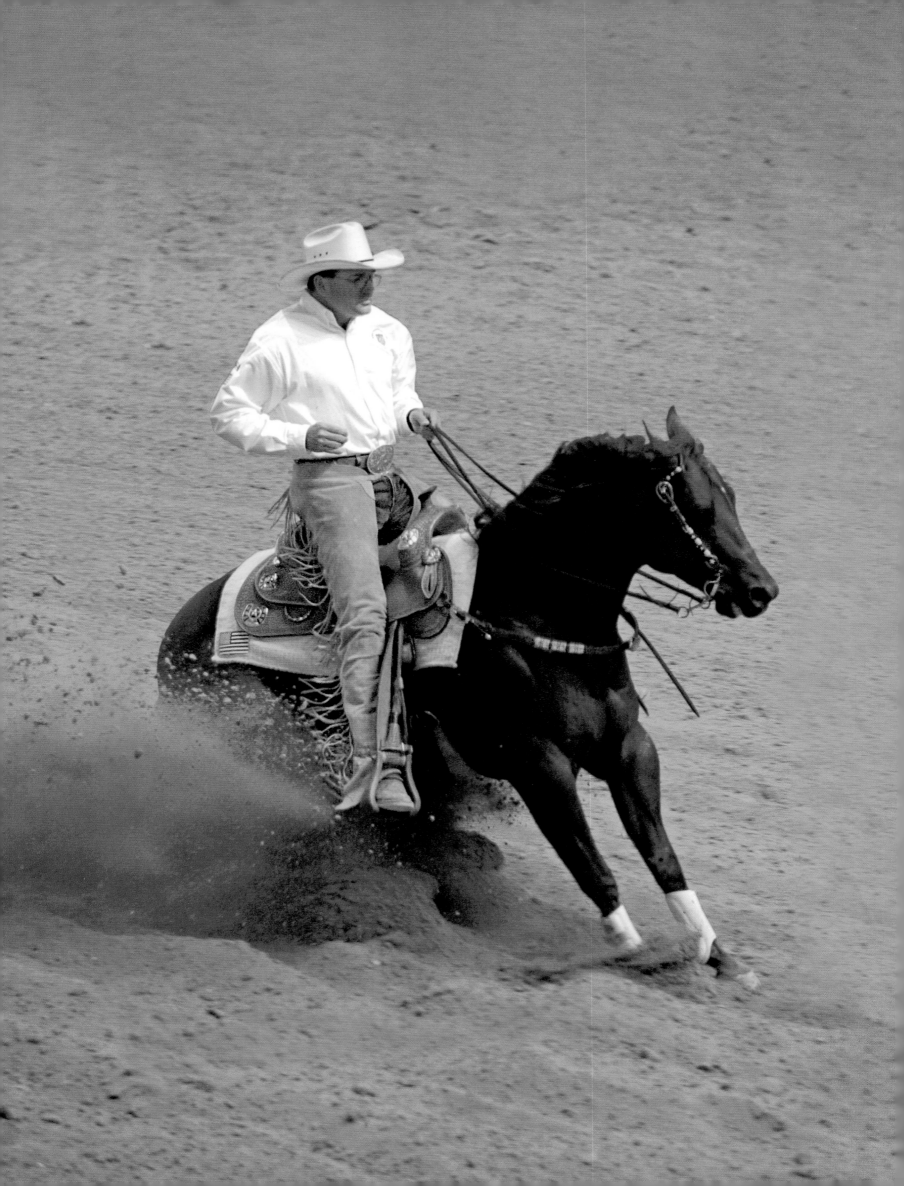

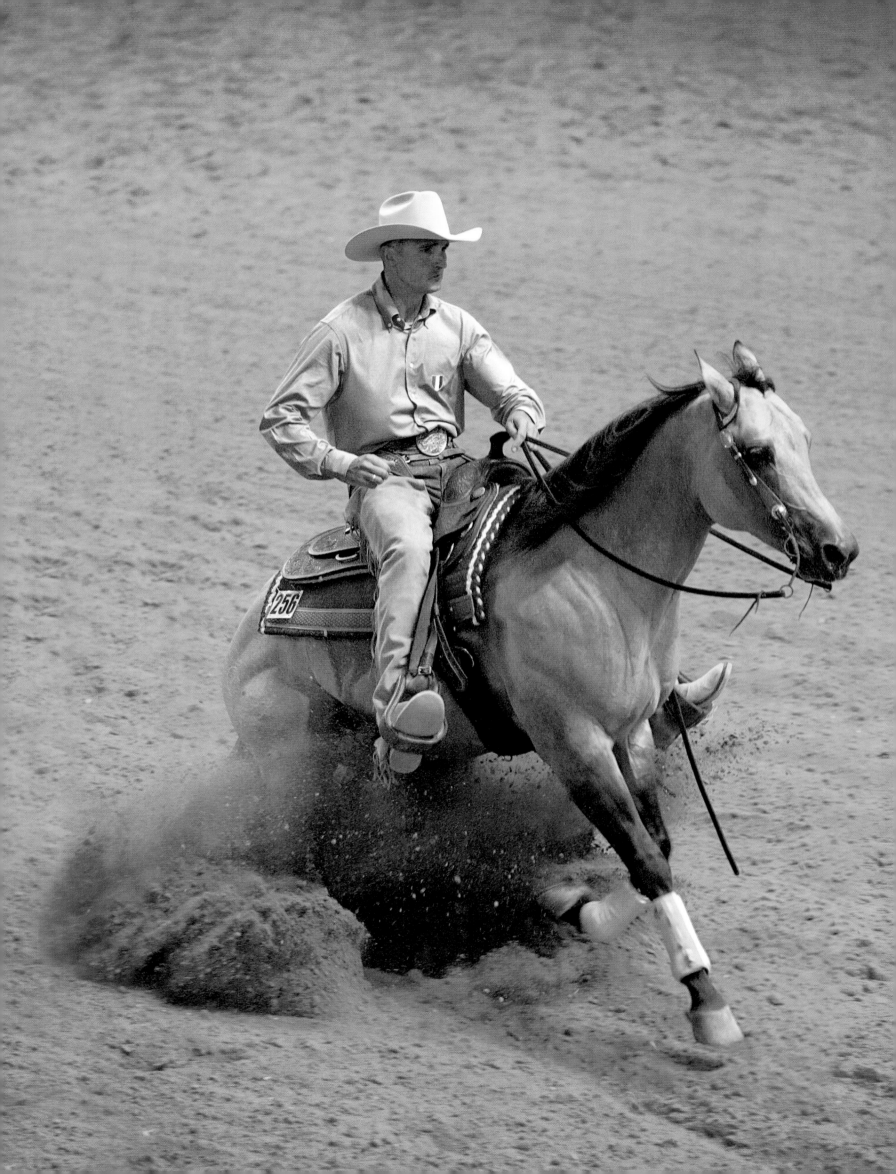

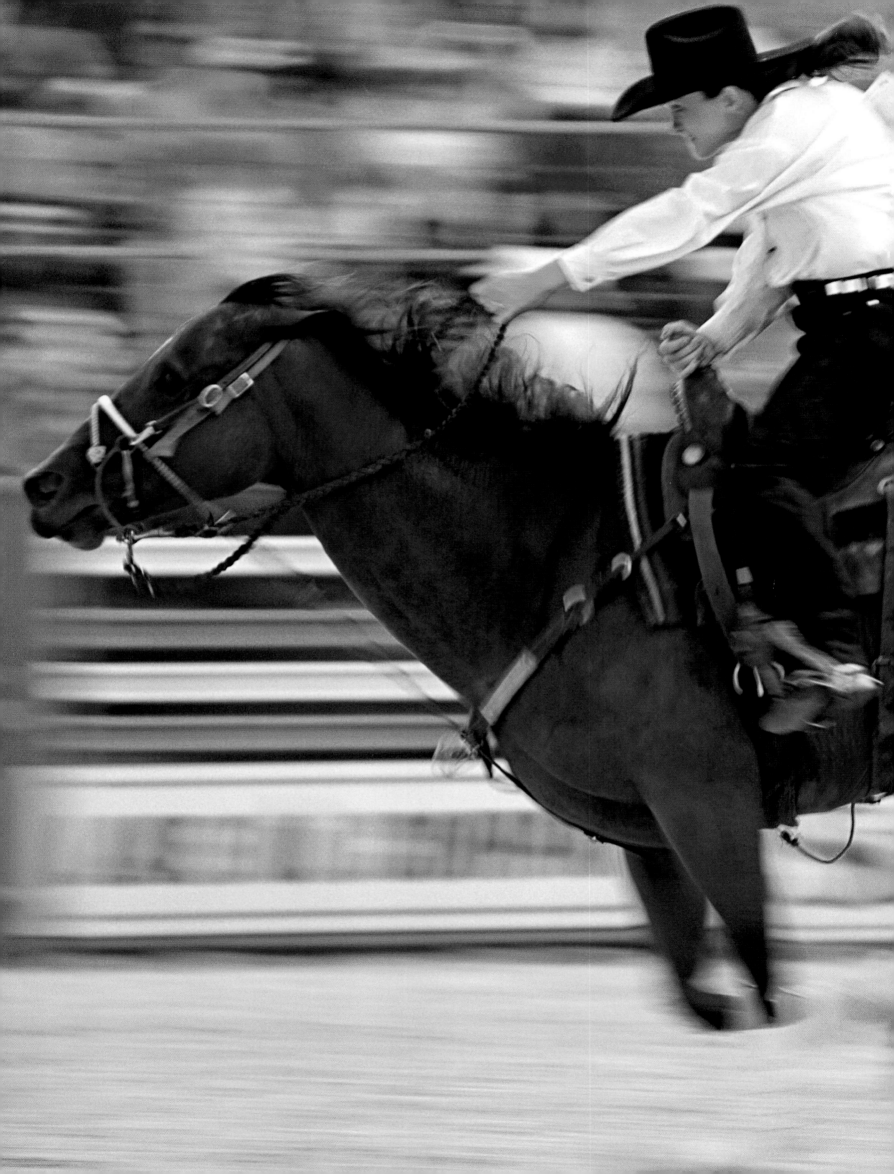

Previous Page

Perfect stop: two reining riders.

Perfekter Stopp: zwei Westernreiter.

Arrêt parfait : deux cavaliers western.

Parada perfecta: Dos jinetes del oeste.

Controllo perfetto per fermare il cavallo: due cavalieri western.

Reining: Reining goes back to the cowboys and has become a popular sport among leisure riders. Today, reining competitions have become officially recognized as a sport and are part of the World Equestrian Games. The *Cowgirl's Barrel Race* in Okeechobee, Florida, is great fun for horses, riders and spectators.

Westernreiten: Das Westernreiten hat seinen Ursprung bei den Cowboys und ist zur beliebtesten Sportart bei Freizeitreitern geworden. Inzwischen sind die Westernprüfungen auch offiziell als Sport anerkannt und Bestandteil der Weltreiterspiele. Das *Cowgirl's Barrel Race* in Okeechobee, Florida, ist großes Vergnügen für Pferd, Reiter und Zuschauer.

Équitation western : l'équitation western, qui vient des cow-boys, est devenue le sport préféré des cavaliers de loisir. Entre-temps, les épreuves western ont aussi été reconnues officiellement comme sport et font partie des jeux équestres mondiaux. La *Cowgirl's Barrel Race*, à Okeechobee en Floride, est un grand divertissement pour le cheval, le cavalier et le spectateur.

Equitación en el oeste: La equitación en el oeste tiene sus orígenes en los vaqueros y es la disciplina deportiva más popular de los jinetes aficionados. En la actualidad, las pruebas del oeste también están reconocidas oficialmente como deporte y son parte de los juegos mundiales de equitación. La *Cowgirl's Barrel Race* en Okeechobee, Florida, es la mayor diversión para el caballo, el jinete y el espectador.

Cavalcata western: la cavalcata western trova la sua origine presso i cowboy ed è diventata uno degli sport più amati da chi pratica per hobby l'equitazione. Oggi le prove di cavalcata western sono riconosciute ufficialmente come disciplina sportiva e sono entrate a far parte dei giochi equestri mondiali. Il *Cowgirl's Barrel Race* di Okeechobee, in Florida, è un vero piacere per il cavallo, per il cavaliere e per gli spettatori.

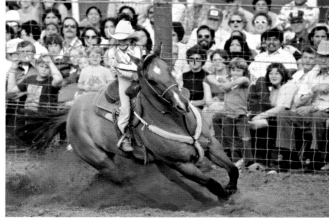

Polo: The Royal Sport

I n ancient Persia, a stick game carried out on horseback called *Chaugán* was already popular at the time of King Darius. In Tibet, it is said that riders armed with sticks hunted and killed muskrats, a leisure sport they called *Pulu* (ball). British officers became familiar with this sport in colonial India, where it was no longer played with rats but rather with actual balls. From there, they introduced it to their native island in the 19th century.

In the Andalusian Sotogrande, the month of August is entirely dedicated to the sport of kings. A total of 18 teams compete in more than 110 matches at the *Torneo Internacional Lexus de Sotogrande*. But in the other months of the year as well, the game of Polo is practiced in the Spanish town with its luxury villas—unparalleled in Europe, because here at the Costa del Sol the thermometer practically never drops below 64 degrees Fahrenheit. It is not surprising therefore, that many lovers of polo consider Sotogrande to be the most beautiful place on earth.

More extreme climatic conditions are found at the Jerudong Park Polo Club of the Sultanate of Brunei located on the northern shore of the island of Borneo. Whenever Sultan Hassan al-Bolkiah, a passionate polo player as is his younger brother Prince Jefri, is not himself on the back of his noble ponies driving the ball, he can watch the happenings from the royal grandstand, where his royal head is fanned by the cool air of the air conditioning system.

In Keitum, on the German North Sea island of Sylt, yet another wind is blowing: this is where the high society meets for the *German Polo Masters* in the white VIP tent. In Hamburg, the rich and the beautiful flock to the polo court to practice the ritual of divot stomping, in which the noble spectators wander all over the field stomping down the turf torn up by the horses. The nobility of the economic world competes at the *Rolex Cup*, where teams by Porsche, Lanson and Focus, Bentley, Berenberg and Bogner fight each other for the win.

In the Austrian Kitzbuhel, Argentinean polo horses chase through the snow, as this is where polo player Reto Gaudenzi organizes the *Snow Arena Polo World Cup*. He also manages a noble private club in Miami Beach in the villa of the late fashion designer Gianni Versace. It was therefore natural to found a variation of the game in Miami as well, *Polo on the Beach*.

The best polo horses hail from Argentina. The expanses of the pampa are the perfect training grounds for fast horses and skilled riders. The horse breeding family of Heguy has produced a notable dynasty of players, winner types with a handicap of 10, almost unbeatable. While the Falkland war was raging, the Duke of Edinburgh suggested leaving the damn isles in the possession of the Argentineans, if in return they would hand over the Heguy family. History, however, has apparently decided otherwise.

Polo, modern heroes: Nachi Heguy is one of the most charismatic members of the famous Heguy family. This family has produced some of the world's best polo players.

Polo, moderne Helden: Nachi Heguy ist eines der charismatischsten Mitglieder der berühmten Heguy-Familie. Ihr entstammen einige der besten Spieler der Welt.

Le polo, des héros modernes : Nachi Heguy est l'un des membres les plus charismatiques de la célèbre famille Heguy. Elle a engendré quelques uns des meilleurs joueurs du monde.

Polo, héroes modernos: Nachi Heguy es uno de los carismáticos miembros de la familia Heguy. En ella han nacido alguno de los mejores jugadores del mundo.

Polo, moderni eroi: Nachi Heguy è uno dei carismatici componenti della celebre famiglia Heguy, da cui provengono alcuni dei migliori giocatori del mondo.

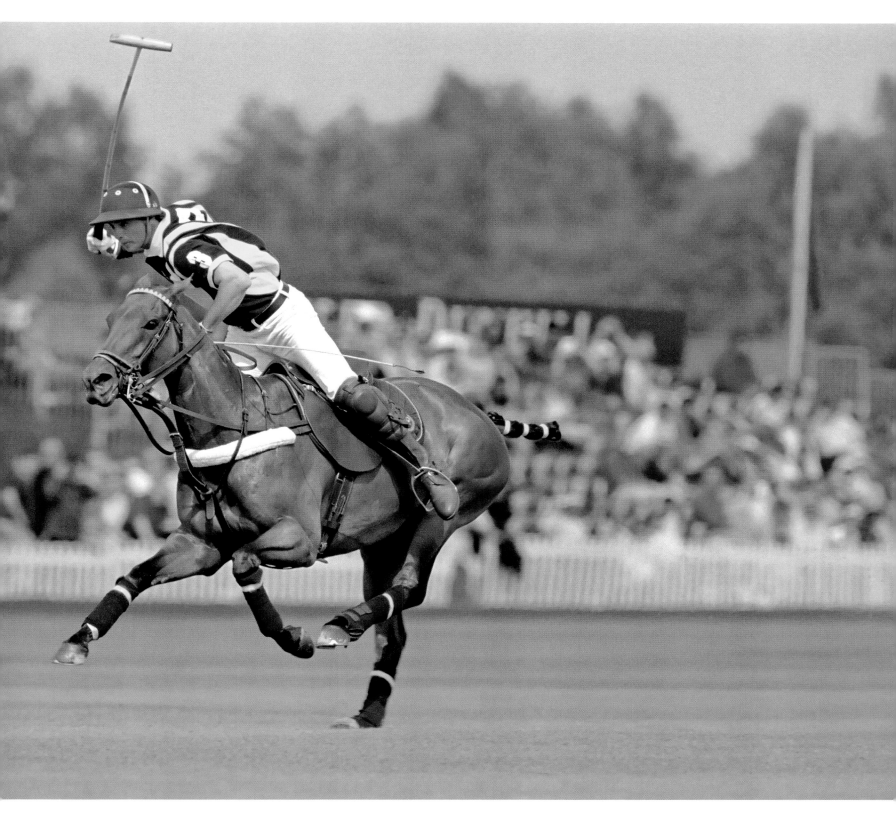

Hard labor: After the training, a keeper is taking the polo horses back to their stables.

Harte Arbeit: Ein Helfer bringt die Polopferde nach dem Training zurück in den Stall.

Dur labeur : un aide reconduit les chevaux de polo à l'écurie après l'entraînemen.

Trabajo duro: Un ayudante lleva a los caballos de polo de vuelta al establo después de un partido.

Un lavoro duro: un aiutante riporta i cavalli in scuderia dopo l'allenamento.

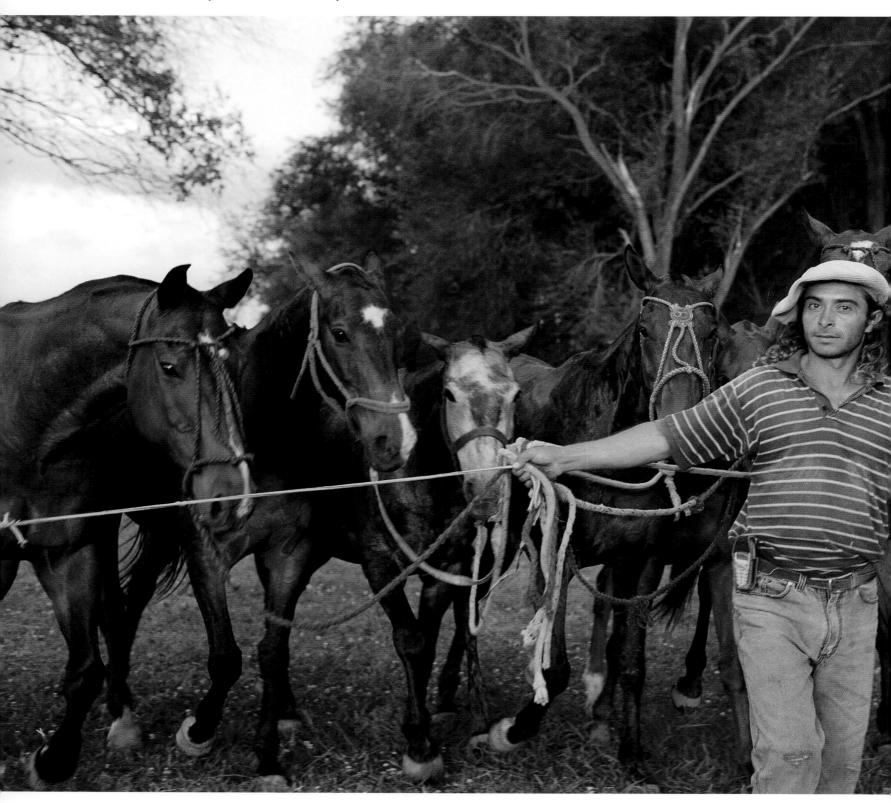

Polo: der Sport der Könige

I m alten Persien erfreute sich ein hoch zu Ross betriebenes Stockspiel namens *Chaugán* schon zu Zeiten des Königs Darius großer Beliebtheit. In Tibet sollen Reiter mit Stöcken Bisamratten gejagt und erschlagen haben, ein Freizeitvergnügen, das sie *Pulu* (Ball) nannten. Britische Offiziere lernten den Sport, nun allerdings nicht mehr mit Ratten, sondern tatsächlich mit Bällen betrieben, im Kolonialreich Indien kennen. Von dort aus führten sie ihn im 19. Jahrhundert auf der heimatlichen Insel ein.

Der Monat August steht im andalusischen Sotogrande ganz im Zeichen des Sports der Könige. 18 Teams tragen hier beim *Torneo Internacional Lexus de Sotogrande* mehr als 110 Wettkämpfe aus. Aber auch in den restlichen Monaten des Jahres wird in dem spanischen Ort mit seinen Luxusvillen das Polospiel gepflegt – einmalig in Europa, denn hier an der Costa del Sol sinkt das Thermometer eigentlich nie unter 18 Grad. Was Wunder, dass viele Polofreunde Sotogrande als schönsten Platz der Welt bezeichnen.

Extremere klimatische Verhältnisse bestimmen das Bild im Jerudong Park Polo Club des Sultanats Brunei an der Nordküste der Insel Borneo. Wenn Sultan Hassan al-Bolkiah, wie auch sein jüngster Bruder Prinz Jefri ein begeisterter Polospieler, nicht selbst auf dem Rücken seiner edlen Ponys den Ball treibt, kann er das Treiben von der königlichen Tribüne aus verfolgen. Das royale Haupt selbstverständlich von der kühlen Luft aus der Air-Condition umfächelt.

In Keitum auf der deutschen Nordseeinsel Sylt weht ein anderer Wind: Hier trifft sich die High Society zu den *German Polo Masters* im weißen VIP-Zelt, in Hamburg schwärmen die Reichen und die Schönen am Poloplatz zum Eintreten aus, dem Ritual des Niedertrampelns, bei dem das noble Publikum das von den Pferden herausgerissene Gras wieder in den Rasen tritt. Die Adelshäuser der Marktwirtschaft treten beim *Rolex-Cup* an, Teams von Porsche, Lanson und Focus, Bentley, Berenberg und Bogner kämpfen um den Sieg.

Im österreichischen Kitzbühel jagen argentinische Polopferde durch den Schnee, hier organisiert der Polospieler Reto Gaudenzi den *Snow Arena Polo World Cup*. In Miami Beach unterhält er in der Villa des verstorbenen Modemachers Gianni Versace einen noblen Privatclub; da lag es nahe, nun auch in Miami eine Variante des Spiels ins Leben zu rufen, *Polo on the Beach*.

Die besten Polopferde kommen aus Argentinien. Die Weiten der Pampa erweisen sich als ideales Trainingsgelände für schnelle Pferde und fulminante Reiter. Eine bedeutende Spieler-Dynastie hat die Pferdezüchter-Familie Heguy hervorgebracht, Siegertypen mit dem Handicap 10, kaum schlagbar. Als der Falklandkrieg tobte, schlug der Herzog von Edinburgh vor, den Argentiniern doch die verdammten Inseln zu lassen, wenn sie dafür die Familie Heguy herausrücken würden. Die Geschichte hat bekanntlich anders entschieden.

Polo : le sport des rois

Dans la Perse antique, dès l'époque du roi Darius, le *Chaugán*, un jeu avec des cavaliers munis d'un maillet, jouissait d'une grande popularité. Au Tibet, on raconte que des cavaliers chassaient et écrasaient des rats musqués avec un bâton, un loisir qu'ils appelaient *Pulu* (balle). Des officiers britanniques découvrirent ce sport, pratiqué non plus avec des rats mais avec de véritables balles, dans leur colonie, l'Inde. De là, ils l'introduisirent au 19ème siècle dans leur île d'origine.

Dans le village de Sotogrande, en Andalousie, le mois d'août est placé sous le signe du sport des rois. Lors du *Torneo Internacional Lexus de Sotogrande*, dix-huit équipes disputent plus de 110 épreuves. Mais dans ce village espagnol avec ses villas de luxe, le polo se joue également pendant les autres mois de l'année – un fait unique en Europe, car, ici, sur la Costa del Sol, le thermomètre ne descend à vrai dire jamais au-dessous de 18 degrés. Rien d'étonnant à ce que nombre de joueurs de polo considèrent Sotogrande comme le plus bel endroit du monde.

Des conditions climatiques encore plus extrêmes déterminent le paysage dans le Jerudong Park Polo Club du sultanat de Brunei sur la côte nord de l'île de Bornéo. Quand le sultan Hassan al-Bolkiah, comme son frère cadet, le prince Jefri, également joueur de polo passionné, ne pourchasse pas lui-même la balle sur le dos de son noble poney, il peut suivre le tumulte de la tribune royale. Bien entendu, la tête du roi est rafraîchie par la brise de l'air conditionné.

A Keitum, sur l'île allemande de Sylt dans la mer du Nord, souffle un autre vent : la haute société s'y rencontre pour les *German Polo Masters* dans la tente blanche des VIP ; à Hambourg, les riches et les élégants se déploient vers le terrain de polo pour le « fouler », c'est-à-dire le rituel du piétinement, où un public distingué ramène sur la pelouse l'herbe arrachée par le chevaux. Les maisons nobles de l'économie de marché se mesurent à l'occasion de la *Rolex Cup*, des équipes de Porsche, Lanson et Focus, Bentley, Berenberg et Bogner se disputent la victoire.

A Kitzbühel en Autriche, des chevaux de polo argentins galopent dans la neige, là où le joueur de polo Reto Gaudenzi organise la *Snow Arena Polo World Cup*. A Miami Beach, il dirige dans la villa du designer de mode défunt Gianni Versace un club privé aristocratique ; dès lors il était évident de créer, à Miami également, une variante du jeu, *polo on the beach*.

Les meilleurs chevaux de polo viennent d'Argentine. L'immensité de la pampa constitue un terrain d'entraînement idéal pour ces chevaux rapides et ces cavaliers éblouissants. La famille d'éleveurs de chevaux Heguy a donné naissance à une importante dynastie de joueurs, une race de champions avec 10 de handicap, pratiquement imbattable. Au moment de la guerre des Malouines, le Duc d'Édimbourg proposa de laisser ces satanées îles aux Argentins à condition qu'ils cèdent la famille Heguy. L'histoire en décida autrement.

Before the game: Just like gladiators, the polo players are sitting on their chairs waiting for their deployment.

Vor dem Spiel: Wie Gladiatoren sitzen die Polospieler auf ihren Stühlen und warten auf ihren Einsatz.

Avant le jeu : comme des gladiateurs, les joueurs de polo, assis sur leurs chaises, attendent leur entrée en jeu.

Antes del encuentro: Jugadores de polo sentados en sus sillas como los gladiadores esperan que empiece el juego.

Prima del gioco: come i gladiatori di un tempo, i giocatori siedono aspettando il loro turno.

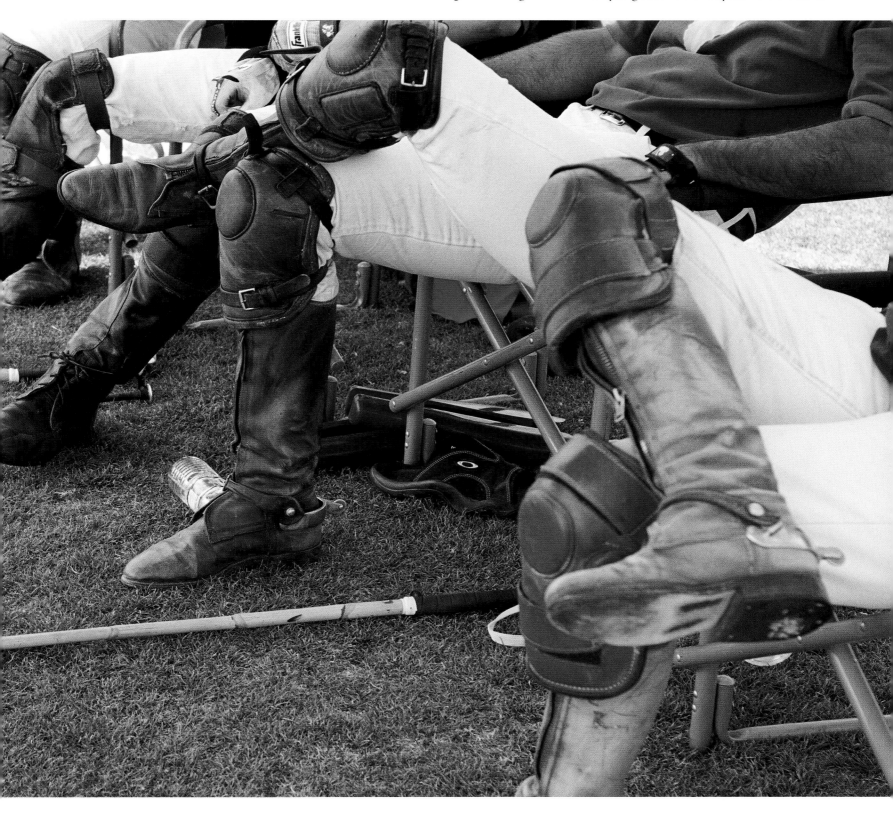

Seeing and buying: At an auction in Pilar, a gaucho examines the horses for his bidder.

Schauen und kaufen: Bei einer Versteigerung in Pilar begutachtet ein Gaucho die Pferde für seinen Bieter.

Regarder et acheter : lors d'une vente aux enchères à Pilar, un gaucho évalue les chevaux pour son enchérisseur.

Ver y comprar: Un gaucho examina los caballos para su pujador durante una subasta en Pilar.

Guardare e comprare: a Pilar, un gaucho valuta i cavalli per il suo offerente durante una vendita all'asta.

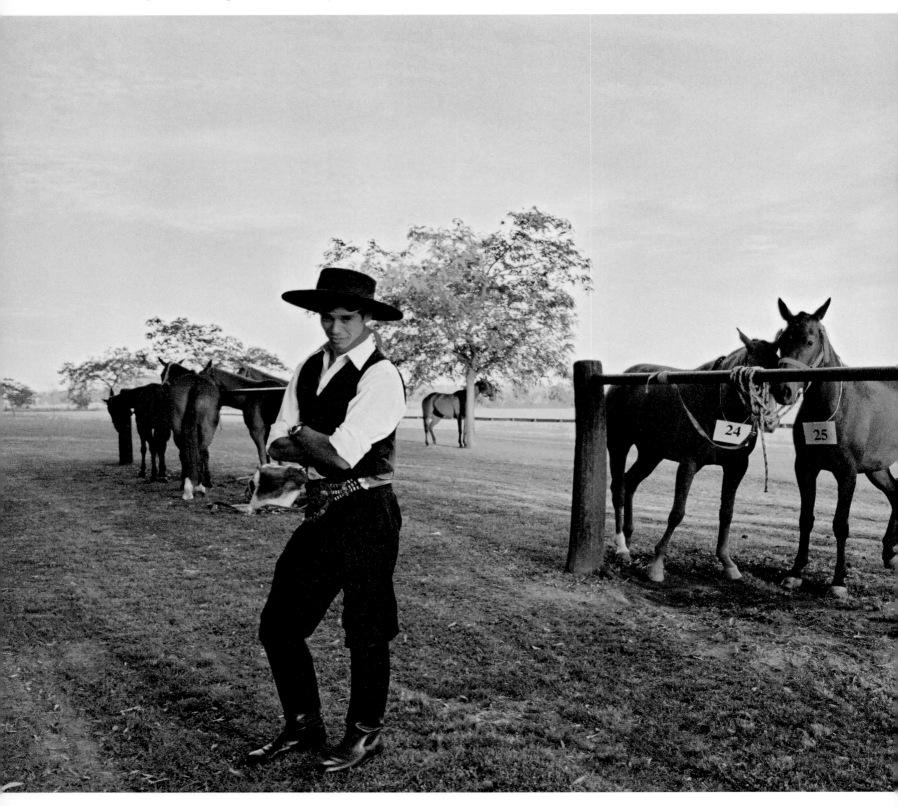

Polo: el deporte de los reyes

En la antigua Persia, en los tiempos del rey Darío, el juego entre jinetes con mazas de palos largos llamado *Chaugán* disfrutaba ya de una gran popularidad. En el Tíbet, los jinetes cazaban y mataban con sus palos ratas almizcleras, un pasatiempo al que llamaron *Pulu* (pelota). Los oficiales británicos aprendieron este deporte en la India colonial, aunque las ratas ya habían sustituidas por pelotas de verdad. Desde aquí lo llevaron en el siglo XIX hasta su patria.

El mes de agosto en el pueblo andaluz de Sotogrande está completamente dedicado al deporte de los reyes. 18 equipos se enfrentan en el *Torneo Internacional Lexus de Sotogrande* en más de 110 competiciones. Y también durante los demás meses del año se practica el polo en esta localidad de lujosas villas, algo único en Europa, porque aquí, en la Costa del Sol, el termómetro nunca baja de los 18 grados. Por eso no sorprende que los entusiastas del polo afirmen que Sotogrande es el lugar más bello del mundo.

En el Jerudong Park Polo Club del sultanado Brunei, en la costa norteña de la isla Borneo, dominan las condiciones climáticas extremas. Cuando el sultán Hassan al-Bolkiah, o su hermano más pequeño el príncipe Jefri, un verdadero amante del polo, no juega al polo montado sobre sus nobles ponis puede seguir el partido desde la tribuna real. La cabeza real, naturalmente, está abanicada por la refrescante brisa del acondicionador de aire.

En Keitum, en la isla alemana del Mar del Norte Sylt, corre otro aire: aquí la alta sociedad se reúne con motivo del *German Polo Masters* en la carpa blanca VIP, en Hamburgo, la flor y nata se lanza al terreno de juego para cumplir con el ritual de tapar pisando los agujeros levantados en la hierba por los caballos. Las casas nobles de la economía se miden en la *Rolex Cup* y los equipos de Porsche, Lanson y Focus, Bentley, Berenberg y Bogner luchan por la victoria.

En la localidad austriaca de Kitzbühel los caballos de polo argentinos corren por la nieve porque aquí el jugador de polo Reto Gaudenzi organiza la *Snow Arena Polo World Cup*. En Miami Beach dirige un elegante club privado en la villa del fallecido diseñador de moda Gianni Versace y falta poco para que en Miami aparezca una nueva variante del juego: *Polo on the Beach*.

Los mejores caballos de polo proceden de Argentina. La vastedad de la pampa ofrece uno terreno ideal para el entrenamiento de caballos rápidos y fulminantes jinetes. La familia de criadores Heguy está compuesta por una importante dinastía de jugadores, vencedores con el handicap 10, casi invencibles. Cuando estalló la guerra de las Malvinas, el duque de Edimburgo propuso darles las malditas islas a los argentinos si éstos, a cambio, les entregaban a la familia Heguy. Como ya se sabe la decisión de la Historia fue otra.

Polo: lo sport dei re

L o *Chaugán*, già molto popolare ai tempi del re Dario, era un gioco che si praticava a cavallo con delle mazze. In Tibet, cavalieri armati di bastoni davano la caccia e uccidevano topi muschiati: questo passatempo era chiamato *Pulu* (palla). Gli ufficiali inglesi appresero questo sport in India, allora colonia britannica, e lo praticarono non più con i topi ma con una vera palla. Nel XIX secolo introdussero il gioco del polo in Inghilterra.

A Sotogrande, in Andalusia, l'intero mese di agosto è dedicato a questo regale sport. Il *Torneo Internaciona Lexus de Sotogrande* prevede più di 110 gare disputate da 18 squadre. Ma in questa località spagnola popolata di ville lussuose il polo si pratica anche negli altri mesi dell'anno, evento unico in Europa, perché sulla Costa del Sol il termometro non scende quasi mai sotto i 18 gradi. Non a caso, molti appassionati di polo affermano che il campo più bello del mondo è quello di Sotogrande.

Condizioni climatiche meno favorevoli fanno da cornice al Jerudong Park Polo Club del sultanato di Brunei, sulla costa settentrionale dell'isola del Borneo. Il sultano Hassan al-Bolkiah è un appassionato giocatore di polo come pure il principe Jefri, suo fratello minore: quando non gioca personalmente in groppa ai suoi prestigiosi pony, il sultano segue la partita dalla tribuna reale, ovviamente dotata di aria condizionata.

A Keitum, nell'isola tedesca di Sylt, nel mare del Nord, si respira un'altra aria: qui l'alta società si incontra nella tenda bianca dei VIP in occasione dei *German Polo Masters*; ad Amburgo, invece, la gente bella e ricca si riversa nel campo da polo per "calpestare" il terreno, secondo il rituale che vuole che il raffinato pubblico rimetta a posto l'erba che i cavalli hanno sradicato dal prato. I nobili casati che gestiscono l'economia di mercato si affrontano nella *Rolex Cup*, in cui le squadre Porsche, Lanson e Focus, Bentley, Berenberg e Bogner si contendono la vittoria.

In Austria, a Kitzbühel, cavalli da polo argentini corrono nella neve: Reto Gaudenzi, giocatore di polo, organizza qui la *Snow Arena Polo World Cup*. Gaudenzi gestisce un elegante circolo privato a Miami Beach, nella villa di Gianni Versace, lo stilista assassinato; da qui a creare anche a Miami una variante del gioco, chiamata *Polo on the Beach,* il passo è stato breve.

I migliori cavalli da polo vengono dall'Argentina. I grandi spazi della pampa sono il luogo ideale per addestrare i cavalli alla velocità e i cavalieri alla destrezza. Alla famiglia di allevatori Heguy fa capo un'importante dinastia di giocatori, campioni quasi invincibili con handicap 10. All'epoca della guerra delle Falkland, il duca di Edinburgo propose di lasciare all'Argentina le maledette isole in cambio della famiglia Heguy. Ma la storia, si sa, ha deciso diversamente.

After the game: Seated on a veranda of a villa in Pilar, Diego Miguens, Ezequiel Ayerza, Santiago Ramos Mejía and Martin Tassara are enjoying themselves.

Nach dem Spiel: Auf einer Veranda in einer Villa in Pilar lassen es sich Diego Miguens, Ezequiel Ayerza, Santiago Ramos Mejía und Martin Tassara gut gehen.

Après le jeu : sur une véranda, dans une villa de Pilar, Diego Miguens, Ezequiel Ayerza, Santiago Ramos Mejía et Martin Tassara se détendent.

Después del juego: En la veranda de una villa en Pilar, Diego Miguens, Ezequiel Ayerza, Santiago Ramos Mejía y Martin Tassara se relajan.

Dopo il gioco: Diego Miguens, Ezequiel Ayerza, Santiago Ramos Mejía e Martin Tassara si rilassano sulla veranda di una villa di Pilar.

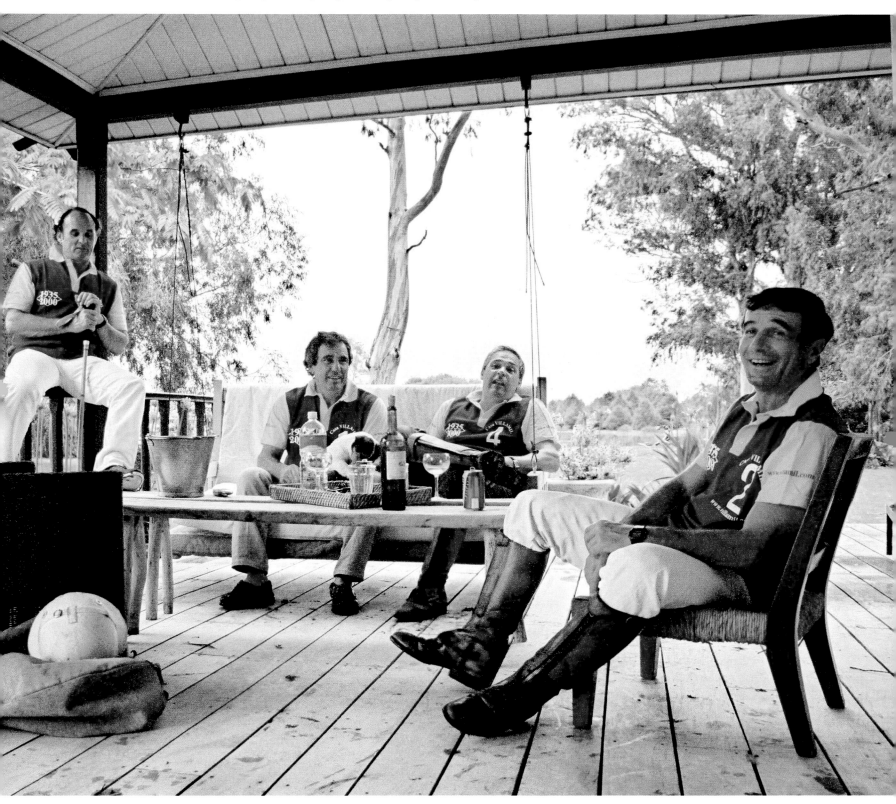

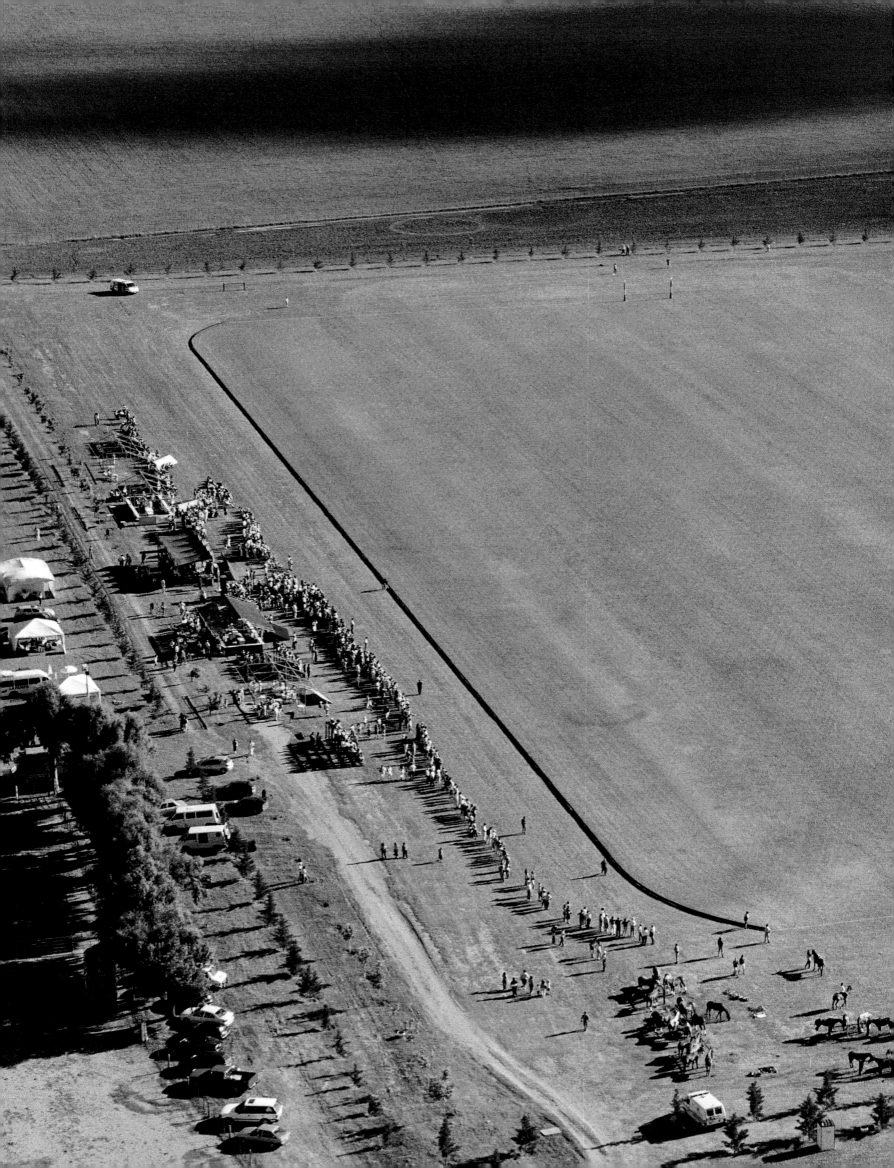

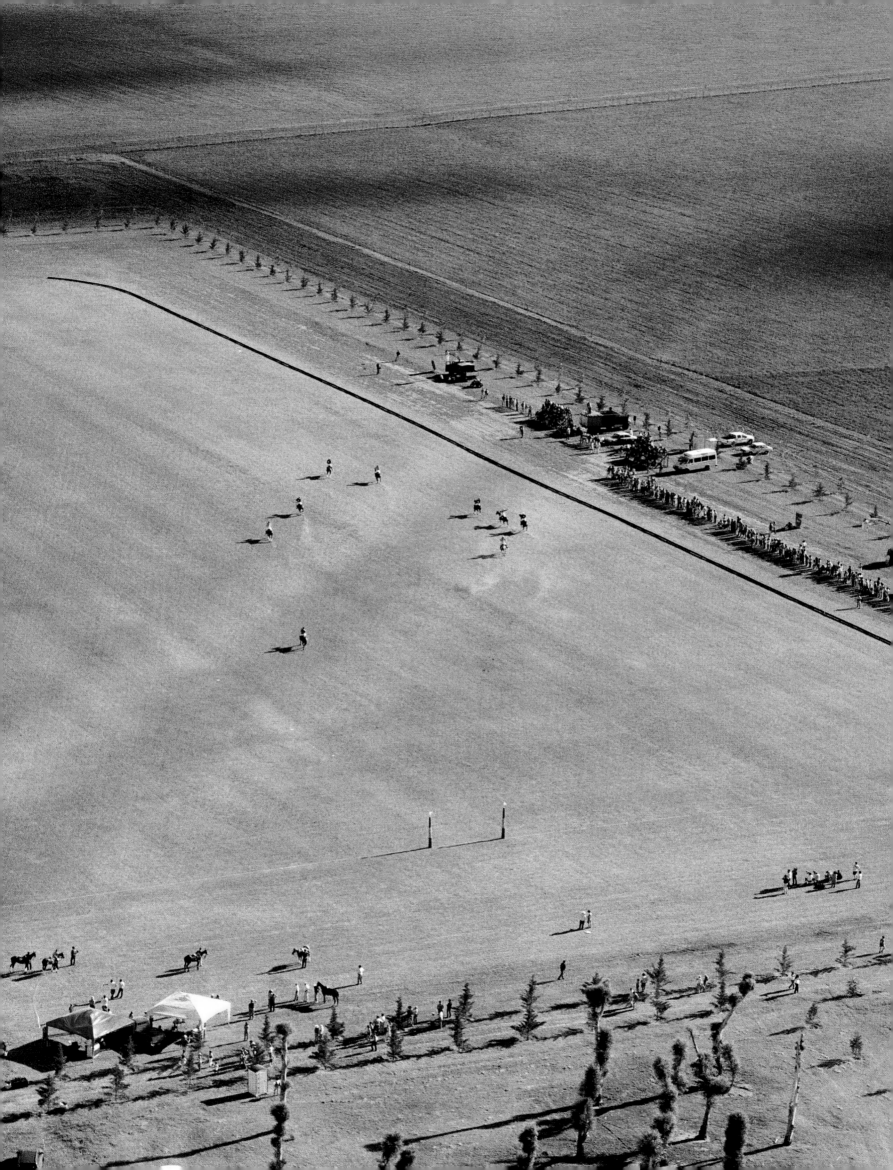

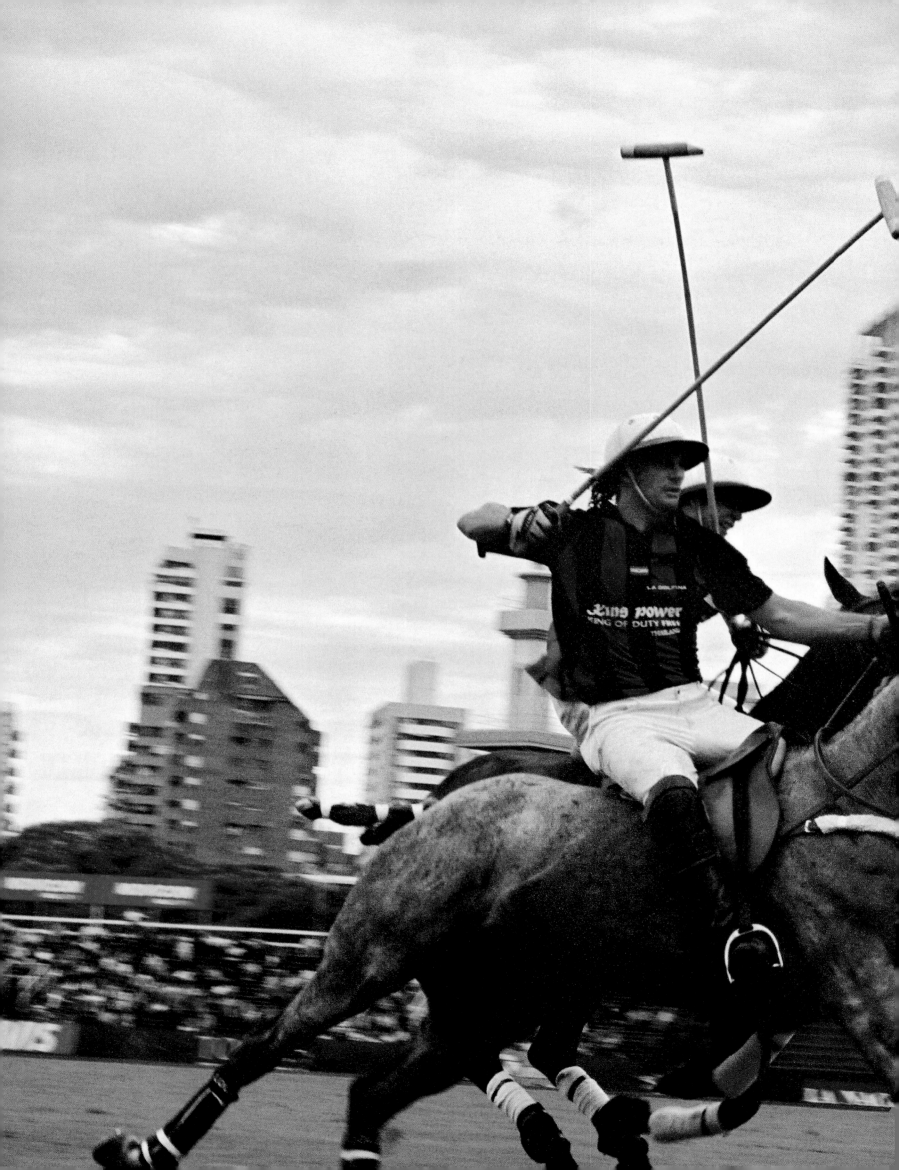

Previous Page

Large Arena: View from a helicopter of the playing field in La Pampa.

Große Arena: Blick aus dem Hubschrauber auf das Spielfeld in La Pampa.

Immense arène : vue de l'hélicoptère sur le terrain de jeu dans La Pampa.

Gran arena: Vista desde el helicóptero sobre el terreno de juego en La Pampa.

La grande arena: veduta aerea del campo di La Pampa.

Exchange of blows: The *Palermo Open* takes place every year in Palermo, Argentina: the meeting of the world's best polo players.

Schlagabtausch: In Palermo in Argentinien finden jährlich die *Palermo Open* statt: das Treffen der besten Polospieler der Welt.

Échange de coups : à Palermo, en Argentine, ont lieu chaque année les *Palermo Open*, la rencontre des meilleurs joueurs de polo au monde.

Pases: En Palermo, en Argentina, se celebra todos los años el *Palermo Open*: el encuentro de los mejores jugadores de polo del mundo.

Scambio di colpi: a Palermo, in Argentina, si svolgono ogni anno i *Palermo Open*, in cui si scontrano i migliori giocatori di polo del mondo.

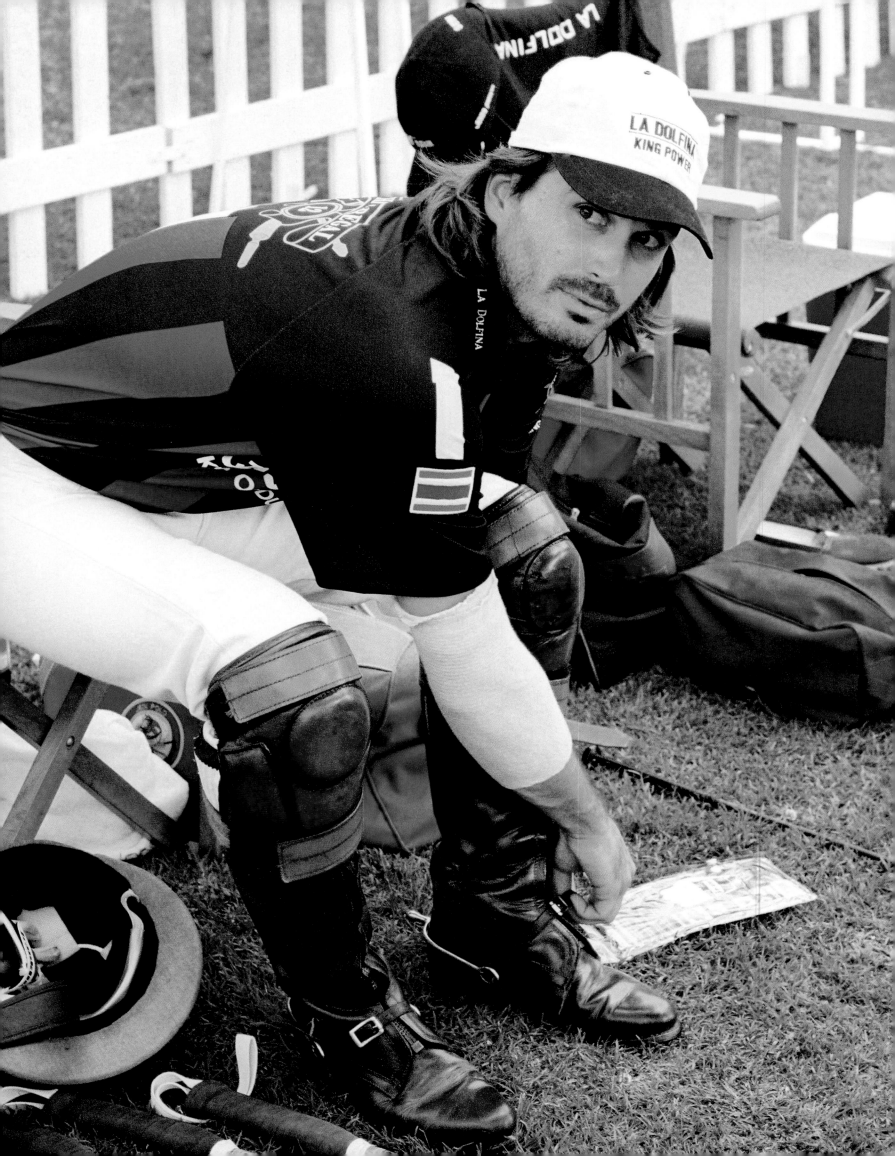

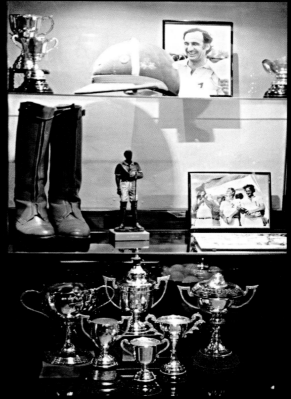

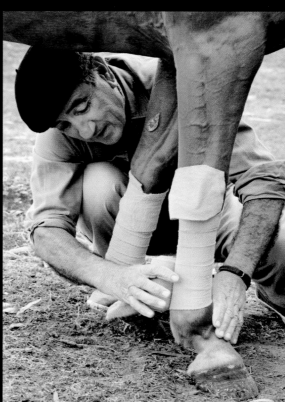

Cult game: Native Argentinean Adolfo Cambiaso is the world's best polo player. Who wants to play polo needs the proper equipment. The Argentinean boot manufacturers Fagliano are considered to be the best in the world. Those who care about their style, shop at *La Martina*.

Kultspiel: Der Argentinier Adolfo Cambiaso ist der beste Polo-Spieler der Welt. Wer Polo spielt, braucht die richtige Ausrüstung. Die argentinischen Stiefelmacher Fagliano gelten als die besten der Welt. Wer etwas auf sich hält, kauft bei *La Martina*.

Jeu culte : l'argentin Adolfo Cambiaso est le meilleur joueur de polo au monde. Celui qui joue au polo a besoin d'un équipement adéquat. Les bottiers argentins Fagliano sont considérés comme les meilleurs au monde. Quiconque prend soin de sa personne se fournit chez *La Martina*.

Juego de culto: El argentino Adolfo Cambiaso es el mejor jugador de polo del mundo. Quien juegue al polo necesita el equipamiento adecuado. Las botas de la casa argentina Fagliano tienen fama de ser las mejores del mundo. Quien busca primera calidad compra en *La Martina*.

Un gioco "cult": l'argentino Adolfo Cambiaso è il miglior giocatore di polo del mondo. Chi gioca a polo ha bisogno dell'attrezzatura adatta. Gli stivali dei produttori argentini "Fagliano" sono considerati i migliori del mondo. Chi cerca la qualità, compra da *La Martina*.

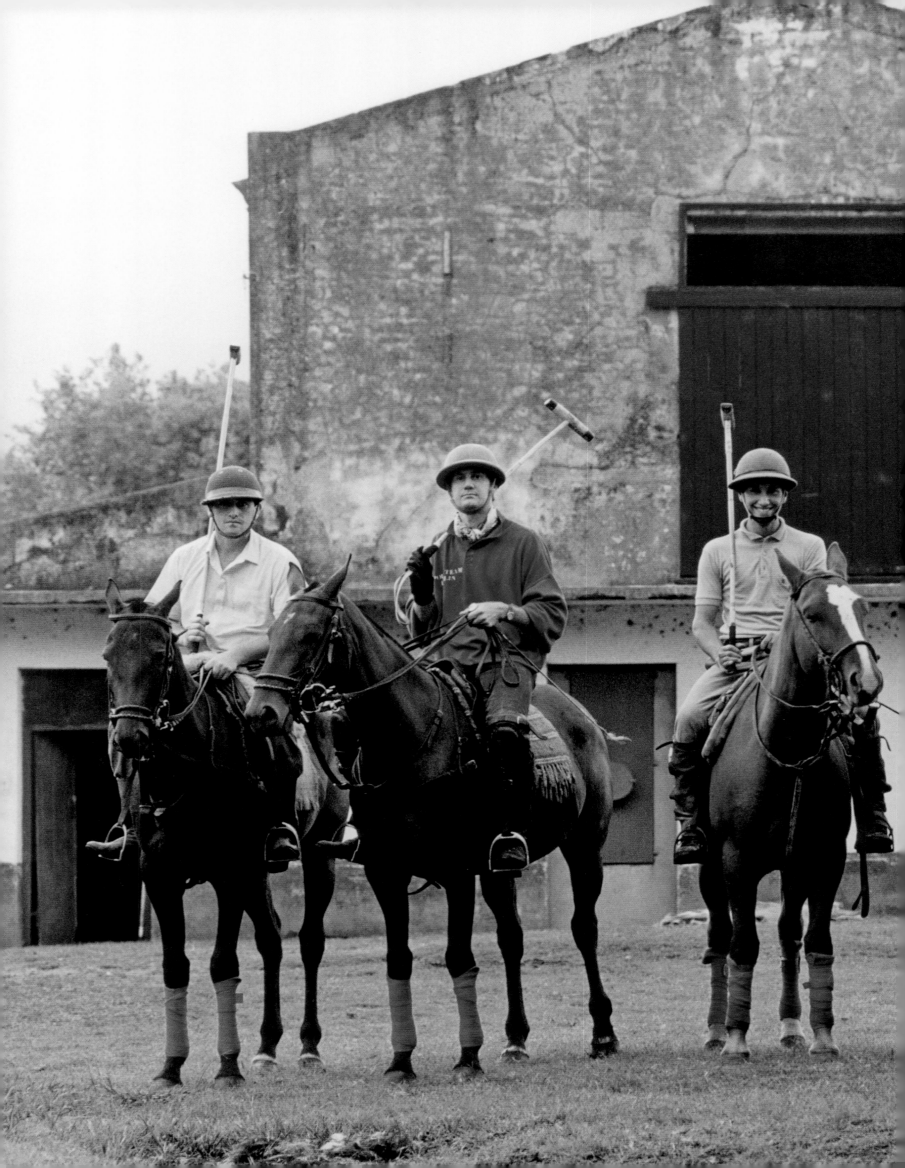

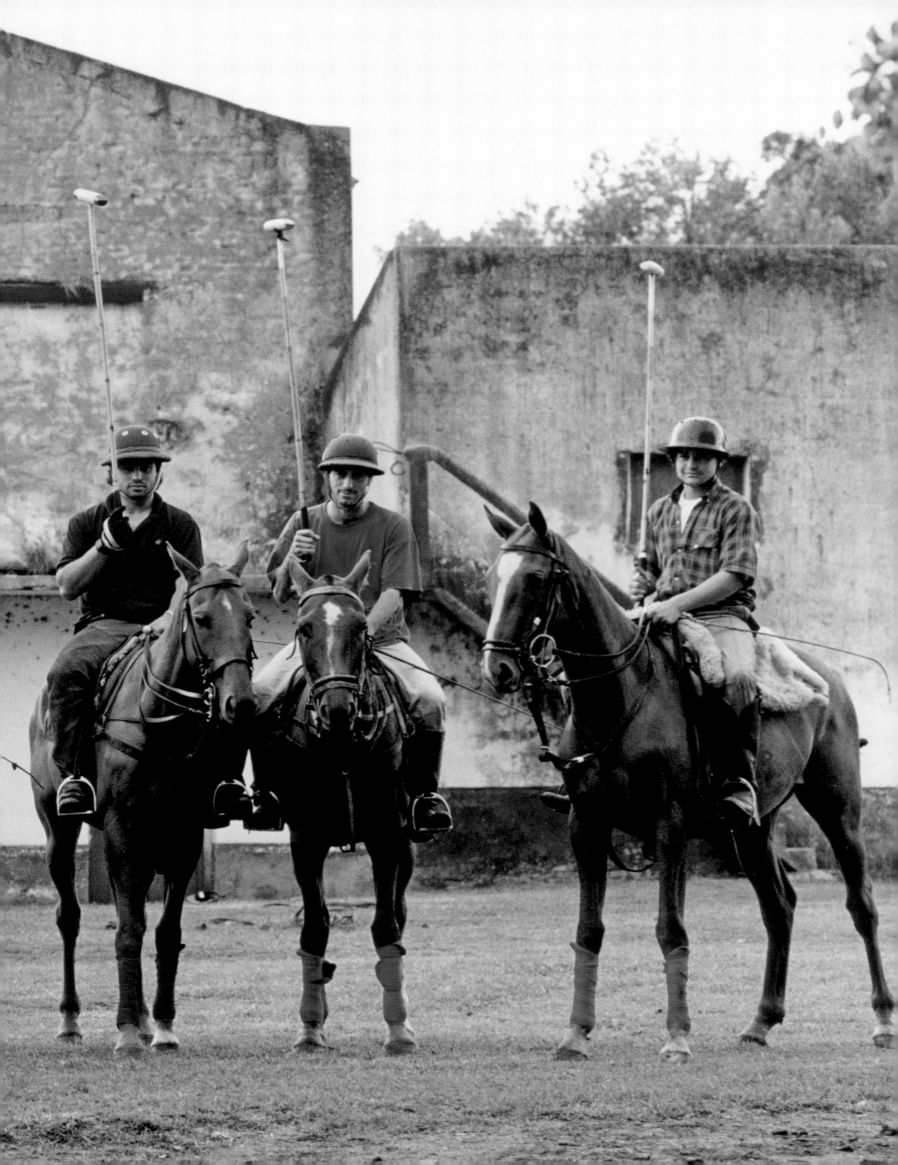

Polo staff: The polo team of Dieter Meier resembles a small enterprise. More than a dozen gauchos take care of the horses. The Swiss native established in 1979 the band *Yello*, one of the pioneers of electronic pop music. He lives in Los Angeles, near Buenos Aires and in Zurich, where he trades with organic wine from his Argentinean farm.

Polo-Stab: Das Polo-Team von Dieter Meier gleicht einem kleinen Unternehmen. Mehr als ein Dutzend Gauchos kümmern sich um die Pferde. Der Schweizer gründete 1979 die Musik-Gruppe *Yello*, die zu den Pionieren der elektronischen Popmusik gehört. Er lebt in Los Angeles, bei Buenos Aires und in Zürich, wo er mit Biowein von seiner argentinischen Farm handelt.

Le personnel : l'équipe de polo de Dieter Meier ressemble à une petite entreprise. Plus d'une douzaine de gauchos s'occupent des chevaux. Le Suisse a fondé en 1979 le groupe de musiciens *Yello* qui fait partie des pionniers de la pop musique électronique. Il vit à Los Angeles, près de Buenos Aires et à Zürich où il commercialise le vin biologique de sa propriété argentine.

El equipo de polo: El equipo de polo de Dieter Meier es como una empresa. Más de una docena de gauchos se ocupan de los caballos. El suizo fundó en 1979 el grupo de música *Yello*, que pertenece a los pioneros de la música por electrónica. Vive en Los Ángeles, en Buenos Aires y en Zurich, donde comercializa con el vino biológico de su granja argentina.

Mazza da polo: la squadra di polo di Dieter Meier è come una piccola impresa. Più di dodici gauchi si prendono cura dei cavalli. Meier, di nazionalità svizzera, ha fondato nel 1979 il gruppo musicale *Yello*, uno dei pionieri della musica pop elettronica. Vive tra Los Angeles, i dintorni di Buenos Aires e Zurigo, dove si occupa del commercio del vino biologico prodotto nella sua fattoria argentina.

Previous Page
Ready for victory:
the polo team of Dieter Meier.

Bereit für den Sieg:
die Polo-Mannschaft von Dieter Meier.

Prête pour la victoire :
l'équipe de polo de Dieter Meier.

Listos para triunfar:
El equipo de polo de Dieter Meier.

Pronti per la vittoria:
la squadra di polo di Dieter Meier.

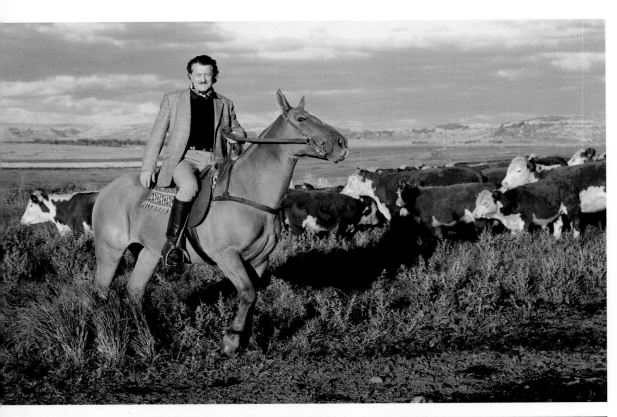

Life after pop music: Dieter Meier during a trail ride near his finca *Ojo de Agua*. This is where he breeds cattle, grows organic wine, and plays polo.

Leben nach der Popmusik: Dieter Meier bei einem Ausritt auf seiner Finca *Ojo de Agua*. Dort züchtet er Rinder, baut Biowein an und spielt Polo.

La vie après la pop musique : Dieter Meier lors d'une promenade à cheval sur sa finca *Ojo de Agua*. Là, il y élève des bovins, cultive un vignoble biologique et joue au polo.

La vida después de la música pop: Dieter Meier en una de sus salidas en su finca *Ojo de Agua*. Aquí cría ganado, elabora vino biológico y juega al polo.

La vita dopo la musica pop: Dieter Meier durante una cavalcata nella sua finca *Ojo de Agua*, dove si dedica all' allevamento dei bovini, alla produzione di vino biologico e al gioco del polo.

Following Page

Winter games: Polo in the snow on the frozen lake in the Swiss St. Moritz.

Winterspiele: Polo im Schnee auf dem zugefrorenen See im schweizerischen St. Moritz.

Jeux d'hiver : le polo dans la neige sur le lac gelé de Saint-Maurice, en Suisse.

Juegos de invierno: Polo en la nieve, sobre un lago helado en St. Moritz.

Giochi invernali: polo nella neve sul lago ghiacciato di St. Moritz, in Svizzera.

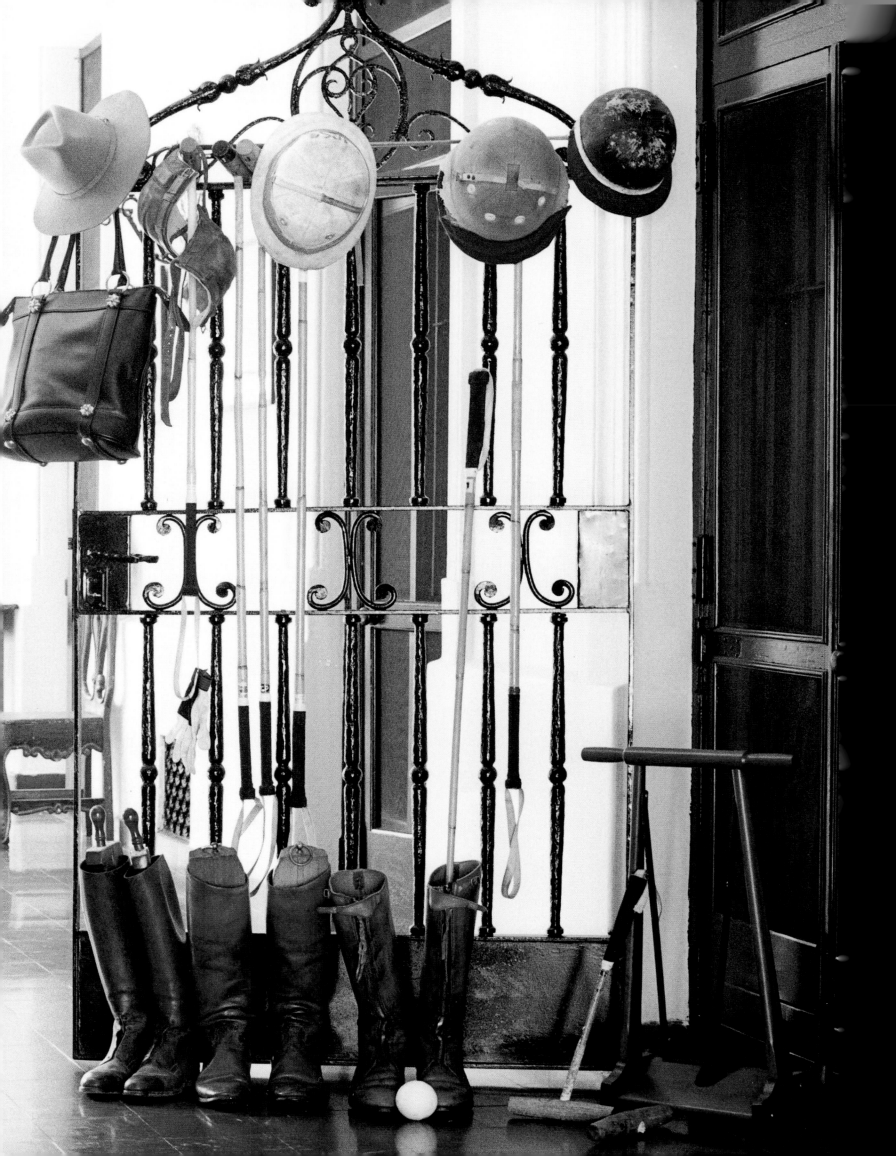

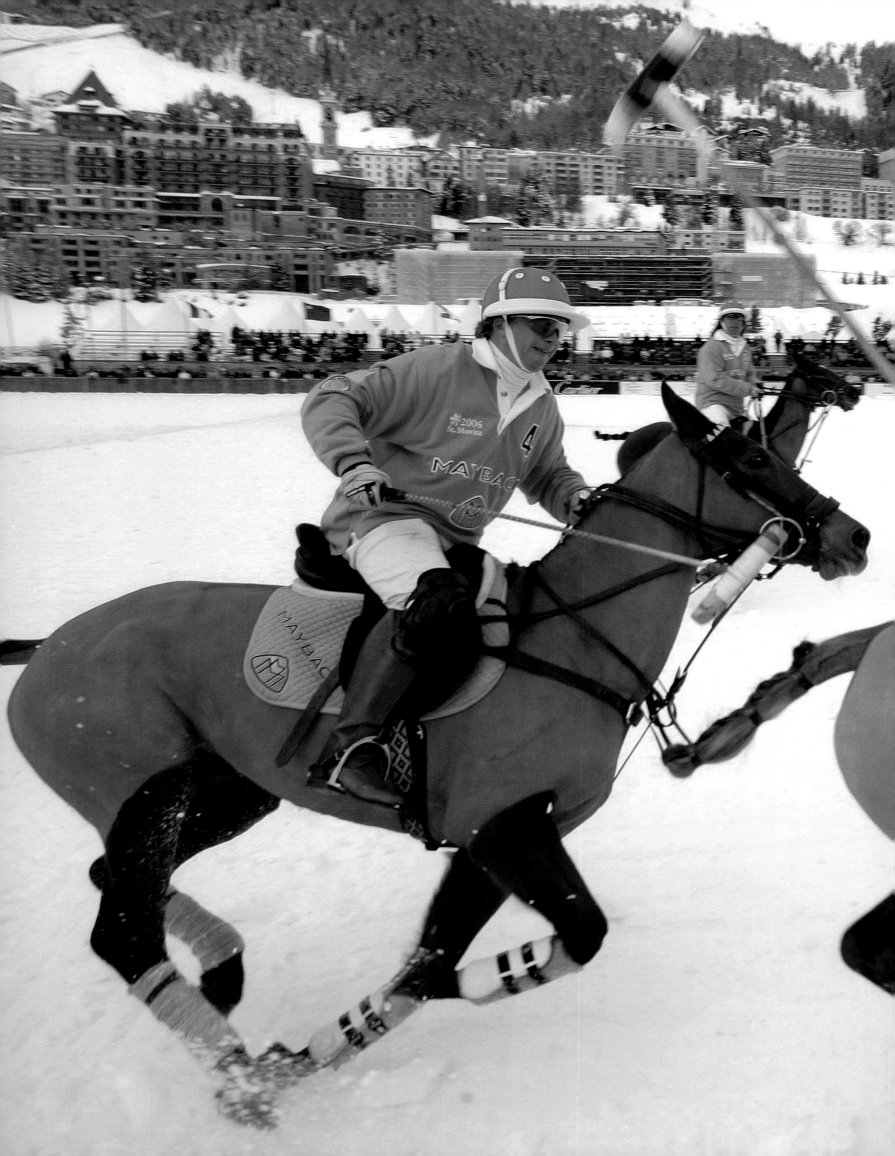

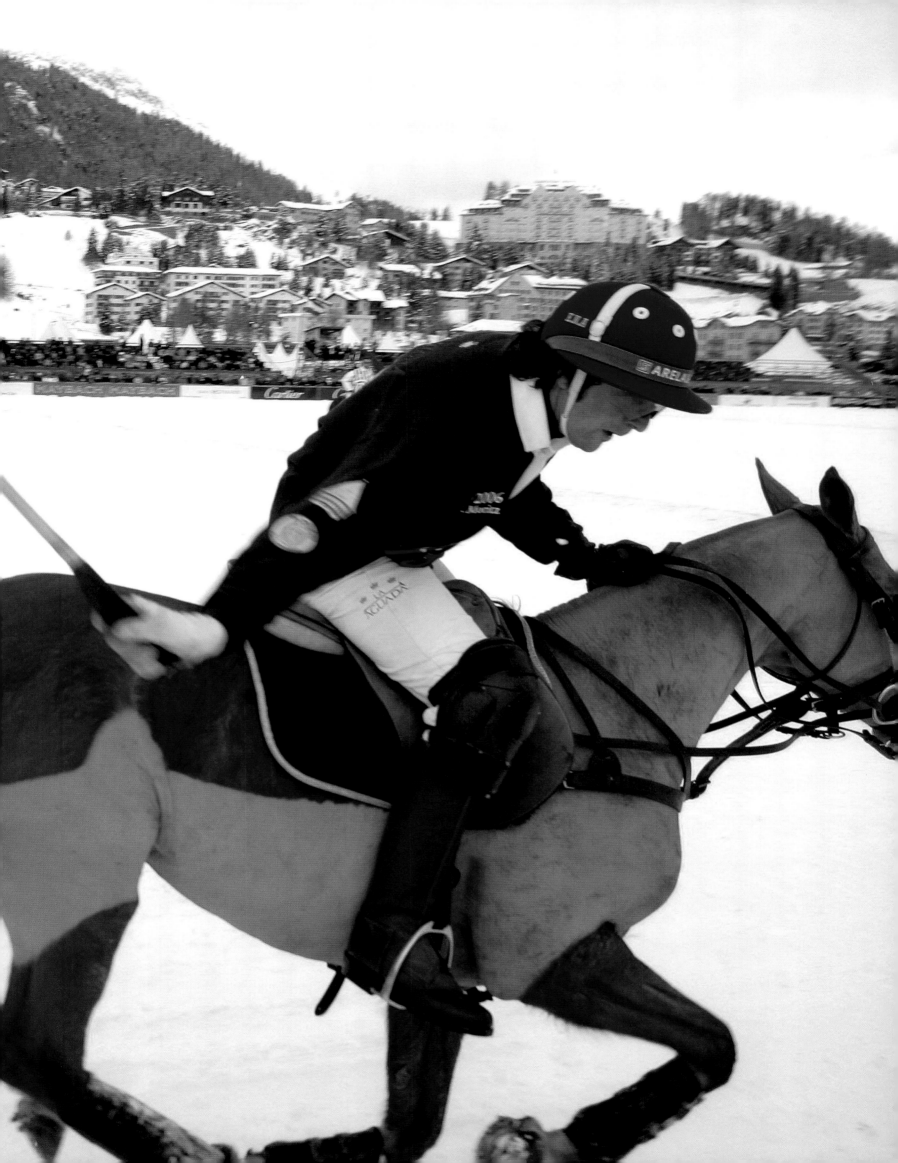

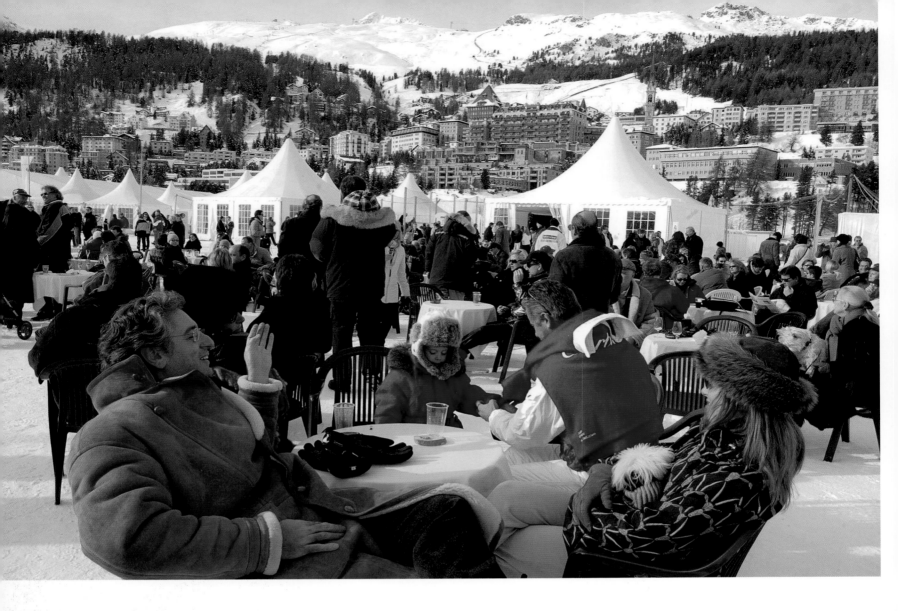

Ice society: Polo in St. Moritz is the social and sportive highlight at the world's most famous winter sport location. The game, played in freezing temperatures, is considered to be especially difficult. Spikes on the hoofs prevent the horses from slipping. The women wear fur coats and to prevent their dogs from feeling cold, they also put them in warming wrappers.

Eis-Society: Polo in St. Moritz ist der gesellschaftliche und sportliche Höhepunkt im bekanntesten Wintersport-ort der Welt. Das Spiel bei eiskalten Temperaturen gilt als besonders schwierig. Spikes an den Hufen verhindern das Rutschen der Pferde. Die Frauen tragen Pelzmäntel und damit es auch ihren Hunden nicht kalt wird, werden die in einen wärmenden Überzug gesteckt.

Société de la glace : le polo à Saint-Maurice est le point d'orgue social et sportif de la station de sports d'hiver la plus connue au monde. Le jeu par des températures glaciales est réputé très difficile. Des crampons sous les sabots empêchent les chevaux de glisser. Les femmes portent des manteaux de fourrure et pour que leurs chiens ne prennent pas froid, ils sont protégés par une housse chaude.

La alta sociedad del hielo: El polo en St. Moritz es uno de los momentos sociales y deportivos más importantes de la localidad más famosa del mundo para el deporte de invierno. El juego a temperaturas heladoras tiene fama de ser especialmente difícil. Las puntas en las herraduras evitan que los caballos se resbalen. Las mujeres llevan abrigos de piel y envuelven a sus mascotas caninas en cálidas fundas para que no pasen frío.

"Ice" society: giocare a polo a St. Moritz è una delle attrazioni sociali e sportive offerte dalla località di sport invernali più famosa del mondo. Giocare a temperature molto basse è considerato particolarmente difficile. Ramponi sui ferri impediscono ai cavalli di scivolare. Le donne indossano pellicce e anche i cani vengono coperti da un caldo cappottino per proteggerli dal freddo.

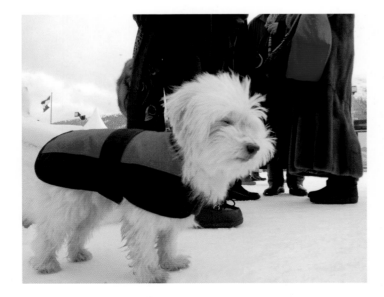

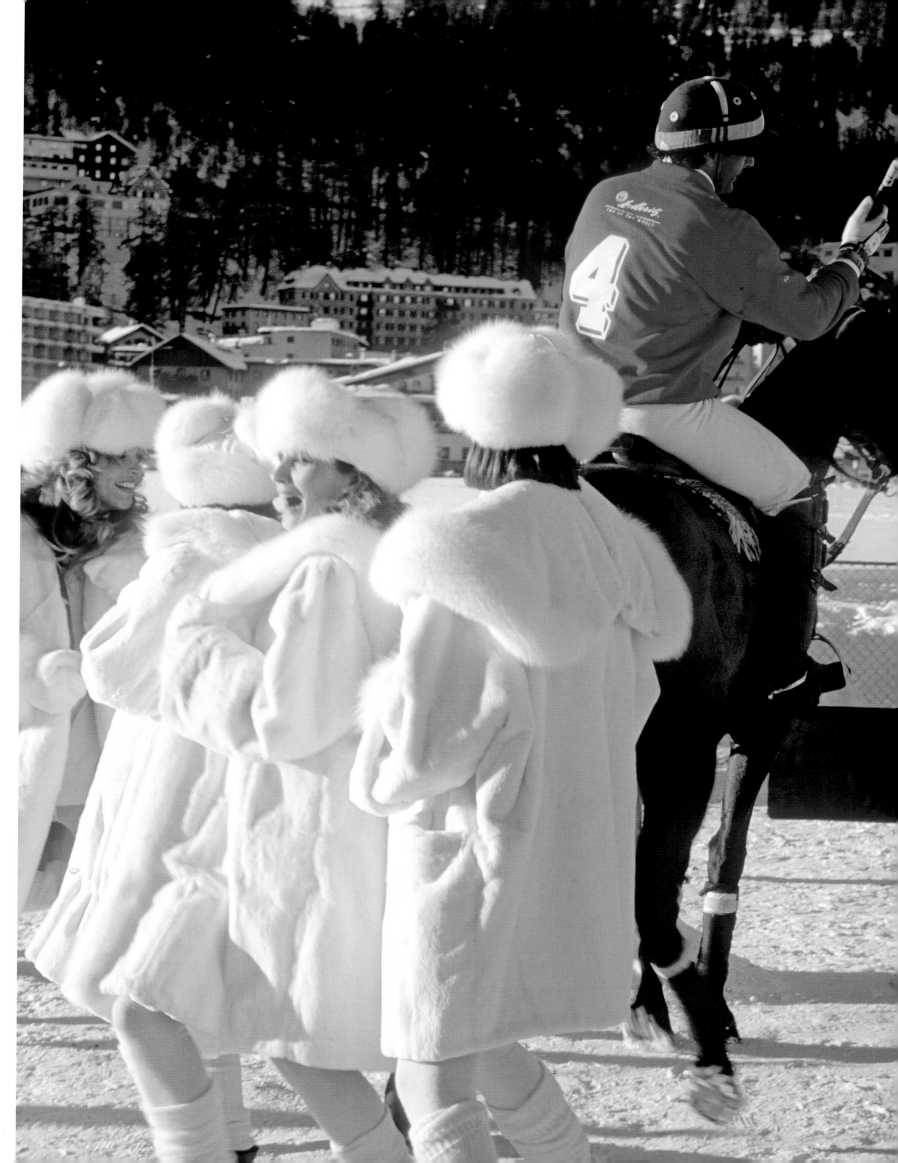

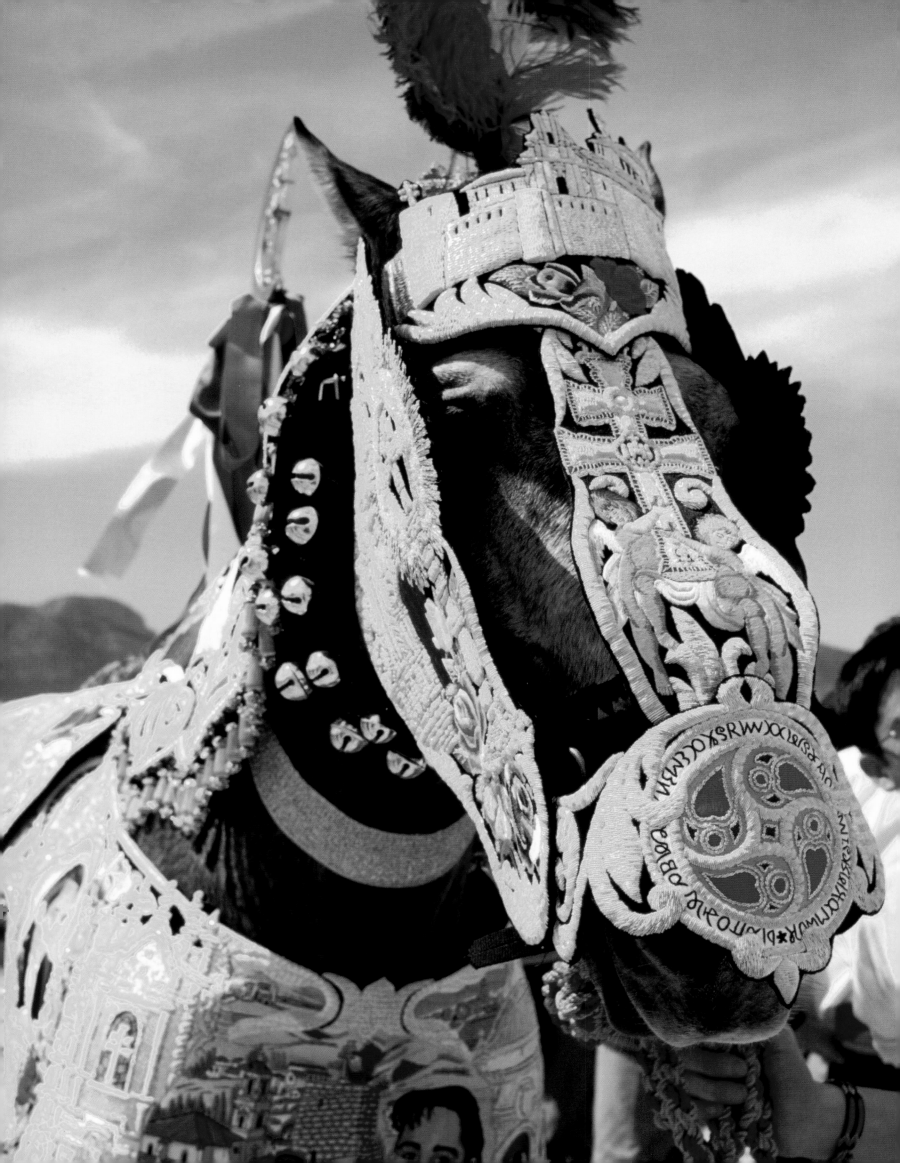

Cult

The largest equestrian festivities, equestrian games, prominent riders and Carthujanos, the horses of monks.

Die größten Pferdefeste, Reiterspiele, prominente Reiter und Cartujanos, die Pferde der Mönche.

Les plus grandes fêtes hippiques, des concours de cavaliers, d'éminents cavaliers et des Cartujanos, les chevaux des moines.

Las mayores fiestas ecuestres, juegos con jinetes, jinetes famosos y Cartujanos, los caballos de los monjes.

Feste famose e giochi che hanno come protagonista il cavallo, cavalieri celebri e i Cartujanos, i cavalli dei monaci.

Piece of Gold: The fiesta *Caballos del Vino* located in Murcia in Spain.

Goldstück: Fiesta *Caballos del Vino* im spanischen Murcia.

Trésor : la fête *Caballos del Vino* à Murcie en Espagne.

Obra de oro: Fiesta *Caballos del Vino* en Murcia, España.

Prezioso come l'oro: la festa *Caballos del Vino* a Murcia, in Spagna.

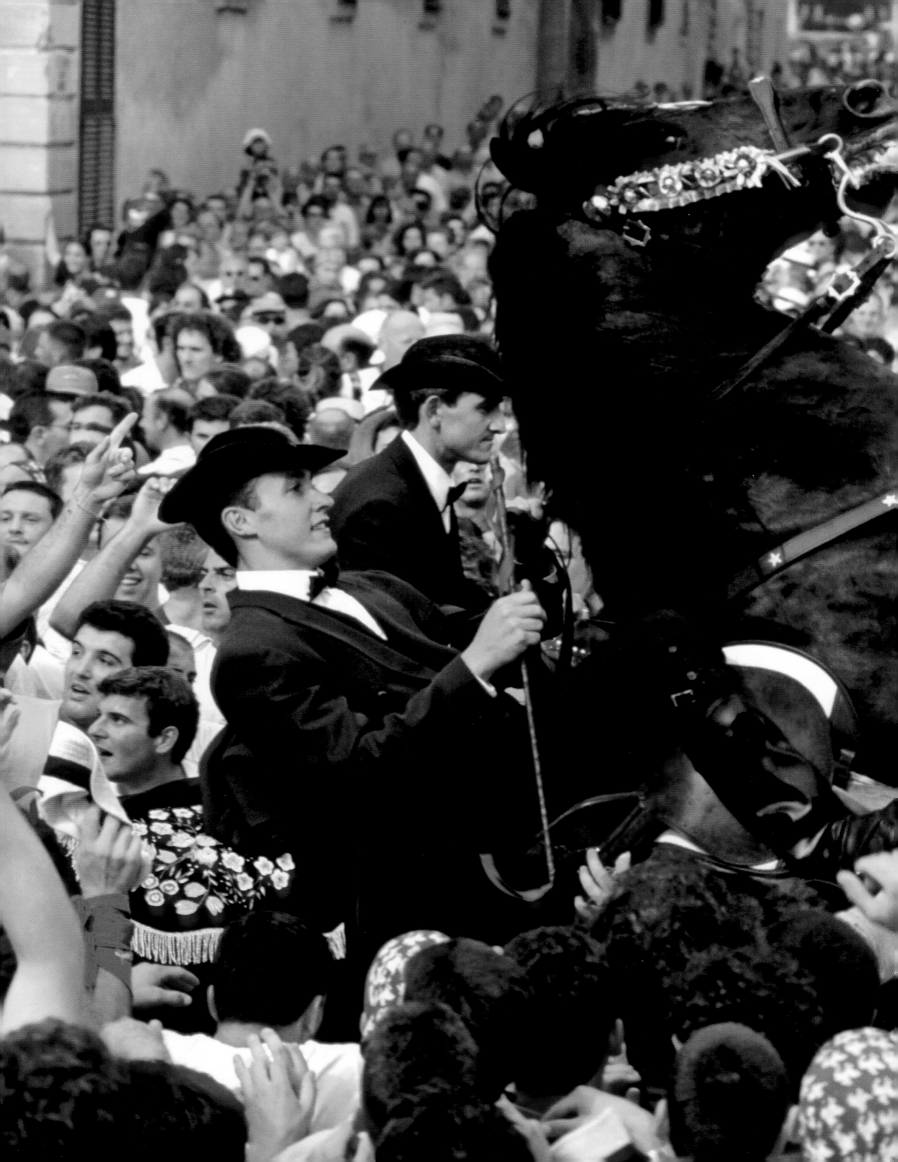

Horses as cult objects: On Menorca, during the Fiesta *Jaleo*, that takes place every year in June, the stallions are frenetically cheered. During the Fiesta *Caballos de Vino*, richly decorated horses are paraded through town every year in May.

Pferde als Kult: Auf Menorca bei der Fiesta *Jaleo*, die jedes Jahr im Juni stattfindet, werden die Hengste frenetisch bejubelt. Bei der Fiesta *Caballos de Vino* werden jedes Jahr im Mai reich geschmückte Pferde durch den Ort geführt.

Culte des chevaux : à Ménorque, lors de la fête *Jaleo* qui se tient chaque année en juin, les étalons sont frénétiquement acclamés. Pour la fête des *Caballos de Vino*, chaque année en mai, des chevaux richement parés sont promenés à travers la ville.

Los caballos como objeto de culto: En Menorca se celebra todos los años la fiesta *Jaleo* en el mes de junio, donde los caballos son frenéticamente aclamados. En la fiesta *Caballos de Vino*, que tiene lugar anualmente en mayo, los animales son ricamente adornados y paseados por el pueblo.

Il cavallo come culto: a Minorca si svolge ogni anno, nel mese di giugno, l'entusiasmante festa del *Jaleo*, in onore degli stalloni. Alla festa *Caballos de Vino*, che ha luogo ogni anno in maggio, cavalli riccamente bardati sfilano attraverso il paese.

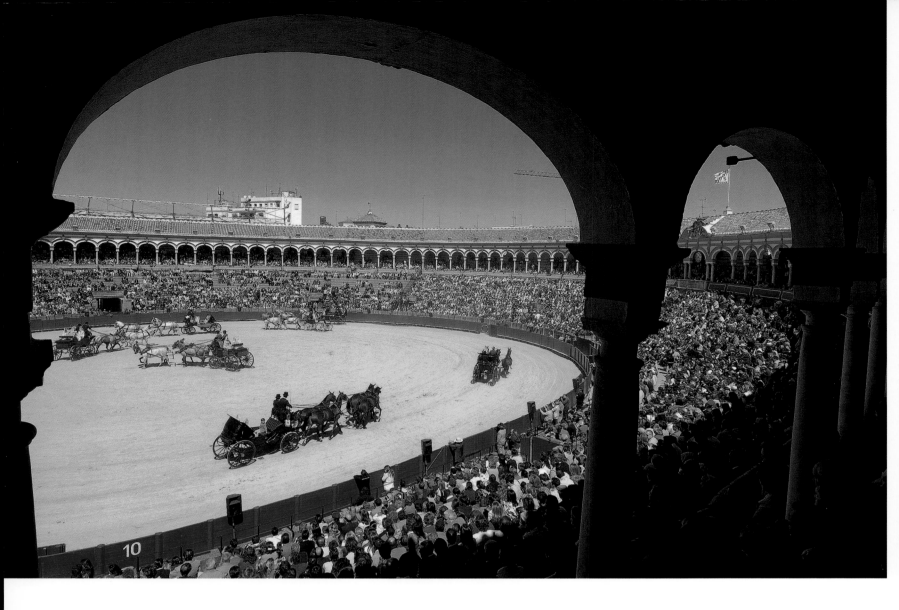

Feria, Andalusia: One week after Easter, the greatest fiesta in Spain commences in Seville. The gathering of up to 3,000 horses and 700 carriages daily is an impressive sight—the gentlemen wear torero hats, red sashes and leather gaucho trousers over their boots, while the women wear flamenco dresses. The highlight is a carriage race in the bullfight arena *La Real Maestranza*.

Feria, Andalusien: Eine Woche nach Ostern beginnt in Sevilla das größte Fest Spaniens. Der Aufmarsch der bis zu 3000 Pferde und 700 Kutschen täglich ist ein prächtiges Bild: Die Herren tragen Torerohut, rote Schärpe und lederne Gaucho-Hosen über den Stiefeln – die Frauen Flamenco-Kleider. Höhepunkt ist ein Kutschenrennen in der Stierkampfarena *La Real Maestranza*.

Feria en Andalousie : une semaine après Pâques commence à Séville la plus grande fête d'Espagne. Le rassemblement quotidien de quelque 3000 chevaux et 700 calèches est un spectacle somptueux : les hommes portent un chapeau de torero, une écharpe rouge et des pantalons de gaucho en cuir par-dessus leurs bottes – les femmes, des robes de flamenco. Le point d'orgue est une course de calèches dans l'arène de corrida *La Real Maestranza*.

Feria, Andalucía: Una semana después de Pascua comienza en Sevilla la mayor fiesta de España. La concentración diaria de hasta 3.000 caballos y 700 carrozas es una imagen impresionante: los hombres llevan un sombrero de torero, fajín rojo y caballos de gaucho de cuero sobre las botas, mientras que las mujeres se visten con típicos vestidos de flamenco. El momento más importante es la carrera de carrozas en la plaza de *La Real Maestranza*.

Feria, Andalusia: una settimana dopo Pasqua inizia a Siviglia la festa più grande di tutta la Spagna. Fino a 3000 cavalli e 700 carrozze sfilano ogni giorno per la gioia degli occhi. Gli uomini portano copricapo da torero, mulete rosse, pantaloni di pelle alla gaucha e stivali, le donne indossano abiti da flamenco. Il clou della festa è la corsa dei carri nell'arena *La Real Maestranza*, dove si disputano le corride.

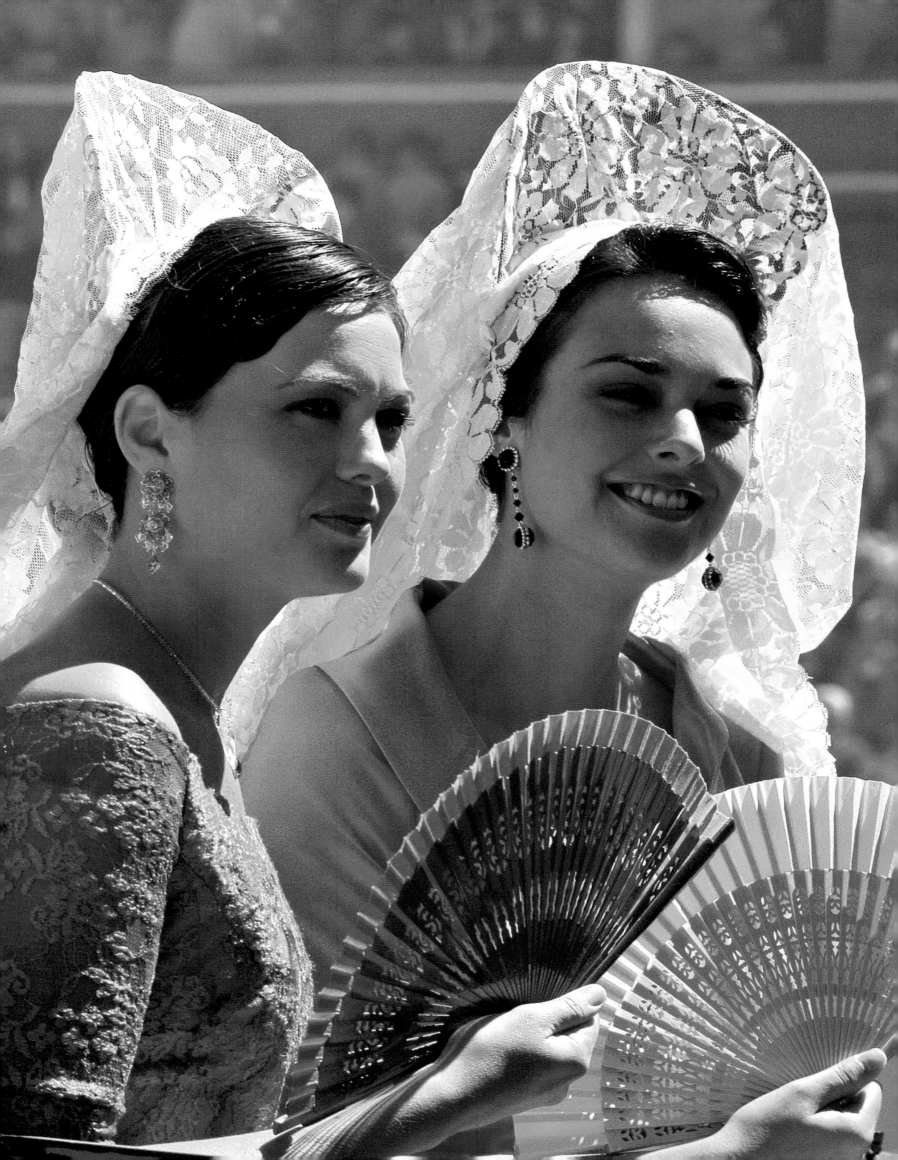

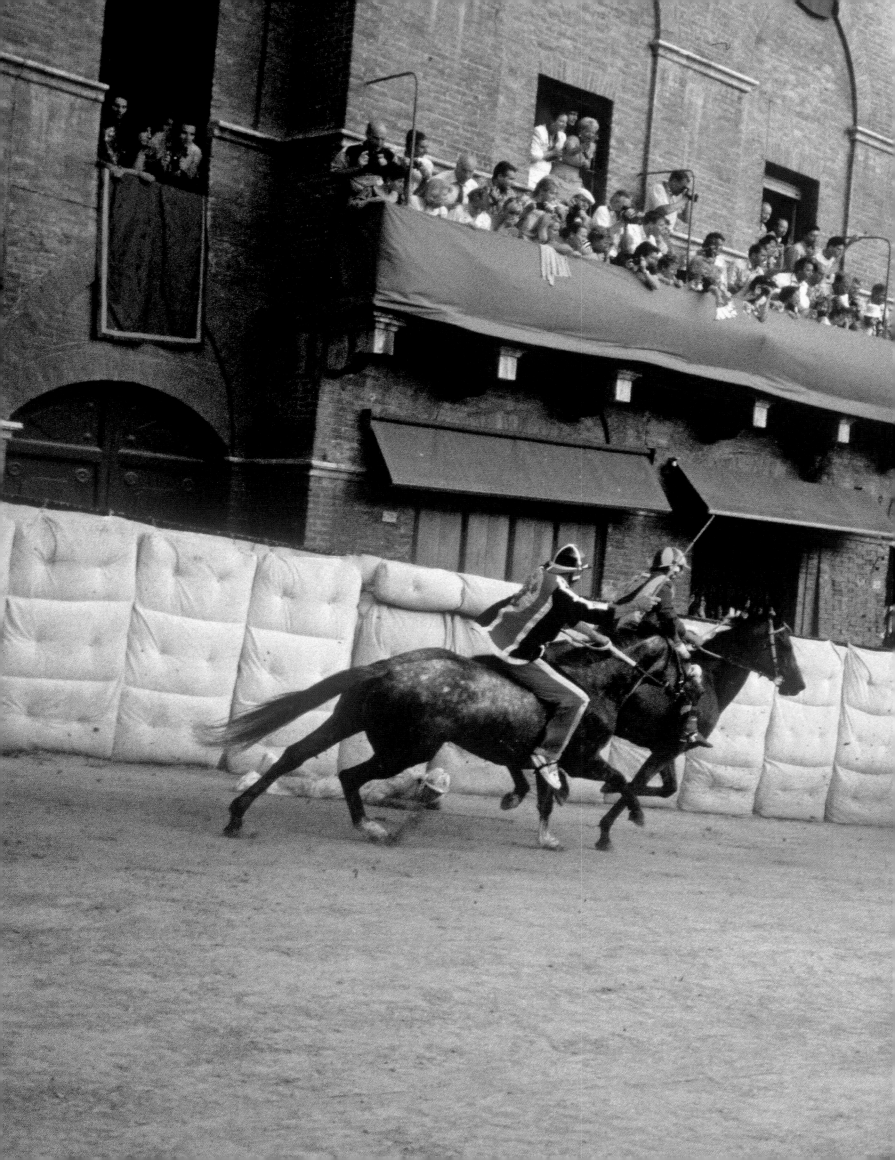

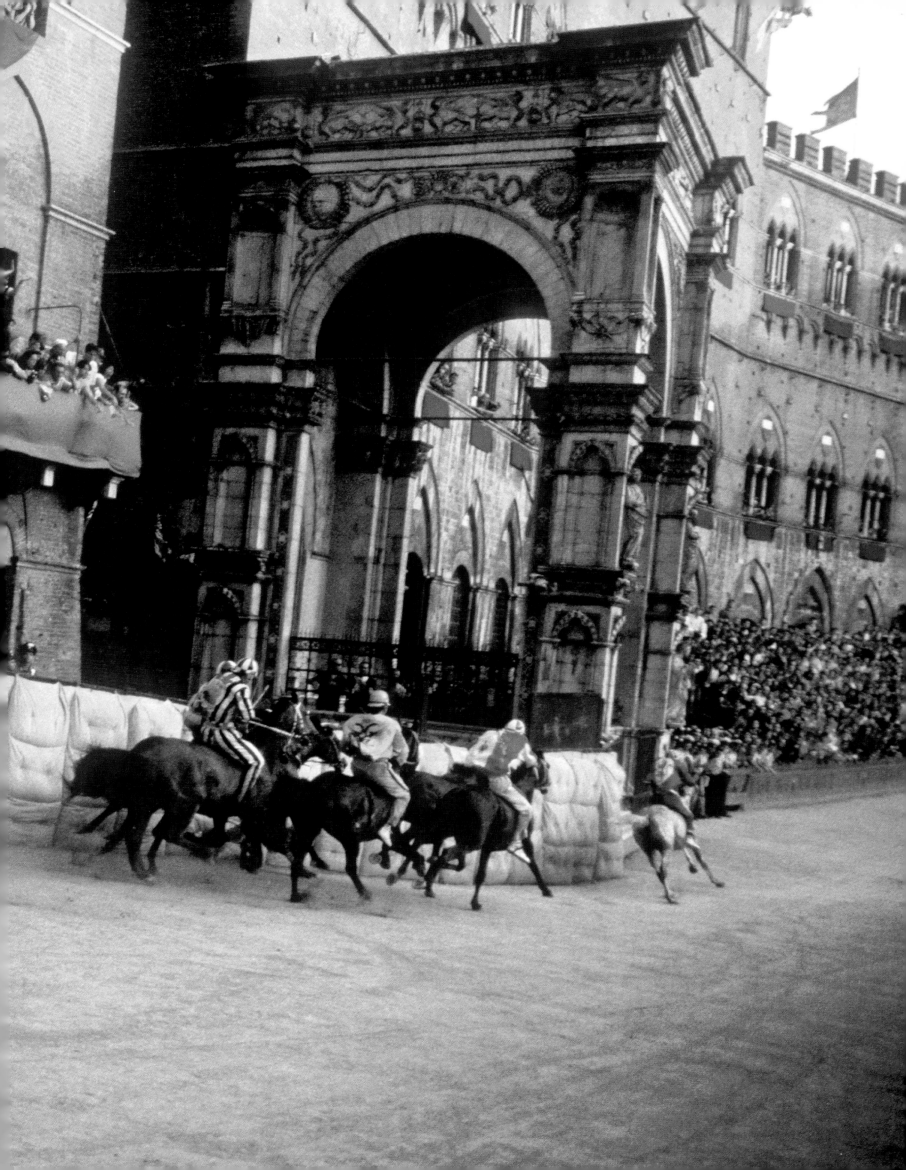

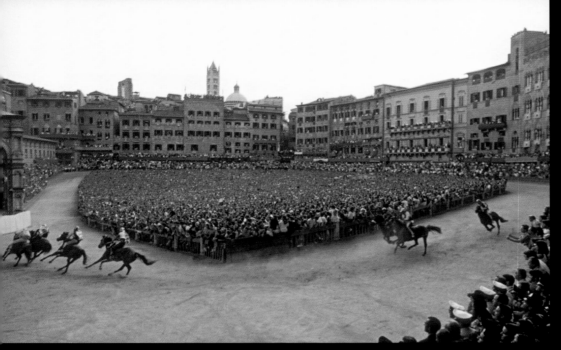

High speed

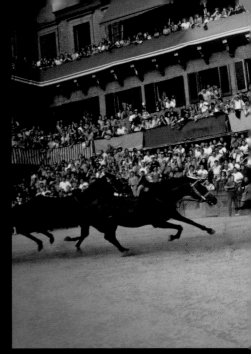

Fight

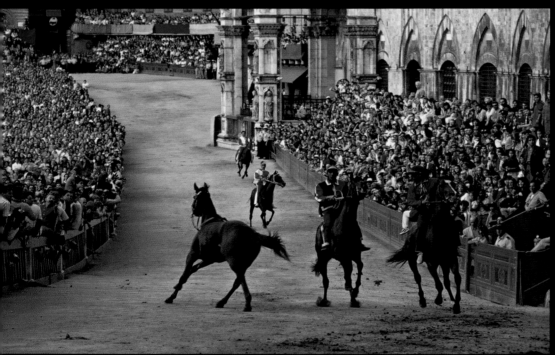

Horse without a rider

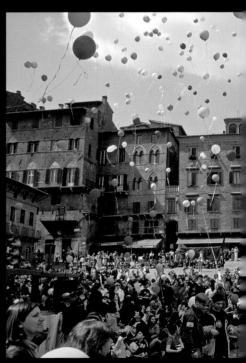

Cheering audience

Previous Page

Siena: The *Piazza del Campo*, the town square of Siena, is turned into a medieval setting.

Siena: Die *Piazza del Campo*, der Rathausplatz in Siena, verwandelt sich in eine mittelalterliche Kulisse.

Sienne : La *Piazza del Campo*, la place de l'hôtel de ville à Sienne, devient un décor médiéval.

Siena: La *Piazza del Campo*, la plaza del ayuntamiento en Siena, transformada en un escenario medieval.

Siena: *Piazza del Campo*, la piazza del municipio di Siena, si trasforma in uno scenario medievale.

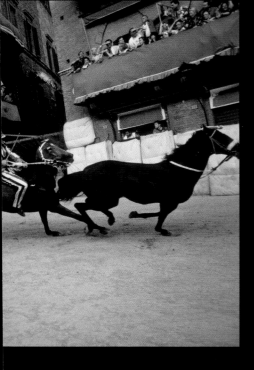

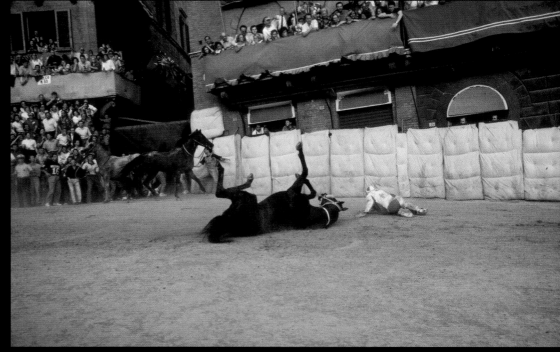

Dangerous game

The winner

Palio: The Palio takes place in the heart of Siena, at the *Piazza del Campo*. In the race in honor of the Virgin Mary today's 17 *Contrade*, city wards of Siena, compete against each other. The tournament has been taking place since the Middle Ages.

Palio: Die Palio wird mitten in Siena ausgetragen, auf der *Piazza del Campo*. Im Rennen zu Ehren der Jungfrau Maria treten die heutigen 17 *Coñtraden*, die Stadtteile Sienas, gegeneinander an. Das Turnier wird seit dem Mittelalter veranstaltet.

Palio : la Palio a lieu au cœur de Sienne sur la *Piazza del Campo*. Dans cette course en honneur de la Vierge Marie, s'affrontent les 17 *contrade* actuels, les arrondissements de Sienne. Le tournoi est organisé depuis le Moyen Âge.

Palio: La Palio se celebra en el centro de Siena, en la *Piazza del Campo*. En la carrera en honor de la Virgen María, compiten los 17 *contrade*, los barrios de Siena. El torneo tiene lugar desde la Edad Media.

Palio: Piazza il Palio si svolge nel cuore di Siena, in *Piazza del Campo*. Alla corsa, organizzata in onore della Vergine Maria, partecipano, le une contro le altre, le attuali 17 *Contrade*, i quartieri di Siena. Il torneo ha luogo sin dall'epoca medievale.

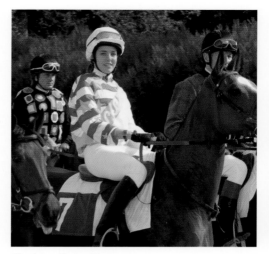

Charlotte Casiraghi

Ronald Reagan

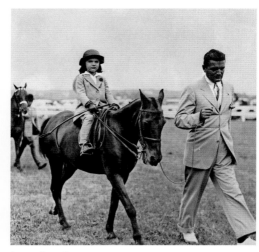

Jacqueline Onassis

H. M. Warner

HRH Princess Haya Bint Al Hussein

Rock Hudson

Ilia Kuligin

Athina Onassis

Christie Brinkley

Great names: Celebrities have always been attracted to horses. For most of them, the animals are a pleasant pastime. A few of them are also breeders and sportsmen.

Große Namen: Seit jeher fühlen sich Prominente von Pferden angezogen. Für die meisten sind die Tiere ein schöner Zeitvertreib. Einige wenige sind Züchter und Sportler.

De grands noms : de tout temps, les célébrités se sont senties attirées par les chevaux. Pour la plupart, ces créatures sont un beau passe-temps. Seules quelques célébrités sont éleveurs et sportifs.

Grandes nombres: Los famosos se sienten atraídos desde siempre por los caballos. Para la mayoría son animales un bonito pasatiempo. Algunos son criadores y deportistas.

Grandi nomi: le celebrità sono state da sempre attirate dai cavalli, considerati dalla maggior parte un piacevole passatempo. Solo alcuni personaggi famosi si dedicano all'allevamento e all'equitazione.

Roy Rogers, *Trigger*

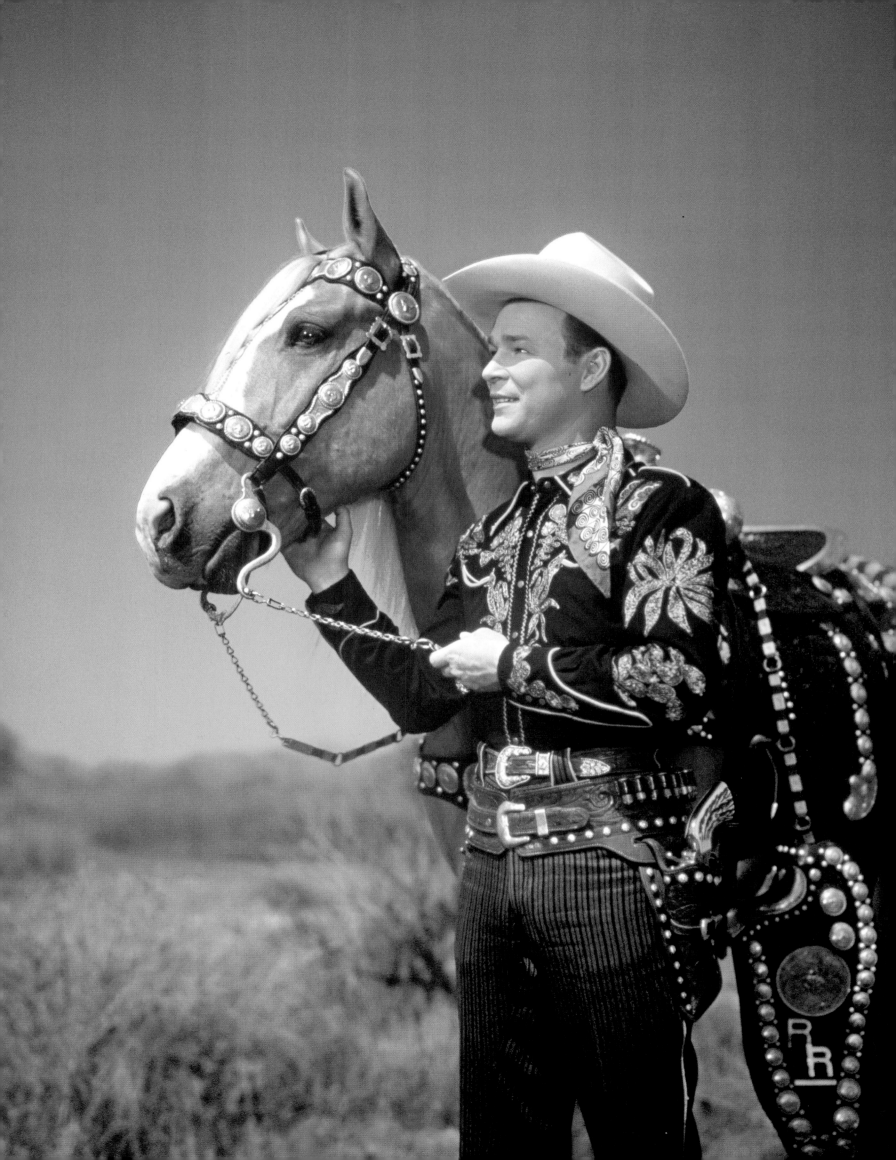

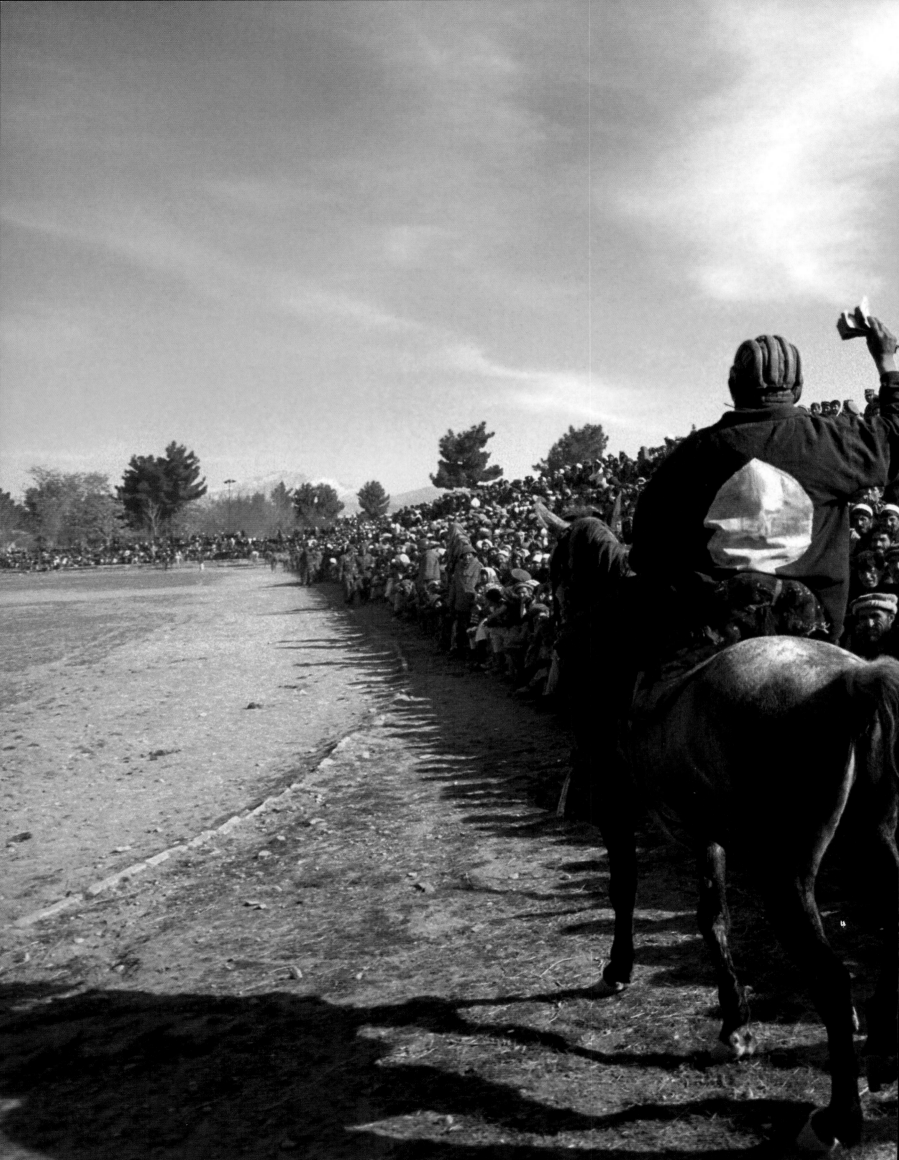

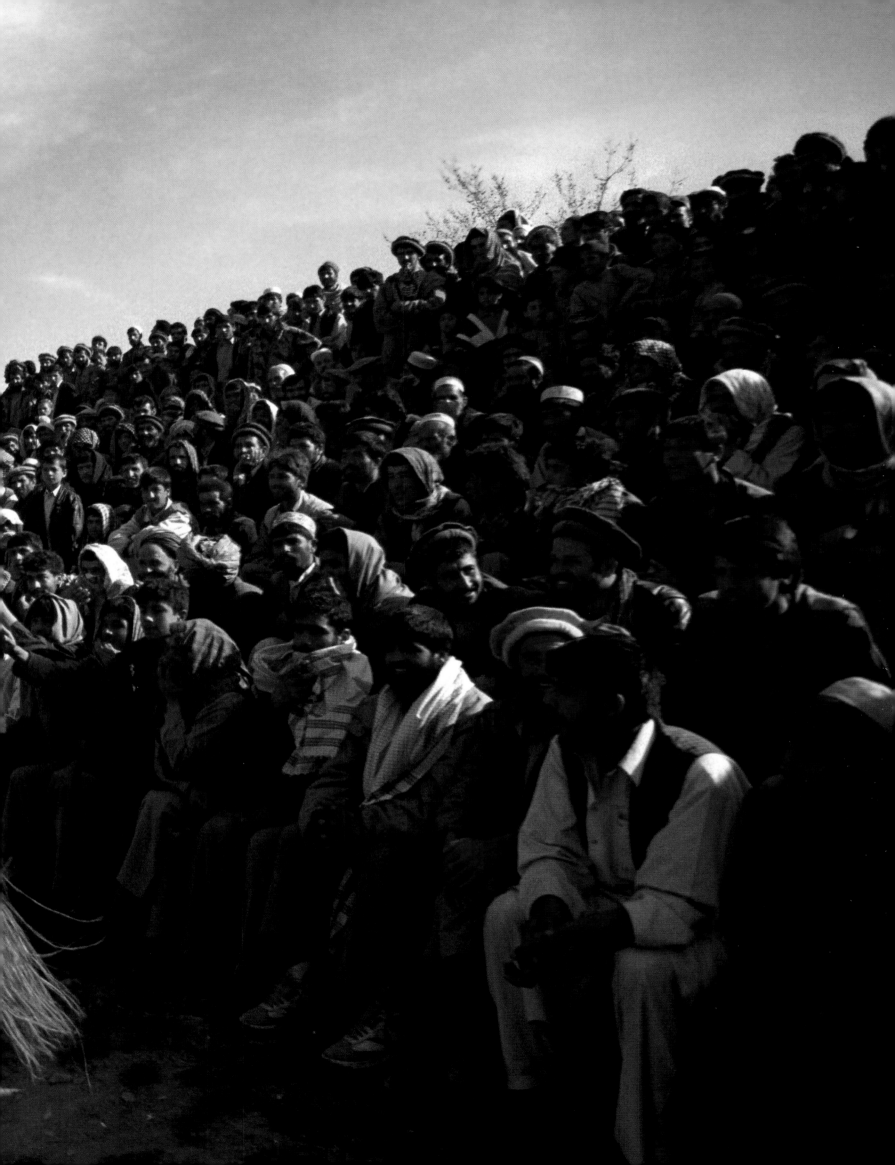

Wild steppe riders: *Buzkashi* is a traditional equestrian game. Literally translated, it means "pull the goat." A total of twenty or more riders participate. At the beginning, a dead goat is placed on the field. The participants have to pick it up while galloping and place it in front of the adjudicator. Everyone plays against everyone else and no holds are barred to get to the goat.

Wilde Steppenreiter: *Buzkashi* ist ein traditionelles Reiterspiel. Wörtlich übersetzt bedeutet es „Ziege zerren". Zwanzig und mehr Reiter nehmen teil. Zu Beginn wird eine tote Ziege auf dem Spielfeld abgelegt. Die Teilnehmer müssen sie im Galopp aufnehmen und vor dem Preisrichter ablegen. Gespielt wird jeder gegen jeden, und erlaubt ist alles, um an die Ziege zu kommen.

Impétueux cavaliers des steppes : le *buzkashi* est un sport équestre traditionnel. Littéralement, il signifie « tirer la chèvre ». Une vingtaine ou plus de cavaliers y prennent part. Au début, une chèvre morte est déposée sur le terrain de jeu. Les participants doivent la saisir au galop et la déposer devant le juge. Chacun joue contre chacun et tout est permis pour parvenir à la chèvre.

Jinetes salvajes de la estepa: El *Buzkashi* es un juego ecuestre tradicional. Literalmente traducido significa "desgarrar la cabra". En él participan veinte jinetes o más. Al comienzo del juego se coloca una cabra muerta en el campo de juego. Los participantes deben cogerla al galope y depositarla delante del jurado. Los jugadores juegan todos contra todos y esta permitido todo lo que sea necesario para coger la cabra.

I selvaggi cavalieri della steppa: il *buzkashi* è un gioco tradizionale a cavallo. Tradotto letteralmente, significa "Afferra la capra". Vi partecipano venti o più cavalieri. All'inizio, la carcassa di una capra viene adagiata sul campo. I partecipanti devono raccoglierla al galoppo e portarla davanti al giudice. Ogni cavaliere gioca contro tutti gli altri. Per impossessarsi della capra, è permesso di tutto.

Previous Page

The archetype of polo: *Buzkashi* in Afghanistan.
Urform des Polos: *Buzkashi* in Afghanistan.
Origine du polo : le *buzkashi* en Afghanistan.
Polo originario: *Buzkashi* en Afganistán.
L'antenato del polo: il gioco del *buzkashi* in Afghanistan.

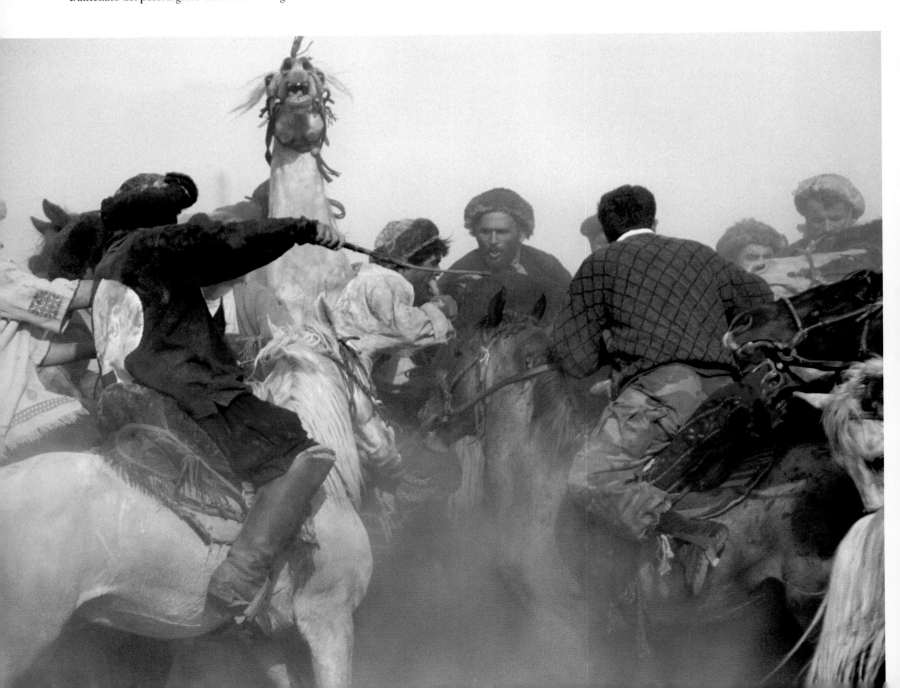

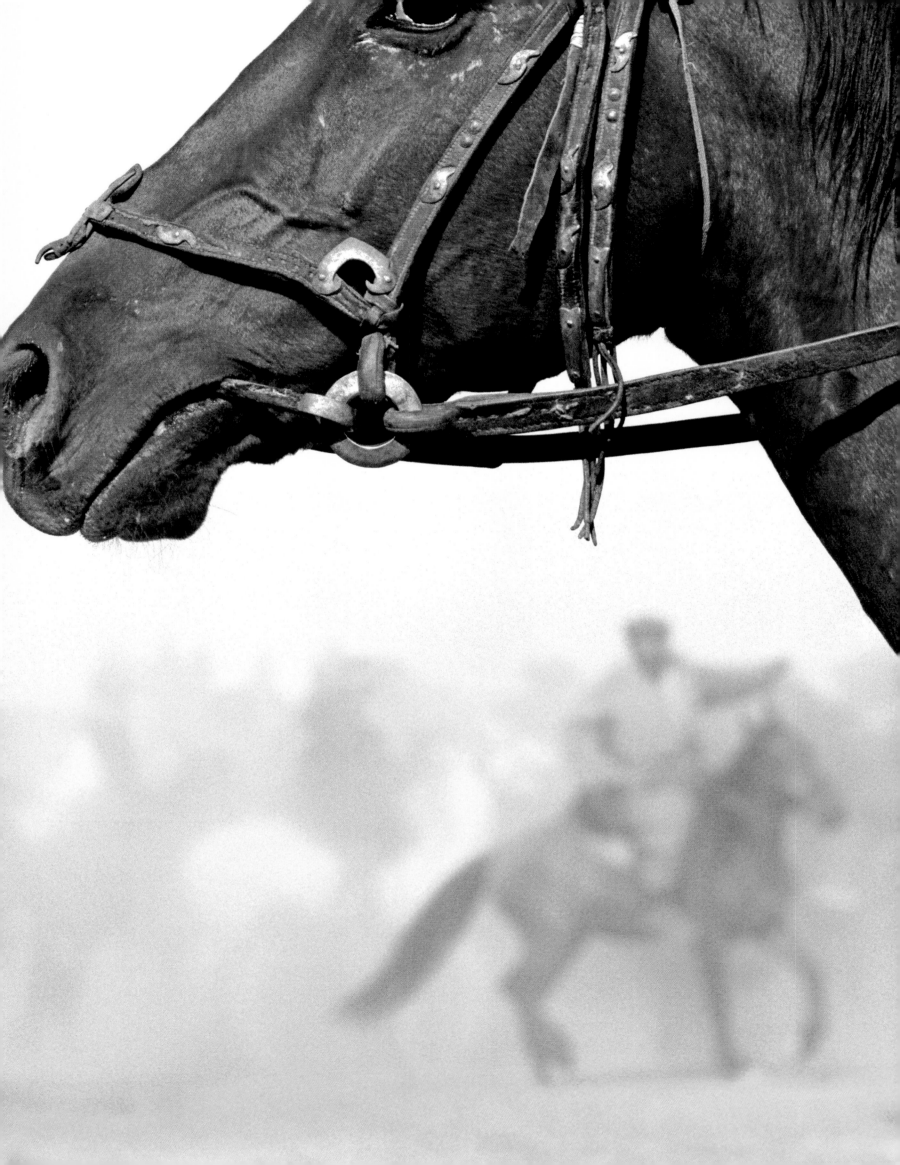

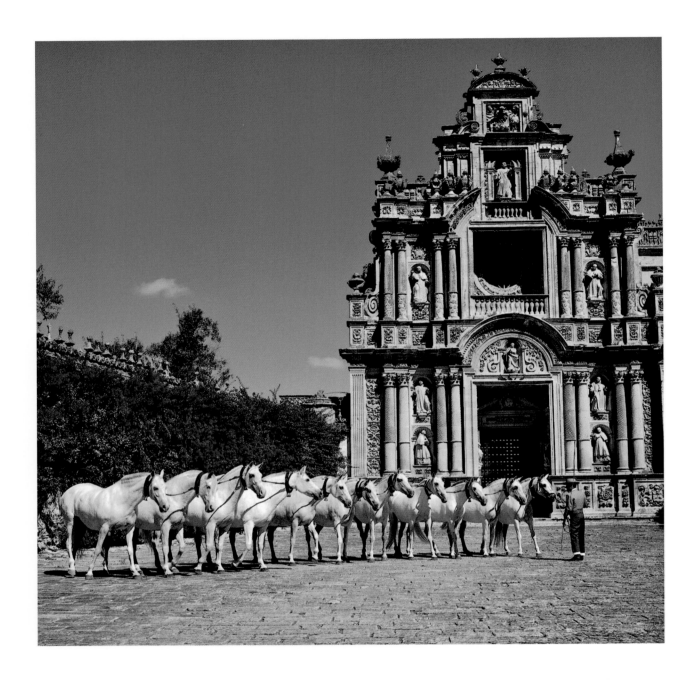

Majestic: Carthujanos are the most beautiful of all beauties. A herd of mares stands in front of the baroque church of the Carthusian order that breeds the noble animals. Horses of this breed stand up tall, have high and wide movements and a character that equally combines strength and tolerance. The animals were sheltered in the vaults of the monastery during the wars of previous centuries.

Majestätisch: Cartujanos sind die Schönsten der Schönen. Eine Stutenherde steht vor der barocken Kirche des Kartäuserordens, der die edlen Tiere züchtet. Es sind Pferde mit hoher Aufrichtung, hohen, weiten Bewegungen und einem Charakter, der Stärke und Duldsamkeit gleichermaßen miteinander vereint. In den Gewölben des Klosters fanden die Tiere Schutz während der Kriege der vergangenen Jahrhunderte.

Majestueux : les Cartujanos sont les plus beaux parmi les plus beaux. Un troupeau de juments se tient devant l'église baroque de l'ordre des Chartreux qui élève ces nobles animaux. Ce sont des chevaux avec un port altier, des mouvements amples et hauts et un caractère alliant puissance et tolérance. Les animaux trouvèrent refuge sous les voûtes du cloître pendant les guerres des siècles passés.

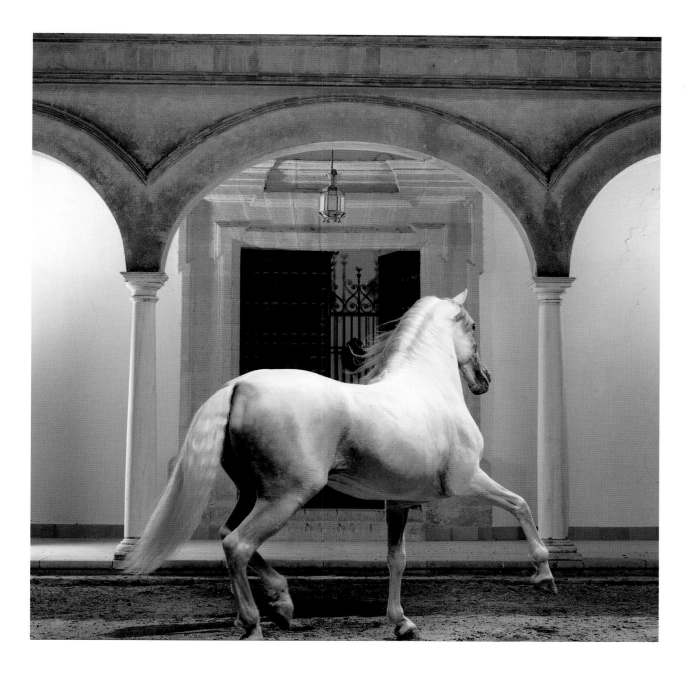

Majestuosos: Los Cartujanos son los más bellos entre los bellos. Una manada de yeguas delante de la iglesia de la orden de los cartujos, que se dedica a la cría de estos nobles animales. Son caballos con un porte elevado, movimientos amplios y altos y un carácter que fusiona la fortaleza con la indulgencia. Bajo las bóvedas del monasterio, los caballos encontraron refugio durante las guerras de los últimos siglos.

Maestoso: i cavalli Cartujanos sono i più belli tra tutti. Un branco di giumente sosta davanti alla chiesa barocca dell'ordine dei Certosini, che allevano questi pregiati animali. Si tratta di cavalli dal portamento regale, dai movimenti maestosi e dal carattere che unisce in ugual misura forza e pazienza. Durante le guerre dei secoli scorsi, i cavalli Cartujanos hanno trovato rifugio sotto le arcate del chiostro.

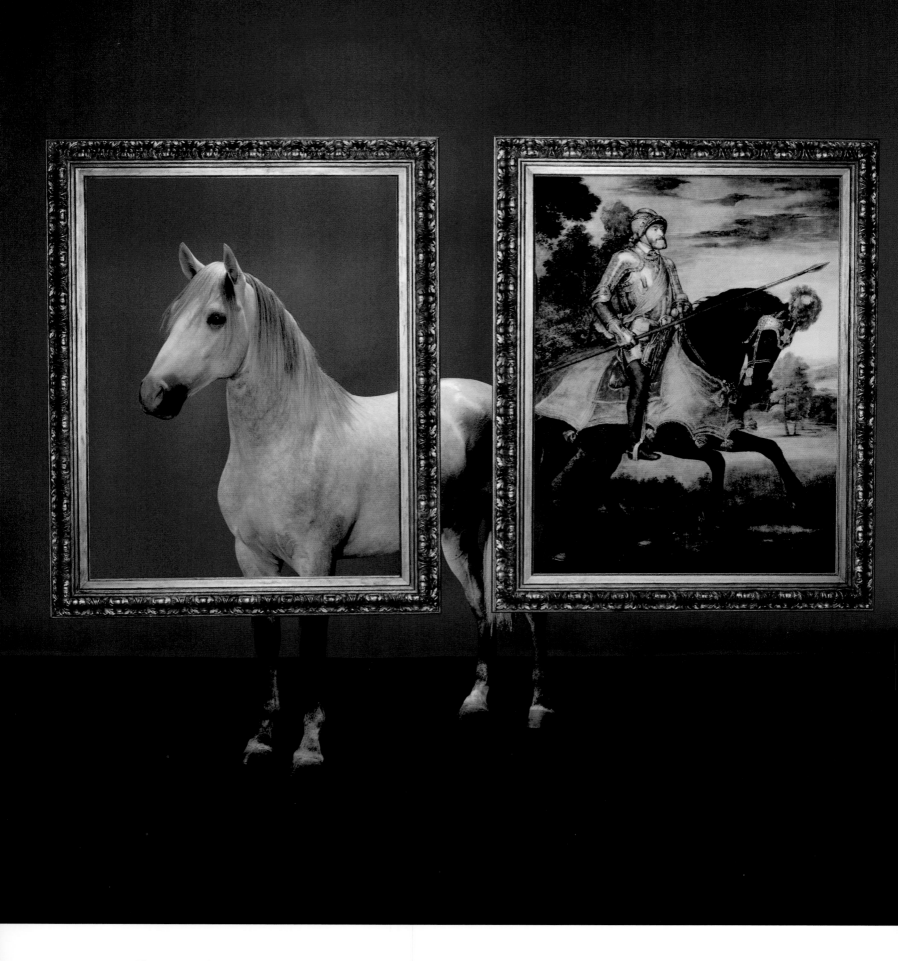

Object of art: The paintings of Renaissance painter Titian are the setting for this set-up work of art.

Kunstobjekt: Die Bilder des Renaissance-Malers Tizian bilden den Rahmen für dieses inszenierte Kunstobjekt.

Objets d'art : les tableaux du peintre de la renaissance Titien offrent un cadre à la mise en scène de cet objet d'art.

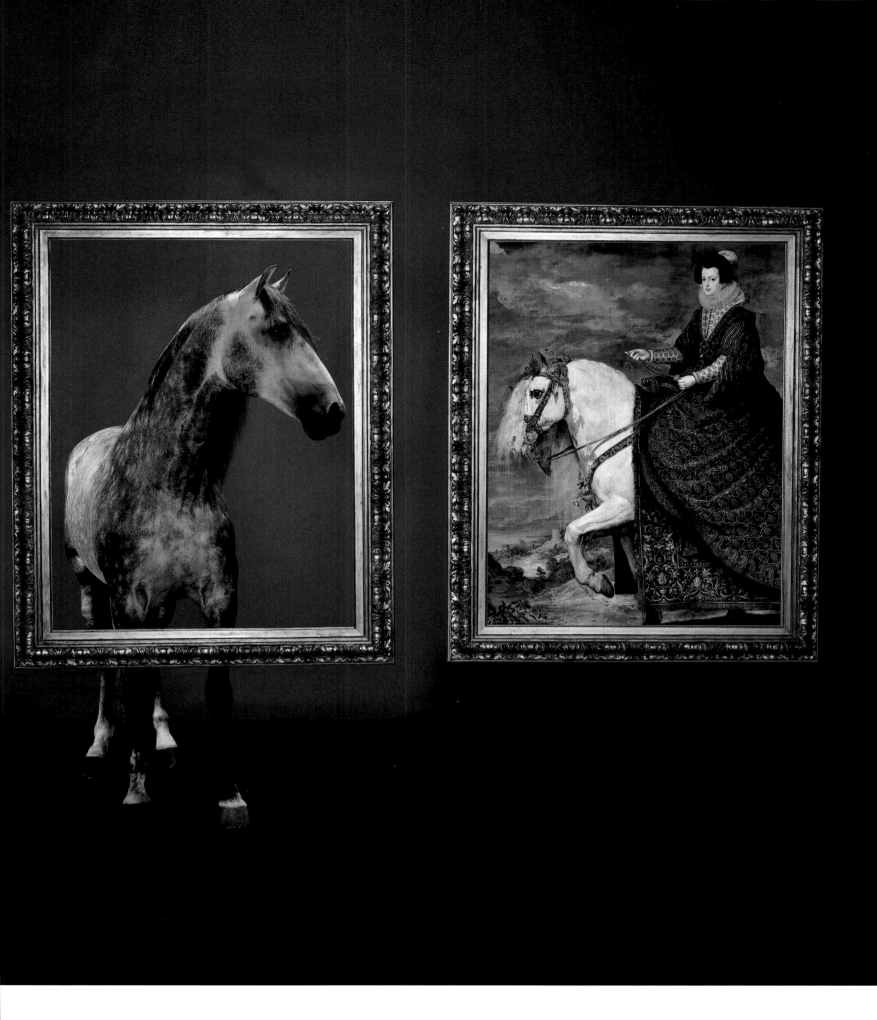

Objeto de arte: Los cuadros del pintor renacentista
Tiziano son el marco para este objeto de arte escenificado.

Opera d'arte: i quadri del pittore rinascimentale Tiziano
fanno da cornice a quest'opera d'arte improvvisata.

Picturesquely beautiful: German painter Franz Marc, co-founder of the artist cooperative *The Blue Rider*, created with his work *The Dream* (1912) the perfect backdrop for this Carthujano.

Malerisch schön: Der deutsche Maler Franz Marc, Mitbegründer der Künstlervereinigung *Der Blaue Reiter*, schuf mit seinem Werk *Der Traum* (1912) eine perfekte Kulisse für diesen Cartujano.

Beauté picturale : le peintre allemand Franz Marc, cofondateur de l'association d'artistes *Le Cavalier Bleu*, a créé, avec son oeuvre *Le rêve* (1912) une coulisse parfaite pour ce cartujano.

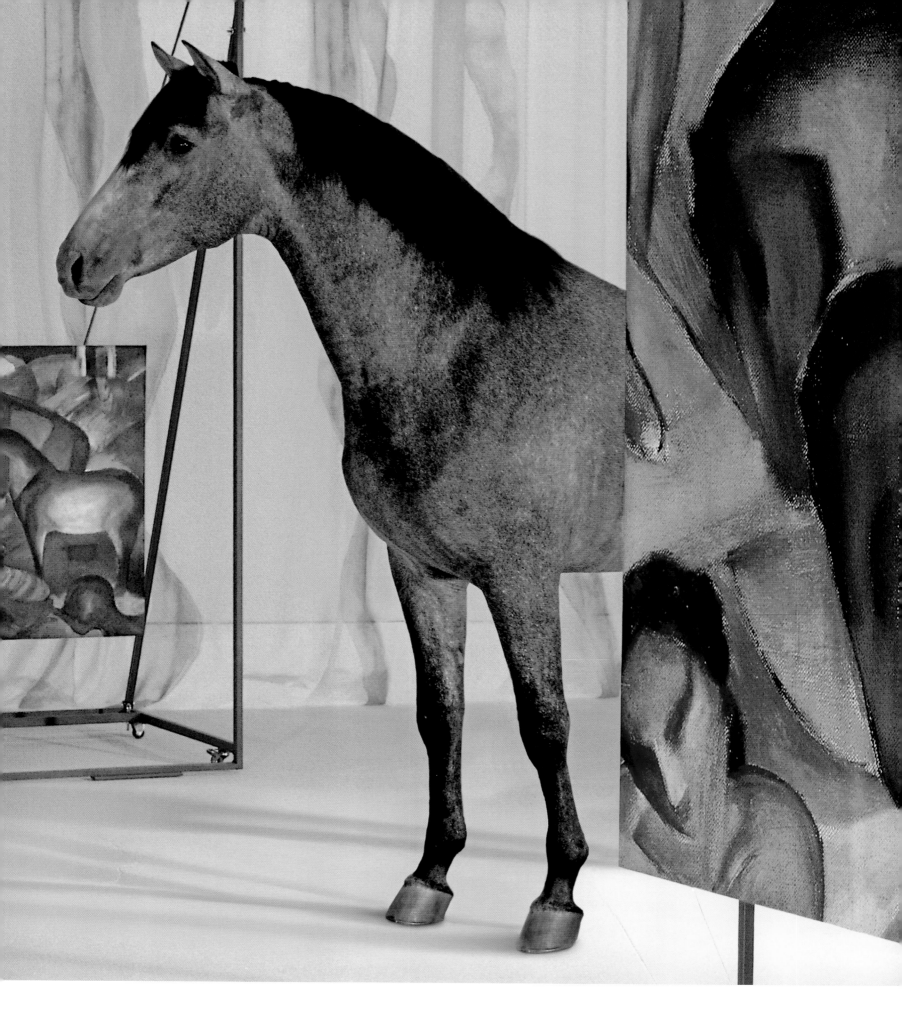

Belleza pictórica: El pintor alemán Franz Marc, cofundador del grupo artístico *El Jinete Azul*, creó con su obra *El sueno* (1912) el escenario perfecto para este Cartujano.

Pittoresco: il pittore tedesco Franz Marc, co-fondatore del circolo artistico *Il cavaliere azzurro*, ha realizzato, nella sua opera *Il sogno* (1912), uno scenario perfetto per questo cavallo Cartujano.

Fashion & Accessories

The famous brands, accessories and clothing for equestrian sports.

Die bekannten Marken, Zubehör und Bekleidung für den Pferdesport.

Les marques connues, les accessoires et l'habillement pour l'équitation.

Las marcas más famosas, los accesorios y la ropa para la hípica.

Celebri marche, accessori e abbigliamento per lo sport equestre.

Interlace: For tournaments in particular, the tail of the horse is artistically braided.

Flechtwerk: Besonders für Turniere wird der Schweif des Pferdes kunstvoll eingeflochten.

Tressage : pour les tournois particulièrement, la queue du cheval est artistiquement tressée.

Trenzado: Especialmente en los torneos se trenza cuidadosamente la cola del caballo.

Una bella treccia: in occasione dei tornei la coda del cavallo viene spesso intrecciata con arte.

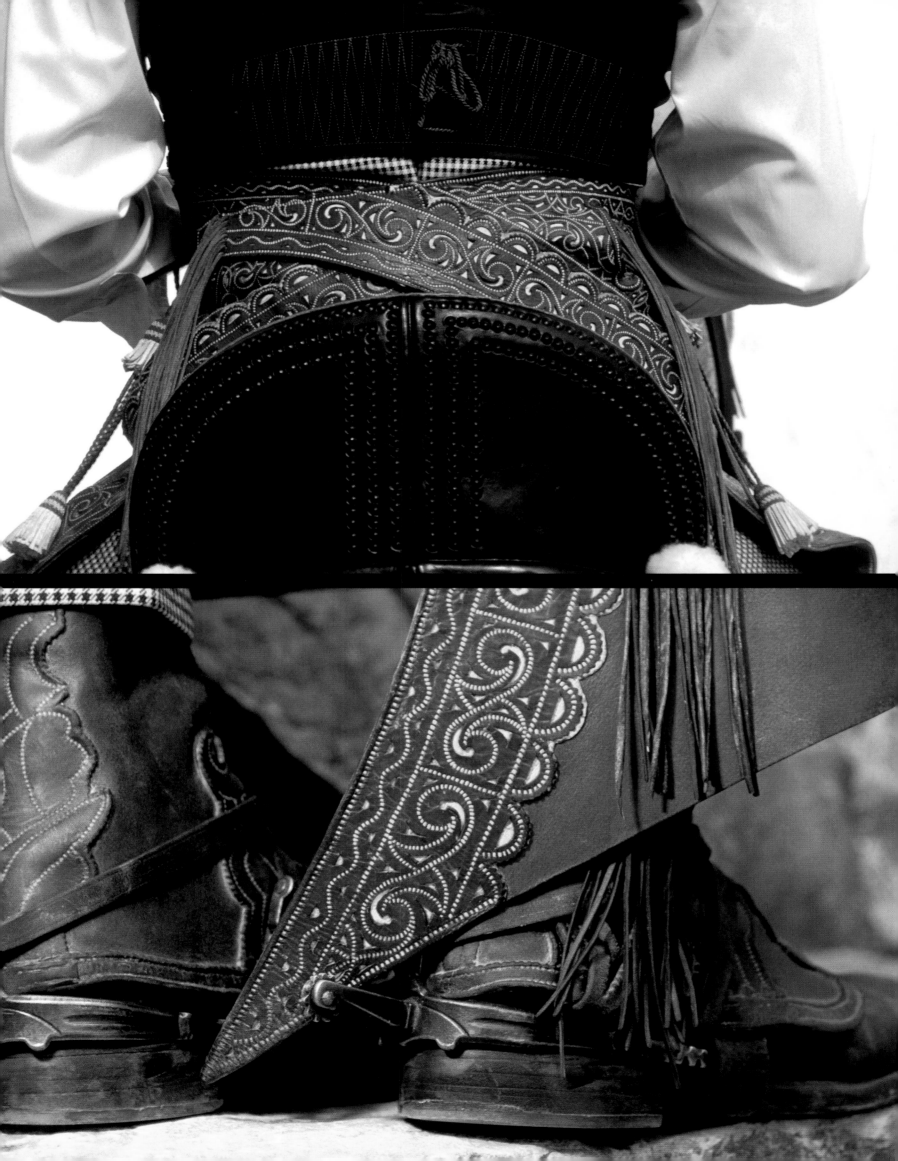

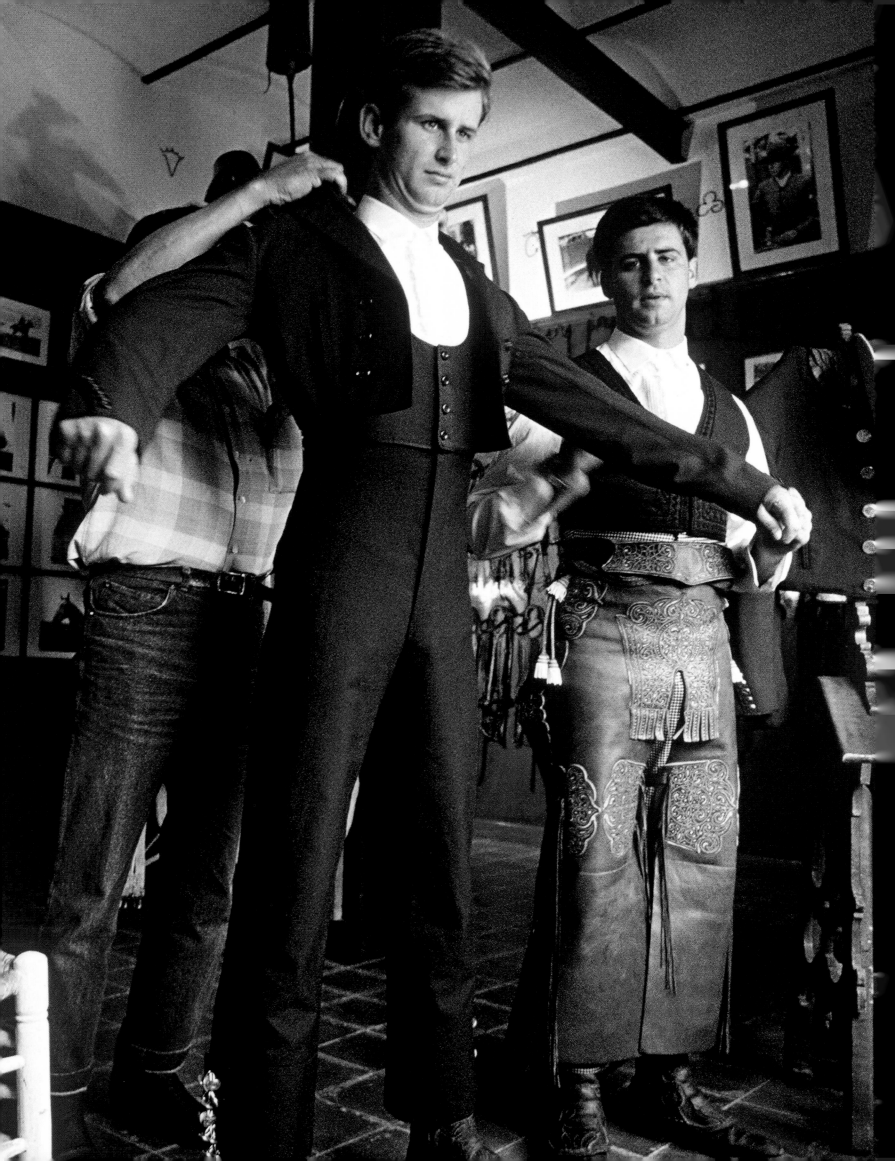

Traditional Andalusian work outfit: The main component of the traditional Andalusian costume is the *Vestido de Corot*, the short jacket of the Andalusian bull herders in combination with the lavishly decorated leather apron that is intended to protect the legs from the thorny undergrowth. The brothers Luis and Antonio Domecq try on their new tailor-made outfits. Handmade fashion is available from *El Caballo*. Gaiters cost between 880 and 1,200 Euro.

Traditionelle andalusische Arbeitskleidung: Hauptbestandteil der andalusischen Tracht sind die *Vestido de Corot*, die kurze Jacke der andalusischen Stiertreiber, und der reich verzierte Lederschurz, der die Beine vor stacheligem Unterholz schützen soll. Die Gebrüder Luis und Antonio Domecq bei der Anprobe ihrer maßgeschneiderten Tracht. Handgefertigte Mode gibt es bei *El Caballo*. Gamaschen kosten zwischen 880 und 1200 Euro.

Vêtement de travail andalou traditionnel : l'élément principal du costume folklorique andalou est le *Vestido de Corot*, la courte veste des rabatteurs de taureaux andalous et le tablier de cuir richement décoré, destiné à protéger les jambes des sous-bois épineux. Les frères Luis et Antonio Domecq pendant l'essayage de leur costume taillé sur mesure. On trouve la mode cousue main chez *El Caballo*. Des jambières coûtent entre 880 et 1200 euros.

Traje tradicional andaluz de trabajo: La pieza principal del traje andaluz es el *vestido de corot*, la chaqueta corta de los encargados de conducir los caballos y la adornada protección de cuero para evitar lesiones en las piernas con la madera afilada. Los hermanos Luis y Antonio Domecq probándose su traje hecho a medida. La ropa hecha a mano puede comprarse en *El Caballo*. Las galochas de cuero cuestan entre 880 y 1.200 euros.

I tradizionali abiti da lavoro andalusi: il costume andaluso è composto essenzialmente dal *Vestido de Corot*, il giacchino corto dei toreri andalusi, e da un grembiule di pelle riccamente ricamato che protegge le gambe dalla vegetazione spinosa del sottobosco. La foto mostra i fratelli Luis e Antonio Domecq mentre provano i loro costumi confezionati su misura. *El Caballo* è specializzato in capi di abbigliamento confezionati a mano. Il prezzo delle gamasce oscilla tra gli 880 e i 1200 euro.

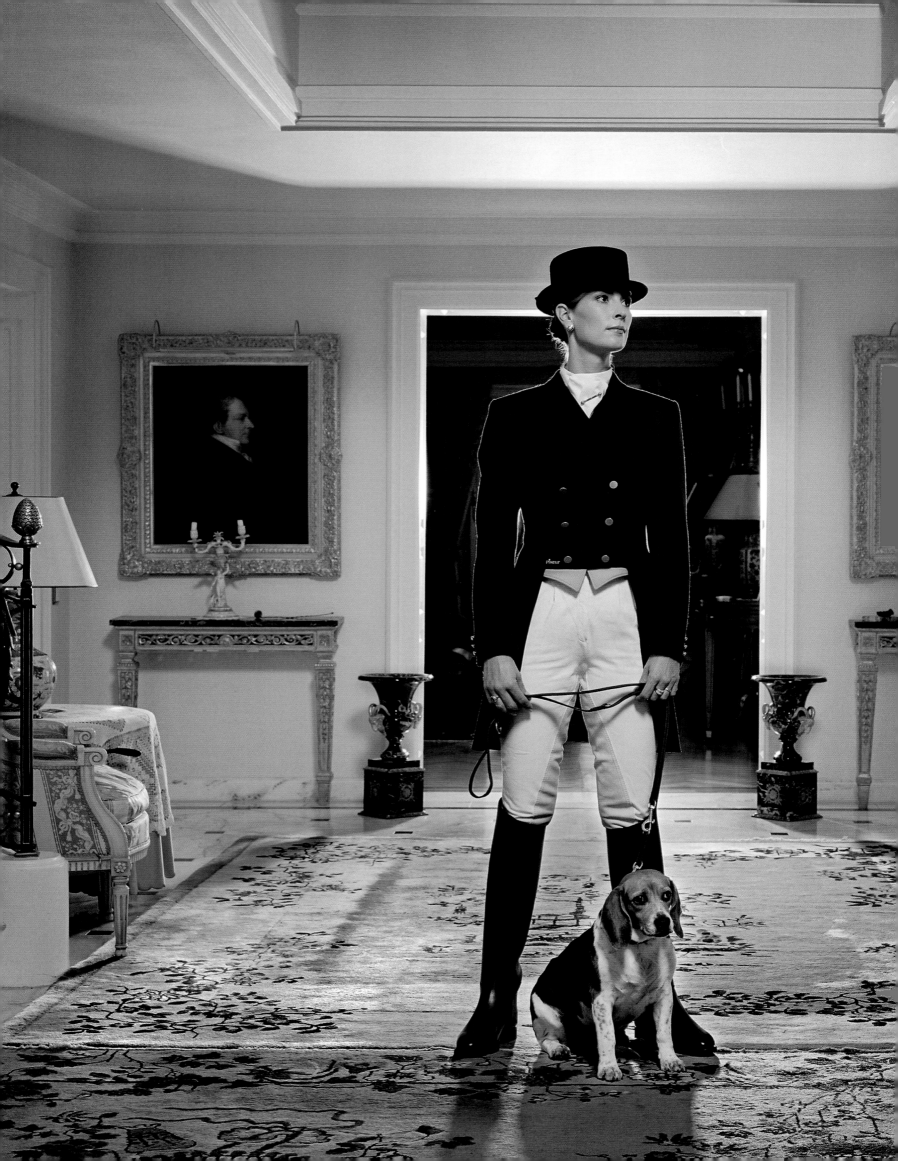

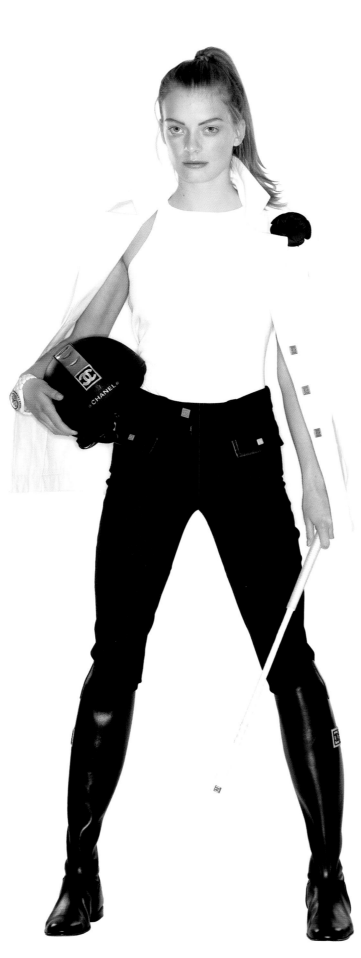

Lady's riding crop,
F. M. Allen

Dress code: each equestrian sport requires the appropriate outfit. On the left the classical outfit of a dressage rider by Pikeur, boots by Cavallo, on the right however, the outfit of a show jumper by Chanel.

Dresscode: Jede Reitsportart verlangt nach geeigneter Kleidung. Links das klassische Outfit einer Dressurreiterin von Pikeur, Stiefel von Cavallo, rechts dagegen das einer Springreiterin von Chanel.

La tenue : chaque discipline du sport équestre exige une tenue appropriée. A gauche, l'équipement classique d'une cavalière de dressage de Pikeur, bottes de Cavallo, à droite celui d'une cavalière d'obstacles de Chanel.

Reglamento de la vestimenta: Cada uno de los deportes hípicos exige una vestimenta especial. A la izquierda, el clásico modelo de una jinete de doma de Pikeur con botas de Cavallo, a la derecha la de una jinete de saltos de Chanel.

Dress code: ogni tipo di sport equestre richiede un abbigliamento adatto. A sinistra, il classico outfit di un'amazzone di dressage di Pikeur, stivali di Cavallo, a destra quello di un'amazzone di salto a ostacoli.

Saddel *Comet FS*,
Passier

Red costume,
Hermès

Horses above all else: From bed decorations to bandannas, horse themes are en vogue. The French brand Hermès started out as saddlers and has become today synonymous for noble clothing and horse accessories.

Pferde über alles: Von der Bettverzierung bis zum Halstuch, Pferdemotive sind en vogue. Die französische Marke Hermès begann als Sattelmacher und ist heute ein Synonym für edle Bekleidung und Pferdeaccessoires.

Des chevaux par-dessus tout : de la décoration du lit au foulard, les motifs de chevaux sont en vogue. La marque française Hermès a commencé dans la sellerie ; elle est aujourd'hui synonyme d'habillement distingué et d'accessoires hippiques.

El caballo por encima de todo: Desde los adornos para la cama hasta el pañuelo; los motivos ecuestres están de moda. La marca francesa Hermès comenzó como fabricante de sillas de montar y, hasta hoy, es sinónimo de ropa y accesorios ecuestres de excelente calidad.

I cavalli dappertutto: dalla testiera del letto al foulard, i motivi equestri sono en vogue. Lo stilista francese Hermès iniziò la sua carriera come sellaio; il suo nome è oggi sinonimo di abbigliamento e accessori equestri particolarmente raffinati.

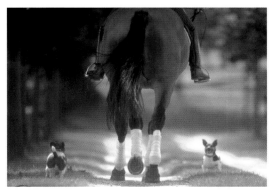

Prêt-à-porter: The latest fashion in the riding look is presented on the catwalks around the globe. Nadja Auermann is showing the fall/winter collection by Hermès.

Prêt-à-porter: Die neueste Mode im Reiterlook wird auf den Catwalks dieser Welt präsentiert. Nadja Auermann zeigt die Herbst-Winter-Kollektion von Hermès.

Prêt-à-porter : la dernière mode style cavalier est présentée sur les estrades du monde entier. Nadja Auermann présente la collection Automne-Hiver d'Hermès.

Prêt-à-porter: La moda más novedosa con *look* de jinete se presenta en las pasarelas de todo el mundo. Nadja Auermann muestra la colección otoño-invierno de Hermès.

Prêt-à-porter: le passerelle del settore presentano la moda di stile equestre più attuale. Nadja Auermann indossa la collezione Hermès autunno-inverno.

Bracelet, Adam Levinson

Shoes, Gucci

Bag, Gucci

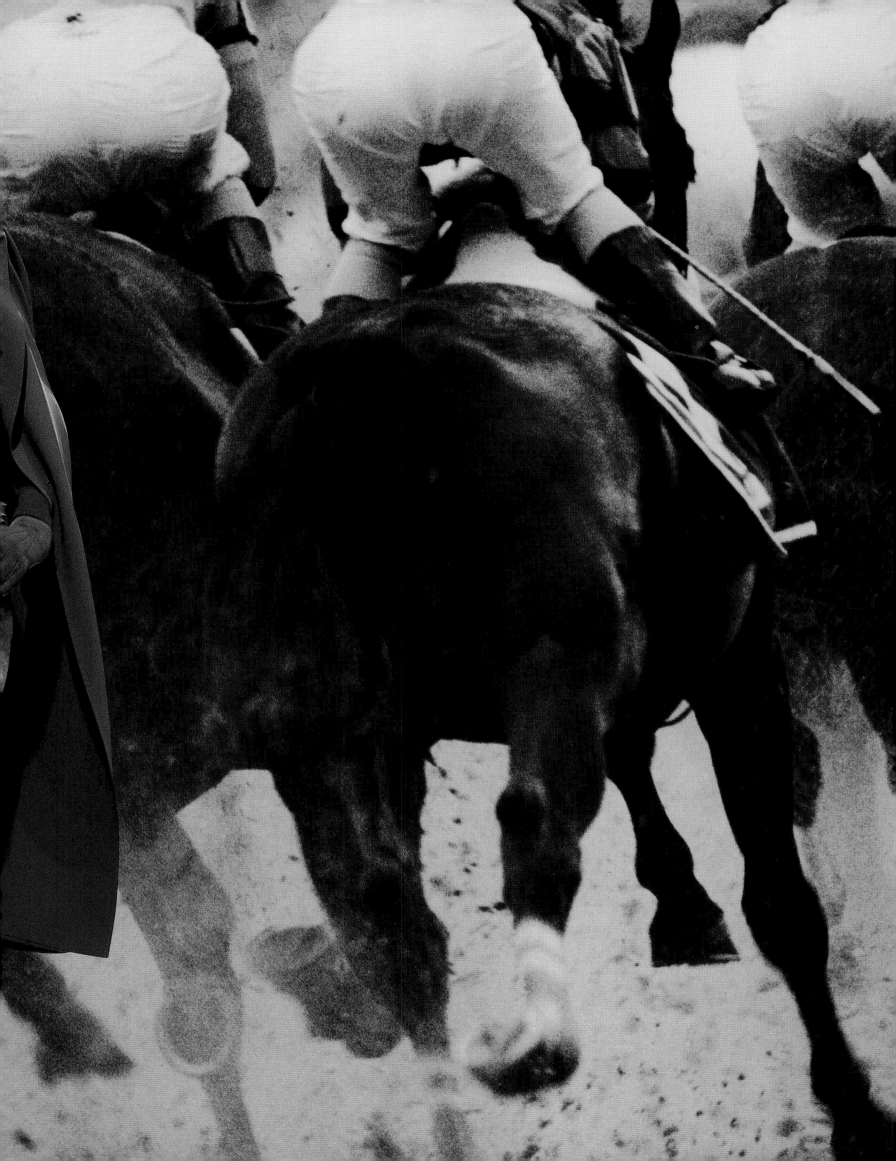

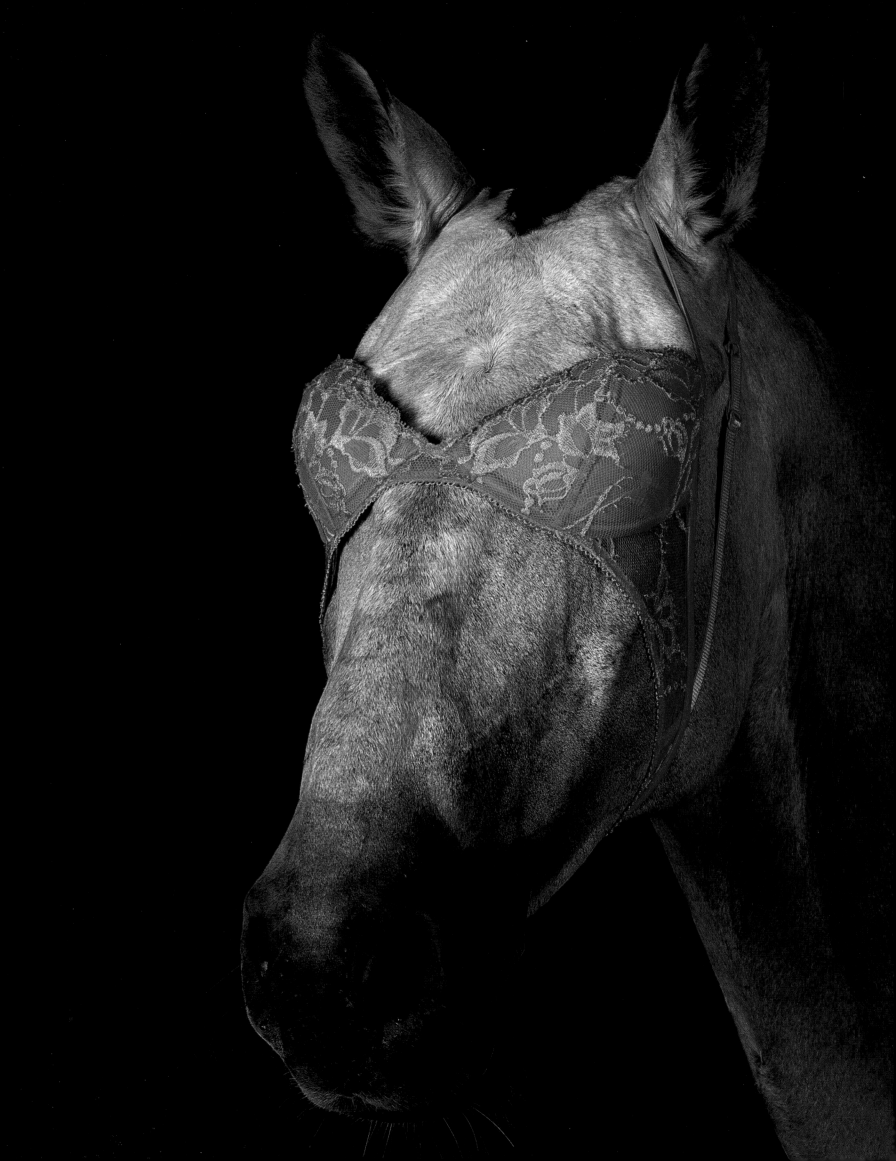

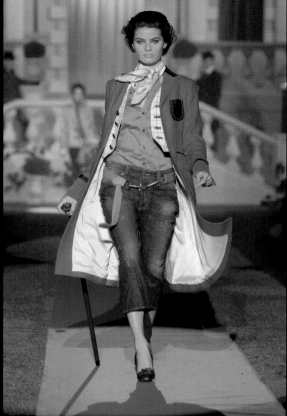
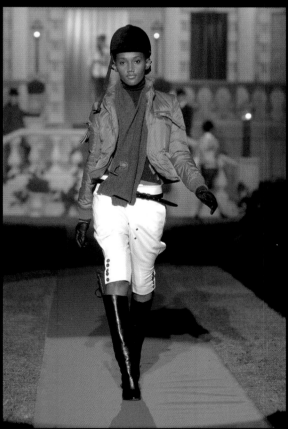
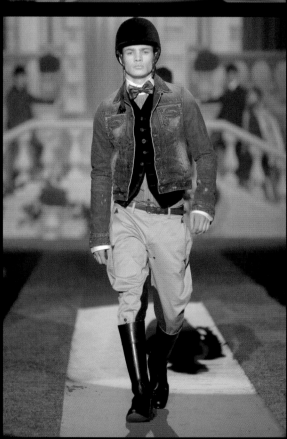

Catwalk: Jeans fashion by the Italian brand Dsquared.

Laufsteg: Jeansmode der italienischen Marke Dsquared.

Podium : la mode en jean de la marque italienne Dsquared.

Pasarela: Moda vaquera de la marca italiana Dsquared.

Sfilata: moda jeans della marca italiana Dsquared.

Horses as advertising means: Lingerie by La Perla presented in an unusual way.

Das Pferd als Werbeträger: Dessous von La Perla einmal ungewöhnlich präsentiert.

Le cheval comme support publicitaire : dessous de La Perla, présentés pour une fois de façon inhabituelle.

El caballo como medio publicitario: Ropa interior de La Perla presentada de una forma poco usual.

Il cavallo come veicolo pubblicitario: dessous di La Perla indossati in maniera insolita.

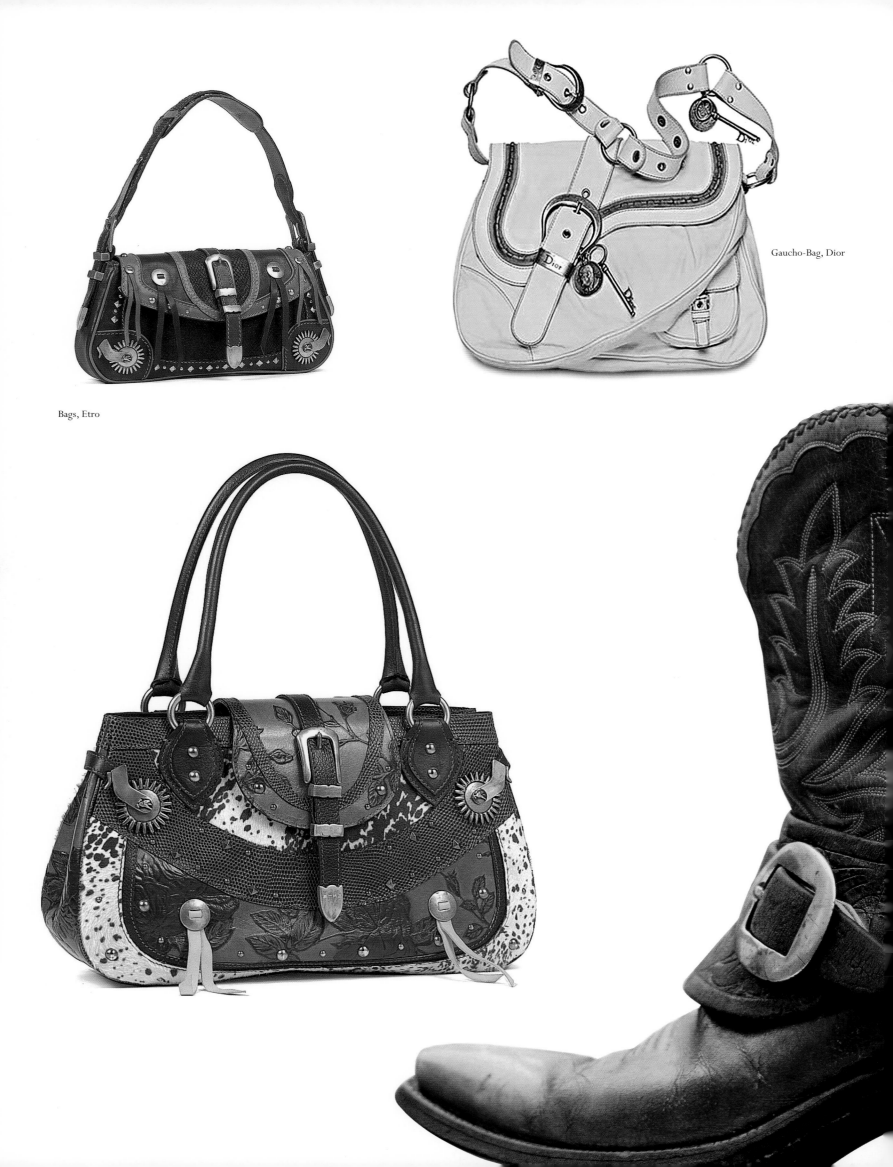

Gaucho-Bag, Dior

Bags, Etro

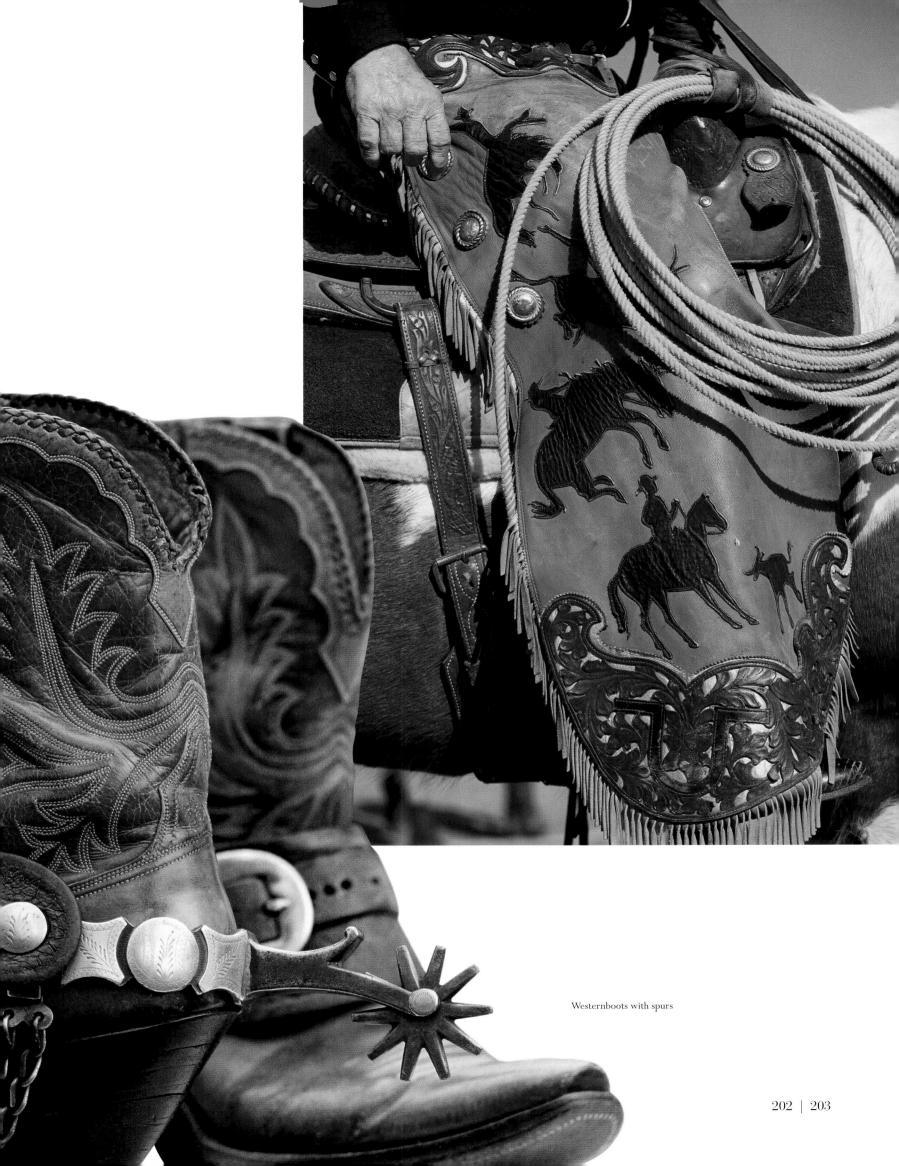

Westernboots with spurs

Luxury Hotel: Before the time of telegraphs, messengers on horseback transported news and letters. A former postal coaching station in Colorado (previous page), where horseback messengers changed their horses and rested, is today the luxurious *Dunton Hot Springs* hotel, inviting visitors to relax and to ride.

Luxus-Hotel: Als es noch keine Telegraphen gab, überbrachten berittene Boten Nachrichten und Briefe. Eine ehemalige Poststation in Colorado (vorherige Seite), an der die Postreiter ihre Pferde wechselten und Rast machten, ist heute das luxuriöse Hotel *Dunton Hot Springs*, das zum Relaxen und Reiten einlädt.

Hôtel de luxe : quand le télégraphe n'existait pas, c'était des messagers à cheval qui transmettaient les nouvelles et les lettres. Un ancien relais de poste dans le Colorado (page précédente), où les cavaliers de la poste faisaient une halte pour changer de chevaux, est devenu l'hôtel de luxe *Dunton Hot Springs*, propice à la détente et à l'équitation.

Hotel de lujo: Cuando aún no existía el telégrafo, los carteros jinetes se encargaban de transportar las noticias y las cartas. Una antigua estación de correos en Colorado (página anterior), donde los jinetes cambiaban los caballos y descansaban, es hoy el lujoso hotel *Dunton Hot Springs*, que invita a relajarse y a montar a caballo.

Hotel di lusso: quando ancora non esistevano i telegrafi, i messaggi e la posta venivano recapitati da corrieri a cavallo. La foto nella pagina precedente mostra un'ex-stazione di posta nel Colorado, dove i corrieri cambiavano il cavallo e facevano una sosta per ristorarsi; oggi, al suo posto si trova il lussuoso hotel *Dunton Hot Springs*, che invita al relax e all'equitazione.

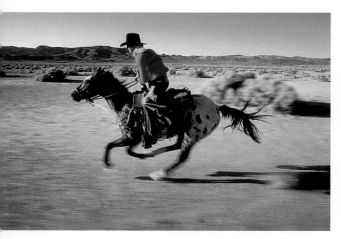

Pony Express: A ride in memory of the legendary horseback postmen.

Pony-Express: Ein Ritt zur Erinnerung an die legendären, berittenen Postboten.

Le Pony-Express : une promenade en souvenir des légendaires facteurs à cheval.

Pony-Express: Una cabalgada en memoria de los legendarios carteros a caballo.

Pony express: una cavalcata in ricordo dei leggendari corrieri a cavallo.

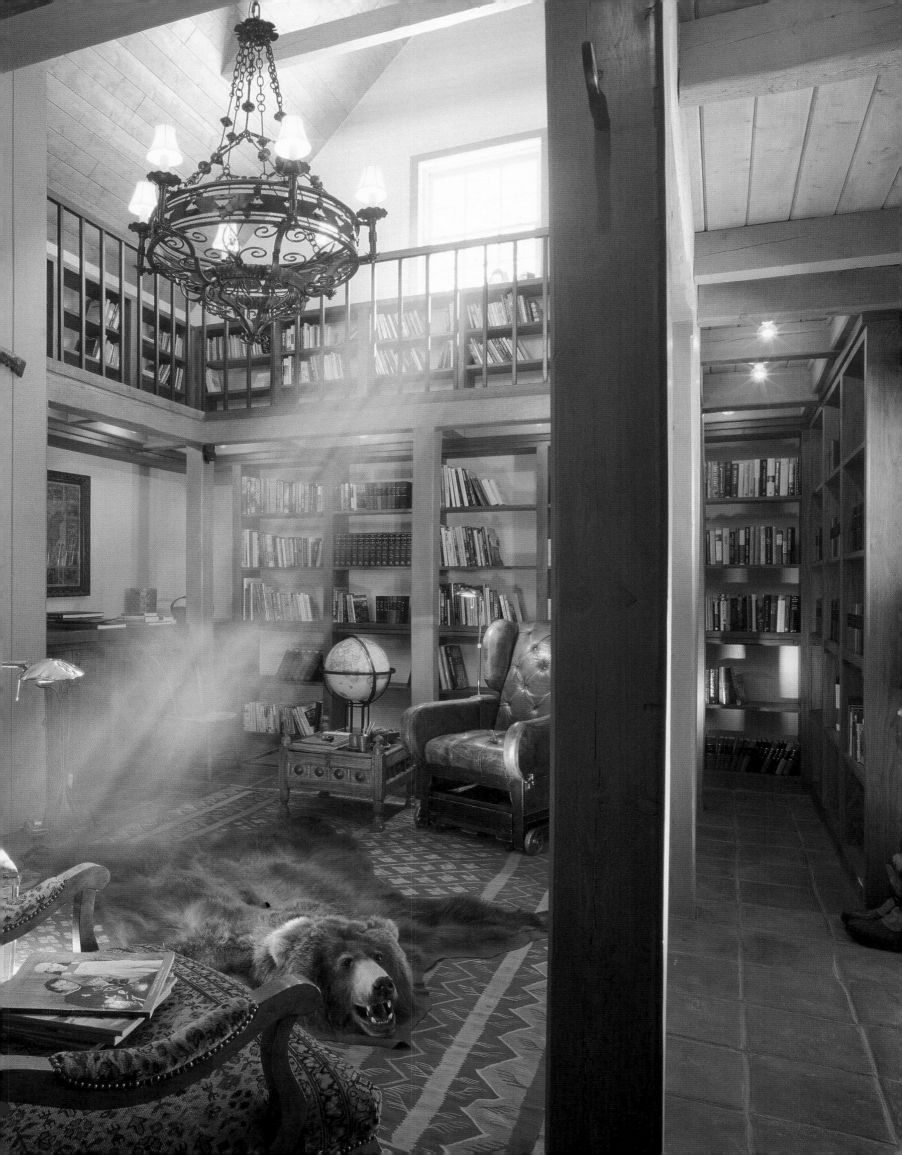

Horse trailer: In 1956, Anton Böckmann together with his wife Brigitte founded the Böckmann company in Lastrup in the Oldenburg region. The corporation manufactures custom-made trailers.

Pferdeanhänger: 1956 gründete Anton Böckmann gemeinsam mit seiner Ehefrau Brigitte die Firma Böckmann im oldenburgischen Lastrup. Das Unternehmen fertigt Anhänger nach Maß.

Vans : en 1956, Anton Böckmann a fondé, avec son épouse Brigitte, la société Böckmann à Lastrup, près d'Oldenburg. L'entreprise fabrique des vans sur mesure.

Caravanas para caballos: En 1956, Anton Böckmann fundó junto con su mujer Brigitte la compañía Böckmann en Lastrup, Oldemburgo. La empresa fabrica caravanas a medida.

Rimorchi per cavalli: nel 1956, insieme a sua moglie Brigitte, Anton Böckmann ha fondato a Lastrup, nella circoscrizione di Oldenburg, la ditta Böckmann. La ditta produce rimorchi per cavalli su misura.

Horse power: Ferrari and Porsche both carry horses in their logos—the symbol of strength and speed. These qualities also distinguish Quarter Horse stallions.

Pferdestärken: Ferrari und Porsche tragen ein Pferd im Wappen – das Symbol für Stärke und Schnelligkeit. Qualitäten, die im Besonderen auch den Quarter-Horse-Hengst auszeichnen.

De puissants chevaux : Ferrari et Porsche portent un cheval sur leur blason – symbole de puissance et de rapidité. Des qualités qui distinguent notamment les étalons Quarter horse.

Caballos de potencia: Ferrari y Porsche tienen un caballo en su blasón, símbolo de fuerza y velocidad. Cualidades que caracterizan también de forma especial al semental Quarter Horse.

HP: l'emblema della Ferrari e della Porsche raffigura un cavallo, simbolo di forza e velocità, qualità che si addicono anche agli stalloni Quarter Horse.

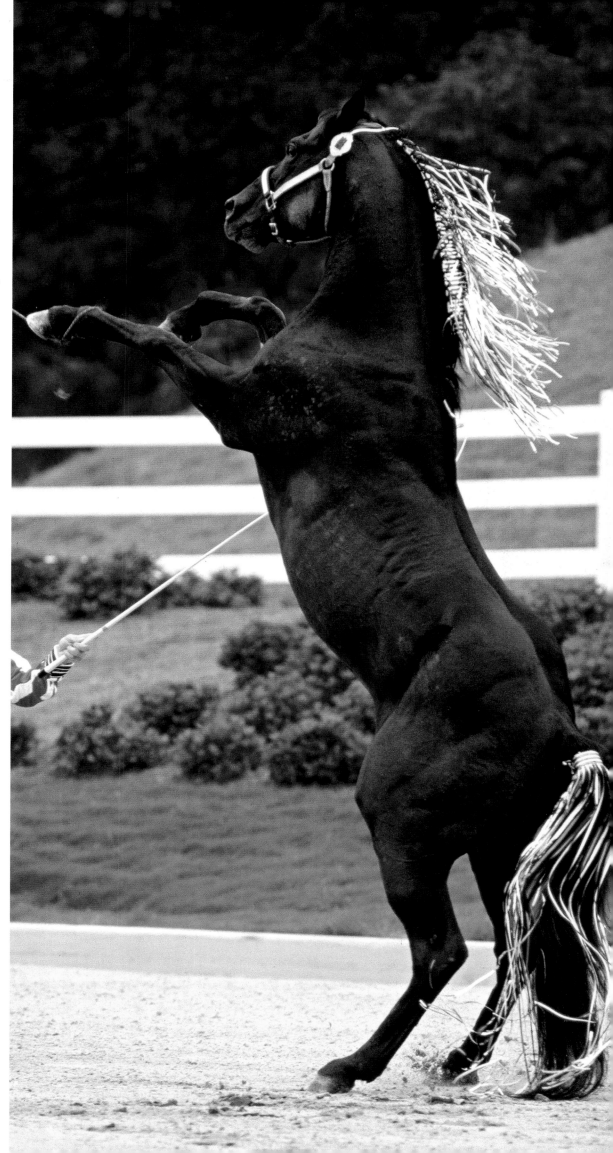

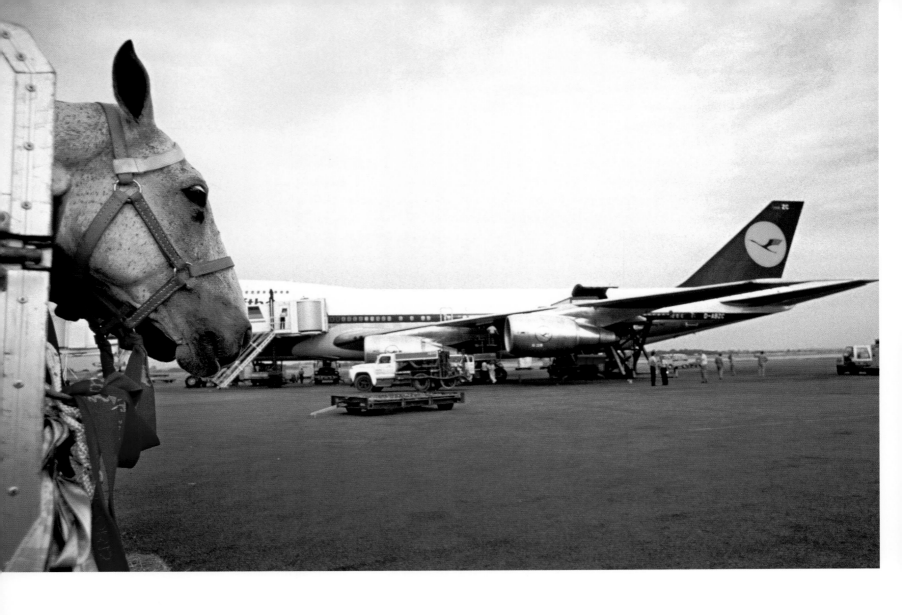

Spats

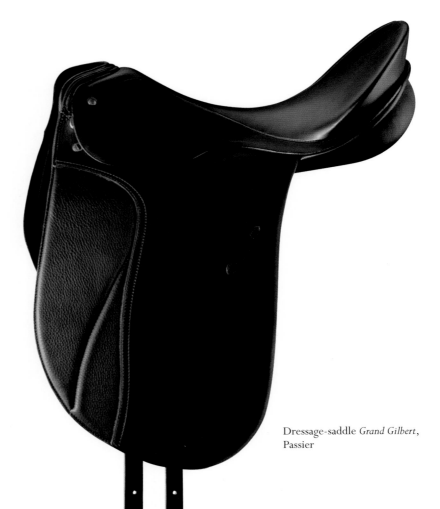

Dressage-saddle *Grand Gilbert*,
Passier

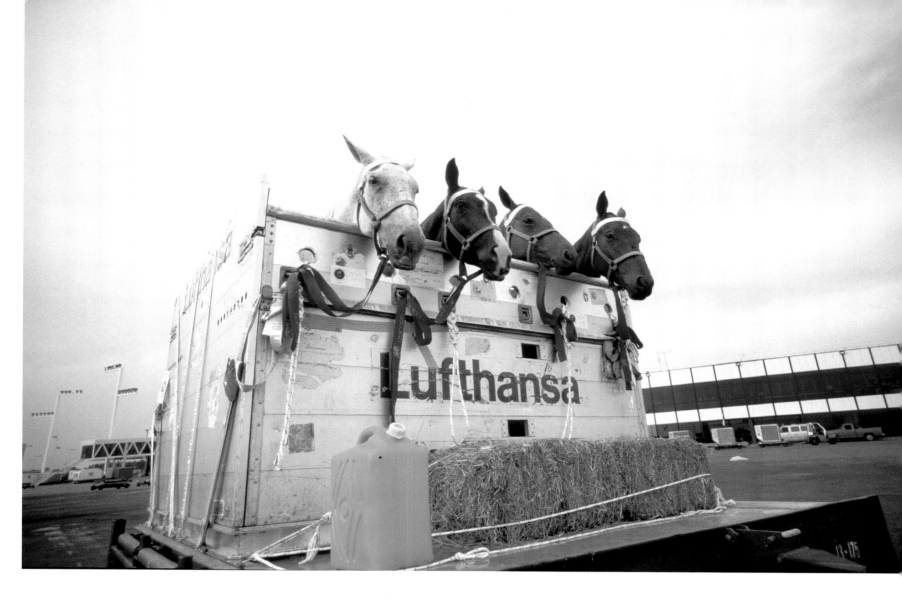

Take-off: Tournament horses nowadays travel like managers. Lufthansa Airlines is among the world's largest horse transporters. The animals travel in especially-constructed transportation boxes.

Abflug: Turnierpferde reisen heute wie die Manager. Die Lufthansa gehört zu den größten Pferdetransporteuren der Welt. Die Tiere fliegen in eigens dafür gefertigten Verlade-Boxen.

Envol : les chevaux de concours voyagent aujourd'hui comme les P.D.G. La Lufthansa fait partie des transporteurs de chevaux les plus importants au monde. Les animaux voyagent en avion dans des box spécialement conçus pour le chargement.

Despegue: Los caballos que participan en los torneos viajan hoy como los ejecutivos. Lufthansa pertenece a las mayores empresas que transportan caballos. Los animales vuelan en boxes especialmente fabricados para ellos.

In volo: oggi i cavalli da concorsi si spostano come manager. La Lufthansa è una delle compagnie più utilizzate del mondo per il trasporto dei cavalli, che viaggiano in appositi box di carico.

Saddle *Optimum*, Passier

Solid seating: The saddle manufacturers Stübben in Krefeld was established in 1894. This is a trade with a long tradition. To this day, all saddle parts that are subject to heavy use—such as the saddle seat, saddle cushion, and stirrup straps—are sewn by hand.

Fester Sitz: Der Sattelhersteller Stübben in Krefeld besteht seit 1894. Das Handwerk hat Tradition: Noch heute werden alle stark beanspruchten Teile des Sattels – wie Sattelsitz, Sattelkissen, Strupfen – von Hand genäht.

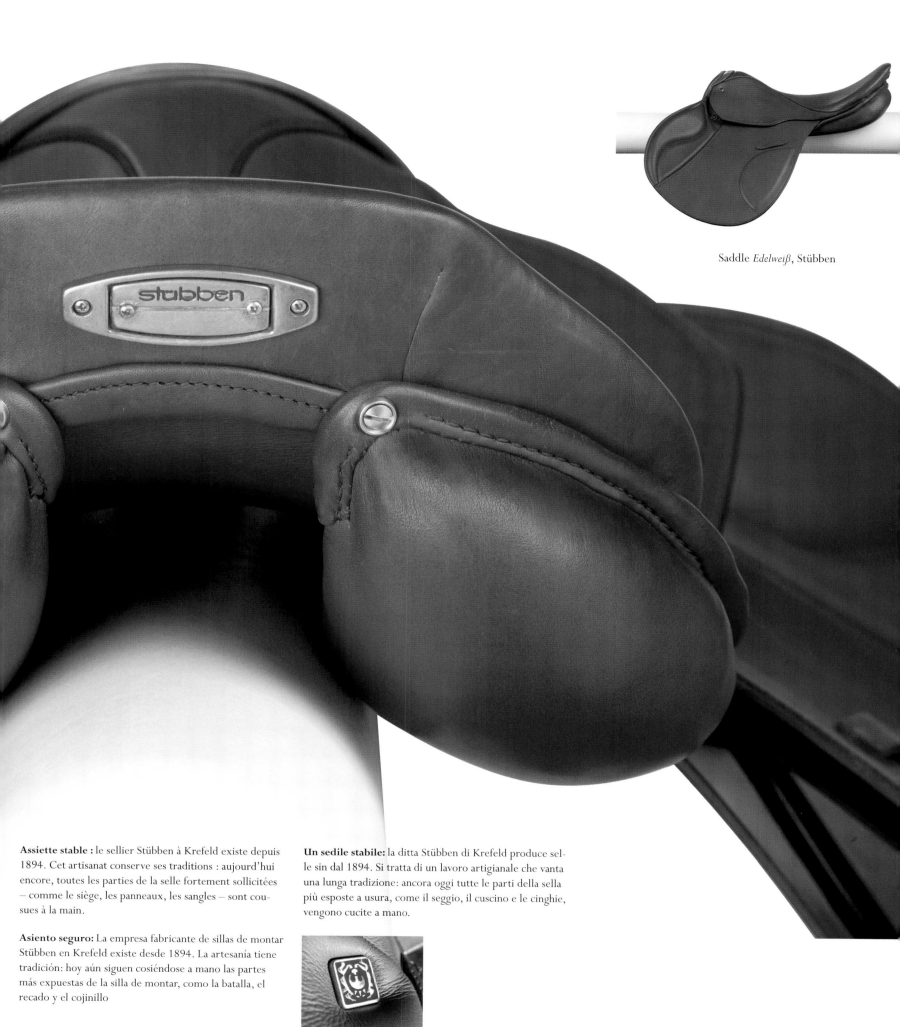

Saddle *Edelweiß*, Stübben

Assiette stable : le sellier Stübben à Krefeld existe depuis 1894. Cet artisanat conserve ses traditions : aujourd'hui encore, toutes les parties de la selle fortement sollicitées – comme le siège, les panneaux, les sangles – sont cousues à la main.

Asiento seguro: La empresa fabricante de sillas de montar Stübben en Krefeld existe desde 1894. La artesanía tiene tradición: hoy aún siguen cosiéndose a mano las partes más expuestas de la silla de montar, como la batalla, el recado y el cojinillo

Un sedile stabile: la ditta Stübben di Krefeld produce selle sin dal 1894. Si tratta di un lavoro artigianale che vanta una lunga tradizione: ancora oggi tutte le parti della sella più esposte a usura, come il seggio, il cuscino e le cinghie, vengono cucite a mano.

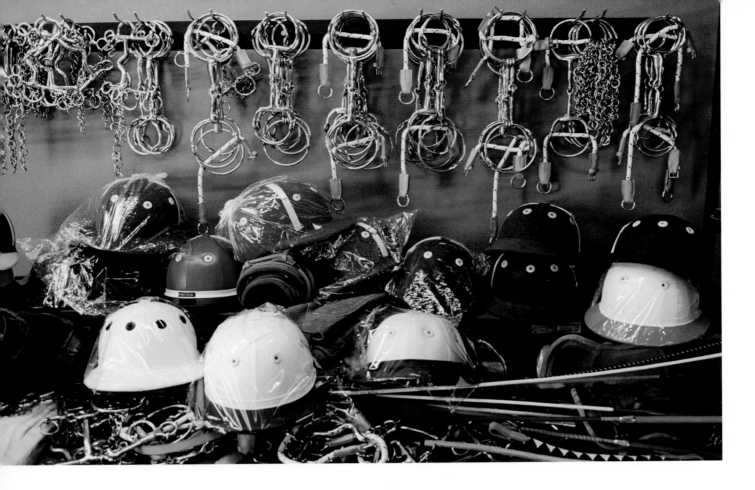

Free hit: Argentinean manufacturer *La Martina* is the best-known brand for polo outerwear. In addition to national teams such as that of Argentina and Germany, *La Martina* also provides uniforms for the teams of the universities of Harvard, Yale, Oxford and Cambridge.

Abschlag: Der argentinische Hersteller *La Martina* ist die bekannteste Marke für Polobekleidung. *La Martina* stattet neben Nationalteams, wie das von Argentinien und von Deutschland, auch die Teams der Universitäten von Harvard, Yale, Oxford und Cambridge aus.

Distribution : le fabricant argentin *La Martina* est la marque la plus connue pour les tenues de polo. Outre les équipes nationales telles que celle d'Argentine et d'Allemagne, *La Martina* fournit également les équipes des universités de Harvard, Yale, Oxford et Cambridge.

Saque: El fabricante argentino *La Martina* es la marca más famosa para la ropa de polo. *La Martina* equipa a equipos nacionales, como el de Argentina y Alemania, y a equipos de universidades como Harvard, Yale, Oxford y Cambridge.

Tiro: la ditta argentina *La Martina* è la marca più conosciuta di abbigliamento da polo. Oltre a squadre nazionali, come quella argentina e quella tedesca, *La Martina* equipaggia anche le squadre delle università di Harvard, Yale, Oxford e Cambridge.

Picnic-case, Burberry

Polo-boots, Santoni

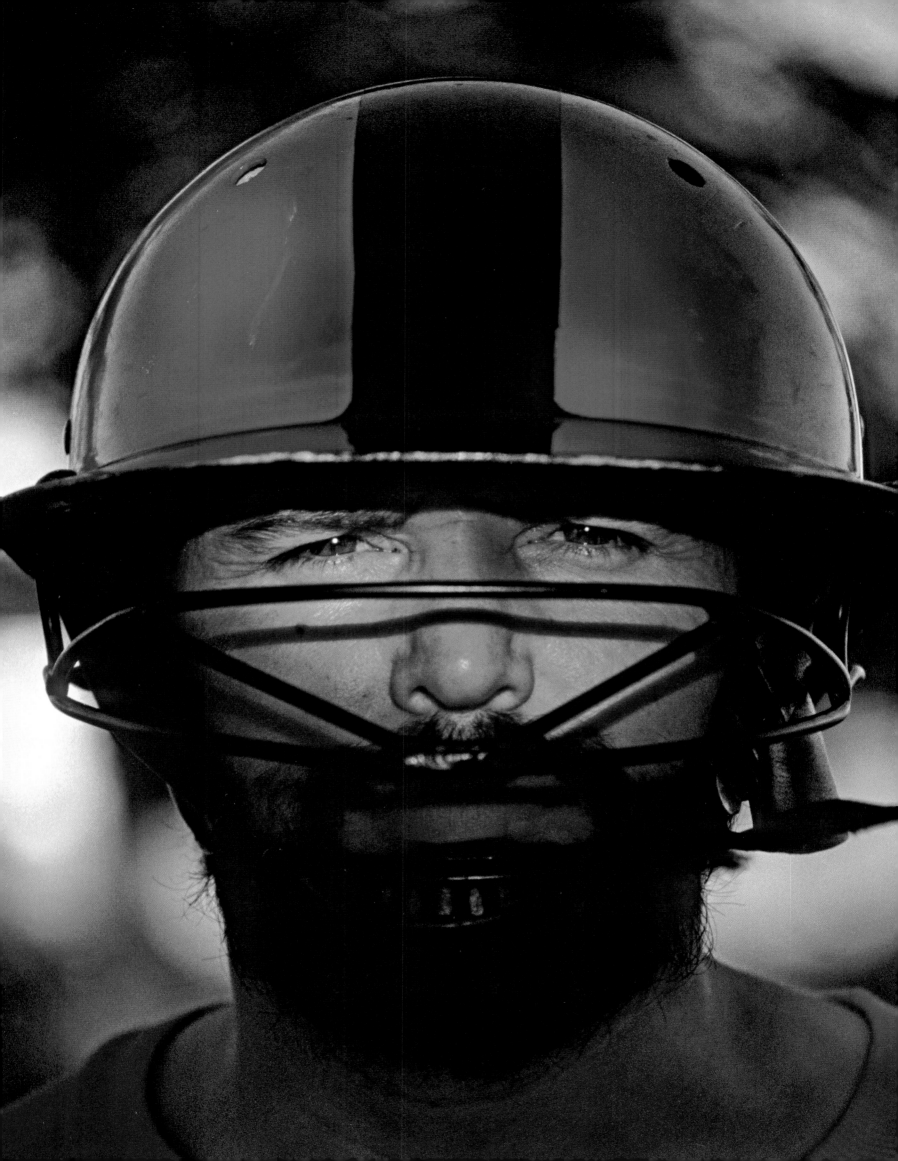

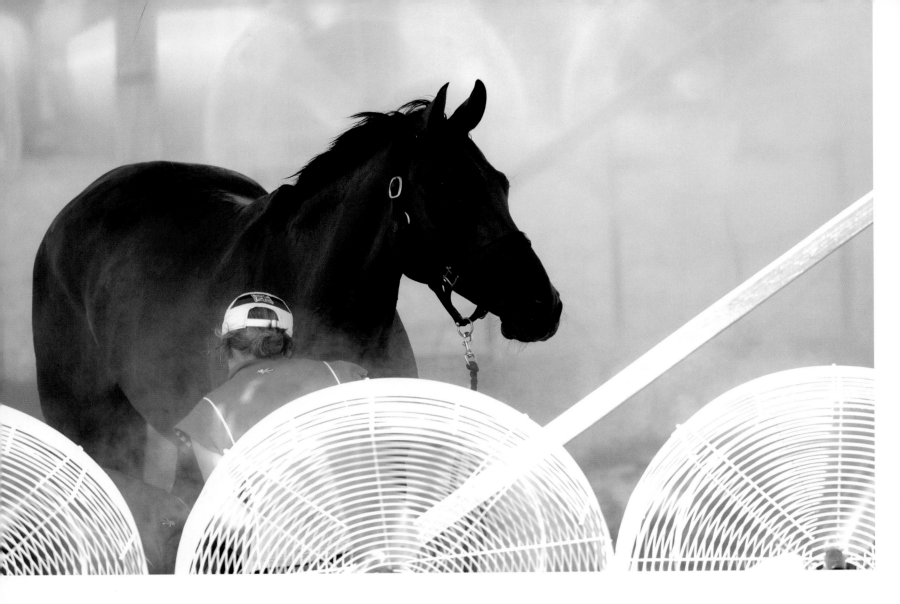

Refreshment: During the Olympic Games, horses are being dried, wind machines provide the animals with cool air.

Abkühlung: Bei den Olympischen Spiele werden die Pferde getrocknet, Windmaschinen fächern den Tieren Luft zu.

Rafraîchissement : lors des Jeux Olympiques, les chevaux sont séchés, des ventilateurs éventent les animaux.

Refrescante: Durante los Juegos Olímpicos los caballos se secan, ventiladores dan aire a los animales.

Rinfresco: ai giochi olimpici i cavalli vengono asciugati, mentre l'aria dei ventilatori li rinfresca.

Shampoo and conditioner, Kiehl's

Care accessories: The horses are cared for with shampoos and creams while blankets protect them from all weather conditions.

Pflege-Accessoires: Mit Shampoos und Cremes werden die Pferde gepflegt, Decken schützen sie bei jeder Witterung.

Accessoires de toilette : les chevaux sont toilettés avec des shampooings et des crèmes et protégés de toute intempérie par des couvertures.

Accesorios para el cuidado: Champús y cremas para el cuidado de los caballos, y mantas que los protegen en las tormentas que los protegen de las inclemencias del tiempo.

Accessori per la cura: per la cura dei cavalli si utilizzano shampoo e creme; per proteggerli dalle intemperie, gli animali vengono avvolti in coperte.

Boots, Ludwig Reiter

Saddle (on the right), Hermès

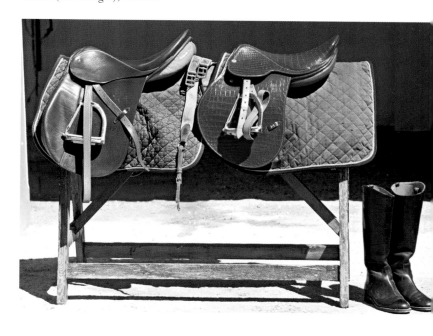

Noble residence: An Argentinean Polo Estancia, that also offers rooms for visitors.

Nobelherberge: Eine argentinische Polo-Estancia, die auch Zimmer für Besucher hat.

Auberge raffinée : une estancia argentine de polo qui propose également des chambres pour les visiteurs.

Un elegante albergue: Una estancia argentina de polo que también tiene habitaciones para los visitantes.

Lussuoso rifugio: una estancia argentina per il gioco del polo, con camere a disposizione degli ospiti.

Shockproof: This Reverso watch by Jaeger-LeCoultre was especially designed for the sport of polo. The casing can be pulled out and turned around to protect the glass from damages. The luxury brand Baldessarini offers luxurious headwear, cuff links and key chains.

Schlagsicher: Diese Reverso-Uhr von Jaeger-LeCoultre wurde eigens für den Polosport konzipiert: Das Gehäuse lässt sich herausziehen und umdrehen, damit das Glas keinen Schaden nimmt. Auch die Luxusmarke Baldessarini bietet luxuriöse Kopfbedeckungen, Manschettenknöpfe und Schlüsselanhänger.

Antichoc : cette montre Reverso de Jaeger-LeCoultre a été spécialement conçue pour le polo. Le boîtier se dégage et se retourne pour éviter que le verre ne soit endommagé. La marque de luxe Baldessarini propose également des couvre-chefs, des boutons de manchette et des porte-clés luxueux.

Cristal de seguridad: Este reloj reversible de Jaeger-LeCoultre ha sido especialmente diseñado para el polo. La caja puede sacarse y girarse para que el cristal no resulte dañado. La marca de lujo Baldessarini también ofrece gorras, gemelos y llaveros.

A prova di colpo: questo orologio reversibile di Jaeger-LeCoultre è stato appositamente creato per lo sport del polo. La cassa può essere estratta e capovolta per proteggere il vetro dai colpi. Anche la prestigiosa marca Baldessarini propone eleganti cappelli da fantino, gemelli e portachiavi.

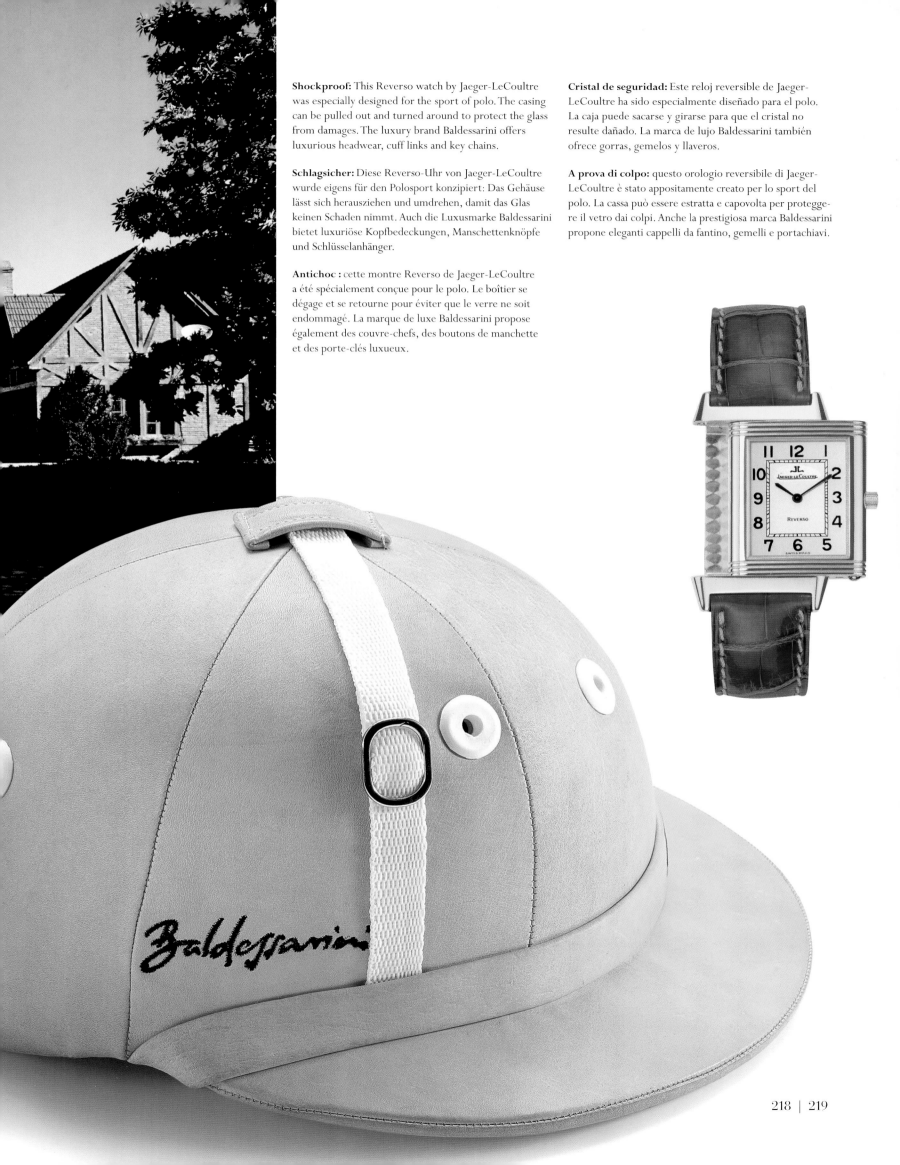

IMPRINT
IMPRINT

Editor: Wolfgang Behnken,
www.funk-behnken.de

Art Director: Wolfgang Behnken/Funk + Behnken

Layout: Constanze Lemke/Funk + Behnken
Aline Hoffbauer/querformat design

Picture Research: Petra Unbehaun/Funk + Behnken
Sonja Himmelberg/Corbis

Text Translations: Emanuel Eckardt, Gerald Drißner
SAW Communications,
Dr. Sabine A. Werner, Mainz
Cosima Talhouni (English)
Brigitte Villaumié (French)
Silvia Gómez de Antonio (Spanish)
Maria-Letizia Haas (Italian)

Editorial Coordination: Nina Tebartz
Edited by: Andreas Feßer, Ricarda Hausen,
Arndt Jasper, Kristina Krüger,
Fjona Stühler, Nina Tebartz,
Sabine Wagner

© 2006 teNeues Verlag GmbH + Co. KG, Kempen

Production by Nele Jansen, teNeues Verlag
Color Separation by Laudert GmbH + Co. KG, Vreden

Photo Credits

Bilderberg, www.bilderberg.de
p 36-37, 44-47, 58-59, 82-84, 110-111, 162-165,
172-175, 176 (photo no. 4, 7), 178-181, 188,199,
209 left column, 211 right column, 215, 217 photo top

Corbis, www.corbis.com
p 10-18 (Yann Arthus-Bertrand), 51-57, 64-71, 80 photo
top, 85, 86 photo right, 87, 88-89, 91 photo bottom, 92-
95, 98,106-109,130-131, 136-137 Reuters,138-139, 176
(photo no.7), 177, 203, 206 photo bottom, 208, 209

Aline Coquelle, p 142-145, 150-151

Aline Coquelle/ Laif / Figaro Magazine, www.laif.de
p 146-149,152-155, 214 photo top, 218-219

Melissa Farlow, www.melissafarlow.com, p 18-35

Agentur Focus, www.agentur-focus.de
p 38-39 (Florian Wagner), 40-43 (Richard Allenby-Pratt),
48-49 (Hans Silvester), 50 (Harf Zimmermann),
72-73 (Richard Allenby-Pratt), 74,75, 80 photo bottom
(Martin Parr), 76-77 (Carl De Keyzer), 78-79 (Patrick
Zachmann), 81 (Steve McCurry), 86 (Jonathan Becker),
90 (Glyn Kirk), 91(Steve Bardens), 96, 97 (Ian Berry),
140-141 (Matthew Clarke)

Reinhard Hunger, www.reinhard-hunger.de, p 200

Stefan Pielow/Agentur Focus, www.pielowphoto.com,
p 194, 196

Jan Riephoff/Agentur Focus, www.janriephoff.com
p 156-157, 158-159, 160-161

Jaques Toffi, www.toffi-images.de
p 104, 112-129, 132-135, 197 photo bottom, 210 photo
bottom, 216 photo top, 220

White Star, www.whitestar.de
p 60-63, 166-171,190-193, 217 photo bottom

**White Star/© EXPASA-Yeguada de la Cartuja-Hierro
del Bocado**, p 2, 6-7, 182-187, cover photo
Yeguada de la Cartuja-Hierro del Bocado: all rights reserved
by EXPASA - Agricultura y Ganaderia S.A.

Fashion & Accessories
p 195 Gucci, www.gucci.com
p 195 Passier, www.passier.de
p 195, 210, 211, 212-213 Stübben, www.stuebben.de
p 198 Andrea Levine, www.andrealevinejewelry.com
p 201 Dsquared, www.dsquared2.com
p 202 Etro, www.etro.it
p 202 Dior, www.dior.com
p 204-207 Dunton Hot Springs, www.duntonhotsprings.com
p 208 Böckmann, www.boeckmann.com
p 214 Burberry, www.burberry.com
p 214 Santoni, www.dailyshoes.de
p 216 Kiehl's, www.kiehls.com
p 216-217 Ludwig Reiter, www.ludwig-reiter.com
p 218-219 Baldessarini, www.baldessarini.com
p 219 Jaeger-LeCoultre, www.jaegerlecoultre.com

Madame Figaro/Laif, www.laif.de
p 197 Renaud Wald
p 198 Anacleto Carraro

Published by teNeues Publishing Group

teNeues Verlag GmbH + Co. KG
Am Selder 37, 47906 Kempen, Germany
Tel.: 0049 / 2152 / 916 - 0
Fax: 0049 / 2152 / 916 - 111

Press department: arehn@teneues.de
Tel.: 0049 / 2152 / 916 - 202

teNeues Verlag International Sales Division
Speditionstraße 17, 40221 Düsseldorf, Germany
Tel.: 0049 / 211 / 99 45 97 - 0
Fax: 0049 / 211 / 99 45 97 - 40

teNeues Publishing Company
16 West 22nd Street, New York, N.Y. 10010, USA
Tel.: 001 / 212 / 627 9090
Fax: 001 / 212 / 627 9511

teNeues Publishing UK Ltd.
P.O. Box 402, West Byfleet, KT14 7ZF, Great Britain
Tel.: 0044 / 1932 / 403509
Fax: 0044 / 1932 / 403514

teNeues France S.A.R.L.
4, rue de Valence, 75005 Paris, France
Tel.: 0033 / 1 / 55766205
Fax: 0033 / 1 / 55766419

teNeues Ibérica S.L.
c/ Velázquez, 57 6.° izda., 28001 Madrid, Spain
Tel.: 0034 / 657 / 132133

teNeues Representative Office Italy
Via San Vittore 36/1, 20123 Milan, Italy
Tel.: 0039 / (0)347 / 7640551

www.teneues.com

Bibliographic information published by Die Deutsche
Bibliothek.
Die Deutsche Bibliothek lists this publication in the
Deutsche Nationalbibliografie; detailed bibliographic data is
available in the Internet at http://dnb.ddb.de.

ISBN-10: 3-8327-9144-2
ISBN-13: 978-3-8327-9144-5

Printed in Italy